P9-DTN-423

STARSTRUCK
IN THE
PROMISED
LAND

STARSTRUCK IN THE PROMISED LAND

HOW THE ARTS SHAPED

AMERICAN PASSIONS ABOUT ISRAEL

Shalom Goldman

The University of North Carolina Press ★ Chapel Hill

This book was published with the assistance of the Authors Fund
of the University of North Carolina Press.

Designed by April Leidig
Set in Garamond by Copperline Book Services, Hillsborough, NC

The University of North Carolina Press has been a member of
the Green Press Initiative since 2003.

Cover illustrations: Paul Newman in the movie *Exodus* (1960, directed
by Otto Preminger), ScreenProd/Photononstop/Alamy Stock Photo.
Jerusalem at sunset, © iStockphoto.com/Doctor_J.

Library of Congress Cataloging-in-Publication Data
Names: Goldman, Shalom, author.
Title: Starstruck in the Promised Land : how the arts shaped American passions
 about Israel / Shalom Goldman.
Description: Chapel Hill : University of North Carolina Press, [2019] |
 Includes bibliographical references and index.
Identifiers: LCCN 2018059435| ISBN 9781469652412 (cloth : alk. paper) |
 ISBN 9781469652429 (ebook)
Subjects: LCSH: United States—Relations—Israel. | Israel—Relations—United
 States. | Popular culture—Political aspects—United States—History—
 20th century. | Artists—Political activity—United States—History—
 20th century. | Christian Zionism—United States—History—20th century.
Classification: LCC E183.8.I7 G66 2019 | DDC 327.7305694—dc23
 LC record available at https://lccn.loc.gov/2018059435

Once again, for Laurie

I don't usually read novels. But I read *Exodus*. As a literary work, it isn't much. But as a piece of propaganda, it's the greatest thing ever written about Israel.—David Ben Gurion

CONTENTS

1 INTRODUCTION

Israel and America:
Sharing the World Stage and
the Performing Arts Stage

10 CHAPTER ONE

Sailing to Jerusalem:
From the Early American Romance with
the Holy Land to Palestine Mania (1817–1917)

31 CHAPTER TWO

American Journalists, Artists, and Adventurers
and the Zionist Movement (1917–1947)

55 CHAPTER THREE

Mozart in the Desert:
The American Creative Class and
the Birth of Israel (1947–1957)

74 CHAPTER FOUR

Advocates for Zion:
Sinatra, Steinbeck, Baldwin,
and Bellow (1957–1967)

103 CHAPTER FIVE

Of Poets, Singers, and a Young Medic:
Israel's Battles and America's
Culture Wars (1967–1977)

131 CHAPTER SIX

Israel at Thirty:
Political Action, Messianic Expectations,
and Literary Controversies (1977–1997)

157 CHAPTER SEVEN

Cross-Cultural Admiration and Upheaval:
Three Divas and Bitter Critiques (1997–2017)

192 EPILOGUE

Israel at Seventy, Dancing on a World Stage

199 Notes

211 Bibliography

229 Index

FIGURES AND MAP

FIGURES

30 The title page of *The Cruise of the Eight Hundred to and Through Palestine*

36 The Jerusalem YMCA

64 Leonard Bernstein performing with the Israel Philharmonic

77 Paul Newman on the set of the film *Exodus*

85 Frank Sinatra listening to President Ephraim Katzir

121 Johnny Cash and June Carter Cash with Prime Minister Menachem Begin

160 Madonna and Guy Ritchie with President Shimon Peres

167 Whitney Houston and Bobby Brown at the Damascus Gate

185 Bob Dylan at the Western Wall

MAP

12 Biblical place-names in New England

STARSTRUCK

IN THE

PROMISED

LAND

Israel and America

Sharing the World Stage and the Performing Arts Stage

I N THE FILM *Walk the Line* (2005), the singer Johnny Cash struggles with depression, substance abuse, and other occupational hazards of stardom. What the film doesn't tell us is that his partner, June Carter, was convinced that only in Israel, the land where Jesus had walked the earth, would Johnny free himself of his demons. This idea came to her in a dream in which she saw Johnny Cash standing on a mountain in Galilee, preaching to the multitudes with a Bible in his hand. June understood the dream to mean that the man she loved could be saved from the demons of addiction only if he were to walk in Jesus's footsteps—not just metaphorically, but literally. So when Johnny proposed to June onstage at a concert in Ontario in February 1968, she accepted on the condition that they honeymoon in Jerusalem. A few months later, in January 1969, they flew to Israel. While on their honeymoon, an Israeli jeweler made them wedding rings engraved with a biblical inscription from the Song of Songs: "I am my beloved's and my beloved is mine." They wore these rings for the rest of their lives.

The Cashes were among the throngs of Christian visitors from Europe and the United States who flocked to Jerusalem and Bethlehem after the Six-Day War to "walk where Jesus walked." Following that honeymoon visit, Johnny and June recorded a concept album for Columbia Records titled *In the Holy Land*, a curious but effective combination of songs about the sacred places, woven together with snippets of their sightseeing observations. Cash had documented these observations with a portable tape recorder, describing with excitement and enthusiasm what they saw as they explored the holy sites with an Israeli tour guide. Like their close friend the Reverend Billy Graham, the Cashes saw the Israeli conquest of Jerusalem in June 1967 as deeply significant; God's hand could again be seen moving in history.[1]

The Cashes' intense connection to Israel reflects a deep American interest in—even obsession with—that storied land, an interest that long preceded the 1948 establishment of the Jewish state. Perhaps the wittiest and most trenchant observation about America's affinity with that territory is Mark Twain's reflection on his own 1867 visit to the Holy Land, immortalized in his book *Innocents Abroad*: "The word Palestine always brought to my mind a vague suggestion of a country as large as the United States. I do not know why, but such was the case. I suppose it was because I could not conceive of a small country having so large a history."[2]

Anchored in an early nineteenth-century romance with the Holy Land, the American fascination with Israel is perhaps more intense than ever in the twenty-first century. But how did we get to this point? While much has been written about the diplomatic, military, and religious aspects of the special relationship between Israel and the United States, very little has been said about the mediating role that culture has played in that relationship. In fact, the soft power of the arts—including music, theater, dance, film, literature, and television—has helped shape one of the most significant and consequential relationships in the world, the relationship between the United States and Israel.

Drawing on rich veins of never-before-used materials from both the United States and Israel, this superstars-filled story shines a new spotlight on their intertwined cultural histories, for the American-Israeli relationship has played out not only on the world stage, but on actual stages. From the days of steamship travel to the Holy Land to today's era of Christian Zionist fixation on the state of Israel, some of America's greatest writers, painters, singers, actors, musicians, and dancers have traveled repeatedly to Israel to observe, record, and perform. Each decade of the travel and cultural exchange chronicled here corresponds in fascinating ways to the wider historical trajectory of Israel and its ties to the United States.

Starstruck in the Promised Land brings together this cultural history within the broader U.S.-Israel historical relationship, while in the process tracing how artists in both Israel and the United States attempted to influence ideas and policies, and it examines the extent to which these efforts succeeded or failed, as well as the unintended consequences of this mutual cultural interdependence. The Israeli stories of superstars like Frank Sinatra, Ray Charles, Johnny Cash, Barbra Streisand, Bob Dylan, Madonna, Whitney Houston, and Leonard Bernstein helped articulate, shape, and solidify the American relationship with Israel.

More specifically, in the early 1960s, we see the novelist and essayist James Baldwin spending a few weeks in Israel, writing glowingly of his experiences

there. He reflected in his diary how "the visit seems, so far, to have been a great success. Israel and I seem to like each other."[3] He returned there in the mid-1960s for the Tel Aviv performance of his Harlem-based play, *The Amen Corner*. But by the mid-1970s, Baldwin's view of Israel had changed radically. He saw its policies as an extension of the colonial legacy that was at the root of African nations' postindependence struggles. Baldwin wasn't alone in his critique; changing perceptions of American power, coupled with the harshness of the Israeli policy toward the Palestinians, altered many American artists and intellectuals' attitudes toward Israel. While the Jewish state was the darling of the political and cultural Left in the 1950s and early 1960s, since the late 1970s it has been the darling of the political Right.

As the diplomatic, political, and military ties between the two nations have grown from the 1960s to the present, artists' and performers' soft diplomacy has complemented and strengthened those ties significantly. Indeed, the relationship between American cultural figures and Israel has reflected, pro and con, the highly fraught geopolitics of the Middle East and American entanglements in those conflicts. For what was at stake on the world stage was the direction that U.S. foreign policy in the Middle East would take in the future.

Our story opens in the nineteenth century. In the United States, Palestine as a destination for both pilgrims and travelers was so attractive and books about the Holy Land so popular that literary pundits dubbed the phenomenon "Palestine Mania." A decade before Mark Twain visited the Holy Land in 1867, Herman Melville, deeply upset by the critical and commercial failure (as he saw it at the time) of *Moby Dick*, traveled to Jerusalem. He hoped, as he told his friend Nathaniel Hawthorne, that a pilgrimage might lift his spirits after such severe disappointment. Unfortunately, his three weeks in the Holy Land made Melville even more depressed. The novelist confided to his journal, "No country will more quickly dissipate romantic expectation than Palestine. To some the disappointment is heart sickening."[4]

But for many Americans, romantic expectations about the Holy Land persisted. The expectations, based on biblical references in both the Old and the New Testaments, tended to obscure the actual reality of the place and its peoples. It was easy to imagine Palestine as empty and desolate, a land out of the book of Lamentations. The nineteenth-century phrase "a land without a people," a phrase that made the argument for Zionist colonization of an empty territory, resonated with many Americans.

During British rule in Palestine, from 1917 to 1948, American journalists, artists, and adventurers flocked to the British Mandate territory. Jerusalem was now

controlled by an Anglican Christian power that replaced the Ottoman Muslim rule of four centuries. This Christian triumph over Islam resonated with many Americans. Even the celebrated American journalist H. L. Mencken, accompanied by his wife, Sara, visited the Holy City in 1934. However, he found it less than holy, and boring. There were no bars or clubs to speak of, the American raconteur complained. "Jerusalem," Mencken wrote, "would be a swell place for sleep if it were not for the church bells."[5]

At midcentury, with the end of the British Mandate and the withdrawal of the British army's forces, war broke out between Jews and Arabs. In the military and political struggle that ensued, many in the American creative class supported Israel. Led by the then twenty-seven-year-old musician and composer Leonard Bernstein, stellar artists including Aaron Copland, Jerome Robbins, and Martha Graham raised money for the Zionist cause, put on performances to celebrate Israeli statehood, and traveled to Israel to express their solidarity with the new state. In an October 1948 letter from Tel Aviv, Bernstein wrote of his time there: "This is such a beautiful experience that I can hardly write of it. Truly I feel I never want to leave, despite all the tragedy and difficulty."[6] Throughout the next decade, unbounded enthusiasm for Israel continued to grip many other popular American stars. In 1957 Marilyn Monroe helped promote the Israeli national soccer team's visit to the United States. The press reported that she wore a "dress of Israeli colors" for the occasion.[7] And the following year Monroe joined Senator John Fitzgerald Kennedy at the Madison Square Garden celebration of Israel's tenth independence day.

But American enthusiasm for what Zionists dubbed "the return of the Jews" was not limited to the creative class. In the middle of the twentieth century, most Americans expressed strong support for a Jewish state in Palestine. As Harry Truman biographer David McCullough wrote about the president's decision to grant Israel recognition, "Beyond the so called 'Jewish vote' there was the country at large, where popular support for a Jewish homeland was overwhelming. As would sometimes be forgotten, it was not just American Jews who were stirred by the prospect of a new nation for the Jewish people, it was most of America."[8] Against this background, advocacy for the Arabs in general, or for the Palestinians in particular, had little chance of success.

While movie stars and politicians celebrated Israel in theaters and stadiums, local communities throughout the United States celebrated on a smaller, more intimate scale. These events were initiated by Jewish groups, but many Christians, as well as many Jews, attended these parades, rallies, and musical performances in support of Israel.

As a child of ten, I participated in an Israel celebration in the State Capitol building in Hartford, Connecticut. Along with other children from my Hebrew school, I danced to an Israeli folk song while Governor Abraham Ribicoff and local politicians clapped and sang along. The children carried fruit baskets as we danced; the song—with its biblical overtones—spoke of Israel's agricultural bounty. Among the guests were Jewish community leaders and a number of Christian pastors.

There were, of course, prominent Americans who objected to Truman's recognition of Israel, despite the popularity of the move. In this book, we will encounter and examine many of these voices, too. A small group of Americans made the case for the support of Arab nationalism and for Palestinian autonomy. Opponents of the pro-Israel policies claimed that these initiatives deepened America's entanglement in the unfolding Middle Eastern conflicts. Dissenters were particularly shaken by Secretary of State George Marshall's warning to President Truman that recognition of Israel would lead to years of war in the Middle East. Over the seven decades since Truman granted Israel recognition, it has become clear that his decision was as consequential for world affairs as his decision to use the atomic bomb.

Attempts by Israel and its supporters to quell the criticism of Israeli policies are as old as the U.S.-Israel relationship itself. As early as 1951, the crusading journalist Dorothy Thompson tried to address these moves to stifle disapproval. Initially a supporter of Zionism, Thompson expressed sharp criticism of Israel soon after its establishment. Israel advocates of the time quickly branded her an anti-Semite. In response, Thompson wrote of "the extreme danger to the Jewish community of branding people like myself as anti-Semitic. The State of Israel has got to learn to live in the same atmosphere of free criticism which every other state in the world must endure."[9] But by the late 1950s and 1960s, Thompson and her supporters no longer had a mainstream voice, and criticism of Israel was increasingly muted.

During the decade bracketed by two Arab-Israeli wars—the Sinai campaign of 1956 and the Six-Day War of 1967—American enthusiasm for Israel was at its height, particularly among liberals who depicted Israel as a beleaguered democratic and socialist state peopled by survivors of the Holocaust. American voters who supported the spread of liberal democracy, advocacy for civil rights, and progressive economic policies could thus support Israel. Again, public enthusiasm spilled over into the creative class: Leon Uris's novel *Exodus*, published in 1958 and made into a blockbuster film in 1960, strengthened and solidified American identification with Israel. And, as we shall see, the novel further distanced

readers from any sympathy for the Arabs of Palestine. Prime Minister David Ben Gurion said of the novel, "As a literary work, it isn't much. But as a piece of propaganda, it's the greatest thing ever written about Israel."[10] Frank Sinatra would likely have agreed. In 1962 he made the first of a number of excursions to Israel. Performing for Israeli troops, he also met with David Ben Gurion, Moshe Dayan, and other leaders. As Sinatra's personal assistant George Jacobs noted, "Sinatra adored Israel, and Israel adored him right back."[11]

As a teenager growing up in New York City in the early 1960s, I witnessed this liberal enthusiasm for Israel on many occasions. That my fellow Jews—in a city in which every fourth person was Jewish—celebrated Israel was no great surprise. But the fact that musical icons like Harry Belafonte and Pete Seeger would sing rousing versions of Israeli songs at their Town Hall concerts I found a bit surprising. When I heard Pete Seeger and the Weavers sing the Israeli folk song "Tsenah, Tsenah" at a Town Hall Hootenany concert—and the whole audience joined in—it confirmed my dawning realization that Israel was an American cause, and not just a Jewish-American cause.

As American popular culture shifted from the era of Sinatra to the age of rock and roll, the cultural style of America's enthusiasm for Israel shifted along with it. Starting in the late 1960s, the most influential popular culture promoters of Israel in the United States were Johnny and June Carter Cash; in 1966 Johnny, inspired by the Holy Land pilgrimage of Oral Roberts, paid his first visit to Israel. Three years later, the Cash family made the first of what they dubbed their "family pilgrimages" to Israel, Johnny and June Carter Cash's honeymoon visit. By the early 1990s, they had made five such pilgrimages. Among the direct artistic results were a 1970 record album *In the Holy Land*, and a 1972 film *Gospel Road*. And in a 1992 television program *Return to the Promised Land*, made during a period of extreme Israeli-Palestinian violence, Johnny and June reiterated their unfailing support of Israel and its policies, support expressed three decades earlier in Johnny's *In the Holy Land* record.

Johnny Cash's enthusiasm for Israel drew on deep Christian Zionist roots, and between the 1967 War and the late 1970s, a Christian Zionist undercurrent, first evident in the late nineteenth and early twentieth centuries, emerged again with the entry of Evangelical Christians into the national politics. When Ronald Reagan, early in his presidency, referred to the biblical idea of Armageddon, the term resonated with millions of Bible believers. And when Reagan expressed strong support for Israel, these believers rejoiced. For many Evangelical Christians, reborn Israel was proof that God was acting in history. God's plan for the redemption of the world, a redemption that could take place only when the

children of Israel were gathered from exile and returned to the Promised Land, was unfolding. As will become clear in this cultural history of the relationship between Israel and the United States, the Christian Zionist undercurrent has been a constant in America's relationship to modern Israel, and many of the creative voices who have traveled to Israel to perform have worked to strengthen this particular American Christian stream of belief.

Evangelical support for Zionism did not necessarily express a love for Jews. Rather, many supporters of Zionism viewed Jews and their aspiration for a Jewish state in Palestine as instrumental in hastening the Second Coming, when the righteous would join Jesus, and all others would be left behind. Another potent factor in the heady mix of religion and politics that shaped Christian Zionism was the long-standing American Protestant antipathy toward Islam. As early as the mid-eighteenth century, American Protestant elites were reading and discussing English tracts that condemned Islam as "an impostor religion." Humphrey Prideaux's early eighteenth-century book *The True Nature of Imposture Fully Displayed in the Life of Mahomet* had a place in many American homes and libraries.[12]

In the 1970s and 1980s, American criticism of Israel's treatment of the Palestinians was rare in the public sphere, though such criticism was widely voiced in Europe and even within Israel itself. Accordingly, during this time, American popular culture offered an uncritical celebration of Israel. In May 1978, ABC television broadcast a show called *The Stars Salute Israel at 30*. Attracting over eighteen million viewers, the two-hour prime-time special featured America's top entertainers. Among them were Sammy Davis Jr., Pat Boone, Anne Bancroft, Barry Manilow, Kirk Douglas, and Mikhail Baryshnikov. During the broadcast, Barbra Streisand sang "Hatikvah," the Israeli national anthem, and she spoke via satellite link to former prime minister (and former U.S. citizen) Golda Meir. In the mid-1980s, a deepening Christian Zionism, especially across the American Bible Belt, augmented an already strong pro-Israel sentiment. As the Reverend Jerry Falwell, cofounder of the Moral Majority, told an interviewer, "I am personally a Zionist, having gained my perspective from my belief in Old Testament scriptures."[13]

But while the U.S. government and much of the American public still had a positive view of the Jewish state, Israel faced mounting criticism in the international community. In the United States, leftist groups questioned Israel's status as a liberal cause. When the First Intifada, the Palestinian insurrection against Israeli rule, broke out in 1987, it challenged many liberals to rethink their views. For them, the Israeli response to the uprising, a response perceived as unnecessarily harsh and brutal, was especially troubling.

The writer and filmmaker Woody Allen wrote a 1988 *New York Times* op-ed article condemning Defense Minister Yitzhak Rabin's order to Israeli soldiers to "start using your hands, or clubs, and simply beat the demonstrators in order to restore order."[14] "As a supporter of Israel," Woody Allen responded, "and as one who has always been outraged by the horrors inflicted on this little nation by hostile neighbors and much of the world at large, I am appalled beyond measure by the treatment of the rioting Palestinians by the Jews." Allen's op-ed infuriated many in the American Jewish community and irked their allies in Christian Zionist circles. Later reflecting on this controversy, Woody Allen wrote in a 1991 essay, "I was amazed at how many intellectuals took issue with me over a piece I wrote a while back for the *New York Times* saying I was against the practice of Israeli soldiers going door-to-door and randomly breaking the hands of Palestinians as a method of combating the *intifada*. I said also I was against the too-quick use of real bullets before other riot control methods were tried. I was for a more flexible attitude on negotiating land for peace, all things I felt to be not only more in keeping with Israel's high moral stature but also in its own best interest."[15]

By the late 1990s, open criticism of Israel was somewhat more acceptable than ten years earlier, though it continued to generate a vociferous response from Israel advocates. Nevertheless, enthusiasm for Israel ran high in many quarters of American life. Many American artists, performers, and entertainers continued to visit Israel. But others, expressing their disapproval of Israeli policies, refused to perform there. Among them were entertainers who had once embraced the Jewish state. Stevie Wonder, who in the 1980s and 1990s had given sold-out concerts in Tel Aviv, decided in 2012 that he could no longer support Israeli policies.

The September 11, 2001, attacks on the World Trade Center towers shifted already pro-Israel American public opinion toward an even more positive view. The widely held perception that Arabs and Muslims were at war with the United States engendered a surge of pro-Israeli sentiment. Prominent Evangelical leaders, identified with Christian Zionism, issued sweeping condemnations of Islam. Pat Robertson of *The 700 Club* described the Koran as "teaching warfare, so at the core of this faith is militant warfare." Billy Graham's son, Franklin Graham, described Islam as "a wicked and evil religion."[16] And the U.S. War on Terror, conducted in the wake of the attacks, modeled itself on Israel's war against its adversaries. As the Israeli historian Ronen Bergman noted in 2018, "The U.S. has taken the intelligence gathering and assassination techniques developed in Israel as a model, and after 9/11 and President Bush's decision to launch a campaign of targeted killings against Al Qaeda, it transplanted some of these methods into its own intelligence and war-on-terror systems."[17]

In the years after 9/11, three of the most spectacular American divas of song—Madonna, Whitney Houston, and Barbra Streisand—visited Israel. Madonna and Streisand performed to wildly enthusiastic Israeli audiences. Houston and her husband, Bobby Brown, visited the African Hebrew Israelites of Dimona and met with Prime Minister Ariel Sharon. *Starstruck in the Promised Land* covers these twenty-first-century cultural icons in detail as each of them spoke out forcefully about what brought them to make their pilgrimage.

By the second decade of the twenty-first century, Israeli culture began to influence American culture in numerous ways. Perhaps the most visible form came in the realm of high-quality television production. *Homeland, The Affair,* and *In Treatment* were three of the many adaptations of Israeli shows that have been strikingly successful in the American market. As *Variety*, the trade journal of the entertainment industry, noted, "Israel has now firmly positioned itself as a TV content breeding ground—from silly game shows to subversive comedies—with massive global reach."[18] Among the reasons for Israel's creativity in TV programming are its standing as a high-tech innovator and its television industry's engagement with vivid and real-time reporting on Middle Eastern conflicts.

While TV programming has helped cement American/Israeli cultural exchange even further, recent political developments continue to demonstrate the rapport between the two nations. The White House announcement in late 2017 that the United States would move the American Embassy in Israel from Tel Aviv to Jerusalem sent shock waves through the international diplomatic community, while at the same time generating passionate expressions of approval or disapproval in the United States. But, as in earlier periods in the American-Israeli relationship, approval of Israel was the dominant voice. A March 2018 Gallup Poll revealed that 83 percent of Republicans, 72 percent of Independents, and 64 percent of Democrats viewed Israel favorably.[19]

In the following pages, we can see not only the political roots of the special relationship that continues to exist between the United States and Israel, but also how a powerful cultural interdependence nurtured the two countries despite upheavals that may otherwise have damaged the relationship. Most significantly, international artistic and intellectual exchange reveals a multifaceted American obsession with Israel in which the Promised Land was both a model and metaphor for the New World. The metaphor in many ways endures today, influencing not only the fraught stage of American public opinion but also U.S. political, policy, intelligence, and military theaters.

Sailing to Jerusalem

From the Early American Romance with the Holy Land to Palestine Mania (1817–1917)

N OCTOBER 1819, Pliny Fisk and Levi Parsons, two young clergymen fresh from Middlebury College and the Andover Theological Seminary, took to the pulpit of Boston's Old South Church. As the first American missionaries to the Holy Land, Fisk and Parsons were preparing to embark on a journey to Palestine. They believed that everyone in Palestine needed spiritual help, but as they told the rapt audience that packed the church that day, they were especially intent on "bringing the Good News" to the Jews of Palestine.

Parsons spoke first. His talk, "The Dereliction and Restoration of the Jews," made reference to the American fascination with end-time speculation. He assured the assembled congregation that at that very time, in the first decades of the nineteenth century, "there still exists in the breast of every Jew an unconquerable desire to inhabit the land which was given to the fathers; a desire which even conversion to Christianity cannot eradicate."[1] In Parsons's view, the call to Zion was so powerful that even Jewish converts to Christianity would act on it.

Several hours later, Fisk delivered his sermon, "Destination Judea: The Holy Land, an Interesting Field of Missionary Enterprise." The times, he told the congregation, were full of signs of the Second Coming, and they should ardently pray for the conversion of the Jews to Christianity as this would hasten Jesus's return to earth.[2]

The audience hung on every word. Fisk was an accomplished orator, and his subject matter held keen interest. At that time, Societies for the Amelioration of the Condition of the Jews were flourishing in large American cities—even those with few Jewish residents. The crowd present in Old South Church that day likely included members of the Boston chapter. They believed that amelioration of the Jewish situation could be accomplished only by conversion to Christianity.

Simply by attempting to bring Jews to Christianity, Christians could strengthen their own faith. It was the missionary effort itself, rather than any successful conversions, that mattered.

Jerusalem, Fisk and Parsons's ultimate destination, had occupied an exalted place in the American imagination since colonial times. The Bostonian author Julia Adams, who was in attendance that day, called the Holy City "the seat of the most important events in our world."[3] Her contemporary, Professor Edward Robinson of Andover Theological Seminary, remarked that like many of his fellow New Englanders, he knew the map of Jerusalem better than the map of his own city.[4]

Fisk ended on a presciently sober note, touching on the potential difficulty and dangers of the missionary voyage he and Parsons would soon undertake: "But though we are cheered with animating hopes, yet we go, not knowing the things that shall befall us . . . whether we shall be buried in a watery tomb; whether disease shall bring us to an early grave."[5]

THE TIES BETWEEN the United States and the Holy Land had long preceded even Fisk and Parsons. In fact, these ties, both cultural and religious, predate the founding of the United States itself. The idea of a reborn Israel was embryonic in the American imagination, shaping first the establishment of the British colonies and later the creation of the American republic. Many English colonists in the New World thought of themselves as Israelites fleeing the slavery of the British pharaoh. And African slaves in the American colonies came to see themselves as oppressed by white Egyptians from whom they would one day be delivered. Thus, for various groups, the American colonies were understood as a *new* Holy Land, a Promised Land inextricably linked to the ancient Holy Land. Throughout the original thirteen colonies, settlers gave biblical names to hundreds of localities. Jerusalems, Shilohs, Pisgahs, and Bethlehems dot the landscape of the United States.

Yet the actual Holy Land remained a beguiling place—as the land where Jesus had lived, and as the land of the Old Testament narratives. Of Palestine's many holy places, Jerusalem held a special fascination. Americans raised in Protestant denominations studied sacred geography in church and school. In those lessons, Jerusalem and its environs had pride of place. Many educated mid-nineteenth-century Americans like Professor Robinson remarked that they knew the geography of the Holy Land better than they knew the geography of their native towns and cities. Yet, for some who traveled to Palestine, the reality of the small

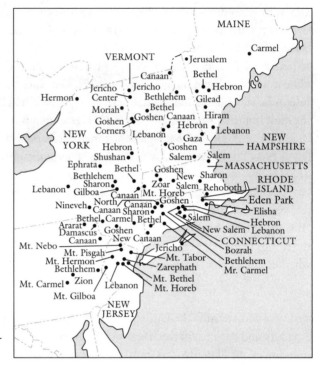

Biblical place-names in New England. Adapted from Davis, *America and the Holy Land*; used by permission of the International Center for University Teaching of Jewish Civilization, Hebrew University of Jerusalem.

region—particularly in comparison to the vast American continent—proved unduly surprising. As one traveler noted, "So great are the distances between the oceans in the United States that Palestine when seen by Americans will seem pitiably small, insignificant in area and natural product.... For Palestine is not as wide as the state of New Hampshire."[6]

PARSONS AND FISK, departing from Boston, set out for this narrow territory in November 1819. After a long and difficult voyage, they arrived in Jerusalem in 1820. As the first American missionaries to make souls for Protestant Christianity in the Holy Land, they distributed thousands of Bibles and religious tracts in Arabic, Hebrew, Greek, and Turkish.[7] But they focused their greatest efforts on the Jews—not only for theological reasons but also to avoid interference from the Ottoman authorities who had imprisoned American missionaries in Egypt for proselytizing among Muslims. As Professor Moses Stuart had warned Fisk and his fellow graduates at their Andover seminary ordination, attempts to bring

Christianity to the Holy Land were likely to be met by "Jewish obstinacy, or Pagan superstition, or Mohammaden cruelty."[8]

Parsons's and Fisk's missionary efforts were short-lived, but not due to any of Stuart's reasons. In February 1822, Parsons died in Alexandria, Egypt, felled by a tropical disease. Fisk died three years later in Beirut, also of a tropical disease. Many of the American missionaries who served in the Middle East during the first half of the nineteenth century suffered a similar fate. Discouraged by the hardships and eager to find more fertile missionary territory, American Protestant missionary organizations soon ceded the Palestine mission to their British counterparts, who seemed better adapted to the rigors of "oriental life"—perhaps because many of them had served in India, where they developed resistance to tropical diseases. The efforts of Parsons and Fisk, however, were hardly a failure. Their short tenure in the Middle East helped establish a Protestant missionary presence in Palestine, and their journals and letters back home helped develop American awareness of Middle Eastern affairs.

Between 1817 and 1917, dozens more vessels carrying intrepid American missionaries, adventurers, and eventually tourists, set sail for Palestine, with varying results. Before the advent of steamship travel in the mid-nineteenth century, the voyage from Boston to Jaffa could take up to three months, with a number of stops along the way. The trip was slow and arduous, and it was dangerous, due to the threat of disease and the uncertainties of sea travel. Following the Civil War, however, the rapid development of long-distance passenger steamships cut the travel time to three weeks, significantly decreasing the difficulty of reaching the Holy Land. As travel conditions improved, the number of people willing to undertake such a voyage increased steadily.

American writers, visual artists, and religious leaders recounted such voyages, often in vivid detail, creating an important historical record that, in turn, inspired further travel to the Holy Land. Writers like Herman Melville and Mark Twain, and artists like Frederick Church, whose Holy Land paintings became extremely popular in the mid-nineteenth century, responded—at times critically and satirically—to the accounts of these pilgrimages and the popular excitement about the Holy Land that they generated. These artists, in turn, made their own expeditions to Palestine. Photographers, cartographers, surveyors, and archaeologists followed in their wake, sparking intense public interest in biblical archaeology. Americans, like their British cousins, hungered to learn about archaeological discoveries that shed light on the biblical narratives familiar to them from church sermons and Sunday-school lessons. By the turn of the twentieth century, the Holy Land that had long played a significant role in the American

imagination had become more of a reality, an actual place available to American pilgrims, missionaries, explorers, and tourists.

DURING THE SECOND HALF of the nineteenth century, two groups of religious migrants settled in Ottoman Palestine. American Christians, mostly Protestants influenced by end-time ideas, aimed to establish a presence in a Holy Land Christianity long dominated by the Roman Catholic and Eastern Orthodox Churches. European Jews, predominantly from Russia, immigrated to Palestine as much to escape persecution as to settle in the Promised Land. Both groups considered Palestine holy, though for different reasons. Yes it was the land of the Bible, but which Bible? For Christians—whether Protestant, Catholic, or Eastern Orthodox, Jerusalem was the scene of the Passion, and they sought connection to specific New Testament sites and events. By settling in Palestine, they were walking in the footsteps of Jesus. The New Testament Gospels were their map and guide to the Holy Land, while the Old Testament narratives served as mere preludes to the story of Jesus.

The Jewish settlers, on the other hand, hoped to reinhabit biblical sites, as well as promote the idea of a Hebrew nation. Thus, Jewish attachment to the land of Israel was broader and more abstract than the heavily localized Christian interest in specific sites. But for Jewish émigrés, there were some sites associated with biblical and postbiblical history that attracted special attention; in the second half of the twentieth century, these sites emerged as modern symbols of a renewed Israel. For example, Masada, the desert mountaintop fortress discovered by the American explorer Edward Robinson in 1836, was not only the historic site of a mass suicide by Jewish defenders trapped by ancient Roman troops; it became, for Zionists, a symbol of renewed Jewish grit and determination. For decades, elite Israeli army troops were sworn in there, and to this day, it remains a favorite sunrise destination of American Jewish tourists seeking connection with Israel.

Edward Robinson, the founder of biblical archaeology, and other Western explorers in nineteenth-century Ottoman Palestine did more than discover or uncover biblical sites. Following the latest findings in the sciences of philology and comparative linguistics, these explorers postulated that the Arabic names of cities, towns, and villages in Palestine were forms of the ancient Hebrew names of those same places. Thus, the Sea of Galilee town *Majdal* was actually *Magdala*, the town of Mary Magdalene, and the Arab town *Asdud* had originally

been *Ashdod*. What seemed to be a purely academic point soon became a political one; as early twentieth-century Zionists settled in Palestine and reclaimed these towns and villages, the Hebrew-sounding place-names facilitated the Jewish claim on them.

Those claims increased as the population of Jewish immigrants arriving from Europe grew. While many of these Jewish settlers were Russians fleeing the pogroms of the early 1880s, Palestine was not their only destination; tens of thousands left Russia for the United States.

My Russian Jewish ancestors were among those who chose America, even as other members of my extended family chose Palestine. This kind of family constellation—relatives spread from New York to Jerusalem, with Russia in between—was common among Jewish families between 1881 and 1924, when U.S. immigration policy began to enforce strict limits on the number of immigrants admitted to the United States. This legacy of seeking disparate new homes had a deep impact, not only on family relationships but also on American perceptions of the Holy Land. While my great-grandparents were adjusting to life on the Lower East Side of Manhattan, my great-uncle Eliezer was adapting to the Old City of Jerusalem. But unlike my great-grandparents, who immersed themselves in the vibrant diversity of American life, Eliezer ensconced himself within Jerusalem's Orthodox enclave, where he hoped to live out his final days. My New York relatives came to view Eliezer—whom they never saw again— more as a legend than a real person or a family member. When I was born in 1947, my parents gave me the middle name Eliezer, and I grew up hearing stories that made my great-uncle seem as exalted and remote as a Bible character from two thousand years ago. For my family and others similarly divided by history and geography, the saga of these relatives gave Israel not merely an elevated status but an aura approaching the mythic.

During the nineteenth century, as European Jewish immigration to Palestine was increasing, the idea of a reborn ancient Israel—an idea that appealed so powerfully to many Jews—found resonance with many American Christians as well, particularly in the Protestant denominations. The European and American Evangelical movements, influenced by end-time ideas, brought about a renewed interest in Palestine as a Christian Holy Land. Protestants of many denominations made claims on Jerusalem, where the Christian presence—in terms of sacred sites, population, and real estate holdings—was predominantly Roman Catholic and Eastern Orthodox. The American Protestant denominations felt the need to assert their presence in the Holy City. This renewed interest

coincided fortuitously with the new accessibility of Palestine through steamboat travel. By the 1860s one could make the long voyage from New York to Jaffa in a mere three weeks; this improved access greatly increased the number of American missionaries, settlers, and tourists who would visit the Holy Land in the latter decades of the nineteenth century.

But one did not have to board a steamship bound for Ottoman Palestine to see a Holy Land; one had to travel only as far as New York State, to Palestine Park in Chautauqua, New York. There, on the banks of Chautauqua Lake in the northwestern corner of the state, was a living map, a geographically correct scale model of Palestine in the time of Jesus, complete with sites of biblical significance, including Jerusalem and the Second Temple. Built in the late 1870s as part of a summer camp for Sunday-school teachers, the model was designed to teach biblical history and geography. The park's founders hoped that Chautauqua would become a local Holy Land, a spiritual retreat for future generations of Americans. And indeed, it has. Today, Palestine Park is part of a national historic district and continues to operate during the summer months.

Whether in Palestine or western New York State, American Protestants relied on the Old Testament and the Gospels as their guide to the Holy Land. But the Bible was not their only guide. American novels, travelogues, and memoirs about voyages to Palestine abounded. Among the most popular was Elizabeth Champney's best-selling *Three Vassar Girls in the Holy Land*, published in 1892. The novel, the final book in a popular series of fictional travelogues, included chapters on Jerusalem and Bethlehem that provided a detailed itinerary of Holy Land sites.

At the end of the nineteenth century, the famous American orator the Reverend Thomas DeWitt Talmage would convey this idea of the Gospels as travel guide in poetic fashion. "Do you see how the Holy Land and the Holy Book fit each other?," he asked. "God with His left hand built Palestine, and with His right wrote the Scriptures, the two hands of the same Being. And in proportion as Palestine is brought under close inspection, the Bible will be found more glorious and more true."[9] In effect, Talmage's close inspection required setting sail for Jerusalem. Of course, one cannot sail to Jerusalem, as the Holy City lies inland, surrounded by mountains. But for the many seafaring American pilgrims who boarded ship for the Mediterranean throughout the nineteenth century, Jerusalem was their ultimate destination. Their ships docked in the Port of Beirut, or in less accessible Jaffa, but these were merely way stations along the path to the Holy City.

Interlude: Terra Damnata—Herman Melville in Palestine, 1857

Not all American travelers to Palestine in the nineteenth century had a missionary purpose; some were seeking personal spiritual fulfillment. When the novelist Herman Melville set sail for the Holy Land in 1856, he was thirty-seven years old and deeply depressed. Though he had already published a shelf-full of novels, he was convinced that his books were failures and that his literary career was over. *Moby Dick*, published in 1851, was neither a critical nor a financial success. The last of his novels published during his lifetime, *The Confidence Man*, appeared in 1857, while the author was traveling in Europe and the Middle East. Compounding his financial and artistic worries, Melville was in the depths of a spiritual-religious crisis, which he hoped the spiritual power of the Holy Land might ease.

On his way to the Middle East, Melville stopped in Liverpool to visit his close friend Nathaniel Hawthorne, who was serving as the American consul there. Hawthorne noted in his journal that Melville had "not been well of late; he has been affected with neuralgic complaints in his head and limbs, and has no doubt suffered from his too constant literary occupation, pursued without much success, latterly; and his writings, for a long time past, have indicated a morbid state of mind."[10] Elsewhere, Hawthorne addressed his friend's spiritual crisis more directly, noting that Melville "will never rest unless he gets hold of a definite belief. . . . He can neither believe or be comfortable in his unbelief, and he is too honest and courageous not to try to do one or the other."[11]

Unfortunately, the Holy Land did not provide the hoped-for panacea. Melville spent less than three weeks in Palestine, which he dubbed "Terra Damnata." Jerusalem—which he found gray, desolate, and sad—did not come close to his high expectations, and he failed to experience any sort of meaningful religious encounter there. As he confided to his journal: "No country will more quickly dissipate romantic expectation than Palestine. To some the disappointment is heartsickening."[12]

Particularly disenchanting to Melville was the futility of the hoped-for restoration of the Jews to Palestine. "The idea of making farmers of the Jews is vain," he wrote in his travel journal. "In the first place, Judea is a desert with few exceptions. In the second place, the Jews hate farming." The presence of the Arab population further complicated the situation: "All who cultivate the soil in Palestine are Arabs. The Jews dare not live outside walled towns or villages for fear of the malicious persecution of the Arabs and Turks." Ultimately, the possibility

of increasing the Jewish population in Palestine seemed doomed to failure: "The number of Jews in Palestine is comparatively small. And how are the hosts of them, scattered in other lands, to be brought here? Only by a miracle."[13]

Melville returned home as depressed as when he had left, with little hope that his future literary projects would find an audience. Over the next twenty years, he labored over *Clarel*, a book-length poem based on his Holy Land experiences. The protagonist, as James E. Miller Jr. has noted, bears no small resemblance to Melville: "An American student-tourist beset by questions and doubts, he hopes on his tour of the Holy Land to resolve them and, in the resolution discover intellectual peace."[14] By looking to "an older race, the Jews, with a remoter history," the *Clarel* protagonist hopes, according to Lewis Mumford, to find "some clue to the unsettled and uneasy state in which he lives, and some path of development which will lead him again to wholeness."[15]

Melville considered *Clarel* to be "eminently adapted for unpopularity," an assessment that proved remarkably accurate. Published in 1876, the poem languished in obscurity for more than a century. Unlike *Moby Dick*, which was rediscovered to great acclaim in the 1920s, *Clarel* was not published in a critical edition until the 1970s.

Second Journey: The Adams Colony, 1866

In contrast to Melville's solitary journey and his melancholic response to the Holy Land, the Adams colonists, who set out nine years later, could barely contain their enthusiasm. They firmly believed that Palestine could support a return of the Jews *and* an American Christian presence. In their post–Civil War optimism, they foresaw a glorious future for themselves in reborn Palestine.

In August 1866, after years of intensive planning, a group of more than 150 people from Maine and New Hampshire set sail for Palestine. All were former members of mainstream Protestant churches who had, under the charismatic leadership of George Adams, formed a new denomination, the Church of the Messiah. The 157 church members who departed with Adams that August chose to join him out of religious enthusiasm and a sense of adventure. Their voyage to the Eastern Mediterranean aboard the *Nellie Chapin* was expected to take roughly forty days, a much shorter passage than Fisk's and Parsons's journey nearly half a century earlier.

Adams's expedition was neither tour nor pilgrimage; his followers were too hardscrabble to indulge in such diversions. They were farmers and artisans from small New England towns who were following their preacher to a new life in the

Holy Land. Adams claimed to have purchased a parcel of land in Jaffa, where they could build houses, start farms, and create new businesses, including a hotel and carriage service to carry pilgrims from Jaffa to Jerusalem. The *Nellie Chapin* carried in her hold a coach with wagon wheels, as well as a supply of New England timber for building American-style houses. Also onboard the colonists had stowed agricultural supplies, seeds, and mechanical devices to facilitate farming on the Plains of Sharon. It is worth noting, in light of George Adams's taste for alcohol, that the *Nellie Chapin* was well stocked with a supply of strong drink, including many casks of brandy.

Adams and his church drew heavily on elements of proto-Zionism and philo-Semitism that he had absorbed during his prior association with the Mormon Church. Unlike Fisk and Parsons, Adams and his followers were not moving to the Holy Land to convert Muslims and Jews. Rather, they believed that, like the peoples of Palestine, they were, in a sense, descendants of the tribes of Israel, though in a more attenuated and spiritual manner than the Jewish claimants to that lineage. They considered their move to Palestine to be a type of homecoming.

Adams had founded the Church of the Messiah five years earlier in Lebanon, Maine, and the congregation had been contemplating relocating to Palestine for at least the past two years. But George Adams's fascination with the Holy Land had a longer and more complex history. In the 1862 inaugural issue of his monthly magazine, *The Sword of Truth and Harbinger of Peace*, he included two main features: one on American slavery, which Church of the Messiah members staunchly opposed, and one on "the Jews, Jerusalem, and the Holy Land."[16] In the latter feature, Adams, unlike other nineteenth-century zealots for Zion, did not call for the conversion of the Jews to Christianity. Rather, he believed Jews should return to Zion "as Jews not as Christians." Judaism, Adams implied, had its own integrity as a religion, and he considered members of the Church of the Messiah to be spiritual brothers of the Jews.

These ideas stemmed from Adams's earlier affiliation with the Mormon Church. Before his move to Maine and the establishment of the Church of the Messiah, he had been an elder—one of fifty central figures—in the Church of Jesus Christ of Latter-day Saints. Indeed, from 1841 to 1842, Adams served as the church founder Joseph Smith's emissary in England. Joseph Smith identified with Israel and its prophets, and he saw himself as an actor in Israel's future. During its first decade, the Mormon Church referred to itself as the Church of Latter-day Israel. Smith understood his church's trials and tribulations as analogous to Israel's biblical saga, and he believed the Mormons' hope for the future was linked to the fulfillment of the biblical promise to Israel—that its land and

temple would be restored. In the near future, Joseph Smith implied, the Church of Latter-day Israel and the restored Kingdom of Israel would both triumph.

After Smith's assassination in 1844, Adams fell out with Smith's successor, Brigham Young. Though he left the church, Adams did not abandon the Mormon interest in proto-Zionism and philo-Semitism. The return of the Jews to Palestine and a deep fascination with the Jewish people and their traditions—foundational elements of Joseph Smith's teachings—remained central tenets of Adams's thought throughout his tenure as leader of the Church of the Messiah and the colony in Palestine.

Identification with biblical Israel was not unusual among American Protestant leaders and visionaries in the late eighteenth and early nineteenth centuries; American colonists had, from the start of their sojourn in North America, identified with the Israelites who fled Egypt and entered the Promised Land. But Mormon identification with ancient Israel differed. Smith encouraged his followers to understand their history—beginning in New York and Vermont, with subsequent excursions to Illinois—as an exodus of biblical proportions. According to the Book of Mormon, America's prehistory is replete with actual connections to the tribes of Israel.

Joseph Smith's conception of the Holy Land encompassed two coexisting territories: one in the Middle East and one in North America. While affirming the sanctity of the biblical Holy Land, Joseph Smith attested to the sanctity of holy places on the American continent. In Mormon thought, the American Zion and the ancient Zion shared a sacred relationship. Holy places in the American landscape drew their sanctity and narratives from the Holy Land originals that had held sway over the religious imagination of early Americans. Ultimately, this sacred relationship would be expressed in the mid-twentieth century, when Brigham Young University, the Mormon Church's premier institution of higher education, established a campus in East Jerusalem on land conquered by Israel in the 1967 Arab-Israeli war.

At the March 1836 dedication of the Mormon Temple in Kirtland, Ohio, Joseph Smith made the connection between his church and Israel explicit. In a public prayer for his followers and their new temple, he asked God "to have mercy upon the children of Jacob, that Jerusalem, from this hour, may begin to be redeemed, and the yoke of bondage may be broken off from the house of David, and the children of Judah may begin to return to the lands which thou didst give to Abraham 'their father.'"[17]

The early Mormon Church was completely confident in the eventual restoration of the Jews to Palestine. In 1843 Smith sent Orson Hyde, one of his closest

associates, on a pilgrimage to Jerusalem to visit the sites associated with Jesus's life and to "pray for the return of the Jews to their land." For Smith, the members of the Church of Jesus Christ of Latter-day Saints were "children of Ephraim," descendants of the Ten Lost Tribes of Israel. In an 1842 letter to the Brethren of the Twelve, the Mormon Church hierarchy responsible for foreign missions, Hyde wrote: "It was by political power and influence that the Jewish nation was broken down, and her subjects dispersed abroad, and I will here hazard the opinion, that by political power and influence, they will be gathered and built up; and further, that England is destined, in the wisdom and economy of heaven, to stretch forth the arm of political power, and advance in the front ranks of this glorious enterprise." This prediction, made seventy-five years before the British government's Balfour Declaration promised the Jewish people a national home in Palestine, was prescient. Lest his correspondents construe his prediction as an endorsement of the Anglican Church and the British Empire, Hyde quickly added, "The Lord once raised up a Cyrus to restore the Jews, but that was not evidence that he owned the religion of the Persians."[18]

Thus, Mormon ideas shaped George Adams's outlook and thereby influenced the Adams Colony pioneers. Adopting the genealogical predisposition of their leader, Adams's followers dubbed themselves "Ephraimites." Unlike the Middlebury missionaries Fisk and Parsons, who sailed with other American travelers bound for Eastern Mediterranean ports, the passengers of the *Nellie Chapin* had only their fellow colonists for company. They were isolated, unchallenged, and subjected to George Adams's constant exhortations about the glorious future that awaited them "on Zion's shore." While Fisk and Parsons faced resistance from the Muslims, Jews, and Eastern Christians they sought to convert to Protestant Christianity, the Adams colonists reported no such challenges. Rather, their letters home to family in Maine and New Hampshire were full of hope and excitement, expressing great confidence in Adams's leadership and judgment.

The reality, however, was considerably more complicated. Almost as soon as they boarded the *Nellie Chapin*, the colonists began to doubt their leader's probity. When Adams was not preaching, he was drinking heavily, making a huge dent in the large supply of brandy stored onboard. Eventually, his promises of glory began to unravel. When the colonists arrived in Jaffa on September 22, 1866, Herman Lowenthal, the land agent who had accompanied Adams during his previous visit to Palestine the year before, met them with discouraging news. Despite Lowenthal's earlier promise that the Turkish government would permit the colonists to purchase land in Jaffa, the Ottoman authorities had turned down their request. Lowenthal presented Adams with a letter from Jay Morris,

the U.S. minister resident in Istanbul, confirming the ruling. "The sultan has no domain at his disposition for those who are not Ottoman subjects," it read.[19]

Undeterred, Adams and his followers disembarked and set up camp. They had planned to build houses, prepare land for farming, and establish a school for their children. Now they found themselves living in flimsy tents on the beach as the rainy season set in. Within weeks, many of the colonists fell ill with cholera. In a letter to families and financial supporters back home, Adams wrote: "For two weeks after we arrived all went well. But soon the hand of sickness and death reach us."[20]

Those colonists who remained healthy, however, became fascinated with the renewed Jewish presence in Palestine, especially their agricultural projects. For Adams and his followers, the efforts of these Jewish immigrants were a sign of the end time and a confirmation that their decision to move to the Holy Land conformed to God's plan. Abigail Alley, one of Adams's followers, wrote to family back home: "The Jews are gathering as fast as the land will hold them, forming colonies. They're trying to buy more land just above where we live. . . . Many of them are being converted in Jerusalem to Christ . . . outside Jerusalem the Jews set up a large colony just outside the Jaffa gate."[21]

Despite these hopeful developments, the circumstances of the Adams Colony continued to deteriorate. As their situation worsened, the colonists began to realize that their leader was more concerned with securing a steady supply of alcohol than with caring for the sick, building houses, or starting farms. To replenish his liquor supply, Adams ordered hundreds of bottles of brandy, wine, and English ale from local suppliers, as well as casks of Arak, the drink favored in southern Mediterranean ports.[22]

Adams appeared increasingly detached from reality. In a letter to his American supporters, he reported the latest casualties of their settlement efforts: "Thus of our colony of one hundred and fifty-six persons, nine now sleep in peace and quiet in the beautiful Protestant graveyard, near the upper gate of Jaffa. Of these nine, six were children." Following this bleak account, he then strikes an oddly upbeat note: "The colony is now in a most prosperous condition—we may say first-rate."[23] That was clearly not the case. The colonists were dispirited and disappointed; many were mourning the deaths of relatives. A group of forty wished to return to the United States, but they had no means to do so. Adams had squandered their money, which he held in common, on liquor. He responded to their complaints that the colony was collapsing around them with belligerent denial, followed by retreat into an alcoholic stupor.

Meeting Mark Twain, 1867

The dissidents, desperate to leave Palestine, found their way back to New England in 1867 through the generosity of a New York newspaper publisher, who offered them passage on the *Quaker City*, an American ship docked in Beirut. Onboard, they met none other than Mark Twain. Twain had joined the *Quaker City* voyage to write about its wealthy passengers and their travels through Europe and the Middle East. He was employed by the *Alta California* newspaper, which had paid his fare and expenses. Twain also sold weekly articles about the voyage to the *New York Tribune* and the *New York Herald*.

Mark Twain first became interested in the *Quaker City*'s chartered voyage when he saw the celebrity list of passengers, who had signed up for what was essentially the first American luxury cruise, though it was not called that at the time.[24] Rather, the organizers of the expedition promoted it as "an oceangoing excursion to the Holy Land, Egypt, the Crimea, Greece and intermediate points of interest."[25] They hinted that the Reverend Henry Ward Beecher of Brooklyn, the most celebrated preacher of his day, would lead the Holy Land portion of the tour, though business affairs in the end kept the reverend stateside. As Twain biographer Justin Kaplan summarized the travel plans, "Carefully selected on the basis of character and credit, the passengers would use the steamer *Quaker City* as a traveling home while they visited Europe and the Middle East."[26] These passengers became the unwitting protagonists of Twain's first popular book, *The Innocents Abroad, or The New Pilgrim's Promise*.

Aboard ship, Twain debriefed the retreating Adams colonists. He concluded that their dashed messianic expedition had been "a complete fiasco," and "one of the strangest chapters in American history." He noted that Adams's followers believed in "the long-prophesized assembly of the Jews in Palestine from the four quarters of the world, and restoration of their ancient power and grandeur," but, like Melville before him, Twain questioned how realistic such an effort might prove to be. The sorry state of the colonists did not "make it appear that an immigration of Yankees to the Holy Land was contemplated by the old prophets as part of the programme; and now the Jews have not 'swarmed,' yet one is left to understand why that circumstance should distress the American colony of Mr. Adams." Ultimately, Twain found the teachings of Adams's Church of the Messiah incoherent and confusing, concluding, "I can make neither head nor tail of this religion." An account of the colony's failure fills several paragraphs of *The Innocents Abroad*.[27]

Twain's account of his meeting with the dispirited colonists is amusing, but if accepted as reportage rather than satire, it distorts the colony's history and its positive influence on later colonization projects. Although the Adams Colony was short-lived—within two years of sailing to Jaffa, most of the colonists had returned to Maine or New Hampshire—the colonists left an indelible mark. The houses they constructed from their ship's timber remained long after they had departed, as did the high-grade farming equipment they had brought with them. Indeed, German Templer settlers would take possession of several of the buildings a few years later. And European Jewish Zionists, taking note of the Adams Colony's efforts, would encourage their followers to establish agricultural settlements in Palestine, though without Adams's religious enthusiasms.[28]

Most of Adams's followers returned to the United States, but a few stalwarts remained in Jaffa. Rolla Floyd, who was thirty years old when he set sail with Adams, was perhaps the most effective and influential of those who stayed. Aboard ship, Floyd had told Adams that he hoped to open a hotel in Jaffa for Christian pilgrims, and that as soon as a new road opened up between Jaffa and Jerusalem, he would establish a carriage service to transport those pilgrims to the Holy City. Like Catholic functionaries who had long catered to American Catholic pilgrims, Floyd intended to serve the more recent influx of Protestant pilgrims. Floyd eventually accomplished his goals, establishing the American Hotel in an abandoned Adams Colony building and developing a thriving transportation business within a few years of the colony's demise. He would provide considerable help to our next set of voyagers, the Chicago families who established the American Colony in Jerusalem.

Despite the influence of the Adams Colony on later settlements, Twain's portrait of the Holy Land has had the longer-lasting cultural and political impact. Like Melville, Twain did not find the Holy Land attractive. He ends the Palestine section of *The Innocents Abroad* with a dirge, written in biblical cadence and replete with biblical allusions: "Palestine sits in Sackcloth and ashes. Over it broods the spell of a curse that has withered its fields and fettered its energies. . . . Renowned Jerusalem itself, that stateliest name in history, has lost all its ancient grandeur, and is become a pauper village; the riches of Solomon are no longer there to compel the admiration of visiting Oriental queens; the wonderful temple which was the pride and glory of Israel is gone, and the Ottoman crescent is lifted above the spot where, on that most memorable day in the annals of the world, they reared the Holy Cross."[29]

This grim description has had a curious and unintended afterlife. Many Zionist accounts of Palestine's history have quoted this passage as a point of contrast,

to emphasize the later Jewish success in "making the desert bloom." For decades, excerpts of Twain's work were a standard part of the Israeli school curriculum. In 1968, sections of *The Innocents Abroad* were required reading in the History of the Land of Israel course I took at the Hebrew University in Jerusalem.

But Twain's descriptions of Palestine served as more than a simple contrast to the Jewish effort to make the desert bloom; they reinforced the Zionist view that Palestine was empty and that the land was there for the taking when the Jews began to arrive in the late nineteenth century. Many Israeli spokespersons have cited Twain's book when arguing this point, often quoting the following passage: "Of all the lands there are for dismal scenery, I think Palestine must be the prince. The hills are barren, they are dull of color, they are unpicturesque in shape. The valleys are unsightly deserts fringed with feeble vegetation that have an expression about it of being sorrowful and despondent. . . . It is a hopeless, dreary, heart-broken land."[30] At the 1991 Madrid peace talks, Israeli prime minister Yitzhak Shamir referred to Twain's dismal portrait of a barren and empty nineteenth-century Palestine in his defense of Israel's claim to the land.

Clearly, Twain's less-than-inviting description did not dissuade his readers from flocking to Palestine. Pilgrims, tourists, and colonists continued to visit the Holy Land. In the decade after the Adams Colony experiment and Mark Twain's visit, Zionist activity increased in European Jewish communities; the situation of the Jews living in the Russian Empire grew worse in the 1870s, and the pogroms of the early 1880s prompted many to immigrate to Palestine. These immigrants set up urban and rural settlements that received considerable Zionist support—both ideological and financial—from the United States. In 1891 a remarkable public petition advocating the "restoration of the Jews to Zion" garnered wide public backing. Conceived by the evangelist William Blackstone after attending a "prophecy conference" at Niagara Falls, the Blackstone Memorial called on U.S. president Benjamin Harrison to "further the purposes of God concerning his ancient people" by facilitating the emigration of Russian Jews to Palestine. More than four hundred prominent business leaders, politicians, clergymen, and newspaper editors signed the petition, including John D. Rockefeller, J. P. Morgan, and Melville Fuller, chief justice of the United States Supreme Court.

Third Journey: The American Colony in Jerusalem, 1881

Against this background rests the American Colony story. Fifteen years after the Adams Colony, twenty American Christians from Chicago boarded a steamship

bound for Palestine to establish a new settlement in the Holy Land. Only later would they be known as the American Colony. They arrived in Jaffa in September 1881. Though their journey was not eventful, it had been inspired by an earlier dramatic—and traumatic—shipboard tragedy.

In 1873 the wealthy Chicago society matron Anna Spafford and her four daughters set sail for England on the French luxury liner the *Ville du Havre*. Anna's husband, Horatio, preoccupied with business ventures in Chicago, planned to join the family in France a few weeks later. But on the night of November 21, the *Ville du Havre* collided with a British ship and sank in minutes. The four Spafford daughters drowned. A rescue ship plucked Anna, floating unconscious on a bit of debris, from the wreckage.

The tragedy brought the Spaffords, who had been somewhat conventional American Presbyterians, into the world of spiritualism, revivalism, and end-time speculation. Dissatisfied with the Presbyterian Church, Horatio and his friend the famed preacher Dwight L. Moody had discovered the teachings of the firebrand John Nelson Darby and the Plymouth Brethren. Darby preached that the Second Coming was imminent, and those who did not repent would be destroyed in the final tribulation. The maritime disaster and the loss of their daughters only pushed the Spaffords further toward these new ideas, resulting in their mission to the Holy Land. Anna retold the story of the *Ville du Havre* disaster in many books and articles. She recalled that as she struggled to stay afloat and find her children amid the ship's wreckage, a heavenly voice spoke to her. It told her that, though her daughters were lost, she had to survive for "her work was not finished." After a period of rest and recovery in London, Anna concluded that her future work was in the Holy City. Anna and Horatio, along with daughters Bertha and Grace, born after the *Ville du Havre* tragedy, would move to Jerusalem.

Upon arrival in Jerusalem, the Spaffords and their companions settled in a large, Ottoman-era house to the east of Jerusalem's walled Old City. Joined by other Protestant pilgrims and missionaries, the colony grew rapidly. It would eventually include schools, an orphanage, infirmaries, shops, and the first photography studio in Jerusalem.

The colony flourished, but it had its detractors. Selah Merrill, who arrived in 1882 as the American consul in Jerusalem, objected to the colony's communal lifestyle, and he tried repeatedly to have the colony shut down and its members deported. Among the accusations he made against the Spaffords was that the colony forbade marriage but encouraged sexual relations outside of marriage. It was not unusual in nineteenth-century America for detractors to accuse dissident Protestant sects of sexual impropriety; enemies of the colony were simply

extending this smear technique to the Americans in Palestine. Merrill also disseminated an alternative and contradictory slander, that the colonists were practicing celibacy.

Initially, Merrill's accusations had the desired effect. He denied the colonists consular representation, blocking their ability to appeal for U.S. government assistance. But with the passage of time, American visitors to Jerusalem as well as the public back in the States realized that the colonists were exemplary ambassadors of goodwill and that Merrill's accusations against them were false.

The American Colony would play a significant role in local relief work during and immediately following the First World War, but by the mid-1920s it had begun to unravel. Internal tensions and new economic pressures under the British Mandate weighed heavily on the members. The communal lifestyle that had defined the colony for nearly half a century collapsed, but many of the institutions that it had founded persisted. Members of the Spafford family privatized some of these enterprises, including a hotel in one of their main buildings. Today, the American Colony Hotel Jerusalem is a luxury hotel that, though managed by a Swiss firm, is still owned by descendants of the original colony members. In the 1990s, this hotel was the site of American attempts at Palestinian-Israeli reconciliation. Mediators from the United States encouraged intellectuals, artists, activists, and performers from both sides of the conflict to meet there. These meetings, some of which I was privileged to attend, concluded in the mid-1990s when the Oslo Accords between Israel and the Palestinian Authority broke down under pressure from extremists on both sides.

Fourth Journey: The Voyage of the Eight Hundred, 1904

On March 8, 1904, 701 American Sunday-school teachers boarded the German steamer the *Grosser Kurfurst* in Hoboken, New Jersey, aiming to arrive in the Holy Land in time to celebrate Easter in Jerusalem. William Hartshorn, the leader of the American affiliate of the British World's Sunday School Association, had laid out the plan at the close of their 1903 meeting in Denver, saying in dramatic fashion, "We should all convene . . . Easter morning, 1904, at the Savior's tomb, Jerusalem."[31]

The American group was not alone on this pilgrimage. A week after the *Grosser Kurfurst* sailed, a group of 258 European Protestant Sunday-school teachers departed from Marseille. The two groups planned to meet in Jaffa and proceed to Jerusalem, where they would join an additional 500 Christians from Middle Eastern denominations. These three groups, totaling more than 1,500 people, would assemble for the World's Fourth Sunday-School Convention.

Once in Jerusalem, the three groups planned to congregate at the "Savior's Tomb" outside the Old City walls, near the Damascus Gate. The choice of this location as the designated meeting place was a pointed endorsement of the Protestant view that the authentic tomb of Jesus was not the Tomb of the Holy Sepulchre, as the Catholic and Orthodox churches believed, but the "Garden Tomb," discovered by General Charles Gordon in the 1880s. Unlike the centuries-old Church of the Holy Sepulchre, a massive structure inside the Old City shared by eight distinct Catholic, Orthodox, and Coptic denominations, the Garden Tomb is an open enclosure devoid of decoration. There, Protestant pilgrims could worship free of the encumbrances imposed by the Catholic and Orthodox traditions.

In Jerusalem, the American Sunday-school teachers crossed paths with their predecessors, the American Colonists. By 1904 the American Colony and its charitable institutions were thriving; members of the colony helped plan and implement the Sunday-school convention. Even the American consul Selah Merrill, longtime nemesis of the American Colony, greeted and addressed the convention.[32] "We experienced great kindness and hospitality from the brothers and sisters of the Colony," read the official record of the convention. "They opened their houses on the highest part of the wall near the Damascus Gate, the rooms for entertainment and the roof for a view of the city and the surrounding country, including Calvary."[33]

The convention included conference sessions on both Old and New Testament research, as well as on biblical archaeology. Professor L. B. Paton of Hartford Theological Seminary lectured on "Jerusalem in Old Testament Times." Paton was then serving as the director of the American School of Oriental Study and Research in Palestine, and he used a large wall map of Jerusalem to walk his audience through the local geography, "pinning verses of scripture" to different locations on the map. He emphasized that the Holy Land where they were standing was indeed the land where Jesus had lived and walked. Professor Paton, affirming the historical reality of the New Testament, "expressed his unhesitating belief in the Mosque of Omar as being the site of the temples of Solomon and Herod."[34] He assured the Sunday-school teachers that the mosque they had recently visited was indeed the site of the ancient temple where Jesus had cast out the money changers.

For the American Sunday-school teachers, their pilgrimage had an educational as well as a spiritual aim: to study the "Fifth Gospel," the land itself. The organizers had noted that the participants would enjoy a tour of the Mediterranean on the way to Palestine, but this was only "an accompaniment to the

chief motive—the Holy Land."[35] As they toured the region, the convention participants viewed the Arabs then inhabiting the land as descendants of Ishmael; thus, as Abraham's progeny, their presence in Palestine fulfilled biblical prophecy. As the official account of the convention explained: "The Scriptures and many of the prophecies in it concerning the Ishmaelites are fulfilled in the modern Arab. . . . The wild, suspicious and ready-to-fight Arab of today is a perpetuated reality of Ishmael and his early descendants."[36] Decades earlier, Mark Twain had satirized this trope of the Bedouin as biblical patriarch in a humorous anecdote in *The Innocents Abroad*. Traveling through the Galilee, Twain and his party encountered a group of Bedouin and their sheep. "The shepherds that tended them were the very picture of Joseph and his brethren, I have no doubt in the world. They wore . . . the dress that one sees in all pictures of the swarthy sons of the desert. These chaps would sell their younger brother if they had a chance, I think."[37]

The 1904 Sunday-school convention had a profound impact, not only on its American participants but also on American Protestants in general. Upon their return to the United States, hundreds of members of the American contingent commemorated their experiences. Many included accounts of their pilgrimage, often illustrated with photographs, in their Sunday-school lessons. Others shared their Holy Land experiences in books and articles—whether reverential, humorous, or both, and the American public devoured these accounts. The popular monthly magazine *Woman's Home Companion*, for example, published an article titled "The International Sunday School Invasion of the Holy Land" in its February 1905 issue. Within a year of the convention, a New York publisher had produced *The Cruise of the Eight Hundred to and through Palestine*, a lavishly illustrated volume commemorating and chronicling the pilgrimage. The dedication asserted that "the information herein contained, with the interesting illustrations, will aid those who read it to better understand the Land, the Birth, the Life, the Death, the Resurrection and Ascension of The Christ."[38]

A Pilgrimage to Jerusalem, Charles Gallaudet Trumbull's four-hundred-page personal account of the expedition, opens with a vivid image of the American pilgrim's departure: "Just before the *Grosser Kurfurst* left her moorings, the sun won its fight with the clouds. . . . It is a voyage to Jerusalem, to the land where Jesus was born, and lived, and laid down his life, and took it again. God's sunlight is upon the pilgrims and upon the homeland that is dearer this moment to the wanderers than it ever was before."[39] Trumbull goes on to describe the biblical lens through which these Americans saw Jerusalem. Upon glimpsing the city's massive Damascus Gate for the first time, he notes that through the portal

The
Cruise of the Eight Hundred
TO AND THROUGH PALESTINE

GLIMPSES OF BIBLE LANDS: Two Hundred and Twelve
Full-Page Photo-Engravings, Two Twelve-inch Pano-
ramic Views of Jerusalem, Four Colored Plates of
Palestine Wild Flowers, and Fifty-eight other Photographs
of Persons and Places Connected with the World's
Fourth Sunday-School Convention, Jerusalem, April, 1904

The Christian Herald
Louis Klopsch, Proprietor
91 to 115 Bible House, New York City

The Jerusalem Cross

The title page of *The Cruise of the Eight Hundred to and Through Palestine.*

"came and went a stream of humanity that turned back time to the pages of the New Testament and the Old."[40]

It was a far more upbeat and inspiring image than the ones evoked in American arts and letters by Melville and Twain. While Melville, for instance, returned from Palestine in greater despair than before he left, and Twain could not help but satirize the gullibility of wealthy American tourists, thousands of other American pilgrims were able to turn back time to the pages of the Bible, and then return to the United States with their biblical beliefs strengthened. The cultural influence of the pilgrims' reports created an atmosphere that one modern critic has described as "American Palestine Mania."[41] Support for the return of the Jews was inherent in this enthusiasm. One indication of this fervor was the widespread backing for the second Blackstone Memorial of 1916. In this petition to the White House, hundreds of prominent Americans, including members of Congress, sought American support for Zionism. Another indication was American Christians' overwhelming support for the British government's 1917 Balfour Declaration. In both cases, the notion of American exceptionalism resonated with Zionist aspirations, foreshadowing the way America and Zionism would become intertwined for more than a century.

American Journalists, Artists, and Adventurers and the Zionist Movement (1917–1947)

W HEN BRITISH FORCES under General Edmund Allenby entered Jerusalem's Old City in December 1917, the response among Zionists, both Jewish and Christian, was jubilation. Three years earlier, the Ottoman Empire had entered the First World War on the side of the Germans, setting the stage for Ottoman-ruled Palestine to become a battlefront in the Great War. By the end of the war, the entire region—including Palestine, Transjordan, Syria, and Lebanon—was under British and French control or influence.

The Ottoman defeat seemed to bode well for the barely two-decades-old Zionist movement and its plans for a Jewish state, particularly since a month before Allenby's victory, the British government had issued the Balfour Declaration, a public statement that promised to establish a "Jewish national home in Palestine." For Zionists, the British victory over the Turks meant that Britain's promise to aid the Jewish cause would be fulfilled. For American Evangelicals, the Allied victory in Palestine combined with the promise embedded in the Balfour Declaration served as signs of the times—evidence of divine intervention in history pointing toward the unfolding of God's plan for humanity's redemption. That the United States had entered the war in 1917 and thus shared in the Allied victory made this theological understanding of the grand historical events even more attractive to U.S. Christians. In short, U.S. engagement in World War I brought the Middle East in general, and the Holy Land in particular, closer than ever before to the minds of Americans. President Woodrow Wilson's support for the British government's declaration in favor of "the establishment in Palestine of a National Home for the Jewish people" was welcomed by Jews and Christians throughout the United States.

For my Orthodox Jewish grandparents, all of whom were born in the beginning of the twentieth century to immigrant parents, the Balfour Declaration

and the British conquest of Jerusalem must have seemed nothing less than miraculous. I can imagine my grandparents reading the editorial in the *New York City Evening Mail* on January 15, 1918, which declared Zionism "an experiment in human happiness and usefulness." And a month earlier the *New York American* had noted on December 13, 1917, that with the British conquest of Palestine, "the Universal Jew, who for centuries has been a religion not a nation, is to come at last unto his own."

But the Balfour Declaration was not the only promise made by the British government, and Jews were not the only ones hoping for victory over the Turks. To weaken Ottoman rule in the Middle Eastern theater, the British had encouraged the Arab population to rebel against the Turks. Negotiations between Sharif Hussein of Mecca and the British high commissioner in Egypt resulted in the 1916 outbreak of the Arab Revolt against the Ottoman forces. In return for Arab support against the Turks, the British agreed to recognize postwar independence for a group of Arab states. In 1917 Arab guerrilla forces drove the Ottoman armies out of central Arabia and into what is now Jordan, where they were defeated by forces led by T. E. Lawrence, the British adventurer known as "Lawrence of Arabia." These Arab victories helped set the stage for General Allenby's triumphant entry into Jerusalem.

Yet Britain's conflicting political promises, made in the heat of battle to both the Jews and the Arabs, would bedevil their leadership for much of the next three decades, eroding British credibility and undermining any attempt to rule Palestine. And in the United States, British rule in Palestine generated passionate debates about the future of that territory.

While many artists, writers, musicians, dramatists, actors, and dancers joined in the Palestine debate, others remained indifferent to it, preoccupied with other socialist and progressive causes. The great pro-Israel shift in American culture would not take place for another fifty years, following the 1967 Arab-Israeli War. But as early as the 1920s, outspoken members of the creative class—Jews and non-Jews alike—became among the most committed and influential early American Zionists. They used their art and their public platforms to condemn anti-Semitism and to work for the establishment of a Jewish state.

Opponents of Zionism

At the same time, other Americans with political and cultural clout were organizing against the Zionist cause for mixed reasons: some were isolationists who did not want the United States entangled in Middle Eastern affairs; others

sympathized with the Arab view that Zionism was a new form of European colonialism. And without a doubt, some in the emerging anti-Zionist camp were anti-Semites.

America's creative class had its share of naysayers. Among the most prominent was the esteemed journalist and broadcaster Dorothy Thompson. Thompson, who wrote for the *New York Post*, the *New York Tribune*, and the *Ladies' Home Journal*, in addition to hosting a news commentary on NBC radio for several years during the late 1930s, initially supported the Zionist cause, condemning the Nazis as "a repudiation of the whole past of western man" and calling their anti-Semitic movement "full of fetish and black magic . . . a kind of modern witchcraft."[1] After Hitler personally expelled her from Germany in 1934, Dorothy Thompson became a leading Christian Zionist, serving as keynote speaker at the 1942 Zionist conference at New York's Biltmore Hotel. But Thompson's views shifted following her 1944 visit to Palestine. She was appalled by the terrorist tactics that the Jewish paramilitary groups the Irgun and the Stern Gang were using against the British. In 1946, when the Irgun attacked the British Mandate's headquarters at the King David Hotel, killing ninety-five people, many non-Jewish proponents of Zionism broke with the movement. But Thompson brought the full force of her journalistic talents to bear in opposing Zionism. By the end of the 1940s, she was warning American Jews that their civic status was jeopardized by "the claim that every Jew in the world is a member of the Jewish People, or Nation." Thompson asserted that Zionist propaganda incorrectly promoted the idea that "Jews exist in this country, as everywhere outside of Israel, on dubious sufferance, and that whatever happened in Germany could happen here any minute."[2]

Joseph P. Kennedy, patriarch of the Kennedy clan, also fought against Zionism. Though better known as a politician and a financier than a member of the creative class, he worked during the 1920s in the Hollywood film industry where he developed and spread his critiques of Jews and Jewish nationalism.

When he entered the movie business in 1926, Kennedy presented himself to potential investors as thoroughly American—from Harvard University and Boston—and by inference not foreign, at the time a thinly veiled code for Jewish. According to Kennedy, Hollywood was run by "a bunch of ignorant Jewish furies." Bitter that he had not gotten into the industry earlier, Kennedy accused his successful Jewish rivals of having "unethically pushed their way into a wide-open virgin field."[3]

In 1938 President Franklin D. Roosevelt appointed Kennedy U.S. ambassador to the Court of St. James. In London, Kennedy grew close to the Nazi-appointed

German ambassador, who described him as "Germany's best friend in London." When war broke out in 1939, Kennedy's avowal of U.S. neutrality put him increasingly at odds with the U.S. government, and he resigned following Roosevelt's reelection in 1940.[4] Ultimately, he blamed the "Jew Media" and the "Jewish pundits in New York and Los Angeles" for Roosevelt's victory.[5]

Before he left London, Kennedy made a trip to California to see his son John. While in Hollywood, he invited some fifty Jewish studio executives, producers, and writers to meet with him.[6] During the meeting, Kennedy harangued the assembled group, warning them of the dangers anti-Nazi films posed to world peace. According to the actor and producer Douglas Fairbanks Jr., who attended the meeting, Kennedy "threw the fear of God into many of our producers and executives by telling them that the Jews were on the spot and that they should stop making anti-Nazi pictures."[7] Among the films Kennedy criticized were *Clouds over Europe* and *Confessions of a Nazi Spy*, both distributed in 1939, as well as the British thriller, *Night Train to Munich*, which was distributed in America in 1940. President Roosevelt's decision to ask for Kennedy's resignation stemmed in part from the account of that meeting supplied by Fairbanks, a close friend of the president.

In the larger picture, Kennedy's opposition to Zionism was part and parcel of his appeasement policy toward Nazi Germany. He was sure that Britain would not stand up to the German dictator. By the time Kennedy launched his diatribe against the Hollywood Jewish community, those film producers had themselves been struggling with the issue of neutrality since the Nazi rise to power in 1933. How much should their films dare to expose and criticize Nazi crimes?[8]

To what extent did Kennedy's pro-fascist and anti-Jewish attitudes influence his children? Joe Jr., his eldest son and the first of his nine children, clearly adopted many of his father's political and social attitudes. Writing from Germany in the spring of 1934, the nineteen-year-old Harvard University student extolled the Nazi regime: "They had tried liberalism, and it had seriously failed. They had no leader, and as time went on Germany was sinking lower and lower. The German people were scattered, despondent, and were divorced from home. Hitler came in. He saw the need of a common enemy, someone of whom to make the goat. Someone, by whose riddance the Germans would feel they had cast out the cause of their predicament. It was excellent psychology, and it was too bad that it had to be done to the Jews. This dislike of the Jews, however, was well-founded. . . . They were at the heads of all big business, in law etc."[9]

As Doris Kearns Goodwin noted, this letter "reveals a certain grounding in anti-Semitism that can only have come from his family background."[10]

British Jerusalem and the American-Funded YMCA

During the British Mandate, American Jewish Zionists raised considerable amounts of money for the Jewish National Fund and other organizations building Jewish institutions in Palestine. Wealthy American Christians who were eager to see the Protestant presence in Palestine strengthened donated money to their respective church organizations. And a group of influential and wealthy Americans were eager to fund projects that would encourage interreligious cooperation. The Jerusalem YMCA was the most spectacular of these projects, and in many respects the most successful in British Jerusalem.

The professor and journalist John H. Finley, who dubbed himself "the first American pilgrim to visit the Holy Land after General Edmund Allenby's recovery of the Holy Land," wrote that Americans should thank Britain "and its great leaders for making it possible for Christendom to walk again in its holy places free of the Turk."[11] Indeed, Finley, who had served as head of the American Red Cross mission to the British forces during the war, was so impressed with General Allenby that he viewed him in messianic terms, speculating about the prophetic origins of his name. "I suspect that it is of Irish association, but an oriental origin may easily be found for it in the euphonious union of two words, 'Allah' meaning 'God' and 'Nebi' meaning 'prophet,'" Finley wrote. "So 'Allah-Nebi' a God-prophet. And surely no one in the history of Palestine in the Christian era has come with a more Godlike prophecy."[12]

To many churchgoing citizens of England and the United States, Britain's victory in the Holy Land was suffused with both political and religious meaning. The defeat of the Ottoman Turks, who had ruled the Holy City for four hundred years, was a victory not just for the Allied forces but also for the Christian faith: proof that God had again intervened in history. Some soldiers in the British forces described their victory in religious terms. One British officer called it "a Christian reconquest of Jerusalem," a city that had been under Muslim control since the Crusades. This soldier saw himself, he later wrote, as part of "an army victorious after 600 years."[13] Echoing Finley's idea that Allenby's entry into Jerusalem was for many in the Christian West a major world event, another observer noted: "Wireless messages flashed round the world. Every newspaper in the English language was full of the capture of Jerusalem. . . . Allenby's name was on everyone's lips, as no other general's had been during the war."[14]

Yet not all observers were so ecstatic. After the Allied victory over the Turks in 1918, Palestine was placed under British military rule. Four years later, in 1922, the new League of Nations approved a mandate formally granting the British

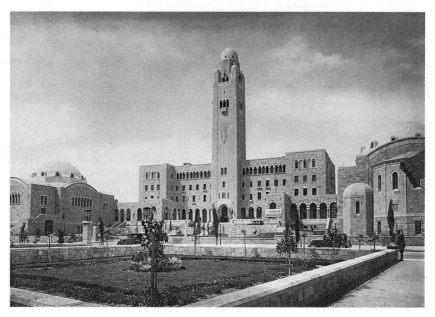

The Jerusalem YMCA. Completed in 1933, designed by H. Arthur Harmon, architect of the Empire State Building. Wikimedia Commons.

Crown legal right to administer the territory. From 1922 to 1948, the British tried, unsuccessfully, to govern the Arab and Jewish populations with some semblance of fairness. Each side was convinced that the British favored the other. Perfidious Albion—"Britain the traitorous!"—was a cry commonly heard from both sides of the emerging conflict.

The celebrated American journalist H. L. Mencken visited Jerusalem during a 1934 Mediterranean cruise and noted other problems. Mencken was at the height of his fame as America's most outspoken and cantankerous cultural critic, having made his name reporting from the 1925 Scopes Trial. Like Twain and his earlier satirical approach to Holy Land pieties, Mencken was not taken in by the sanctity and sanctuaries of Jerusalem. "Mencken . . . took on American Protestants who thought they could export their Christianity to Palestine," wrote David Klatzker.[15] Mencken presciently noted the different factions—secularist and Orthodox—emerging among Palestine's Jews. And he derided Jerusalem's chronic lack of nightlife: "And so to bed, and sweet dreams of Abraham, Jeremiah, Micah, Elijah, and company. Jerusalem would be a swell place for sleep

if it were not for the church bells."[16] Such comments reinforced Americans' impressions of Jerusalem as a provincial city lacking in nightlife—an impression that would persist after the 1967 War.

Finley, too, saw shortcomings. Dismayed by what he saw as the squalor of Ottoman Jerusalem, Finley employed religious imagery in his widely read travelogue, *A Pilgrim in Palestine*, to win American support for the Holy City's resurrection under Christian rule. "Under the British Government it is being cleansed and prepared for the genius of the nations . . . to adorn it, make it the most beautiful city on the planet, and give it a most fitting setting amid the mountains round about it."[17] Finley's words carried a lot of weight; he was a renowned Princeton University professor who later became editor in chief of the *New York Times*. Indeed, his sentiments played a significant role in inspiring Americans to lavish attention and funds on Jerusalem building and restoration projects, among them the construction of a new international YMCA.

SOON AFTER THE British Mandate in Palestine established its headquarters in Jerusalem, a group of wealthy and influential American Protestants promoted the idea of building what they described as "the world's most beautiful YMCA" in the Holy City. As a global center for the rapidly growing Young Men's Christian Association movement, this building would leave a permanent mark on the city, contributing both to its international status and its cultural efflorescence. With an auditorium, gym, swimming pool, library, and meeting rooms, the Jerusalem Y would become the city's cultural center, a venue for every kind of physical and mental exercise, including lectures, musical performances, sporting events, and public ceremonies. Although it might seem strange to classify a building or an organization in the same terms as a well-known writer, painter, or performer, the Jerusalem YMCA made rich cultural exchange possible in the somewhat chaotic postwar order.

Over the subsequent decades, the YMCA would promote the musical arts as a bridge between the contending cultures of Jerusalem. In the twenty-first century, the Y's Jerusalem Youth Chorus, in which Israelis and Palestinians perform together, is one of the region's more successful reconciliation efforts.

The organizers of the YMCA planned on a scale befitting the age of the American robber barons when taxes were low and sights were high. First, they chose Arthur Harmon, chief architect of New York City's Empire State Building, to design the new facility. Next, they purchased land in West Jerusalem from the Greek Orthodox Church, which owned a considerable amount of the

city's most valuable real estate. Funds to purchase the land came from three main sources: the British National Council, the International Committee of the YMCA in North America, and a group of Jewish philanthropists in Manchester, England. New Jersey coffee and sugar magnate James Newbegin Jarvie made the largest single donation to the project. This cross-cultural, interfaith fund-raising effort reflected the YMCA's philosophy of welcoming and respecting people of all faiths.

The grand scale of the completed building didn't escape the notice of H. L. Mencken on his 1934 visit to the Holy City. At the height of his fame, he and his wife Sara stayed in Jerusalem at the King David Hotel, directly across the street from the YMCA. Writing in his widely read magazine *American Mercury*, Mencken described the structure as resembling "in a way a country-club in Florida and in another way the General Motors Building at a World's Fair." He recalled asking the hotel driver how Jerusalem could support such a large establishment, "for Protestants are almost as rare there as in South Boston or the Bronx. The driver replied that the money came from America, and the actual patrons were Moslems and Jews."[18]

Mencken was an astute observer of the relationship between politics and religion, and his caustic eye spared no one in Jerusalem. But the founders of the new Jerusalem Y harbored more idealistic views and aspired to become a meeting place for the Holy City's distinct religious communities: Christians, Muslims, and Jews. This ecumenism, based on American liberal ideals, is clearly expressed in the building's architecture and decor. The facade features three large inscriptions, one for each faith. Each appears in its original language—Aramaic, Arabic, and Hebrew—but has been truncated to remove references to its distinctive religious tradition. For example, the Jewish quotation from the Hebrew Bible reads, "The Lord is our God, the Lord is One," but omits the crucial preceding phrase, "Hear, O Israel." The Christian inscription, "I am the way," leaves off the identifying attribution, "Jesus said." And the Muslim caption, "There is no God but Allah," eliminates the ensuing, "And Mohammed is his Prophet." With these sanitized inscriptions, the builders hoped to honor the three religious traditions without offending any one group.

The building's Protestant organizers, however, still had their own evangelizing interests at heart. They wanted to create a space for Protestant religious life in a city where Christianity had been defined by the ancient Catholic and Orthodox churches and their claims to the authentic sites of biblical history. American Protestant missionaries had not had much success winning Jewish or Muslim converts, but the Jerusalem Y would give them a new platform for

expanding their evangelical efforts to local Catholics and Orthodox Christians. The International YMCA Committee, which was strongly affiliated with Protestant missionary movements, agreed; it saw the new building as a foothold for spreading the Gospel in the Holy Land.

Aspects of the building itself reflect this aspiration for Protestant influence in Jerusalem. The George Williams Room was constructed as an exact replica of the London room where the YMCA had been founded in 1844, complete with period furniture, rugs, and a painting of Queen Victoria. This little piece of Victorian England in Mandate Palestine conveyed the message that Jerusalem and Britain were inextricably linked through spiritual ties. The George Williams Room remains a part of the Jerusalem Y today, though the original in London's Russell Square no longer exists. Many visitors assume the copy is the original; the room in the Jerusalem Y must be authentic, because it resides in the Holy City.[19] In contrast to this nod to its Protestant origins, the Jerusalem Y's basement chapel was designed to express its biblical roots. It was constructed from twelve large stones transported from the bed of the Jordan River, stones that represent the altar Joshua built after the Israelites crossed into Canaan.

Not everyone saw the construction of the Jerusalem Y as a positive development. Before the building was finished, there were conservative Christian, Muslim, and Jewish clerics who urged their followers to boycott the institution. They feared that the new YMCA would become a center of Protestant missionary activity. Even if there was no direct proselytizing, these clerics reasoned, social interaction among the different religious groups would nevertheless blur ethnic lines and weaken traditions. In another conflict, arguments also developed over the Y's prospective library holdings. What sorts of books and periodicals would be featured in the collections? Tensions boiled over when the library director ordered, among other European newspapers for the reading room, the Nazi German *Völkischer Beobachter*. Incensed, the Jewish community, fearing the spread of Nazi propaganda in Jerusalem, threatened to boycott the new building. Their protest worked, and the library director withdrew the offending subscription.

Construction of the Jerusalem Y took five years. When it was finished in 1933, organizers staged an elaborate dedication ceremony, inviting political and religious leaders from Palestine, England, and the United States. Enthusiasm ran high among American YMCA members, many of whom had donated generously to the effort. Asked to deliver the keynote address, General—now Lord—Allenby deftly managed to invoke the theme of world brotherhood and memorialize the principal donor James Jarvie of New Jersey, all in a single short paragraph: "Completed, after five years under construction, a noble architectural

group stands unrivalled in the world for beauty and dignity; it is a worthy home for the Young Men's Christian Association in the Holy Land. A large-hearted friend has given it, as a memorial and a pious offering to the One Lord; God of Christian, Jew, and Muslim, alike."[20]

Allenby went on to highlight the ecumenical intentions underlying the building's development, describing the project as "a gesture of friendship by British and American citizens towards Muslims, Jews, and their own Palestinian co-religionists; intended and calculated to promote a better understanding of each other; in the city which is Holy to all three faiths. Its works will be inter-racial, inter-faith, without any distinction of country or creed; in the interests and for the benefit of both sexes." He concluded his remarks with this hopeful credo: "Here is the spot whose atmosphere is peace: where political and religious jealousies can be forgotten, and international unity be fostered and developed."[21]

Though founded in the spirit of post–World War I optimism, the Jerusalem YMCA was soon enmeshed in the stark realities of the 1930s: severe economic depression, the rise of totalitarian regimes, and the threat of another world war. Jerusalem, far from being a symbol of peace, now seemed at the center of an emerging conflict between Jews and Arabs, and at risk of civil war. More than ever, the YMCA staff hoped to serve as a bridge between peoples and a center for negotiation, if not reconciliation. As the Nazi rise to power in the 1930s brought increased restrictions on Jewish life in Germany, Jewish emigration to Palestine accelerated. Many professional musicians joined the exodus, and in Tel Aviv they established the Palestine Philharmonic Orchestra, which often performed at the Jerusalem YMCA.

When the Second World War broke out, British soldiers flooded Egypt and Palestine. Many of them became regular visitors to the Jerusalem YMCA, which served as a refuge for their families. In the words of one British chaplain, "All that was best in the social life of the Holy City, not only for men in uniform, but amongst young Jews and Arabs, centered in that pinnacle of white stone with adjacent buildings clustering at its foot."[22]

Ultimately, Allenby's hopes were well-founded; the Jerusalem YMCA became a microcosm of Jerusalem's diverse population. At first, during the early 1930s, many of the Y's members were Christians—primarily British officials and servicemen. Congregants of Jerusalem's Middle Eastern churches occasionally used the Y's facilities, as did a smaller number of Jews and Muslims. But as the decade wore on, the YMCA began to occupy a significant place in the cultural life of Jerusalem, with more Muslims and Jews becoming regular members. By the end of World War II, half of the Y's membership was Christian, one quarter

was Jewish, and one quarter was Muslim. Over time, the numbers continued to shift as the building became increasingly central to the city and its population. By 2003, 62 percent of the Y's members were Jewish, 20 percent Muslim, and 18 percent Christian.[23]

Culture and Ideology in Jewish Palestine

The politics of the Yishuv, Palestine's Jewish community, coalesced around two main camps: Labor Zionism and Revisionism. Each thought of itself as the correct Zionist ideology, and each sought to establish a strong Jewish presence in Palestine. There were significant differences between the two camps. During the 1920s, the Revisionists called for an actual Jewish *state*, while the Labor Zionists—part of the international socialist movement and thus less focused on nationalism—framed their more modest goal as the need for a national home.

Both camps had American supporters—including journalists, writers, artists, and entertainers—who backed them financially as well as culturally. Because the American intelligentsia of the 1930s was predominantly leftist in orientation, the Labor Zionists attracted greater American support. American Jewish Zionists, the great majority of whom were immigrants or the children of immigrants, followed these political struggles closely and were often engaged in these struggles directly. Labor Zionist perspectives were featured on the radio programs of New York City's WEVD. Since 1932, broadcasting in Yiddish, this station's "Jewish News Hour" reported on developments in British Mandate Palestine, and, after 1948, on the State of Israel. These are the same broadcasts that I remember listening to in the late 1950s on visits to my maternal grandmother and her Yiddish-speaking siblings.

The Revisionists did have some powerful American backers, most prominently—as we shall see—the Chicago journalist and Hollywood screenwriter Ben Hecht. By the end of the twentieth century, this dynamic would shift, with American Jews moving to the right. But before we get there, we need to take a closer look at the Revisionist movement.

TENSIONS BETWEEN Labor Zionists and Revisionists boiled over at the 1925 Zionist Congress, with the factions bitterly divided over how to establish a Jewish political entity; intractable fights over the definition of borders and the establishment of political systems led to a formal split. By the early 1930s, observers spoke of an "ongoing war between the Revisionists and the Histadrut," the trade

union that served as the mainstay of the Labor Zionists.[24] Further complicating the picture, each Zionist faction had internal divisions. Like the Republican and Democratic Parties in the United States, these political groups were big-tent organizations sheltering many smaller movements.

The competing Jewish youth movements of the time expressed their contending ideologies through culture as much as politics. Like their European counterparts, leftist youth affected a more relaxed and bohemian style of dress, donning red shirts or kerchiefs and marching with red banners. Their rightist adversaries were more formal, wearing dark colors and embodying military discipline. Both groups considered music and poetry to be essential forms of political expression; at meetings and demonstrations, the Labor Zionists sang a Hebrew version of "The Internationale," the anthem of the international socialist movement, while the Revisionists had their own rousing song, the Beitar Hymn, which spoke of the necessity of a violent struggle for a recovered land. As the lyrics proclaimed, "In blood and fire Judea fell; in blood and fire Judea will rise." Established in 1925 by Vladimir Jabotinsky, Revisionism drew its name from its wish to revise the central aims of the Zionist movement, which had been founded in 1897 by Theodor Herzl. Jabotinsky criticized Herzl's brand of political Zionism for failing to articulate its aims clearly. "What is the practical objective of Zionism?," Jabotinsky asked in a 1926 essay. "To say: we want to create a 'national home' is not enough as the term has no fixed meaning and can therefore be interpreted by interested persons to mean nothing—to mean the equivalent of a new ghetto. The only precise way of describing our objective is this: we want to create in Palestine a Jewish majority. This does not mean that we intend to rule over our neighbors; but want Zion to become a country where the Jew can no longer be overruled."[25]

Jabotinsky called for an assertive military and diplomatic path to achieve immediate statehood. His approach stood in sharp contrast to the gradualist efforts of the Labor Zionists, including Chaim Weizmann, David Ben Gurion, and others, who were focused on slowly building a Jewish infrastructure in Palestine through agriculture and industry. While the Labor Zionists were content to leave their territorial ambitions undefined, the Revisionists outlined a bold, clear plan: the Jewish state should include both banks of the Jordan River, and any compromise with the Palestinian Arabs or the neighboring Arab states was out of the question, because such compromises would prove unworkable.

Indeed, Jabotinsky not only spoke of revising Zionist aims but also invoked the concept of nationalist self-determination articulated by President Woodrow Wilson at the end of World War I. Some representatives of the Palestinian Arabs understood the Wilsonian principle as a validation of their right to determine

their own political future. Jabotinsky, however, thought otherwise; he believed that the Balfour Declaration—the British government's 1917 proclamation supporting the establishment of a Jewish homeland in Palestine—and the Jewish historical claim on the Holy Land superseded any Arab aspirations or Wilsonian principles. In Jobotinsky's view, the fact that Arabs constituted the majority population in Palestine did not mean that they should decide its future; rather, the future of Palestine should be determined by Jews because they held prior claim to the Land.

Militant Zionism became the Revisionist movement's creed as Jabotinsky believed that "only concerted pressure for a Jewish state would force the British to accede."[26] Coining the phrase "iron wall" to describe the Jewish community's defense needs, he predicted that the Arabs would not accept a Jewish state until the Yishuv organized an iron wall of military strength to defend its borders and protect its citizens. Jabotinsky demanded that the British allow the Yishuv to organize its own army, particularly after Arab attacks in 1920 and 1929 led Jewish leadership to believe it could not rely on the British administration to safeguard its people and settlements. But the Mandate authorities, struggling to balance the needs of both Arab and Jewish residents, denied Jabotinsky's request; a Jewish army was the last thing they wanted. In response, Jabotinsky helped establish the Haganah (The Defense) as an early self-defense force of the Yishuv, but it eventually developed, under the leadership of the Labor Zionists, into a working-class, collectivist organization associated with the Kibbutz movement.[27] The Revisionist fighting force, the Irgun, would break away from the Haganah in the early 1930s.[28] But by then, Jabotinsky no longer resided in Palestine. Following a trip to South Africa in 1930, the British refused him reentry, banning him from Palestine. However, Jabotinsky never abandoned the Revisionist cause. As an international figure, he traveled extensively throughout Europe to develop Revisionist support. When World War II broke out, he moved to the United States, where he died in 1940.

The Revisionists had their share of critics, both inside and outside of Palestine. The Labor leader David Ben Gurion harbored a lifelong antipathy toward the Revisionists and their leader, whom he called a "Hitlerite." During his tenure as prime minister of Israel from 1948 to 1963, Ben Gurion refused to allow Jabotinsky's remains to be transferred from New York to Jerusalem and reburied there. Only after Ben Gurion's resignation in 1963 did his successor, Levi Eshkol, permit reinterment and a state funeral for Jabotinsky.

In 1929 the American journalist Vincent Sheean, borrowing terminology used by the Labor Zionists, dubbed Jabotinsky's followers "Jewish fascists" for their role in a violent outbreak that began in Jerusalem in August. The dispute

erupted from a Jewish demand for a screen to separate male and female worshippers at the Western Wall. After a week of fighting, Arabs had killed 133 Jews and injured 339 more; Jews had killed 6 Arabs, and the British police had killed 110 Arabs and wounded 232 more.[29] In Sheean's account of the clashes, the Revisionists were partially responsible for instigating the riots. Published in the *New York World*, his article generated a firestorm of protest, garnering more than three thousand letters of condemnation in a single day.[30] Sheean's suggestion that some Jews shared responsibility for the violence implied that the conflict in Palestine was more complex than a simple battle of good versus evil, but the subsequent outcry from American readers cost Sheean his job. Soon after the events of August 1929, his contract was terminated. Sheean continued to work as a journalist, but he would make his living and reputation from writing books rather than publishing newspaper articles.

Mussolini thought that Sheean had a point. Believing that Jabotinsky's followers shared an affinity for European dictators, the Italian called the Revisionist leader a "Jewish fascist."[31] If we keep in mind that Italian fascism did not adopt Nazi Germany's racial policies until the late 1930s, this identification seems less strange. "Whatever we may think of Fascism's other points, there is no doubt that the Italian brand of Fascist ideology is, at least, an ideology of racial equality," Jabotinsky told his followers in 1935. "Equality comes first . . . and Jews should be the first to remember it."[32] Only three years later, however, the Italian government under pressure from Germany would issue its own racial laws, limiting Jewish participation in Italian public life and eventually targeting its Jews for expulsion and extermination.

KNOWLEDGE OF THE ideological and historical division between Revisionists and Labor Zionists is the key to understanding the evolution of Israeli politics. During Israel's first three decades, from 1948 to 1977, the Socialist-oriented Labor movement ruled the country. But in 1977, in the aftermath of the 1973 Yom Kippur War, the heirs of Jabotinsky's Revisionist tradition rose to power in the Israeli government. They were led by Prime Minister Menachem Begin, who referred to Jabotinsky as "our immortal teacher and leader."[33] Indeed, since 1977, most Israeli coalition governments have been controlled by the Likud, Begin's political party and Revisionism's political heir. Benjamin Netanyahu, now serving his fourth term as prime minister, is the child of one of Revisionism's leading intellectuals, Ben Zion Netanyahu, who in his youth served as Jabotinsky's secretary. The elder Netanyahu later became an eminent historian of the Jewish

experience. He taught at Cornell University for decades and wrote many books that lent intellectual authority to Revisionism. His son Benjamin Netanyahu has carried on that Revisionist tradition in the process of presiding over one of the most violent and divisive periods in Arab-Jewish relations.

Rabbi Magnes and Brit Shalom

Though Socialist Zionism and Revisionism were of great importance to the development of Israeli politics, they were not the only ideological options available to the Jews of Palestine. A much smaller political group called Brit Shalom, or Covenant of Peace, lay outside the broad Zionist consensus. While the prominent Zionist factions promoted the goal of a Jewish homeland, Brit Shalom sought a different solution: a binational state where Jews and Arabs would share power. Brit Shalom found support among a segment of American elites that included prominent journalists, creative artists, and academics. Chief among them was the California-born intellectual Judah L. Magnes, a Reform rabbi who moved to Jerusalem in 1925 to become the first president of Hebrew University. Unlike his ideological opponent Vladimir Jabotinsky, Magnes settled in Palestine and remained there for most of his life.

A pacifist, socialist, and ardent Zionist, Magnes believed that "Palestine should be neither a Jewish nor an Arab state, but a binational state in which Jews and Arabs should enjoy equal civil, political, and social rights, without distinction between majority and minority."[34] As early as 1917, when virtually all Zionists thrilled to the announcement of the British government's Balfour Declaration, Magnes withheld his approval. In 1919, at a New York City meeting of Socialist Zionists, the rabbi told his audience that the terms of the British Mandate, intended to implement the Balfour Declaration, were unjust. "To my mind no Peace Conference has the right to give any land to any people, even though it be the Land of Israel to the People of Israel," he said. "If self-determination be a true principle for other peoples, it is just as true for the Jewish people, here, there, and everywhere. If democracy means something for the oppressed peoples of the world, it must mean just that thing for the Jewish people. . . . Our new beginnings in Palestine are burdened by this gift."[35]

Magnes noted that what the Zionist movement referred to as the Arab Question in fact included many additional questions, such as the nature and future of Judaism and the Jewish relationship to nationalism, internationalism, imperialism, and pacifism. In contrast to most Zionists, who claimed simply that God had granted the Jews the land, Magnes had a more nuanced understanding of

the situation. "I begin with the thesis that Palestine is *sui generis*—it does not 'belong' to anyone in particular in the spiritual sense. 'For the land belongs to me,' says God in Exodus (19.5). Palestine belongs in a very real sense to all the nations that have come under the influence of Judaism—Christianity and Islam. It is historically, spiritually, geographically of too great importance to say that it belongs to its inhabitants for the time being."[36]

These views directly opposed Jabotinsky's revision of the doctrine of self-determination. Mainstream Zionists roundly criticized Magnes, and Brit Shalom's membership never exceeded two hundred. Nor did Magnes's proposal gain much traction among Arab leaders; despite his pacifism and aversion to armed conflict, Magnes called for a stronger Jewish presence in Palestine, which was unacceptable to the Arabs of Palestine. Furthermore, Brit Shalom's idea that Palestine would be neither an Arab nor a Jewish state but a federation of the two challenged the emerging consensus among Palestinian Arab leaders that they should control their own destiny rather than have their future determined by the colonial powers—of which the Zionists, in their view, were agents. Yet Magnes remained undeterred. As the first chancellor of Hebrew University, which he had helped establish, he sought to make Jewish-Arab peace a part of the institution's mission. Not only did he hire faculty to teach Arab language, culture, and civilization, but in 1932 he also inaugurated a professorship dedicated to the field of peacemaking.[37] The paramilitary arm of the Revisionists, the Biryonim (Thugs), threatened violence if the inaugural lecture of that course were to take place.

Such violence was becoming increasingly common in British Mandate Palestine, with armed political groups across the spectrum gaining strength. By the mid-1930s, it was clear that the combined efforts of the British police and the British military were unequal to the task of keeping order in Palestine. The Arab Revolt of 1936, which targeted both the British Mandate authorities and the Jews, deepened the chaos. It convinced Ben Gurion and other Zionist leaders that any further conversations or negotiations with Palestinian Arab leaders were pointless. According to Walter Laqueur, "Only the indefatigable Magnes and some of his closest friends continued to believe that with a little more goodwill on the part of the Jews agreement could be reached," and even Magnes had his moments of doubt.[38] In March 1936, Ben Gurion, who called on the British to allow—in the wake of the deteriorating situation of the Jews in Europe—large-scale Jewish immigration to Palestine, told Rabbi Magnes: "The difference between you and me is that you are ready to sacrifice immigration for peace,

while I am not, though peace is dear to me. And even if I were prepared to make a concession, the Jews of Poland and Germany would not be, because they have no other choice. For them immigration comes before peace."[39]

A year later, in 1937, a British Royal Commission headed by Lord Peel called for the partition of Palestine into two states, one Arab and one Jewish. This official British recommendation only strengthened the determination of the majority in the Yishuv to reject further attempts at Arab-Jewish binationalism and work for full Jewish statehood. According to historians of Zionism, the idea of partition was "an admission of the failure to achieve accord between two people . . . not only as failure with respect to the past, but as a powder keg for the future: the establishment of two sovereign states in such a small area would engender continuous strife between Jews and Arabs."[40]

The various groups that made up the Zionist movement in the United States disagreed with Magnes's conciliatory approach toward the Arabs of Palestine. In the wake of the Arab-Jewish riots of 1929 and the rise of Nazism in the early 1930s, attitudes had begun to harden, and by the late 1930s an explicit call for an independent Jewish state in Palestine had become the platform of almost all Zionists.

Prominent American Jews affiliated with Reform Judaism, many of whom were of German Jewish origin, reconsidered their earlier opposition to the Zionist movement and became ardent supporters. In the mid-1930s, German Jewish immigration to the United States and to Palestine increased greatly, and American Jewish charitable groups were eager to aid those new arrivals and immigrants from other European countries. American Zionists began to develop effective organizational and financial structures. They also put considerable effort into political advocacy, not only in Washington, D.C., but also in state and local jurisdictions.

As conditions in Europe deteriorated through the 1930s, Jewish leaders there became urgently focused on community welfare and survival; fewer and fewer resources were available to promote the Zionist cause. While British Jews maintained a strong voice in the movement, the center of Zionism gradually shifted to the more secure, stable Jewish communities in the United States. As their role in the movement increased, American Zionists realized that to influence public opinion on the Palestine question, they could not limit themselves to the domestic arena; they had to reach out to the international community. As Europe seemed to turn against its Jews and against Zionism, some American Zionists looked to emerging Asian leaders for support.

Gandhi and the American Zionists

In October 1931, Rabbi Stephen S. Wise, one of the most prominent Reform rabbis in the United States and a leader of the Zionist Organization of America, spoke at the Friends of Gandhi Dinner in New York City, an event held to commemorate the Mahatma's sixty-second birthday. In his remarks, Rabbi Wise challenged Gandhi's recent pronouncement that the Jews were entitled to settle in Palestine only by peaceful means, not as a result of British or Jewish force. Wise, though respectful of Gandhi's views, insisted that the use of force was in this case an issue of self-defense. "There were virtually no Jewish bayonets in Palestine until Arab bayonets perpetuated the massacre of August–September 1929," he argued. The Jewish settlers in Palestine were merely defending themselves against Arab attacks. With their "immemorial" title to the land, Jewish settlers had "returned to Palestine not to hurt and to wound, but to serve to enrich and to bless the land and all its people." In Wise's view, the settlers had succeeded "from every point of view, economically, culturally, morally, and spiritually."[41]

This exchange between an American rabbi and the Hindu leader of the Indian independence movement arguing over the fate of Palestine may seem surprising, but over the course of several decades following the First World War, Gandhi engaged in an ongoing conversation with some of the most prominent Jewish intellectuals of the Zionist movement, many of them American. As an opponent of British imperialism, Gandhi criticized the Balfour Declaration's call for a "Jewish National Home" in Palestine and spoke out against the British Mandate. He insisted that Palestine should be under Muslim control. As he argued, "No canon, however, of ethics or war can possibly justify the gift by the Allies of Palestine to the Jews. It would be a breach of implied faith with Indian Mussulmans in particular and the whole of India in general."[42]

In Gandhi's view, no European power had the right to take away a territory from its inhabitants. More importantly, he linked his support for the Arabs of Palestine to his support for the Muslim minority in India. Though a member of the Hindu majority, Gandhi hoped to establish a unified India that would include Hindus and Muslims living together in a single nation.[43] If India was not to be exclusively Hindu, he reasoned, why should a proposed state in Palestine be exclusively Jewish? Thus, Gandhi's support of Muslim opposition to Zionism was consistent with his larger pluralistic concerns and served in part to further his domestic vision.

In 1937, as the Nazi regime was persecuting German Jews, the American essayist and scholar Hayim Greenberg published an open letter to Gandhi in New York's *Jewish Frontier* magazine, calling on the Indian leader to protest the German persecutions and the dire condition of Europe's Jews. Greenberg argued that, though India was "remote from Jewish wretchedness" and "taken up with her own great cares and unsolved problems," Gandhi should still be concerned with "what has happened to millions of my fellow-Jews in Europe, North Africa, and parts of Asia."[44]

Aware that Gandhi had condemned the treatment of African Americans in the American South, Greenberg suggested that the black population in the United States and the Jewish population in Europe were in fact in positions similar to India's untouchables. "We Jews strive to redeem ourselves from our state of 'untouchability.' We seek bread, work, freedom, and human dignity. . . . We need a country for the millions of persecuted Jews, and this country must be the land which cradled the civilization we once created there." Greenberg went on to point out that encouraging "harmful and thoroughly false propaganda against Jews and Zionism" in the Indian Muslim community was destructive, as "Jew-hatred is a dangerous poison not only for the hated but for the haters." Greenberg suggested that if Gandhi were truly concerned about the fate of the Muslim minority in India, he should educate India's Muslims as to what the aims of the Zionist are.[45] As we shall see, Gandhi would adopt Greenberg's description of European Jews as untouchables in later articles and correspondence.

In the November 26, 1938, issue of his weekly newspaper *Harijan*, Gandhi addressed the deteriorating situation of the Jews in Germany, and the prospects of providing a refuge in Palestine for Jews fleeing Nazi persecution. Though he did not name Greenberg directly, Gandhi was clearly responding to Jewish interlocutors, including Herman Kallenbach, who had been his closest ally during his years in South Africa before the First World War. Kallenbach had become a Zionist and was serving on the board of the South African Zionist Federation.

Gandhi's statement on the question of Palestine was, to the profound disappointment of his Jewish friends, decidedly unsympathetic to Zionism. Palestine, he categorically declared, "belongs to the Arabs."[46] In the same article, however, Gandhi expressed his unqualified support for Germany's Jews, who since 1933 had been deprived of citizenship and civil rights. "My sympathies are all with the Jews," he wrote. "They have been the untouchables of Christianity. . . . The German persecution of a whole race seems to have no parallel in history." Despite this declaration of support, his proffered solution was problematic. He said of the

German Jews, "If someone with courage and vision can arise among them to lead them in nonviolent action, the winter of their despair can in the twinkling of an eye be turned into the summer of hope."[47]

Here, Gandhi was applying his principle of *satyagraha*—"the force of truth"—to a European situation. Gandhi based his civil resistance campaigns in South Africa and India on this nonviolent principle, which he considered to be universally applicable. If this was so, Germany's Jews, too, could apply the technique. Conflict could be resolved through a process in which each side recognized the kernel of truth in the other side's position. Missing from Gandhi's analysis, however, was a scenario in which one side denies the possibility of dialogue and rests its claim on total force. In his view, there were no exceptions to the power of *satyagraha*; Hitler and the Nazi regime—like all human beings—were susceptible to political and moral persuasion.

When critics responded that the Jewish tradition had always promoted a form of passive resistance in the face of oppression, Gandhi responded in this way: "The Jews, so far as I know, have never practiced nonviolence as an article of faith or even a deliberate policy." He aligned himself with two of the Christian theological tradition's most contentious stereotypes of Jews, arguing that "their ancestors crucified Jesus," and that their religion espoused an ethical order rooted in vengeance. He then concluded that Jewish nonviolence, "if it may be so-called, is of the helpless and the weak."[48]

Rabbi Judah Magnes, the American-born president of Hebrew University, and Martin Buber, the German Jewish philosopher who had recently arrived in Palestine as a refugee from Nazi Germany, both responded to Gandhi, aiming to correct his misunderstandings of the Jewish tradition. Their letters, published together in pamphlet form near the end of 1939, circulated widely in England and the United States.

But before that, in March 1939, Buber sent his first ten-page letter to Gandhi's ashram in India; when Gandhi failed to reply, Buber made the letter public. In it, Buber questioned Gandhi's universal application of *satyagraha*. "Jews are being persecuted, robbed, maltreated, tortured, murdered," Buber wrote. "And you, Mahatma Gandhi, say that their position in the country where they suffer all this is an exact parallel to the position of Indians in South Africa at the time you inaugurated your famous 'Force of Truth' or 'Strength of the Soul' (Satyagraha) campaign." What was happening in Germany, countered Buber, was much more severe. Unlike the rulers of South Africa and India, the Nazis had explicitly rejected conventional morality. Drawing on his recent experiences in Germany, Buber argued that he had "observed many instances of genuine

satyagraha among the Jews, instances showing a strength of spirit in which there was no question of bartering their rights or of being bowed down," but these actions "exerted apparently not the slightest influence on their opponents."[49]

Buber also addressed Gandhi's categorical pronouncement that Palestine belonged to the Arabs. After presenting his own views on the Jewish links—both historical and religious—to the Land of Israel, Buber added that he belonged "to a group of people who, from the time when Britain conquered Palestine, have not ceased to strive for the achievement of genuine peace between Jew and Arab."[50] Like Magnes, Buber was an advocate of a binational state in Palestine, one in which Jews and Arabs could coexist in equality. Buber revered Gandhi and sought to implement some of his ideas in Palestine. But Buber could not—in the face of "a task of such extreme difficulty"—abide by Gandhi's simple formula that Palestine belonged to the Arabs.

Neither Buber's arguments nor the events of World War II changed Gandhi's thinking. In a 1946 interview with his American biographer Louis Fischer, Gandhi reiterated his position: "Hitler killed five million Jews. It is the greatest crime of our time. But the Jews should have offered themselves to the butcher's knife. They should have thrown themselves into the sea from cliffs.... It would have aroused the world and the people of Germany.... As it is they succumbed anyway in their millions."[51]

In contrast, Zionists called on Jews to fight the Nazis. Though the efforts of these fighters were doomed, they died defending themselves. The Warsaw Ghetto uprising of April 1943 was the most famous of these rebellions, but far from the only one. Once the Nazis were defeated, the Jews who survived, and their coreligionists in Palestine, made self-defense their first priority. This was a position Gandhi could not accept. He remained steadfast in his opinion that European Jews should have gone to their deaths willingly. Gandhi lived for five years after the Warsaw Ghetto uprising, but there is no indication he was persuaded that actively resisting the Nazis had been an act of heroism.

Gandhi was assassinated in 1948, his vision of a united India unfulfilled. On the day after his ashes were spread on the Ganges in February 1948, Hayim Greenberg addressed a New York City memorial meeting in the Mahatma's honor. Greenberg spoke of Gandhi's life and ideas as an attempt to destroy "the thick wall which we ourselves have erected between the transcendental world and the process of history, between ends and means."[52] Curiously, Greenberg studiously avoided any mention of Gandhi's views on the Jews or Zionism, focusing instead on his efforts to tie the spiritual to the political and pointing to parallel ideas in Judaism.

Zionism in New York: On Broadway and at the Biltmore

In the years between 1933 and the outbreak of World War II, some of America's great performing artists opposed the Nazi campaign against Jewish artists in Germany. In 1936 the dancer Martha Graham rejected an invitation from Joseph Goebbels to bring her company to the Berlin Olympics. As she explained in an open letter to the minister of propaganda, "I would find it impossible to dance in Germany at the present time. So many artists whom I respect and admire have been persecuted, have been deprived of the right to work for ridiculous and unsatisfactory reasons, that I should consider it impossible to identify myself, by accepting the invitation, with the regime that has made such things possible. In addition, some of my concert group would not be welcomed in Germany."[53]

If the Zionists were disappointed by Gandhi's response to their cause, they found much stronger support among America's creative class. With the outbreak of World War II, news of increasing Nazi persecution and the worsening situation of European Jews awoke in some secularized American Jews a powerful sense of communal affiliation, and a growing appreciation for the message of Zionism and its promise of refuge. Among the most articulate of these returnees to the Jewish fold was Ben Hecht, a Chicago journalist, novelist, and Hollywood screenwriter who helped organize a series of theatrical pageants concerning the fate of Europe's Jews. These productions toured major American cities in the 1940s.

By the time that Hecht joined the Zionist cause, he was one of Hollywood's top screenwriters, author of *Scarface* (1932), *Nothing Sacred* (1938), and *Wuthering Heights* (1939). And, like many other Zionists of that era, he was an advocate for civil rights for African Americans. In Chicago in the 1920s Hecht organized an anti–Ku Klux Klan committee that was joined by hundreds of artists and activists. And he wrote the screenplay for Frank Capra's documentary tribute, *The Negro Soldier*.

To be sure, Hecht was a latecomer to Jewish activism; he did not convert to Jewish nationalism until 1939. "I had before then been only related to Jews," he said. "In that year I became a Jew and looked on the world with Jewish eyes."[54] Hecht quickly became a forceful advocate and spokesman for Europe's Jews, chastising his fellow American Jewish writers for remaining neutral while Nazi persecution increased, and as British authorities severely limited immigration to Palestine. Hecht noted, "Around me the most potent and articulate Jews in the world kept their mouths fearfully closed."[55] While the traditional Jewish

communities spoke openly of the Nazi horrors in their homes and synagogues, "the Americanized Jews who ran newspapers and movie studios, who wrote plays and novels, who were high in government and in power in the financial, industrial, and even social life of the nation were silent."[56]

So, Hecht took the job of raising public awareness upon himself. With the Broadway director Moss Hart, the composer Kurt Weill, and the producer Billy Rose, he organized a dramatic pageant titled *We Will Never Die* about the fate of Europe's Jews. Initially staged at Madison Square Garden in March 1943, the show played two performances in a single night and attracted an audience of forty thousand, while thousands more listened outside over loudspeakers.[57] It then traveled to Washington, Philadelphia, Boston, Chicago, St. Louis, and the Hollywood Bowl in Los Angeles. More than two hundred members of Congress and six Supreme Court justices attended the performance in April 1943 at Constitution Hall in Washington. Also in attendance was First Lady Eleanor Roosevelt, who had promoted the play in her popular newspaper column, "My Day."[58]

Hecht's next pageant, *A Flag Is Born*, in 1946, was, in Stephen Whitfield's description, "a play designed to validate the fight for Jewish sovereignty in Palestine."[59] Among the actors were Paul Muni and a very young Marlon Brando. Sponsored by the American League for a Free Palestine, a group affiliated with the Irgun, the Revisionist armed force, this show was "not ordinary theater." It was written, according to its sponsors, specifically "to make money to provide ships to get Hebrews to Palestine . . . and [to] arouse American public opinion to support the fight for freedom and independence now being waged by the resistance in Palestine."[60] And make money it did, earning a million dollars over 120 Broadway performances and a subsequent national tour. In Hecht's hometown of Chicago, the play ran for a month. With some of the profits, the play's organizers purchased an ocean liner, renamed the SS *Ben Hecht*, to carry Jewish refugees from Europe to Palestine. Two years later that liner became the flagship of the Israeli navy. The loyalty of the writers and producers to Revisionist Zionism was clear; the play roundly attacked British policy in Palestine, especially the restrictions on Jewish immigration. Indeed, with the tagline "It is 1776 in Palestine," *A Flag Is Born* was as much an indictment of British imperialism as it was a call for a Jewish state.[61]

The success of these pageants stemmed in part from the A-list of Broadway actors who starred in them—and who supported Zionism in other ways. Among them were Frank Sinatra, Marlon Brando, and scores of other actors who would later become legends of stage and screen. In subsequent decades, many of these

celebrities would support the State of Israel both culturally and financially. These singers, actors, directors, and producers helped lay the groundwork for an American-Israeli alliance that would prove to be powerful and enduring.

Over the preceding five years, while Europe was at war and the continent's Jews were being murdered by the Nazis, New York City was a center of Zionist activism. A meeting of American Zionists at the Biltmore Hotel in May 1941 condemned British restrictions on Jewish refugee entry into Palestine. The Biltmore Declaration called for a transfer of immigration authority from British to Jewish hands and linked that demand to a call for the establishment of a Jewish commonwealth. David Ben Gurion, head of the Jewish Agency, endorsed that declaration and made it the agency's official policy. Thus New York City was setting policy for Jerusalem and Tel Aviv.

Mozart in the Desert

The American Creative Class and the Birth of Israel (1947–1957)

AT THE AGE OF TWENTY-SEVEN Leonard Bernstein was in love again—not with a new person, but with a new country, Israel. Raised in Boston in a unique synthesis of American identity and Jewish commitment, the composer, conductor, and pianist Leonard Bernstein fell in love with the idea of Israel even before the state was established. In April 1947, Bernstein made his first trip to British Palestine in response to an invitation from the Palestine Symphony Orchestra to conduct a series of concerts. During the British Mandate, European musical culture had flourished in the bitterly contested territory; classical music had considerable prestige among the Jews of Palestine and boasted a remarkably large audience. Smitten by the land and its people, Bernstein, over the next few decades, would cultivate and work to expand that audience.

In letters to his mentor, the Boston Symphony Orchestra conductor Serge Koussevitzky, Bernstein expressed his great enthusiasm for the musicians of the Palestine Symphony Orchestra and for the Zionist enterprise in general. Maestro Koussevitzky must have been surprised and somewhat shaken by Bernstein's passion for Zionism; after all, Koussevitzky, born into a Jewish family in Russia in 1874, had converted to the Russian Orthodox Church as a teenager. That was the only way he could advance his musical career, as Jews were not permitted in the Moscow Philharmonic Society's orchestra training program. In 1942, when Bernstein first emerged as a gifted and popular figure in the classical music world, Koussevitzky cited his own experience with Russian anti-Semitism and urged his protégé to change his surname to Burns. "Your name is too Jewish, and too ordinary," he said.[1]

But Bernstein would have none of it. Mid-twentieth-century America was not late nineteenth-century Russia, and the Boston Symphony Orchestra was a far cry from the Moscow Philharmonic. Bernstein sensed that performing artists

with ethnic names and commitments would be accepted in American culture. And of course, he was right. In that same decade, Frank Sinatra's managers encouraged Ol' Blue Eyes to change his name to something less ethnic. He, too, declined the suggestion, though in a manner less polite than Bernstein.[2]

Bernstein's first trip to Palestine was a great triumph. The Palestine Symphony Orchestra offered to make him its musical director, and for a few weeks while guest-conducting in Europe, he considered it. But Koussevitzky's Boston Symphony, with its summer series at Tanglewood, the music venue in the Berkshire Hills of western Massachusetts, proved a greater attraction, and in the summer of 1947, Bernstein returned to the United States where he led a small group of American artists who had become dedicated Zionist activists. Indeed, the composer and conductor—a central figure in both the classical and Broadway musical traditions—would become a pivotal figure in Israel's early cultural life.

IN FEBRUARY, several months earlier, frustrated in their attempts to administer Palestine, the British had sought help from the fledgling United Nations. Since the end of World War II, many in British political and cultural circles had been calling for an end to their country's mandate over the territory. In fact, a few months after Victory in Europe Day, Winston Churchill himself called Palestine a "very difficult place," writing that he was "not aware of the slightest advantage that ever accrued to Great Britain from this painful and thankless task."[3] The international body agreed to tackle the issue and formed a committee to take up a question that would occupy much of the UN's time for the next seventy years: What to do about the worsening conflict in Palestine? It was hardly the first time an international group had considered the Palestine issue; by one count, the United Nations Special Committee on Palestine (UNSCOP) was the twenty-second such investigating body.

In June 1947 the committee began its work at the Jerusalem YMCA. Over the next month, the delegates, representing eleven UN member nations, traveled throughout Palestine, taking testimony from representatives of Jewish and Arab groups. "Who is willing and capable of guaranteeing that what happened to us in Europe will not recur?," asked David Ben Gurion, leader of the Yishuv—the territory's Jewish population—and its organizational arm, the Jewish Agency. "Can the conscience of humanity absolve itself of all responsibility for that Holocaust? There is only one security guarantee: a homeland and a state."[4]

While the committee was busy hearing the impassioned testimony of the competing parties, guerrilla warfare raged in Palestine. It was "an increasingly

chaotic and violent environment," notes the historian Mark Tessler. "Not only had Zionist terrorism continued, with the principal target being the British, but Arab terrorism had resumed as well and was directed against the Jews."[5] While UNSCOP was in Palestine, the effort to bring European Jewish refugees to Palestine was ramping up. The *Exodus 1947*, a former U.S. Navy ship purchased by American supporters of the Haganah, was bound for Palestine with more than four thousand refugees aboard. The crew was aware that the British navy was tracking their route and would try to board the boat before it reached Palestine's shores. In actuality, the British attacked the *Exodus 1947*, wounding many of the passengers and crew. The passengers were transported on other ships to Hamburg, Germany, and placed in prison camps. International outrage followed: that the British would take Jewish refugees to German prison camps shocked newspaper readers around the world. The case for open Jewish immigration had been dramatically made, and the eleven members of the UNSCOP committee were influenced in the direction of ending the British mandate.

After leaving Palestine, the committee members visited Arab representatives in Jordan, Syria, and Lebanon. They reiterated the sentiments expressed a year earlier in a report from the Arab Office in Jerusalem. "The whole Arab people is unalterably opposed to the attempt to impose Jewish immigration and settlement upon it, and ultimately to establish a Jewish State in Palestine," the report read. "If Zionism succeeds in its aim, the Arabs will become a minority in their own country, a minority which can hope for no more than a minor share in the government. . . . It should not be forgotten too that Palestine contains places holy to Moslems and Christians, and neither Arab Moslems nor Arab Christians would willingly see such places subjected to the control of a Jewish Government."[6]

UNSCOP moved quickly, and by the end of August it presented its recommendations: The mandate should end and Palestine should be separated into Arab and Jewish states. The two new states would then sign a treaty regulating economic and political ties between them. The Old City of Jerusalem, with its holy places, would become an international city under the auspices of the United Nations.

As the United Nations prepared to vote on the proposal, interested parties in the United States and elsewhere hotly debated its merits. Passions ran high, with proponents on each side vehemently arguing their case, in private as well as in the media. The partition question touched on deeply emotional issues with huge geopolitical consequences: the fate of the European Jews who had survived Nazi rule; the independence and future of Britain's colonies; the fate of Palestine's

Arab majority; and the emerging postwar system, which would soon divide along Cold War lines. The Arab states and the Palestinians feared that approval of the partition proposal would be a *nakba* or catastrophe, an unfolding disaster that would doom the Palestinians to refugee status and the Arab states to domination by a Western-supported Jewish state.

Opinion did not break down neatly along religious or political lines. The U.S. government and American Zionist organizations lobbied hard in support of the UN proposal, while many prominent public figures remained staunchly opposed. American Christian religious leaders, both Catholic and Protestant, were divided on the matter, and, like other opinion makers, sought to present their message, whether for or against, to the public. Most American Jews supported the Zionist cause, but their views were conflicting among them. From the outset, the Conservative movement firmly supported a Jewish state in Palestine, while the leadership and laity of the ultra-Orthodox and Reform denominations had to be won over. In fact, some of the most vociferous dissenters were prominent Reform rabbis who considered America to be the real Zion because it afforded Jews freedoms and opportunities denied them in Christian Europe. And ultra-Orthodox Jews, many of them war refugees, were by no means supportive of a Zionism they saw as secular and godless.

My parents, Orthodox Jews whose grandparents had emigrated to the United States from Russia and Poland, were among the fervent supporters of Jewish statehood. As "religious Zionists," they not only lobbied for UN recognition of a Jewish state; they prayed for it. They gave me, their eldest son, born in the summer of 1947, a Hebrew name—Shalom—a name that would evoke both the Jewish religious past and the Zionist future. My brothers, born in 1949 and 1954, were also blessed (or saddled) with Hebrew names: Ari and Dov. Unlike most American Jews, we were not given two sets of names, Anglo-Saxon names for use at school and work, and Jewish names for synagogue rituals. Only as an adult did I understand that my parents believed that only a combination of Zionism and Orthodox Judaism could ensure a Jewish future in America.

From the United States, Leonard Bernstein and his fellow artists continued to work for Zionism, first and foremost by supporting the musical institutions already operating in British Mandate Palestine. The Palestine Symphony Orchestra was the most prestigious of these, formed by European Jewish refugees in 1936. During the 1930s, as the Nazis evicted Jewish musicians from German orchestras, many went into exile; some immigrated to Palestine and joined the Jewish orchestra-in-formation. Arturo Toscanini, the most renowned conductor of his time, led the orchestra in its inaugural concert in 1937. A refugee from

Italian Fascism, Toscanini viewed the opportunity to conduct an orchestra of exiled Jewish musicians as the fulfillment of his duty to "fight for the cause of artists persecuted by the Nazis." He was drawn to the Palestine Symphony Orchestra not only because of its musical excellence, the conductor asserted, but also because it was his responsibility to humanity.[7]

One of the young people in the audience at that inaugural concert in 1937 was Menachem Meir, the son of future Israeli prime minister Golda Meir. Decades later, in the early 1980s, Meir wrote that he could still "retrieve the incredible excitement of the first Palestine symphony concerts at which so many of the best musicians in the world gathered. The Jews of Palestine were starved for culture; many of them were highly educated, cultivated German and Austrian Jews who, flocking to Palestine during the early years of Hitler's rise, had brought with them their taste for the amenities of middle-class European life."[8]

Bernstein was delighted to help carry on that tradition. His advocacy from a distance—as an American Jew supporting Israel, a faraway nation that had not yet come into existence—made his engagement both representative and unique. Many Americans of his generation shared his enthusiasm for Zionism, though few had the means to travel regularly to the Middle East. Bernstein's rarefied position as a top conductor allowed him to make extended visits to Palestine; for a time, he considered making his home there. On these sojourns, he helped define the new state's emerging musical culture.

The Support of Christian Zionists

Bernstein and his Jewish coreligionists were not the only ones excited by the promise of a Jewish state. In the run-up to the UN vote, many members of America's Protestant and Catholic elites also embraced the Zionist cause.

Chief among them was the prominent Protestant theologian Reinhold Niebuhr, professor at Union Theological Seminary and founder of Americans for Democratic Action. A left-leaning social activist in 1930s Detroit, Niebuhr forged relationships with artists, novelists, and poets associated with the politics of the Popular Front. Though he moved later to the political center, Niebuhr's ties to the creative class remained strong. The only prominent theologian to be elected to the American Academy of Arts and Letters, Niebuhr's longest-lasting and most recognizable influence on American popular culture was his authorship of the Serenity Prayer, which Alcoholics Anonymous and other twelve-step programs adopted as a staple of their recovery programs. Public figures who have acknowledged and lauded Niebuhr's theological and political influence

include presidents Jimmy Carter and Barack Obama, the Reverend Martin Luther King Jr., and the historian Arthur Schlesinger Jr.

As debates over the fate of Palestine erupted within creative and political circles in the late 1940s, Niebuhr strongly advocated the establishment of Israel. His 1943 article in the *Nation*, "Jews after the War," argued for the proposed Jewish state as a refuge from Nazi persecution. His support for Zionism was also linked to his philo-Semitism, specifically to his call for Protestants to stop funding missionary expeditions to convert Jews. According to Niebuhr, Jews have their own valid religion, and they should not be pressured to abandon it.

William Foxwell Albright, a professor at Johns Hopkins University known as the "Dean of Near Eastern Archaeologists," was another American public intellectual who supported Zionism. With substantive contributions to both biblical scholarship and biblical archaeology, Albright was enormously influential in academic circles, and he used that influence to bring many Christian clergy and academicians to the Zionist cause. In 1946 he was one of the founders of the American Christian Palestine Committee, a group that advocated the establishment of a Jewish state in British Mandate Palestine. Later, he would train the first Israeli archaeologists. Because of the efforts of Niebuhr, Albright, and others, many influential American Christians became deeply committed to Zionism, bolstering the movement. Most of these mid-twentieth-century Christian Zionists were Protestant; the Catholic Church had at the time a more ambivalent response to the idea of a Jewish state. The Vatican would not see fit to grant Israel diplomatic recognition until the 1990s.

ONE VERY PROMINENT American Catholic family radically changed attitudes toward Jews and Israel over the course of the mid-twentieth century. In contrast to their father, Joseph P. Kennedy, John and Robert Kennedy developed more sympathetic attitudes toward Jews and Zionism. They found their father's opposition to a Jewish state, couched as it was in anti-Semitic and isolationist terms, deeply troubling. And they both worked hard to change the perception that the Kennedys were anti-Semitic.

John F. Kennedy first visited Palestine in 1937 when he was twenty-two years old, sent by his father as part of a fact-finding mission to the Middle East. Later, during his three terms as a Massachusetts congressman and two terms as a senator, Kennedy consistently supported Israel. Speaking to Massachusetts Jewish War Veterans in April 1948, Representative Kennedy sharply criticized President Truman for backpedaling on the question of Jewish statehood and suggesting

instead "a U.N. trusteeship" to replace the departing British. The young congressman called it "one of the most discouraging aspects of recent American foreign policy."[9] Fourteen years later, during a 1962 meeting with Israeli foreign minister Golda Meir, Kennedy became the first U.S. president to use the term "special relationship" to describe U.S. ties to Israel; previously, the phrase had been applied only to Britain.[10]

Like his older brother, Robert Kennedy was twenty-two when he made his first trip to Palestine, in April 1948. He spent several weeks in Tel Aviv and Jerusalem as a correspondent for the *Boston Post*, covering the waning days of the British Mandate. In his first article, Kennedy noted that both Jews and Arabs shared "a basic violent hatred of the British." He traced Arab hostility to the ruthless British suppression of the 1936–38 Arab insurrection, while pointing out that Jewish attitudes toward the British had never been particularly friendly. "The Jews have looked upon the British Civil Administration, which some years ago took over from the army, as most unfriendly and uncooperative and which therefore led to much mutual distrust."[11] Though the tone of this first article was remarkably objective and nonpartisan, and did not favor either the Jews or the Arabs, Robert Kennedy later would become a strong supporter of Israel. His 1968 assassination at the hand of Sirhan was linked by the assassin to Kennedy's pro-Israel stance.

The Jewish State Is Born

On November 29, 1947, months of fierce debate finally came to an end: the UN General Assembly convened at its then-headquarters in Lake Success, New York, to vote on the Partition Plan for Palestine. Approval of the plan to split the British Mandate territory into two states, one Jewish and one Arab, required a two-thirds majority. "Right up to the moment of the actual vote it was hard to foresee the outcome."[12]

The resolution passed, 33 to 13, with ten abstentions and one voting member absent. Jews and their overseas supporters rejoiced. Like many Jews in Palestine, Amos Oz—then ten-year-old Amos Klausner of Jerusalem—stayed up much of that night, listening to the radio broadcast from Lake Success and celebrating with the rest of Jewish Jerusalem. "There was dancing and weeping . . . in all the Jewish neighborhoods," he wrote. "Strangers hugged each other in the streets and kissed each other with tears . . . and waved the flag of the state that had not been established yet, but tonight, over there in Lake Success, it had been decided that it had the right to be established."[13] The vote conferred long-sought legitimacy

and gave the Zionist cause an international seal of approval. "This is the greatest moment in Jewish history," David Ben Gurion declared. "The principle of Jewish statehood is now established; only the borders remain to be defined."[14] For Palestinian Arabs and their supporters, however, the UN vote was devastating. "The Palestine leadership unequivocally rejected the plan and called a three-day general strike," wrote Adam LeBor. "Fighting erupted within a few hours of the vote. . . . Palestine burned throughout the winter of 1947–48."[15]

After eight months of fighting among the British, Arab, and Jewish forces, the British left Palestine on May 14, 1948. Eight hours after the British departure, in a crowded ceremony at the Tel Aviv Museum, David Ben Gurion declared the establishment of the State of Israel. Eleven minutes later, President Harry Truman announced American support. At the end of the festivities in Tel Aviv, the Palestine Symphony Orchestra, now renamed the Israel Philharmonic Orchestra, played "Hatikvah," the anthem of the Zionist movement.

The declaration of Israeli statehood precipitated the First Arab-Israeli War, known in Israel as the War of Independence. For the Arabs—especially the Palestinians—it became known as the *Nakba*, or catastrophe. Israeli forces faced troops from Egypt, Syria, Lebanon, and Jordan, as well as an expeditionary force from Iraq—all under the aegis of the Arab League. Before war broke out, several hundred poorly equipped Palestinian Arab fighters, who had been skirmishing with Jewish and British forces before the approval of the partition proposal, engaged the Israeli forces. The Arab League concluded that these Palestinian forces alone could not defeat the official Jewish army, the Haganah, and its paramilitary allies, the Irgun and the Stern Gang. The league's member states agreed to deploy their regular armed forces. But these combined Arab forces were in the end not enough to counter Israeli military strength. On October 20, the Israelis defeated the Egyptian forces that had occupied Beersheba since mid-May. Overall, the fighting had sent 750,000 Palestinian refugees into exile, mostly to neighboring countries; the Israeli state classified those who stayed—approximately 150,000—as "Israeli Arabs."

Launching what would become a decades-long movement to isolate Israel, the Arab League called for a boycott of all Western firms doing business with the newly established state. Participation in the boycott varied among the league's twenty-plus member states. The North African states of Morocco, Tunisia, and Algeria, for instance, paid little attention to the Arab League's demand, while the front-line states in the conflict—Egypt, Jordan, Lebanon, Syria, and Iraq—took it more seriously. American companies operating internationally in the 1950s had to take sides, too. Coca-Cola, for example, chose to do business with

the Israelis, while Pepsi-Cola built its business in the Arab world. But America's cultural establishment experienced no such divisions: most of the creative class were squarely in Israel's camp, deploying music, film, art, and dance in support of the new state. Such activity served as a form of soft power to complement and encourage the hard power of American economic, military, and diplomatic assistance to Israel.

Bernstein Redux

Against the background of the emergence of Jewish statehood, Leonard Bernstein returned to the region in October 1948. He performed in the same cities he had visited a year and a half earlier—Jerusalem, Tel Aviv, and Haifa—but now these cities were not only part of the new State of Israel, but also battlefronts in the Arab-Israeli War. In a letter from Tel Aviv to his close friend Richard Romney, Bernstein expressed his fierce attachment to Israel—and his antipathy toward her enemies. "This is such a beautiful experience that I can hardly write of it," he wrote. "Truly I feel I never want to leave, despite all the tragedy and difficulty. I sit here in this charming city in a blackout, with the fucking Egyptians raising hell to the south, my beloved Jerusalem without water, and in siege." Despite the war, Bernstein continued to conduct the Israel Philharmonic Orchestra. As he explained to Romney, "The concerts go on—dozens of them— never one missed—with huge and cheering audiences—sometimes accompanied by shells and machine guns outside. . . . Life is hectic, but pleasant beyond words: the orchestra is the most intelligent and responsive I've known." Amid the fighting, Bernstein noted that he had "fallen in love" with the Israeli people and their new state. "This is a most miraculous people, with a heroism and devotion I have never before seen. I visited the front in Jerusalem. I could weep with the inspiration of it. Everyone is young, inspired, beautiful in this new Army, and everyone is truly alive in this new State. So they slander and babble in Paris, but these people will never be drowned."[16]

After performances in Israel's three main cities, Bernstein embarked on a particularly dangerous adventure: he sought to organize a concert for Israeli troops in the Negev.[17] Just three weeks after the Battle of Beersheba, he appealed to the patriotism of the musicians in the recently established Israel Philharmonic Orchestra. Bernstein did not envision a desert concert performed by the full eighty-member orchestra; he was happy to find thirty-five musicians willing to make the dangerous bus journey from Tel Aviv to Beersheba. He also needed to arrange transport for a suitable piano, as he planned to perform three piano

Leonard Bernstein giving a recital in Negev with the Israel Philharmonic,
November 1948. Bettman/Getty Images.

concertos—Mozart's Piano Concerto No. 15 in B-flat Major, K.450; Beethoven's
Piano Concerto No. 1 in C Major, Op. 15; and Gershwin's *Rhapsody in Blue*—
and conduct the orchestra from the piano bench.

As the musicians performed in a sandy, vacant lot, over one thousand soldiers
"overflowed the benches, squatted in the sand, or sat on the flat roofs of the sur-
rounding Arab houses."[18] Soon after the performance began, Bernstein realized
the audience was quite familiar with the music he had selected. "I had thought I
was bringing Mozart to the desert, but I found it there already," he said. For the
men and women present at this electrifying performance, the concert provided
a powerful emotional release; it served as a memorial for those who had died in
a long and bloody war, a war in which six thousand Israeli soldiers—1 percent
of the new state's six hundred thousand Jewish inhabitants—died. Bernstein
conveyed the emotional impact of his 1948 concerts in a letter to Maestro Kous-
sevitzky, then at rehearsals in Boston: "Which of all the glorious facts, faces,

actions, ideals, beauties of scenery, nobilities of purpose shall I report? I am simply overcome with this land and its people. I have never so gloried in an army, in simple farmers, in a concert public." The Israel concerts, he wrote, "are a marvelous success, the audience tremendous and cheering, the greatest being special concerts for soldiers. Never could you imagine so intelligent and cultured and music-loving an army."[19]

Attendees weren't the only ones captivated by the powerful performance; American readers found news of the concert riveting. *Time* magazine's article, "Mozart in the Desert," reinforced the perception of many Americans that the Arab-Israeli War was a biblical drama being acted out in modern form. It described the musicians of the Israel Philharmonic Orchestra as having "crossed the Negev desert to give the battle-scarred Old Testament town of Beersheba the first symphony concert of its history."[20] With his Beersheba concert, Bernstein became the first in a long line of American musicians to entertain Israeli troops; the list would grow to include Frank Sinatra in the 1960s and B. B. King and Leonard Cohen in the 1970s. These musical performances were almost always coupled with the artists' pilgrimages to Israel's historical and religious sites. Ancient Israel had long been a model and metaphor for the American experience; modern Israel now provided a stage for the American creative class and the celebration of the U.S. role in Israel's creation. Several weeks after the concert in the desert, Bernstein performed in Jerusalem with the full Israel Philharmonic Orchestra. On the program, at Bernstein's insistence, was Mahler's *Resurrection* Symphony. The message was clear: Jewish life, destroyed in the Second World War, was now resurrected in Israel. To drive this point home, the audience was given a Hebrew-language explanation of Mahler's narrative program. It detailed the progression of the symphony's five movements from death to resurrection.

Following that Mahler concert in Jerusalem, the Israel Philharmonic Orchestra offered Bernstein the position of music director, but Bernstein declined. "I wanted to do it," he told a journalist a few months later, "but I can't do everything." As Humphrey Burton, Bernstein's astute biographer, noted, "The admission that he couldn't do everything was a rare flash of insight." For in the subsequent decades, it seemed that Bernstein could in fact do it all—or at least try to do it all.[21]

BERNSTEIN LEFT ISRAEL in November 1948, his ties to the new country and the Israel Philharmonic Orchestra much deepened. He agreed to return for a visit during the next concert season. Bernstein's work on behalf of the Israeli

cause—and especially the country's nascent classical musical culture—catalyzed his overall political activism. As Humphrey Burton noted, Bernstein's engagement with Israel encouraged him to become more active in supporting liberal American causes. Among his many later political acts in support of civil rights in the United States was the publication of "a trailblazing article in the *New York Times* blaming the educational system for the disturbing lack of trained black musicians in New York orchestras and pit bands."[22]

"Middle-East-Side Story"

A week after he returned to the United States, Bernstein attended a fund-raiser that the New York Philharmonic held for the Israel Philharmonic Orchestra. Enthusiasm for the Jewish state was so great that the concert tickets sold out immediately—and not only to Jews, who in the late 1940s constituted a quarter of New York City's eight million residents. Despite his frenetic rehearsal and performance schedule, Bernstein also made time that month for a meeting with the dancer and choreographer Jerome Robbins, whom he had first met in the mid-1940s. Robbins pitched an idea to Bernstein with the working title *East Side Story*. Bernstein described it in his diary as "a modern version of *Romeo and Juliet* set in the slums at the coincidence of Easter-Passover celebrations. Feelings run high between Jews and Catholics." The goal, he wrote, was to make "a musical that tells a story in musical-comedy terms . . . never falling into the 'operatic' trap."[23]

Bernstein's and Robbins's idea for a new type of American show changed musical history. In the late 1940s, Catholic-Jewish differences in New York City were pronounced. The early drafts of *East Side Story* used these religious tensions as a backdrop for the love story between a Jewish teenager and a Catholic teenager. But the project was shelved for several years, and by the time Bernstein and Robbins revisited it in the mid-1950s, religious strife had diminished, and ethnic strife had increased. So the authors revised the plot to focus on conflict between white and Hispanic teenagers rather than Jewish and Catholic ones.

The musical—with concept and choreography by Jerome Robbins, music by Leonard Bernstein, lyrics by Stephen Sondheim, and a book by Arthur Laurents—was a smash hit when it opened on Broadway in 1957; all four of its creators were Jewish Americans. They were also all gay or bisexual,[24] but as Laurents noted about the musical's origins, "I know gays were a minority, but gays didn't figure much in the 1950s. Jews figured then, now and always. I think that was more what we had in common, what drove it—drove the feeling of injustice,

at any rate."[25] For the four creators of *West Side Story*, as for many other Jewish artists, excitement over Israel—linked to a sense of injustices suffered—fueled their vision of creative possibility in America. The emergence of a Jewish state in Palestine energized and enthused them. Israel could now serve as an extension of American culture—the old-new country to which they were eager to link America. For Bernstein and Robbins in particular, the birth of Israel was, in a sense, a great musical that they drew upon for inspiration. Their devotion to the Jewish state overlapped with their shared vision of a new fusion of American music and dance. It is hardly surprising, then, that when the film version of *West Side Story* was released in 1961, Israel was one of three international venues chosen for the premiere.

Bernstein and Robbins had other causes in common. Like many in the creative class of the 1940s, their politics skewed sharply to the left. Socialism and New Deal policies were of great importance to them. And Zionism, then deemed a liberal or progressive cause, fit into that potent mix of culture and politics. When they first met in the mid-1940s, both Bernstein and Robbins were active on the political left. Robbins had joined the Communist Party in 1943, partly because of its advocacy for civil and labor rights, and partly because Russia was America's ally in the war against the Nazis. The American Communist Party had not yet been declared illegal. Though Bernstein never actually joined the party, he affiliated with progressive organizations that were later dubbed "Communist fronts" by the House Un-American Activities Committee. Among these organizations were the National Council on American-Soviet Friendship and the United Negro and Allied Veterans of America. These leftist affiliations made Bernstein a target of Red-baiters in the 1950s; he was one of the artists named as anti-American—along with Aaron Copland, Zero Mostel, and Burl Ives—in the right-wing partisan publication *Red Channels: The Report of Communist Influence in Radio and Television*. The House Un-American Activities Committee later summoned Robbins to testify about his communist affiliations, but they left Bernstein alone. Some have suggested this was because Bernstein wrote a letter to the committee invoking his commitment to Israel and the Jewish religion, and thus in the eyes of the political conservatives on the committee, he was distancing himself from revolutionary politics.

Both Bernstein and Robbins saw their Zionism as an extension of their commitment to progressive causes. For progressives in the late 1940s and early 1950s, Zionism was a worthy endeavor, in keeping with the socialist ideas and the struggle for racial equality they espoused. That the Palestinians were dispossessed in the process of creating a Jewish state seems not to have been a concern. For

Jewish supporters of Zionism, the practical and emotional need for a Jewish state in the wake of World War II overcame all other considerations. From the declaration of Israeli statehood until the Six-Day War in 1967, liberals in Israel and their supporters in the United States sustained the myth of Israel as a democracy in which all citizens were treated equally. Evidence to the contrary was ignored.

Dancing to Jerusalem

Jerome Robbins's personal romance with Israel began a few years after Bernstein's. As one of Robbins's biographers noted, "Bernstein had a much more open and direct connection with Israel, based on his many concerts there. Jerry didn't have that direct connection. Later in life he took more of an interest in his Jewishness, but he remained secular."[26]

Born Jerome Wilson Rabinowitz in 1918, Robbins first visited Israel in 1951.[27] He was on an "artistic mission," seeking to promote and enrich dance connections between Israel and the United States. Bernstein had forged these connections for classical music. Robbins, however, was more ambivalent about his Jewish origins and identity. Unlike Bernstein, who refused to follow his mentor's advice and change his name, Jerome Rabinowitz changed his name to Robbins. Though both men thoroughly assimilated to—and ultimately helped shape—American culture, they were moved enough by the idea and reality of Israel to visit on many occasions, and to work there for months at a time. Through their engagements with Israel, both of them deepened their connections to Judaism and Jewish identity.

Robbins's Jewish roots did not run as deep as Bernstein's. While the composer's parents were active in their Conservative Boston synagogue—Mishkan Tefila Temple, which espoused "liberalism, Zionism, and social service"—Robbins's parents were secular Jews with no synagogue affiliation; the family spoke Yiddish rather than Hebrew. This meant that the young dancer, with limited experience of the synagogue, knew little about Jewish liturgy and cantorial music. As a result, when he arrived in Tel Aviv in 1951 as a guest of the American Fund for Israel Institutions, a cultural organization that wanted him to investigate the prospects of bringing an Israeli dance troupe to the Unites States, Robbins found the rich variety of Israeli musical culture a welcome surprise. According to Deborah Jowitt, "Like Bernstein . . . Jerome Robbins continued to be enthralled by the spirit of the country . . . its sense of new beginnings and possibilities. . . . He was to make a survey of dance, ballet, and folkdance . . . and was excited by Israel and by the spirit of the people he met. The experience gave his

perceptions of Judaism a new dimension."[28] In a 1952 letter to the Israeli director of the American Israel Cultural Foundation, Robbins enthused, "I found in Israel a strong desire to feel a connection with the past and to create an Israeli culture."[29]

Robbins continued to support the Jewish state by introducing Israeli culture to the United States. In fact, Robbins brought Israeli dancers to America well before his U.S. ballet troupe made the reverse trip. In 1956, five years after his initial visit to Israel, he arranged for a group of Israeli dancers, sponsored by the American Israel Cultural Foundation, to tour the United States. The dancers drew on Middle Eastern traditions of music and dance and featured costumes of the Jews of Yemen, who were considered to be exemplars of the exotic among Israel's Jews from Arab countries. Three years later, Robbins's dance troupe, Ballets: USA, performed in Israel during its 1959 world tour. The nine performances in Tel Aviv attracted an audience of thirty thousand—including some Israeli cabinet members—and established Robbins as "Ballet Ambassador to Israel."[30]

For many American Zionist artists, supporting the Jewish state meant sharing their talents in Israel, and introducing Israeli culture to the United States. In 1947, the same year that Leonard Bernstein first visited Israel, the American impresario Sol Hurok and the American Fund for Israel Institutions arranged for the Palestine Symphony Orchestra to tour the United States. Israel's Habimah Theatre Company followed a year later. Both tours were wildly successful. Then, in 1950–51, Bernstein invited the Israel Philharmonic Orchestra to the United States. The three-month tour, in over forty American cities, was a raging success, as much for what it represented—reborn Israel—as for the music performed. Though he planned to share conducting duties on the tour with his mentor Koussevitzky, Bernstein was concerned that the Israeli musicians would object to being led by a *meshummad*—an apostate from Judaism to Russian Orthodoxy. But Bernstein, according to Humphrey Burton, "convinced his Israeli friends that the maestro's teenage conversion . . . had been an aberration."[31] The strategy worked, and Koussevitzky joined the tour. We can imagine that, for the musicians of the IPO, Koussevitzky's apostasy was of little importance; it was the result of Russian anti-Jewish prejudice. The important thing, now that a Jewish state had been created, was that Koussevitzky identified with it.

Robbins also saw Israel as a welcome escape from the United States. Called to testify before the House Un-American Activities Committee, he had provided names of show business associates who, he claimed, had been members of the Communist Party USA. "Naming names" allowed Robbins to clear his own name and relieve suspicion of his potential communist sympathies. Many, if not most, of his associates vilified him for this betrayal.

AS THE 1950–51 DATES of the first Israel Philharmonic performances approached, classical music aficionados wondered whether Bernstein and his mentor Koussevitzky would both be leading the performances. As it turned out, Koussevitzky was often too ill to conduct, so Bernstein and other guest conductors stepped in. The great Russian conductor died in June 1951, toward the end of the tour. Despite Bernstein's assurances to his Israeli colleagues that Koussevitzky's conversion had not been sincere, his funeral and burial were emphatically Christian. As one newspaper reported, "A double service, Russian Orthodox and American Episcopal, was held in Boston and [the] next day a second service took place a hundred miles West in Lenox, Massachusetts, at the Church on the Hill . . . the nearest consecrated ground to Tanglewood."[32]

Dual Loyalty

Despite their enthusiasm for Israel, many American Jews of the mid-1950s experienced a nagging tension. Were American Jews expected to emigrate to Israel? If they remained in the United States and actively supported Israel, would they be accused of dual loyalty? Leonard Bernstein's life and career seemed to offer a solution. Bernstein considered himself fully American, but he also identified solidly with Israel. The connection was so strong that, "overcome with this land and its people," he sought to persuade Americans—both Jews and Christians—that as U.S. citizens, they should hold Israel at the center of their concerns.

One model and mentor helped Bernstein bridge the Israeli-American divide: the Israeli founding father David Ben Gurion. The men met during one of Bernstein's trips to Israel in the late 1940s and over time became close friends.[33] Like Bernstein, Ben Gurion felt at home in both cultures: he had lived in the United States during World War I and met his American wife, Paula, in New York. As prime minister of Israel from 1948 to 1963, Ben Gurion worked assiduously to ensure the American Jewish community's support for the fledgling state. When the question of "dual loyalty" became a burning issue for American Jews in the early 1950s, he was the obvious person to address it.

Ben Gurion achieved a partial resolution of the identity issue through an unorthodox agreement with the industrialist Jacob Blaustein. At the time, Blaustein was president of the American Jewish Committee (AJC), an advocacy group established in 1906 to promote the civil and religious rights of Jews in the United States and to fight prejudice and persecution. In the 1930s and early 1940s, the organization was reluctant to commit itself to the Zionist cause. Once Israeli statehood was declared in 1948, the organization became more Zionist in

its orientation. Blaustein and Ben Gurion met in Jerusalem in the summer of 1950 to plan the prime minister's two-week fund-raising trip to the United States the following year. During the meeting, Ben Gurion asked Blaustein for help with selling Israeli bonds and with arranging a billion-dollar loan from the U.S. government. Blaustein agreed to help secure the loan, but only if Israel stopped "trying to pressure American Jews into Aliyah," meaning immigration to Israel. Ben Gurion readily accepted this condition.[34] The September 1950 "Blaustein–Ben Gurion agreement," issued by the AJC is titled, "Israeli Premier's First Official Declaration Clarifying Relationships between Israel and Jews in the United States and Other Free Democracies."[35] Declaring the political loyalty of American Jews to be solely to their country of residence, the agreement aimed to put an end to any question of dual loyalty on the part of American Jews.

Ultimately, neither the head of the AJC nor the head of the Israeli government could impose their will on the heterogeneous American Jewish population. It was something of a myth that the American Jewish community was a unified group. But this agreement between the prime minister of Israel and the head of a powerful American Jewish organization would have considerable influence in the subsequent decades.

In the early 1950s, cultural connections between the United States and Israel continued to expand. The same year that Ben Gurion and Blaustein hammered out their agreement, Leonard Bernstein returned to Israel, playing for Israeli troops once again, but this time farther south, in Eilat. He spent two months in the country, boasting in a letter to his sister, Shirley, about his sexual conquests while there.[36] Both men and women attracted Bernstein's attentions, and by his accounts these attentions were often reciprocated. In 1953 Bernstein and his wife, Felicia, spent a month in Tel Aviv, where he conducted twenty-one concerts in four weeks. "The concerts have been brilliant," wrote Felicia. "Lenny is their God, his name is magic everywhere. I never saw such a thing. It's really very touching."[37] But for all his clout in Israel, there were still certain cultural taboos Bernstein could not violate, like the Israeli ban on playing Wagner's music, which would stand until Daniel Barenboim defied it decades later. Wagner's music, a favorite of Hitler and the Nazi hierarchy, was never played by Israeli orchestras or heard on Israeli radio.

Between 1953 and 1958, Bernstein was too busy in the United States to visit Israel. Rising rapidly in the musical firmament, he conducted widely, composed many new works, and cocreated *West Side Story*. By the time he returned to Israel in 1958, a transformation had taken place in U.S.-Israel relations due to the 1956 Suez War. In 1956 Israel joined Britain and France in attacking Egypt. The three

countries planned the attack in response to Egyptian president Gamal Abdel Nasser's move to nationalize the Suez Canal and claim the toll revenue for his country. In what became known as the Suez Crisis (or the Sinai Campaign in Israeli parlance), the Israeli army invaded the Sinai Peninsula.

At that time, Washington still hoped to draw Egypt and the other Arab states into the American sphere of influence, largely to counter the Soviet threat. The State Department saw Israel, and U.S. support for Israel, as obstacles to that effort, and led the international movement to press Israel to withdraw from the Sinai. That effort created a temporary chill in U.S-Israel relations and delayed the sale of major American arms to Israel. But this chill was diplomatic; it was not reflected culturally. American artists, musicians, and dancers continued to flock to the Jewish state. During Eisenhower's second term, when it became clear that Egypt would not ally itself with the United States, Washington began to see Israel as a strategic asset rather than an impediment to American influence in the Middle East.

Bernstein's 1958 visit coincided with lingering tension in official U.S.-Israel relations and with an important milestone: the tenth anniversary of Israeli independence. The day after *West Side Story* opened on Broadway, Bernstein and Felicia flew to Tel Aviv for the dedication of the Fredric R. Mann Auditorium, the new home of the Israel Philharmonic Orchestra.[38] Though tempted to stay in New York and enjoy the accolades for *West Side Story*, Bernstein honored his commitment to the Israelis and joined his fellow American musicians Isaac Stern and Arthur Rubinstein in the Tel Aviv performances. To the surprise of many in Mann Auditorium, the concert opened not with the Israeli anthem "Hatikvah," as was customary, but with "The Star-Spangled Banner." Prime Minister Ben Gurion had suggested relegating Israel's anthem to second place as a gesture to the esteemed American musicians. So, despite the lingering misgivings of some diplomats in the U.S. State Department in the wake of the Suez Crisis, the public face of Israeli-American relations was an enthusiastic and celebratory one.

While Bernstein was in Israel, New York City celebrated Israel's tenth anniversary with a series of events great and small, beginning two months before the actual anniversary. In late February a "Purim Salute to Israel" at Town Hall featured Israeli general Meir Amit, who kicked off the fund-raising effort for Israel Bonds. He told the wildly enthusiastic audience that "the people of Israel are prepared, if necessary, to fight and die for their homeland."[39] Others attended a huge rally at Yankee Stadium, where Senator John F. Kennedy spoke, accompanied by Marilyn Monroe.[40] Celebrating Israel at a sports venue was not new for Monroe; a year earlier, she had helped promote the Israeli soccer team's visit to the United

States. For that occasion, in which she kicked the first ball of the game, Monroe wore a dress of "Israeli colors with an Israeli flower in her décolletage."[41]

As supporters celebrated Israel in the home of the Bronx Bombers that day, my eight-year-old brother, Ari, and I joined our schoolmates to collect money for Israel Bonds. We fanned out in pairs on the New York City subway carrying full-size Israeli flags. As we passed through the cars on the train between Queens and Manhattan, Ari and I unfolded our flag, held it by its four corners, and asked the passengers to contribute money for Israel. They responded with great enthusiasm. After a few hours we returned home, our folded flag stuffed with dollar bills. We had collected $400! I had never seen so much money. At school the next day, I discovered that some of my classmates had collected even more on their subway fund-raisers. I was only eleven years old, but I was beginning to understand that support for Israel extended well beyond my family, synagogue, community, and school. Israel, it seemed, was not simply a Jewish cause, but an American one.

Advocates for Zion

Sinatra, Steinbeck, Baldwin, and Bellow (1957–1967)

I WAS TWELVE IN 1959 when the paperback edition of Leon Uris's historical novel *Exodus* came out, and I devoured the sweeping narrative about the creation of the state of Israel in only a few days. In both my intense Jewish parochial-school education and my equally intense Orthodox Jewish upbringing, the State of Israel was a focal point of my life as a Jew, but surely not the only one. As far as I knew, we had no relatives there; our family had immigrated to the United States in the 1890s. We had no close ties to the Jews of Europe who had died in the war, or to those who had settled in Mandate Palestine and later the State of Israel. But the book spoke to me powerfully. The Orthodox Judaism that my family practiced—a form of traditional Judaism that decades later would be described as "modern Orthodoxy"—was deeply committed to a religious Zionist ideal that saw the return to the Promised Land as the fulfillment of both biblical prophecy and Jewish millennial hopes. I also understood that *Exodus* was not a classic like the ones we were assigned in school—*Exodus* was not *The Grapes of Wrath*. But as my two brothers and I had been given Hebrew names, we identified strongly with the male heroes of *Exodus*, and I was thrilled that American readers would now become familiar with these names.

One of the most successful American novels of all time, *Exodus* would remain in print for six decades, sell more than three million copies, spend more than a year on the *New York Times* best-seller list, and be translated into at least fifty languages. The Hollywood producer Dore Schary dubbed the new novel "The Kosher *Battle Cry*." The book's 1958 hardcover success rested partially with Uris's large fan base from his earlier war novel *Battle Cry*, based on his experiences as a marine in World War II. But with the publication of the paperback edition in 1959, sales skyrocketed, and millions of readers absorbed a romanticized, dramatized, and biased account of Middle Eastern history. Then, in 1960, the

Hollywood director Otto Preminger produced an Oscar-winning film based on the novel; it starred Paul Newman as Ari Ben Canaan, the novel's hero, and Eva Marie Saint as Kitty Fremont, the American war widow who falls in love with him and—through him—with Zionism and Israel.

FOR ZIONISTS SEEKING broad American support, *Exodus* could not have appeared at a more crucial moment. As Israel entered its second decade in the crucible of the Cold War, the State Department, which had long believed that support of the Jewish state compromised U.S. standing in the Middle East, began to see Israel as a vital counterbalance to Moscow's embrace of the Arab nations. This policy shift developed in the wake of rapidly changing events. In the mid-1950s, Washington sought to improve relations with newly independent Egypt by offering to help finance construction of the Aswan High Dam, "the most gigantic undertaking in the land of the Nile since the days of the pharaohs." The project would improve flood control and irrigation along the Nile, as well as generate hydroelectric power. "The dam was designed to be seventeen times the size of the Great Pyramid of Cheops and its purpose was to help feed the people of Egypt."[1] Washington hoped that its support of the Aswan Dam would persuade Egypt to be more conciliatory toward U.S. interests, both in the fight against communism, and in its relationship with Israel. But Egypt's new leader Gamal Abdel Nasser was keen to play both sides in the Cold War. When the Soviets stepped in to fund the dam project, the Americans backed out, turning to Israel as an alternative path to influence in the Middle East.

While geopolitical factors played a large part in this change, softer cultural factors like Uris's novel were at work, too. Opinion polls of the late 1950s show Israel's hold on the American imagination becoming stronger, and social scientists of the time noted "a widespread fund of goodwill toward Israel," a tendency that extended well beyond the Jewish community.[2] Furthermore, American impressions of Israel were increasingly sympathetic—significantly more so than impressions of the Arab states—due to perceived similarities between American and Israeli governmental systems and social structures.

Indeed, *Exodus* had a great effect on American attitudes toward the idea and reality of a Jewish state in the Middle East. Critics have compared the novel's cultural influence to that of *Uncle Tom's Cabin* or *The Grapes of Wrath*. Those best sellers addressed the issues of slavery in the American South and poverty during the Great Depression; *Exodus* dealt with the quest for a Jewish homeland, and Uris's depiction of the Israeli-Arab conflict resonated deeply with American

readers who believed that Europe's Jews, persecuted and murdered by the Nazis, needed a place of refuge. Israel would be that place.

Uris crafted the book around the consequences of the Holocaust and his own epic intentions. He resented the prevailing depiction of Europe's Jews as going like "lambs to the slaughter" and told an interviewer, "As a Jew, I was sick of apologizing. We Jews are not what we have been portrayed to be. In truth we have been fighters."[3] Thus, with *Exodus*, Uris sought to redefine the Jewish hero. In contrast to earlier representations of the European Jew as a submissive victim of Hitler's genocide, the "new Jew," the "sabra," the natural-born Israeli, was a strong, determined fighter. The novel presents the founding of the state of Israel as a heroic, miraculous event, and the Israeli victory as moral compensation for Jewish suffering during World War II. It was therefore no accident that the cover for the first edition of *Exodus* portrayed an armed solider in a combat-ready stance, evoking the freedom-fighter protagonist Ari Ben Canaan. The image also represented Uris's intention to write about "people caught in the tides of history" and, as he said, to "call life as he sees it." This intention was partially rooted in his emulation of his literary role model, John Steinbeck, whose books he had devoured as an adolescent.[4] As the historian M. M. Silver noted, Uris's reverence for Steinbeck's novels was based on Steinbeck's ability to write "popularly accessible books that followed family histories stitched in biblical imagery and depicted poignant social histories."[5] For Uris, then, what better title for his novel than that of the second book of the Bible? Exodus means "going out," and the biblical book tells the story of the Hebrew people's flight from oppression in Egypt to freedom in Canaan, the Promised Land. At one and the same time, the title refers to the drama of the SS *Exodus, 1947*, the Haganah ship purchased by American donors, that sailed to Palestine carrying over four thousand refugees in an attempt to break the British blockade and enable Jewish immigration. Further signaling his vision, Uris named his chief protagonist Ari Ben Canaan, which in Hebrew means Lion, son of Canaan, or Lion, son of the Promised Land.

From my standpoint as a young yeshiva student, what was missing from the novel was what was ever-present in the biblical book of Exodus: God and his actions in history. Thus, *Exodus* became my introduction to secular Zionism, which evoked and invoked the Hebrew Bible while at the same time disdaining the practices and beliefs of traditional Judaism. To a budding rebel entering adolescence, this was sweet music indeed. As to where this music would lead me, I had no idea at the time. But I knew that I found the idea of secular Zionism deeply attractive. Ultimately, it would enable me, and other American Jews of

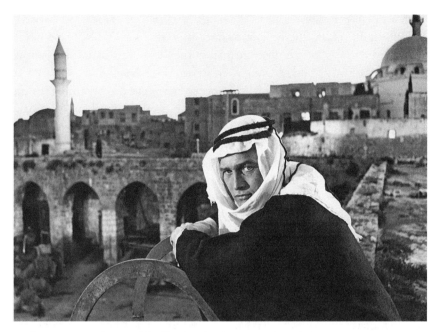

Paul Newman on the set of the film *Exodus*. Sunset Boulevard/Getty Images.

my post–World War II generation, to both rebel against our Jewish past and, at the same time, affirm it.

In both Uris's novel and Preminger's film adaptation, the Jewish struggle for statehood is heroic as well as morally justified. Like the Hollywood Westerns it emulates, *Exodus* conveys a simplistic message: the Jews in Palestine, like the white settlers of the American West, needed to defend themselves; the Arabs, like the American Indians, were savages who must be controlled, and if necessary, eliminated. It is worth noting that, before he wrote *Exodus*, Uris wrote the screenplay for the much-lauded 1957 Hollywood Western *Gun Fight at the O.K. Corral*. As Stephen Whitfield noted, *Exodus* was designed to suggest that "Israel engages in force only to protect its citizens, and that the extremism of their enemies sanctions methods undertaken with moral reservations and ambivalence and with a high level of competence."[6]

In the same way that cowboys and farmers in American Westerns disagreed over how to fight the Indians, the Jewish factions in *Exodus* are in conflict over how to accomplish their goals of fighting both the Arabs and the British

authorities in Palestine. Uris and Preminger fictionalized the struggle between the left-leaning Haganah, the fighting force associated with Labor Zionism, and the right-leaning Irgun, the fighting force of the Revisionist Zionist movement, whom the British and many Labor Zionists described as terrorists.

Uris and Preminger, however, did not see eye to eye on everything. In the novel, Uris denigrates the Arabs, making broad generalizations about "the many-sided Arab character." For example, he explains to the reader, in the voice of the omniscient narrator, how Jossi Rabinsky, a Jewish pioneer, observed that "an Arab man ran his life as though it were a game of chess. Every move was made with an astuteness designed to outfox those he was dealing with." Rabinsky has witnessed "the unscrupulous ethics of the Arab" and been "confounded by the fantastic reasoning that condoned every crime short of murder." Uris concludes Rabinsky's generalized assessment of the Arab character with a litany of three pairs of negative traits: "Greed and lust, hatred and cunning, shrewdness and violence, friendliness and warmth, were all part of the fantastic brew that made the Arab character such an enormous mystery to an outsider."[7] Preminger, on the other hand, thought the book misrepresented the Arab side. He sought to rectify the situation by making the film more evenhanded, but supporters of the Arab cause barely noticed a difference. As one critic noted, "The film is heavily tilted in Israel's favor, although the superficial script, which practically ignores the existence of the Palestinians as a political entity, tries to justify some of the Arab's discontent with the U.N. decision."[8]

The film also placed great emphasis on the struggles of the militant Israeli factions, attempting to provide a rationale for their terrorism. For example, Dov, a member of the Irgun played by actor Sal Mineo, was abused and tortured in a German concentration camp. He exemplifies the Holocaust-Zionism connection at the core of *Exodus*'s argument for a Jewish state. "The central theme of *Exodus* links the creation of the Jewish state with the rescue of Holocaust survivors," noted the critic Deborah Dash Moore. "Although the horrors of the immediate past are not forgotten, the movie graphically proves how creating the state and reclaiming the Jewish homeland is the Jews' answer to Hitler."[9] Preminger's interpretation of the novel, however, did not please everyone in Israel. "I had a big argument in Israel when I made the picture," he told one interviewer. "The ruling group did not like the idea that I gave any credit in the picture to the terrorists. Later, the terrorists also made it difficult for me. They felt that they did not get enough credit. The book by Uris has a pox against all enemies of the Jews in it, and that is difficult to defend."[10]

Great Hollywood director that he was, Preminger played up what would sell best: the love story between Paul Newman's Ari and Eva Marie Saint's Kitty, an American Christian nurse volunteering at an internment camp where Holocaust survivors await transit to Palestine. The film affirms Jewish peoplehood through identification with Israel and at the same time affirms the viability of a Jewish-Christian romance. "Because its perspective is so forthrightly Zionist, *Exodus* spikes the most durable theme in American films (and fiction and plays) about Jews, and that is the attraction of intermarriage," noted Stephen Whitfield. "At the center of *Exodus* is a short-circuited love affair between Ari and Kitty."[11] Handsome, smart, and fearless, Newman's Ari embodies Uris's new kind of Jew: Israeli, not European; victor, not victim. In one of the film's most humorous scenes, Ari negotiates with an anti-Semitic British officer, played by Peter Lawford, who tells him that he "can spot a Jew from a mile away." Ari responds by asking the officer to help him remove a speck of dirt from his eye.

Three and a half hours long, the film has the scale and scope of an epic Western. Some wags dubbed it a "Matzah Opera" or "Jewish Western." Like the novel, the film was a huge success, earning more than $20 million at the box office and winning an Oscar for Best Soundtrack. Yet Uris and Preminger remained at odds, both privately and publicly. In 1965 Preminger told the critic Andrew Sarris, "The author of *Exodus* felt that I didn't do right by his book." In the public imagination, however, the differences between the novel and the film soon faded. "The book and film are now regarded as a single phenomenon that managed to displace the history that inspired it," noted Charles Paul Freund in 2003. "This was no small achievement."[12]

The novel's cultural cachet persists. Fifty years after its publication, *Exodus* was celebrated in the inaugural season of the AMC series *Mad Men*. In an episode set in 1962, two representatives of the Israeli government, a man and a woman, approach Don Draper's advertising agency. "America has a love affair with Israel and we would like to bring the two together," the woman tells the agency partners. She presents Draper with a copy of *Exodus*, mentioning that "it is soon to be a motion picture with Paul Newman." Regarding Israel, Draper says, "All I know is the Bible." The Israeli man responds by saying, "Let's stay away from that." In a later scene, Draper reads his copy of *Exodus* late at night. At his next tryst with his paramour Rachel, a New York Jewish woman, he asks her about Israel. "I don't need to live there," Rachel says. "For me it's more an idea than a place." But for Draper's Israeli clients, Israel is first and foremost a place, and one that they would like to see promoted in the United States.

Uris's novel greatly strengthened the U.S.-Israel relationship; it intensified political Zionism in America, boosted donations to the Jewish National Fund, and increased tourism to Israel. Following the success of *Exodus*, many novelists, filmmakers, artists, and other performers became enamored with Israel and used their work and celebrity to support and promote the U.S.-Israel cultural relationship.

Soon after the film's release, the popular singer Pat Boone wrote lyrics to the theme music of *Exodus*. The song, "This Land Is Mine," became immensely popular in 1961, and I remember listening to it on the radio. Boone's commitment to Evangelical Christianity was deep, and his song, in retrospect, was the first Christian Zionist musical entrée into American popular culture.[13] The lyrics opened with an acknowledgment of the land's biblical history: "This land is mine, God gave this land to me / This brave and ancient land to me."

Perhaps the strongest endorsement of *Exodus* came from the Israeli prime minister. In late 1958, Ben Gurion told the *Christian Science Monitor*, "I don't usually read novels. But I read that one. As a literary work, it isn't much. But as a piece of propaganda, it's the greatest thing ever written about Israel."[14]

His Way: Sinatra in Israel

Following the tremendous success of *Exodus*, some Hollywood producers felt compelled to produce another film about the founding of Israel. Shot on location in 1965 and released in 1966, *Cast a Giant Shadow* is a biopic based on the life of Colonel David "Mickey" Marcus, a U.S. Army Reserve officer who was recruited to go to Israel in 1948 to advise the Israeli army's high command. Unlike its predecessor *Exodus*, *Cast a Giant Shadow* was a box-office disaster. The script and acting were so bad that even the star power of Hollywood heavyweights Kirk Douglas, Yul Brynner, John Wayne, Angie Dickinson, and Frank Sinatra could not save it. Like *Exodus*, it was blatantly one-sided, depicting the Israelis as the good guys, the cowboys, and the Arabs as the bad guys, the Indians. But the plot of *Cast a Giant Shadow* was even more heavy-handed than that of *Exodus*, and it lacked the love story. As the *New Yorker* critic Brendan Gill remarked, the film was "an embarrassing movie." Another American critic wrote that *Cast a Giant Shadow* was "another exercise in movie biography that may be filed as a case of mistaken identity: any resemblance to persons living or dead is sacrificed to make elbow room for hero Kirk Douglas."[15]

Even so, Frank Sinatra's appearance in the film imbued it with another kind of cultural significance. To be sure, his cameo as Vince Talmadge, an American

fighter pilot who agrees to help the new Israeli air force, is not quite convincing. An irony not lost on many in the film's audiences was that Sinatra himself had never served in the American army; he had received a medical exemption in 1943. As the critic Francis Davis noted, "Sinatra spent the Second World War in uniform only on screen, where he always seemed to be on leave or having just been discharged."[16]

Sinatra accepted a role in *Cast a Giant Shadow* as a gesture of support for Israel, which had become a deeply personal cause for him. Sinatra's grandparents had emigrated from Italy to New York in the 1890s, and the anti-immigrant bigotry they faced still lingered during Frank's childhood in 1920s Hoboken, New Jersey. As he told his friend Pete Hamill: "Growing up, I would hear the stories . . . things that happened because you were Italian. . . . The stories were there. The warnings, the prejudice you heard about it at home, in the barbershop, on the corner. You never heard about it in school. But it was there."[17]

Bigotry against Italian Americans made the young Sinatra aware of other forms of bigotry, including anti-Semitism. He had many Jewish friends in his Hoboken childhood. When his mother—who often worked outside the home—was busy at work, she would leave her young son in the care of a woman named Mrs. Golden. Mrs. Golden spoke to Frank in Yiddish, and later as an adult, Sinatra often joked that he "knew more Yiddish than Italian."[18] For decades, he wore a Jewish star pendant that Mrs. Golden had given him. After World War II, Sinatra considered it a moral imperative to support a home for the Jews.

Sinatra's commitment to Israel was but one of a number of liberal causes he supported. He was particularly outspoken about racism and civil rights. Beginning in the mid-1940s, Sinatra used his considerable influence to advocate for equality for African Americans, particularly for those in the entertainment industry. As the historian Jon Weiner noted, "What other star at the top of the charts had thrown himself in the civil rights struggle so directly?"[19]

In 1945 Sinatra made the short film *The House I Live In*, whose title song features the enduring line, "The children in the playground, the faces that I see, all races and religions, that's America to me." The film opens with a shot of Sinatra leaving a band rehearsal and encountering a fight in which a gang of schoolchildren harass a Jewish-looking boy. As he separates the kids, Sinatra tells them not to be "suckers" and that racial and religious distinctions "make no difference except to a Nazi or somebody as stupid." Sinatra later explained his interest in making the film to the Hollywood columnist Louella Parsons: "Children themselves are not to blame for religious and racial intolerance. It's the parents.

. . . Kids hear their parents talking about the McGintys or the Ginsbergs and think there must be something awfully wrong with being a Catholic or a Jew."[20]

The House I Live In won an honorary Academy Award, and the ten-minute film was shown all across the United States. It could not have escaped Sinatra's attention that the creators of the film—the director, the screenwriter, and the songwriter—were all Jews on the political Left.

In 1947, two years after filming *The House I Live In*, Sinatra appeared at a benefit concert for the Zionist cause at the Hollywood Bowl. The event, titled "Action for Palestine," called for approval of the Palestine partition plan being deliberated at the United Nations. The concert drew a crowd of twenty thousand fans, who turned out to applaud both their musical idol and their favorite political cause.

A year later, Sinatra became personally involved in Zionist efforts when he agreed to smuggle a large amount of money for the Haganah. Teddy Kollek, the Haganah representative in the United States, had secretly negotiated a large arms purchase in New York, but he still needed to pay the captain of the ship that would transport the cache to Palestine. Kollek knew that he was being followed by federal agents, so he reached out to Sinatra, who was performing at the Copacabana nightclub, to help him evade the surveillance. "In the early hours of the following morning I walked out the front door of the building with a satchel, and the Feds followed me," Kollek wrote. "Out the back door went Frank Sinatra, carrying a paper bag filled with cash. He went down to the pier, handed it over, and watched the ship sail."[21] Years later, Sinatra told his daughter Nancy that he did it for the Israelis because "I wanted to help, I was afraid they might fall down."[22]

Sinatra made his maiden visit to Israel in 1962, as part of his first world tour, which also included stops in Hong Kong, Japan, Greece, Italy, France, and the United Kingdom. He had strong personal reasons for taking on a major tour at this time. After helping John F. Kennedy with his successful campaign for president of the United States in 1960, he had fallen out with the new president over allegations concerning Sinatra's links to organized crime. Deeply wounded, Sinatra threw his energies into reviving his career and stepping up his philanthropic work. Sinatra organized and sponsored the tour as a humanitarian effort; he planned to donate a percentage of the proceeds to children's charities, an effort that his managers hoped would temper his playboy image. The thirty-concert tour kicked off that May in Tokyo, where legions of fans turned out to hear Sinatra perform. Because the tour included stops in Israel, the Arab League rejected proposals for performances in Cairo and Beirut.

Sinatra earmarked part of the proceeds from his seven Israeli concerts for the "Frank Sinatra Brotherhood and Friendship Center for Arab and Israeli Children," which he planned to build in Nazareth. The singer specified that the center would provide equal opportunities for both Jewish and Arab children. Sinatra imagined that his liberal American vision of a melting pot in which all prejudice is dissolved—the message of *The House I Live In*—could be transferred to Israel.

Sinatra's tour dates in Israel coincided with the nation's fourteenth Independence Day celebrations. He was invited to the Independence Day parade and sat on the reviewing stand with Prime Minister David Ben Gurion and General Moshe Dayan. Later, Sinatra performed at the air force base at Tel Nof; some of this concert was captured on film and included in the 1962 documentary *Sinatra in Israel*. The richest record of Sinatra's first visit to Israel comes from the pen of his African American assistant George Jacobs. In his tell-all book *Mr. S: My Life with Frank Sinatra*, Jacobs said that "Mr. S adored Israel, and Israel adored him right back. Here was a whole country of underdogs and survivors, the people Sinatra respected most, people like himself who had beaten the odds. . . . Israel was the only place on the whole tour where Mr. S took a real interest in the country as anything other than a concert stop. He wanted to see everything, and Israel rolled out the red carpet. When he wanted to cross the Sea of Galilee and see the Golan Heights, the Israelis contacted the Syrians to tell them that our long convoy was not a troop movement and to hold fire. The sundown on the Sea of Galilee was beautiful. 'Another few days and I could become a believer,' Mr. S half-joked."[23]

Sinatra, having been brought up in the Catholic Church, was eager to visit the sites associated with the life of Jesus. That impulse would draw him again and again to Nazareth, where he eventually funded the construction of a Catholic church and the Jewish-Arab youth center. In Jerusalem, Sinatra and Jacobs passed through the Mandelbaum Gate border-crossing—something Israeli citizens were not allowed to do at the time—to visit the Christian holy sites in the Kingdom of Jordan. After their excursion to the Jordanian side of the border, the two men returned to Israeli West Jerusalem, where they toured the Holocaust memorial museum, Yad Vashem. As Jacobs wrote of that experience: "Most moving for both Mr. S and me was The Yad Vashem Holocaust Memorial on the Hill of Memory, where all the trees had been planted in memory of the victims. This was a stunning and solemn place. The external beauty of the land of milk and honey contrasted with the horrors shown within, particularly the

underground Children's Museum, where each of the more than one million tiny lights represented the life of a child that had been snuffed out. Afterward Mr. S said the visit had made him feel rotten about not fighting in World War II and that Israel was 'a wonderful country worth dying for.'"[24]

Two years later, Sinatra, again accompanied by Jacobs, returned to Israel to dedicate the Nazareth Youth Center. Once again, the Israeli public and the nation's officials honored him. The following year, when Kirk Douglas offered him $50,000—considered a huge sum at the time—for his cameo role in *Cast a Giant Shadow*, Sinatra donated his fee directly to the Nazareth Youth Center.

Sinatra remained a staunch Israel supporter throughout his life. Over time, his political views became more conservative—he supported Nixon in the 1970s and Reagan in the 1980s. During this period, as liberals became increasingly critical of Israeli policies in the Occupied Territories, support of Israel became more generally a conservative cause. Sinatra, however, did not abandon his vision of an Israel in which Jews and Arabs would have equal opportunities. In the mid-1970s, he raised $1 million to build a student center on the Mt. Scopus Campus of Hebrew University in Jerusalem; the center was named in his honor in 1978. This center, like the one Sinatra had established in Nazareth in 1964, was to serve both Jewish and Arab students. Yet, as with the center in Nazareth, it does not seem that Sinatra, the other donors, or their Israeli interlocutors seriously considered how this American-style liberal approach might play out in the Israeli context. Tragically, this student center gained notoriety a quarter century later when a Palestinian terrorist detonated a bomb there in 2002, killing nine people, five of whom were American students.

On Sinatra's lifelong connection to Israel, his assistant George Jacobs should get the last word: "We often returned to Israel, which Mr. S decided was his favorite country. Mr. S often boasted he was 'King of the Jews.' He donated big money to Zionist causes, and would plug the place every time he had a chance."[25]

Robert Capa, Shooting Israel

Sinatra was hardly the only American cultural icon courted by Israeli officials. Prime Minister Ben Gurion developed a strong rapport with many visiting celebrities, but the one he seemed to admire most was the photojournalist Robert Capa, famous for his coverage of the Spanish Civil War. Born Endre Friedmann to a Jewish family in Austria-Hungary in 1913, Capa—unlike Sinatra and Bernstein—later changed his name in the hope of advancing his career. As an émigré European Jew living in the United States, Capa had strong emotional ties

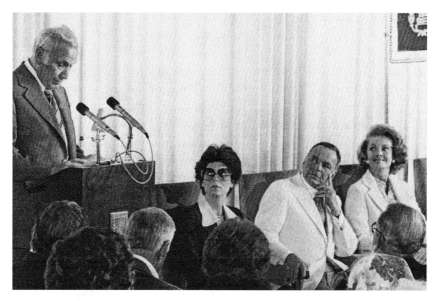

Frank Sinatra listening with wife Barbara (r) and daughter Tina to President Ephraim Katzir, April 5, 1978. Associated Press.

to Israel. He described himself as "born deeply covered by Jewish grandfathers on every side" with a mother who had a "big loving Jewish heart."[26]

Capa was a documentary photographer who sought to capture the authenticity of very dramatic moments. He first garnered international attention for his photos of the Spanish Civil War, many of which were shot under fire, in the heat of battle. In Spain, Capa accompanied Ernest Hemingway as he covered the war, and several of Capa's photos would later be used to illustrate a *Life* magazine article celebrating Hemingway's best-selling novel *For Whom the Bell Tolls*. At the outbreak of World War II, Capa left Europe and immigrated to the United States, though he would soon return to Europe on assignment for *Life* magazine. His handful of photographs of American troops under fire on Omaha Beach would become the most iconic images of the Allied D-Day invasion of France. Soon after the war, Capa collaborated with John Steinbeck, whom he had met in North Africa during the war, on a project about the Soviet Union. The book, *A Russian Journal*, documenting their travels in the war-torn country, was a critical and financial success.

In 1947 Capa cofounded the international photographic cooperative Magnum Photos. The following year, he traveled to the Middle East to document

the "birth of Israel." For this trip, he teamed up with the American novelist and screenwriter Irwin Shaw to produce the 1950 book *Report on Israel*. Capa's 1948 war photos depict Israeli soldiers and civilians; like Uris, Capa endeavored to portray Israelis as heroes. Jewish soldiers are pictured as defenders, and the Jewish immigrants as brave settlers, full of strength and vigor. Jews are shown "reclaiming the land"—farming, resettling, and revitalizing it; no Palestinians are shown at all. As the introduction to the 1998 book *Israel, Fifty Years: As Seen by Magnum Photographers* explained, Capa and his fellow photographer and European émigré David Seymour "shared enormous enthusiasm for the struggle of the arrivals and covered their story with deep affection."[27] Ben Gurion was such a big fan of Capa's work that he reportedly delayed declaring independence at the May 14, 1948, ceremonies until Capa had enough photos of the momentous occasion.

Capa's photographs were celebratory, documenting the success of the Jewish settlers and immigrants who fought hard to establish the State of Israel. Capa was killed in Vietnam in 1954 when he stepped on a land mine. He was forty years old.

On the Two Homelands

A series of dramatic events during the 1960s further shaped the relationship between the United States and Israel. In fact, the harder bonds of political, military, and security cooperation inspired the imagination of many in the American public, paving the way for softer ties facilitated by writers, artists, and popular performers. These ties would further strengthen and reinforce the two countries' relationship. This was especially true during the years from 1948, when Israel was founded, to 1962, when President Kennedy first articulated the "special relationship" between the United States and Israel.

An issue that attracted considerable attention in the United States was the 1950 Israeli Law of Return. Established in response to the Nazi murder of European Jews during World War II, the law allowed any Jew to acquire Israeli citizenship through an expedited process. Non-Jews could apply to become citizens, but the naturalization process took much longer, and outcomes were less assured. In 1954 the Israeli parliament, the Knesset, amended the law to exclude those applicants whom the government deemed harmful to the public welfare.

The Arab states argued that the Law of Return made Israel inherently expansionist, because it encouraged all Jews around the world to immigrate to the new state. For the U.S. State Department, the law presented a challenge to its

relationship with the Arab States. In a 1954 message to American ambassadors in the Middle East, Secretary of State John Foster Dulles identified "the insistence of Israel on a special role as the center of a worldwide 'nation' of Jewry as one of the main obstacles in attaining the objective of peace."[28]

Henry Byroade, Dulles's assistant secretary of state, explained the problem in greater detail. "A constant Arab fear is of greatly expanded immigration," he said. "These fears are enhanced by the knowledge that the only limitation imposed by the state on immigration into Israel is, in fact, the total number of those of the Jewish faith in the entire world."[29] Unlike Secretary Dulles, who spoke in generalities, Byroade explicitly called on the Israeli government to make the Law of Return more restrictive, thus limiting the number of Jews who could claim Israeli citizenship and thereby placating the Arab states.

The Israeli government, however, remained impervious to these American requests. In a May 1954 speech to the Knesset, Prime Minister Moshe Sharett asserted that there was "no way that anybody can force us to accept an agreement contradicting either our existence or our historical mission to serve as a safe haven to all Jews in distress."[30]

In the late 1950s and early 1960s, the U.S. diplomatic tone changed. Instead of expressing apprehension that support for Israel would damage U.S. interests in the Middle East, officials began to see Israel as representative of those interests. Around that time, some members of the Israeli parliament challenged the Law of Return's provision on criminals, arguing that the definition was too narrow. Some Israeli legislators rightly worried that Jews deemed criminals by oppressive regimes—such as Jewish citizens whom the Soviet satellite states judged to be subversive or counterrevolutionary—might be denied the right to live in Israel.

The Case of Robert Soblen

The case that brought these issues to a head involved Dr. Robert Soblen, a fugitive from the United States. A Lithuanian-born psychiatrist with ties to the Communist Party of Germany, Soblen had moved to the United States in 1941. He was indicted in 1960 on charges of spying for the Soviet Union during and after World War II.

In highly dramatic testimony, Soblen's younger brother, Jack, who had been sentenced on related charges in 1957, accused Robert of serving as the head of a Soviet spy ring. Robert Soblen was convicted of providing the Soviet Union with U.S. intelligence agency documents during the war and photographs of U.S.

nuclear test sites after the war. Sentenced to life imprisonment in 1961, Robert Soblen appealed his conviction. He argued that, when he began working for Soviet intelligence, the United States and the USSR were wartime allies; therefore, he had not technically betrayed his country to the enemy.

In June 1962, when the U.S. Supreme Court refused to consider his appeal, Soblen, who was free on bail, fled to Israel, claiming asylum under the Law of Return. But the Israelis rejected his claim; the United States, in contrast to the Soviet Union, was not an oppressive regime and crimes committed there could not be dismissed as trumped-up charges. By this point, U.S. military and political support for Israel had solidified to such an extent that Israeli government officials did not want to alienate their American counterparts by providing a safe haven for a convicted U.S. criminal.

For these reasons, Israel honored the U.S. extradition request and deported Soblen. During a stopover in London on the trip back to the United States, he attempted suicide and was rushed to the hospital, where he immediately petitioned for political asylum in Britain. Several months later, British authorities refused his request, and he was again ordered deported. On the way to the airport, Soblen again attempted suicide, overdosing on barbiturates from which he later died.

In Israel, critics of the government's decision to deny Soblen Israeli citizenship were shaken by his death. Menachem Begin, at the time the leader of the Revisionist opposition party, spoke out strongly against the decision to extradite Soblen to the United States.[31] The question of how the Israeli government would respond to American extradition requests became an Israeli political issue.

The Yossele Case

In that same year, 1962, a second incident demonstrated the growing diplomatic cooperation between the United States and Israel. In the Soblen case, the Israeli government had worked with the U.S. government to return a convicted felon to the United States. In the Yossele Schumacher case, the U.S. government, specifically the FBI and the Department of Justice, worked with the Israeli government to return a kidnapped child to Israel. These two cases required that officials at the highest levels of both governments remain in constant communication and cooperate fully. The Yossele case was widely covered in the U.S. media; the *New York Times* and other national newspapers gave the story front-page coverage.

Yossele Schumacher was eight years old in 1960 when his Orthodox grandparents abducted him from his secular parents, hiding him from both his family

and Israeli authorities. Their reasoning was that the boy was living on a secular kibbutz; to his grandparents this was tantamount to apostasy from Judaism. Within weeks all Israelis knew of the case. The press widely publicized the story, and the Knesset debated its implications. The police avidly searched every Orthodox community in Israel.

For both the ultra-Orthodox communities and the Israeli government, the stakes were high. The ultra-Orthodox groups—especially the anti-Zionist Neturei Karta—were convinced that the desire to return Yossele to his parents was part of a nefarious government plot to secularize as many Orthodox children as possible; Orthodox leaders had made similar accusations about the children of Orthodox Yemenite and Moroccan immigrants. The Israeli government, on the other hand, saw Yossele's abduction as a direct challenge to its authority to govern all sectors of the state's varied religious mosaic.

Yossele's grandparents and their supporters were determined to get the young boy out of the country, but they faced a vexing problem: who in the small Haredi—or ultra-Orthodox community of that period—had the expertise necessary for such an undertaking? In what must have seemed to some Haredim an act of divine intervention, a woman appeared on the scene with the requisite skills to spirit Yossele out of Israel. Ruth Ben David was a forty-year-old French woman, with the given name Madeleine Feraille, whose post–World War II story was remarkable even by Israeli standards. At twenty, she had served in the French Resistance. She later raised her son Claude on her own, managed an import-export firm, and attended graduate schools in both France and Switzerland. In the early 1950s, after a long and arduous spiritual journey, she converted to Judaism through the offices of a Liberal Jewish rabbi in Paris and changed her name to Ruth Ben David.

Over the next few years, Ben David became convinced that liberal and secular ideas dominant among Israeli Jews betrayed the Jewish tradition. She considered Zionism "a calamitous mistake," describing it as "the thesis that nationalism should replace the Torah as the basis of the Jewish people." After moving to Jerusalem in 1960, Ben David was dismayed to find the city decidedly secular in character: "For the purpose of tourism, the government of Israel does not refrain from calling their part of Jerusalem 'the Holy City,' though they do not themselves believe in any holiness."[32]

Disdain for secular Zionism ultimately led Ben David to embrace ultra-Orthodox Judaism, and its leaders wasted little time deciding that she was the ideal person to smuggle Yossele out of Israel. Her experience in the French Resistance, her knowledge of European languages, and her commitment to

anti-Zionism were excellent qualifications for the mission. Leaders of Jerusalem's ultra-Orthodox community assured Ben David that only through her actions could "Torah-true Judaism" resist the secular power of the state.

When Israel's Supreme Court ordered that Yossele be returned to his parents, his grandfather refused and was jailed. Soon Ruth Ben David found herself pitted against Israel's much-vaunted security and intelligence services. The Shin Bet, Israel's internal security service, searched in vain for Yossele in Orthodox neighborhoods, villages, and kibbutzim throughout Israel. Community members mocked security operatives as they searched homes and other buildings, while groups of children taunted them with the words "Where is Yossele?" sung to a popular Hasidic *niggun*, or religious song, conceived specifically to taunt the police and soldiers who were searching for the boy in Israel. Yossele, it was soon assumed, must have been smuggled out of the country; he was nowhere to be found.

In 1962 Prime Minister David Ben Gurion turned to the Mossad, Israel's overseas intelligence agency, for help. The Mossad had recently captured Adolph Eichmann in Argentina and brought him to trial in Jerusalem; surely, the prime minister reasoned, it would have no trouble finding a small child who was being hidden by Orthodox Jews. After all, there were only so many ultra-Orthodox communities throughout the world. Israeli spies could infiltrate them and find out where Yossele was hidden.

That proved to be easier said than done. Mossad agents could not master the nuances of Orthodox Jewish law and custom, so when they attended religious services in these communities, they were quickly identified. Once discovered, agents were summarily and angrily ejected from synagogues and study halls. In his memoirs, Mossad director Isser Harel noted that it was easier for agents to infiltrate Eichmann's Nazi circle in Argentina than it was to infiltrate Haredi communities in Israel or the diaspora.[33]

And where was Yossele while Mossad agents scoured the planet for him? Ben David, it turns out, had taken the boy, disguised as a girl, to Switzerland and enrolled him in a yeshiva there. As she saw it, Yossele's best chance for concealment was among other young ultra-Orthodox boys. The plan had the added benefit of continuing Yossele's religious education and strengthening his ultra-Orthodox identity. When word came that the Mossad was looking for Yossele in Switzerland, Ben David spirited the boy to Brussels and then to Paris. Each time she traveled, she presented the child as her daughter "Claudine," named after her own son Claude. When forty Mossad agents descended on the Haredi commu-

nity of Paris, Ben David whisked Yossele to New York, hiding him with a family of Satmar Hasidim in Williamsburg, Brooklyn. She then returned to France.

The Mossad, anticipating that Ben David might try to hide the boy in the United States, had asked the FBI the previous year to cooperate in the search. In the summer of 1962, FBI agents searched the Catskill Mountains sleepaway camps of New York's ultra-Orthodox Jewish communities. That summer, I was a camper in one of those camps, the all-boys Camp Agudah in Ferndale, New York. I vividly remember the FBI agents searching our campgrounds and our rustic cabins, while the boys, myself included, loudly sang "Where is Yossele?"—the song from Israel's ultra-Orthodox communities that our counselors had taught us a few days before the search. But the cultural reference was lost on the strapping FBI agents, who seemed pleased that we accepted their visit with equanimity, and perhaps even celebration, welcoming them with what to their ears sounded like an ordinary song.

Ben David and the other conspirators who shuttled Yossele Schumacher from country to country managed to keep him hidden for almost three years. Ben Gurion was losing patience with the Mossad and its director Isser Harel. Jewish communities around the world followed the Yossele case with fascination. "The Yossele affair had become an everyday topic throughout the country, and indeed, throughout the Jewish world," Ben David later wrote. "The affair dominated the minds of the Israeli public. It became a matter of prestige for the police, the government, and for Ben Gurion himself."[34] The case exacerbated secular-religious tensions within Israel, and many Orthodox Jewish religious leaders eventually called on the kidnappers to release the child.

In mid-1962 the Mossad caught up with Ben David in Paris. Interrogated by the same team that questioned Adolf Eichmann, she initially denied any connection to the Yossele affair. But when presented with evidence that she had smuggled Yossele out of Israel disguised as her daughter, Ben David proudly admitted her complicity. She refused, however, to disclose the boy's current whereabouts. She relented only after learning that her son, then serving in the Israeli army, had divulged her involvement in the case. She felt betrayed and realized that the plot had failed.

Ben David told the Mossad director Isser Harel that Yossele was living with a Hasidic family in Brooklyn—information that the Mossad chief relayed to the U.S. attorney general Robert Kennedy. Kennedy instructed the FBI to give Mossad their full cooperation. In September 1962, federal agents, accompanied by Mossad operatives, took Yossele into custody and flew him back to his parents

in Israel. Ben Gurion was relieved; some would say triumphant. An inter–Jewish Israeli culture war had been defused, if not won.

Like the Soblen case, the Yossele case underscored the deepening trust and cooperation between U.S. and Israeli law enforcement and intelligence services. The unprecedented collaboration served as a harbinger of greater cooperation in the future.

Jabotinsky's Bones

Two years after the Soblen and Yossele cases came to dramatic conclusions, another dramatic exchange between the United States and Israel took place: not of a live body, but of a dead one. In 1964 the Israeli government of Prime Minister Levi Eshkol approved the transfer of Ze'ev Jabotinsky's bones from his burial place in Upstate New York to Israel's national cemetery in Jerusalem. The leader of the Revisionist Zionists had died of a heart attack in 1940 while visiting a Beitar summer camp in New York State. Following Jewish tradition, he was buried the next day. His will stipulated that he remain buried where he died until a sovereign Jewish government requested the transfer of his remains for reburial in Jerusalem. Soon after Israel attained statehood eight years later, Jabotinsky's followers demanded that the government "bring his bones to Zion." But for sixteen years, the Israeli government refused to honor this demand.

David Ben Gurion, Israel's first prime minister, harbored a lifelong antipathy toward the Revisionists—and especially toward their leader, Jabotinsky, whom he privately called a "Hitlerite." Thus, during his tenure as prime minister from 1948 to 1963, Ben Gurion refused to allow the reinterment of Jabotinsky's remains in Jerusalem. Only after his resignation in 1963 did his successor, Levi Eshkol, permit Jabotinsky's reburial in Israel.

When Jabotinsky's body was exhumed in New York State, Revisionist Zionists held a quasi-religious ceremony to honor their founder. The event included tributes, speeches, and the chanting of Kaddish. Mixing the political symbolism of the Beitar movement and the religious rituals of the Jewish tradition, the American ceremony was small, local, and private. The Israeli ceremony, by contrast, was a national event. Tens of thousands of spectators lined the streets to watch the funeral procession through Jerusalem. Dignitaries in attendance at the funeral included members of the cabinet, the Knesset, and the Supreme Court; Israel's defense forces presented arms as the coffin was lowered.

African Americans and Israel

During the 1950s, support for Israel emerged in an unexpected sector of American society: the African American community. Black musicians and writers were at the forefront of this support. In 1951 the jazz pianist Hazel Scott performed in Israel, where her concerts—dubbed from "Bach to Bop"—proved wildly popular. She appeared in Tel Aviv, Haifa, Ramat Gan, and Jerusalem, traveling with her then-husband, New York congressman Adam Clayton Powell. In 1962 Scott returned to Israel for additional concert performances, and in 1965 she was the featured performer at the cabaret in the Tel Aviv Sheraton's Magic Carpet Room.

Back in the United States, Scott supported Israeli fund-raising efforts. In 1956, in between her two extended visits to Israel, she participated in an Israel Night concert at New York City's Metropolitan Opera House, which also featured baritone Robert Merrill, pianist Eugene List, and cantor David Koussevitzky. The event raised half a million dollars for Israel Bonds. Among the other African American musicians supporting Israel at that time were pianist and vocalist Juanita Smith, and vibraphonist and orchestra leader Lionel Hampton.[35] Hampton, who had considered converting to Judaism, met with Chief Rabbi Herzog during one of his many visits to the Jewish state.

James Baldwin was one of the first African American writers to visit Israel. In the fall of 1961, he spent two weeks in Israel as a guest of the government. He was thirty-seven at the time, and already well-established as an essayist and novelist. He had published his first full-length essay, "Harlem Ghetto: Winter 1948," in February 1948 in *Commentary*, the journal of the American Jewish Committee. Baldwin had published his first short story, "Previous Condition," in the same magazine eight months later.

Much of Baldwin's "Harlem Ghetto" essay was concerned with black-Jewish relations. In religious terms, Baldwin noted, African Americans identified with the Hebrews of the Old Testament: "It is the Old Testament that is clung to and most frequently preached from, which provides the emotional fire and anatomizes the pain of bondage," Baldwin wrote. But for African Americans, this very identification with the ancient Hebrews became, in Baldwin's analysis, a source of bitterness. As Jewish businesses in Harlem were viewed as complicit in white exploitation of blacks, they were "therefore identified with oppression and hated for it."[36]

To escape the racial tensions of American life and focus his energies on writing his first novel, Baldwin had moved in 1948 from his native New York City

to Paris, where he completed *Go Tell It on the Mountain* in 1952. Seeking a place outside of the United States to write his novel, he had considered several options in addition to Paris, including Israel, later writing that he had "seriously considered going to work on a kibbutz in Israel."[37] *Go Tell It on the Mountain* was published to great acclaim in 1953; *Notes of a Native Son*, his first collection of essays, won a similar response two years later. In 1957 Baldwin returned to the United States and again took up residence in New York City. By the early 1960s, his essays on literature, politics, and the civil rights struggle were eagerly sought by the editors of such influential magazines as *Harper's Magazine*, *Esquire*, the *Nation*, and the *New Yorker*.

In fact, it was the *New Yorker* editor William Shawn who approved of Baldwin's suggestion that he report from Israel. In 1961 Baldwin accepted Shawn's assignment to travel to Africa and the Middle East. A fluent French speaker who had begun to explore his African heritage while living in Paris, Baldwin planned to visit some of the emergent Francophile West African nations, including Senegal. On the way, he planned to make short trips to Israel and Turkey. "From the time of his early adolescence until his death, traveling was one of, if not the, driving force of James Baldwin's life," noted Baldwin biographer David Leeming. "He traveled to escape, he traveled to discover, he traveled because traveling was a way of knowing himself, of realizing his vocation."[38]

In October 1961, after several days in Israel, Baldwin confided to his diary, "The visit seems, so far, to have been a great success: Israel and I seem to like each other."[39] He had a keen appreciation of Israel's biblical significance; as a teenager, Baldwin had preached weekly in Pentecostal churches in Harlem, following in the footsteps of his minister father. His passion for the pulpit faded, but in his life and writing the biblical influences remained. As the Baldwin scholar Clarence E. Handy III observed, Baldwin's "religious inheritance did not simply provide a rhythm of speech or a style of rhetoric; it also helped him pursue the very essence of what he described as 'the business of the writer' in a culture like that of the United States, where religion's influence predominates."[40]

For Baldwin, the journalistic assignment to explore the new Jewish homeland pushed him to reflect on his own struggle with cultural belonging and his strong sense of alienation. His reaction to Israel was more positive than one might expect: "All I'm expected to do is observe. This is not going to be easy; and yet, since this trip is clearly my prologue to Africa, it has become very important to me, to assess what Israel makes me feel. The fact that Israel is a home for so many Jews (there are great faces here; in a way the whole world is here) causes me to feel my own homelessness more keenly than ever. . . . But just because

my own homelessness is so inescapably brought home to me, it begins, in some odd way, not only to be bearable, but to be a positive opportunity. It must be, must be made to be. My bones know, somehow, something of what awaits me in Africa."[41]

Baldwin saw Israel and Turkey as cultural and geographic springboards for his projected encounter with Africa and Africans. That Baldwin would see Israel as an entrée to Africa might strike today's reader as odd. But beginning in the late 1950s, Israel and Africa were forging ties. The Israeli government made it a priority to strengthen economic, military, and cultural ties with African countries emerging from colonial rule. Israel provided technical, agricultural, and medical aid to Ghana and Liberia. Golda Meir, foreign minister at the time, was a strong proponent of these ties. Some of her colleagues in the government envisioned Israeli participation in the nonaligned bloc—those emerging states that affiliated neither with the Soviet Union nor with NATO. For the Israeli government and its diplomatic service, the African initiatives were of great significance. Bordered by states with which it was still at war—there was a 1949 armistice, but no treaties or diplomatic relations with the Arab states—Israel sought allies in two spheres: along the periphery, in non-Arab Muslim states such as Iran and Turkey, and among newly independent African nations.[42]

Thus, for African Americans of the 1950s and 1960s, Israel had a positive image, and it seemed like a natural gateway to Africa. In the early 1960s, Israel's Foreign Ministry sent three hundred Israeli instructors abroad and invited some three thousand students from developing nations to Israel for hands-on training. Baldwin was familiar with Israel's outreach to African nations, and it is altogether possible that, during his visit to Israel, he crossed paths with Africans who were in Israel as part of these agricultural, technological, and military training programs.

Baldwin never wrote the article from Israel and Africa that the *New Yorker* had requested. Anticipating criticism of what he might write, Baldwin said, "I suppose the Israel piece will cause some people to say that I'm anti-Semitic."[43] Two years after his return to the United States, *Harper's* published Baldwin's "Letters from a Journey." Addressed to Baldwin's literary agent, these letters included some of his observations concerning his trips to Israel and Turkey.

After a six-month sojourn in Istanbul, Baldwin journeyed to Africa in 1962. He chronicled his experiences there in his 1963 book *The Fire Next Time*, sections of which appeared in the *New Yorker*. As Baldwin biographer David Leeming noted, "This was the book that propelled James Baldwin to fame and led to his picture on the cover of *Time* magazine."[44]

In the summer of 1965, Baldwin returned to Israel to attend a production of his play *The Amen Corner*, which had debuted a decade earlier at Howard University in Washington, D.C. Born out of Baldwin's experience as a preacher in Harlem's Pentecostal churches, *The Amen Corner* was performed at the Israel Festival of Music and Drama by an American cast. The American Israel Cultural Foundation and the U.S. State Department cosponsored the production, and the latter paid for Baldwin's trip. At the Tel Aviv premiere, Baldwin took a curtain call and introduced Claudia McNeil, the African American actress who starred in the production.

Baldwin's two visits to Israel in 1961 and 1965 left lasting impressions on him, and on his understanding and analysis of the Jewish situation in the world and in the United States. His view of Israel and its place in the world would change dramatically over the decades. In his earlier essays, there is no mention of the Palestinians. In the late 1960s and early 1970s, along with many African American intellectuals and activists, Baldwin would move to a more critical view of the Jewish state and a more supportive view of the Palestinians. He described himself as an anti-Zionist in a 1970 interview. "When I was in Israel, I thought I liked Israel. I liked the people. But to me it was obvious why the western world created the State of Israel, which is not really a Jewish state. The West needed a handle in the Middle East. And they created the state as a European pawn. . . . I'm not anti-Semitic at all, but I am anti-Zionist. I don't believe they have the right, after 3,000 years, to reclaim the land with western bombs and guns on biblical injunction."[45]

As the civil rights struggle deepened, James Baldwin emerged as one of its most forceful and perceptive chroniclers and advocates. He did not shy away from addressing the issue of worsening black-Jewish relations in the United States. In a provocative essay in the *New York Times Magazine*, "Negroes Are Anti-Semitic Because They're Anti-White," Baldwin asserted that "the root of anti-Semitism among Negroes is, ironically, the relationship of colored peoples—all over the globe—to the Christian world. . . . The Jew's suffering is recognized as part of the moral history of the world and the Jew is recognized as a contributor to the world's history: this is not true for the blacks. . . . The Jewish battle for Israel was saluted as the most tremendous heroism."[46]

After the 1967 War, when the situation of the Palestinian refugees became a prominent international issue, relations between Israel and Africa became strained. At the United Nations, the Arab states pressured the emerging African nations to censure Israel. Israeli cooperation with apartheid South Africa during the early 1970s caused further tension between Israel and the African states,

and by extension, between Jews and blacks in the United States. The Palestinian cause, along with other revolutionary causes, resonated with American radicals, black and white. James Baldwin, who had accepted Israel as a legitimate state in the early 1960s, opposed its policies. Because of its oppression of the Palestinians, Israel was on the path to becoming a pariah state, not just in the eyes of the developing world but also in the eyes of some of its liberal American supporters.

In a 1973 interview in the journal the *Black Scholar*, Baldwin claimed that "the guilty conscience of the Christian Western nations helped to create the State of Israel. . . . It is not acceptable to me that the people who have been in the refugee camps for the last twenty-five or thirty years have no equal right to the land of Palestine where Jews and Arabs have been for so long."[47] For Baldwin, the inconsistency of American policy would become fully apparent during the Carter administration. Acceding to Israeli demands, President Carter had banned meetings between U.S. officials and members of the Palestinian Liberation Organization (PLO). When news leaked that Andrew Young, the U.S. representative to the United Nations, had met with a PLO delegation in 1979, Carter—who had appointed Young only a year earlier—demanded his resignation. Baldwin was outraged. Writing an "Open Letter to the Born Again" in the *Nation*, he excoriated Carter—"the world's most celebrated born-again Christian"—for failing to support Andrew Young. Baldwin argued that "there is absolutely—repeat: absolutely—no hope of establishing peace in what Europe so arrogantly calls the Middle East . . . without dealing with the Palestinians."[48]

Steinbeck's Sojourn

In contrast to James Baldwin's approach to Israel, which shifted from enthusiastic support in the 1950s and 1960s to condemnation in the 1970s, the novelist John Steinbeck became progressively more pro-Israel over the same time span. Steinbeck, accompanied by his wife, Elaine, first visited Israel in February 1966. They had planned to stay only a short time, but their sojourn lasted more than two months, and it turned into a pilgrimage of sorts, albeit a secular one.

Steinbeck was at the time a world-renowned author, having won the Nobel Prize for literature in 1962. He had published his major novels in the 1940s and 1950s, and he was still widely read by American college students in the mid-1960s; a 1966 Columbia University survey of the reading habits of American high school students found that Steinbeck was in the top rank of popular English-language writers.[49]

In addition to his success as a novelist, Steinbeck was also an accomplished journalist. Indeed, his early reporting on migrant workers during the Depression inspired some of his most successful fiction. His trip to Israel was part of a world tour. Harry Guggenheim, the owner of *New York Newsday*, asked Steinbeck to write a regular column for the newspaper. He would be given the freedom to write about subjects that caught his attention during his travels, with no deadlines and no rigid schedule. Steinbeck's articles ran from November 1965 through May 1966, and then from December 1966 through May 1967. Writing en route from Ireland to Israel, he noted the unusual nature of his itinerary. "Does that migration astonish you? It should not. Both nations begin with 'I,' and both have been kicked around through quite a bit of history. And both peoples have held onto their identity in spite of everything."[50]

Steinbeck had a personal connection to Israel. His paternal grandfather and his great-uncle had been part of a small group of German Christians who established an agricultural mission near Jaffa in the late 1840s. In January 1858, a dispute with local Arabs over a stray cow led to a vicious attack during which Steinbeck's grandfather was killed and his grandmother's sister and her mother were raped. The attacks caused a diplomatic flare-up, with the Prussian and U.S. governments—the men were Germans married to American sisters—pressuring the Ottoman authorities to bring the attackers to justice; meanwhile, the survivors left Jaffa for America before the end of the year. In American diplomatic history this incident is know as the Outrages of Jaffa of 1858.[51] Steinbeck considered this tragic family history a likely source of his initial reluctance to visit Israel. "I've started for there several times and never made it," he wrote. "I wonder if I have an unconscious reluctance because of what my great-grandfather tried to do there in the 1840s."[52]

Yet, within a few days of his arrival in Tel Aviv—where he and Elaine were welcomed by Israeli government officials who subsequently provided them with an official tour guide—Steinbeck wrote a letter to his *Newsday* editor conveying his great enthusiasm for Israel: "This country boils and burbles, squirms and gallops with energy. If there is such a thing as a boisterous ferment, it is here. In most countries I have seen and lived in, everything that can be done has been done. In Israel, in spite of its 4,000 years of history, everything is to be done and as though for the first time. It kind of bears out what I have always felt—that only those people who have nothing to do and no place to go are tired. I see no evidence of weariness here."[53] He continued in this vein, writing, "You can search the world over and you'll not find Israel's equal for a stinking past of

heroic proportions. The present is even worse if that is possible—surrounded by enemies dedicated to her destruction, hemmed in between the sea and illiterate compromises of an absent, but quite an innocent, academy of the nations. And the people, the Israelis, the remnants of the trampled, tormented, and rejected Jews from 87 nations and of course their children, the Sabra."[54]

Steinbeck's enthusiasm for Israel, coupled with his disdain for American youth culture, led him to embrace without a trace of skepticism the official Israeli narrative, in which a persecuted people had made the desert bloom. After visiting Israel's border with Jordan, he reported that "the forest stops at the barbed wire, and beyond is that treeless waste, barren, sullen, intractable." In his encounters with young Israelis, Steinbeck found patriotism, loyalty, and enthusiasm for military service—a stark contrast to the young people in the United States, who were "burning draft cards because war in Vietnam was intolerable." As noted by Steinbeck biographer Jay Parini, the novelist overlooked the fact that the Israelis, "in their quest for statehood, had displaced millions of Palestinians, many of whom were living in filthy camps along the River Jordan and elsewhere. . . . He was intent on contrasting Israel's energetic vision of itself with America's loss of vision."[55] Such blindness to the cost of Israel's creation was not uncommon during this pivotal decade, as the Israeli-American relationship evolved from a somewhat ambivalent affiliation into a thriving cultural embrace and a strategic alliance.

The visit to Israel shook Steinbeck out of his political lethargy. He had supported America's involvement in Vietnam but was critical of the manner in which the war was conducted. Israel's military prowess, which Steinbeck saw as a challenge to Communist support of the Arabs, provided new motivation for that commitment, and he grew even more supportive of President Johnson's escalation of the war. This position further alienated him from the student antiwar movement and from most of his literary colleagues. Almost without exception, American authors condemned American actions in Vietnam. Steinbeck, like many other conservatives of the time, failed to see the human cost of the war or the dangers of American expansionism. That the prosecution of the war might conflict with America's liberal democratic traditions was not something he or other supporters of the war wanted to consider. Admiration of and support for Israel became, for them, a way to maintain their conservative values while continuing to promote the democratic form of government against the perceived communist threat.

Like Baldwin, Steinbeck influenced the American public conversation about the Jewish state and its relationship with the Palestinians. Though they approached

the issue from opposite sides, each helped shape opinions on a subject that Americans were becoming increasingly engaged with as the 1960s drew to a close.

Saul Bellow and Israel

During the 1960s, the novelist Saul Bellow, who was then teaching at the University of Chicago, made several trips to Israel. He had a number of relatives there, cousins who had come to Palestine in the 1930s and 1940s. As Bellow biographer James Atlas has noted, "Israel evoked in him profound feelings of identification."[56]

In the period known within Israel as the *hamtanah*, or waiting period leading up to the 1967 War, Bellow expressed to some of his Chicago friends a wish to visit Israel and report on the political and military situation. Nasser had moved Egyptian troops across the Suez Canal into the Sinai Peninsula, expelled the UN peacekeepers, and closed the Straits of Tiran to Israel-bound shipping; war seemed inevitable. Bellow obtained an assignment from the Long Island newspaper *New York Newsday*—the same newspaper that had published John Steinbeck's columns about his travels in Europe, Israel, and Vietnam—to write about the deteriorating situation in the Middle East. Bellow's explanation for his urge to cover the war is revealing. "I have never been a Zionist," he later wrote to a friend. "I never had strong feelings on the subject. But something about that particular occasion—the fact that for a second time in a quarter of a century the Jews were having a gun pressed to their heads—led me to ask *Newsday* ... to send me as a correspondent."[57]

He may not have been an activist or an advocate for political Zionism, but in the sense of identifying with Israel, Bellow surely was a Zionist. He spent a little over three weeks reporting from Israel, and his articles about the war—reprinted in his book *It All Adds Up*—were celebratory; he made no pretense of being objective or evenhanded. He echoed the Israeli views of the conflict: the war was fought because the Egyptians, Jordanians, and Syrians had mobilized their armies to "threaten to run the Israelis into the sea, to drown them like rats, to annihilate everyone."[58]

Throughout his war reporting, Bellow reminded his American readers that the Israelis were just like us and that the Arabs were not. For Bellow, an early morning visit to a kibbutz near the Syrian border was reminiscent of "a community service working-class camp in New Jersey,"[59] though one that had been shelled in a war. Bellow found Israelis to be similar to Americans, and he found the Arabs to be alien and disgusting. He described traveling with an army unit

into the defeated city of Gaza: "In Tel Aviv, there are ultramodern buildings, but in Gaza, within a few miles there are Arab tents that look like the molted husks of dung beetles. They are patched with dirty sheets of plastic and pieces of cardboard."[60]

For Bellow, the contrast between the Israelis and the Palestinians was stark. Like Steinbeck, he celebrated Israel's much-ballyhooed gift for making the desert bloom. And now the Israelis had won a major war: "One rides through rich orchards, and suddenly the irrigation ends. Waves of sand gush across the road. One leaves a tourist hotel with every modern luxury and an hour later sees Egyptian soldiers swollen in death along the roads of the Sinai Peninsula, black and stinking in the desert sun, and all about them are the most modern machines— Russian—burned out and useless." He ended the passage with a terse celebration of the single-minded grit and ingenuity of the Israelis: "But these puzzling contrasts will not affect an Israeli at this moment. To him the questions are clear. His existence was threatened, and he defended himself."[61]

Bellow showed no awareness that Gaza was in fact a city of refugees who had fled from Israel twenty years earlier. For him, the squalor and disorder were non-Western, Arab, and backward. He even took issue with the music: "The Arab music, too, induces torpor with its endless sweetish winding and its absurd insinuations and seductions. One not only hears it but feels it distressingly in the bowels, like a drug."[62]

Nine years later, in 1976, Bellow, then at the height of his popularity and on the verge of great fame—he was to win the Nobel Prize for literature later that same year—returned to Israel for a longer sojourn. He and his wife, Alexandra, a distinguished mathematician, were given a government apartment in Mishkenot Sha'anaim, the historic first Jewish settlement built outside the walls of Jerusalem's Old City. Their plan was that she would lecture at Hebrew University and he would write.

During that three-month sojourn, Bellow was deeply engaged in conversations with Israeli academics, intellectuals, and military men, as well as with his Israeli relatives. From these encounters, he produced a unique travelogue that offered a sophisticated portrait of the complex political situation in Israel and the Middle East. In the summer of 1976, the work was excerpted in consecutive issues of the *New Yorker*. Then, in the fall, Viking Press published to great acclaim *To Jerusalem and Back: A Personal Account*. In a front-page review in the *New York Times Book Review*, Irving Howe called *To Jerusalem and Back* "an impassioned and thoughtful book, sometimes an exasperating one."[63] Howe, who was to the political left of Bellow, must have found the novelist's portrait of

Israel exasperating—but that exasperation is only subtly expressed in the review. Within days of Howe's review, word leaked of the Nobel Committee's unanimous decision to award Bellow the Nobel Prize in Literature.

By the mid-1970s, Bellow had positioned himself in the United States as a political and cultural conservative. The student activism of the 1960s repelled him, as did the New Left emergent from the student movement—especially the New Left's attitude toward Israel. As he wrote in *To Jerusalem and Back*: "To its more severe leftist critics, some of them Jews, Israel is not the 'democratic exception,' it is said to be. The New Left sees it as a reactionary small country."[64]

In his review of *To Jerusalem and Back*, Irving Howe, more sympathetic to a leftist critique of Israeli policies, uses Bellow's accounts of the lively debates within Israel to call for equally lively debates about Israel in the United States. These debates, Howe writes, "seem to be conducted in Israel with an openness not always present in the United States, among Jews or non-Jews."[65]

In 2006, thirty years after the publication of *To Jerusalem and Back* and one year after Saul Bellow's death, I was invited to a dinner with Bellow's biographer James Atlas. Atlas was in Israel for a series of lectures marking the anniversary of the publication of Bellow's Jerusalem book. To Atlas's dismay, none of the half dozen Israeli intellectuals and academics assembled at the dinner table had anything positive to say about the book. Most of us were, in fact, highly critical of it, primarily because it did not take Israel's own internal critics seriously. It had dismissed these critics as both marginal and as beholden to then-fashionable leftist critiques of Israeli policies toward the Palestinians.

Despite the wide variety of opinions featured in the book, Bellow stuck to a Holocaust-centered understanding of Israel's creation and existence. He saw Israel's wars as ennobling, demonstrating purpose. In response to one prominent critic of Israel, Bellow had written, "Israel has made extraordinary efforts to be democratic, equitable, reasonable, capable of change. It has, in fact, transformed its Jews. In Hitler's Europe they were led to the slaughter; in 1948 the survivors became formidable fighters."[66] None of us at dinner that night in 2006, except perhaps Mr. Atlas, thought of Israel as "equitable, reasonable, and capable of change." Some of us doubted that it was democratic.

Of Poets, Singers, and a Young Medic

Israel's Battles and America's Culture Wars
(1967–1977)

N JUNE 1968, soon after the assassination of Robert F. Kennedy, I joined my college roommate on a trip to Europe that we imagined would also include Israel, though our plans were vague. Broke and restless after several months in Europe, we decided to sail to Israel, departing from Piraeus, the port of Athens. Upon arrival, my roommate was quickly put off by the intensity of life in Israel and soon returned to college in the United States. But I had the opposite reaction. I felt powerfully drawn to Israel—both the landscape and the people—in all its national and religious variety.

I wasn't alone. In the decade between 1967 and 1977, many young Americans—Jews and non-Jews—traveled to Israel as American support for the emergent country reached new levels of enthusiasm and cultural engagement. Prominent activists, religious figures, artists, writers, and musicians—including Bob Dylan and Johnny Cash—flocked to the Holy Land for inspiration and for a chance to expand their audiences and international reputations. Ordinary citizens became increasingly frequent visitors to Masada, the Western Wall, and other historic sites. Israel's decisive victory in the 1967 War had not only expanded the country's physical footprint, but also significantly increased its international political and religious profile as well.

After the 1967 War, known in the West as the Six-Day War, Israel controlled a territory three times larger than when it was established in 1948. It had defeated the combined forces of its three Arab neighbors, and in the process seized control of the Sinai Peninsula and Gaza Strip from Egypt, the West Bank of the Jordan River and East Jerusalem from Jordan, and the Golan Heights from Syria. In particular, the occupation of the West Bank and East Jerusalem changed tourism to the Jewish state, just as it irrevocably changed virtually every other aspect of Israeli and Palestinian life. Tourists to Jerusalem could now visit both the

Jewish and the Christian holy sites in a single pilgrimage; before the war, the Old City had been in the Kingdom of Jordan, separated from the rest of Jerusalem by a militarized border. From late 1967 onward, Americans—both Jews and Christians—thronged to Israel and the Holy City.

W. H. Auden and Yehuda Amichai

In 1970 the poet W. H. Auden became one of the many visitors to make the journey to Jerusalem. Auden came with his spouse, but because his partner was a man, Chester Kallman, this aspect of his pilgrimage was not publicly acknowledged. At the time, Auden was one of the few poets with the status of a rock star. His reputation as a serious-yet-accessible poet was unparalleled in the English-speaking world.

The cultural upheavals of the late 1960s served only to solidify Auden's reputation in Europe and America. Among intellectuals he had a wide range of admirers—from scholars of the modernist tradition to the Beat poets—who both praised his work and revered the man. Yet many of his fans were not particularly literary. As the critic Nicholas Jenkins wrote, "Auden is a poet with 'reach'— a figure of international stature within the realm of literature, but at the same time read by people who do not normally read much, or any, poetry."[1] Auden also had many readers and emulators in Israel, including the poet Yehuda Amichai, who had achieved Auden-like status among Israelis by the end of the 1960s; he, too, was read and quoted by many who did not otherwise read poetry. During my years in the Israeli army, I often saw copies of Amichai volumes among soldiers' few possessions. These volumes were gifts from lovers and friends.

Auden had moved from England to the United States in January 1939, a move later interpreted by some resentful British colleagues—including the influential literary critic Cyril Connolly—as a flight from the impending war in Europe. The novelist Christopher Isherwood, a fellow writer and committed leftist who had grown disillusioned with the divisive politics of the European Left, accompanied Auden. In the United States, both men turned to religion—Isherwood to Hinduism, Auden to Christianity and, to a lesser extent, to Judaism. They did not abandon the socialist cause completely; rather, they found religion to be a richer and more varied form of expression than politics.

Upon his arrival in New York City, Auden, according to his biographer and literary executor Edward Mendelson, "immersed himself in the intense, argumentative life of Jewish exiles."[2] Auden often said that the only people he enjoyed talking to in New York were Jews, but he seems to have found all New

Yorkers equally fascinating, especially the artists and poets who flocked to the city from across the United States. The candid, confrontational style of the city's residents appealed to him. But Jews were admittedly his favorite, which was quite a revelation from a man who claimed he had never met a Jew before he arrived at Oxford.[3] In New York, Auden found himself in political and literary circles where Jews were very active, which is not surprising given that, in 1939, some 25 percent of the city's population were Jews.

In New York, Auden was looking for a fresh start. As Mendelson noted, he "left England with the half-formed resolution that he would begin his career anew in a new country."[4] He often described himself as "not an American, but a New Yorker."[5] Within a year of moving to the city, Auden renewed his commitment to Christian doctrine and practice. He had been baptized and brought up in the Anglican Church, but Christianity had not been a strong force in his adult life. To some extent, his religious reawakening stemmed from his disillusionment with the politics of the international Left, which he had long championed. When he went to Spain in 1936 to volunteer as an ambulance driver for the Republican forces, "he was scorned and ignored because he didn't happen to be a member of the Communist Party." As Paul Fussell wrote, "In Spain, he first experienced the totalitarianism of the Left, and the first stirrings of his return to religion can be traced to his unexpected distress at finding the churches in Barcelona vandalized or blown up and the clergy systematically mistreated."[6]

In 1940 Auden began to attend church in Brooklyn, where he was living, and within a few months he was taking communion regularly. As Mendelson noted, Auden considered himself a "would-be Christian." He explained Christianity as "a way, not a state . . . a Christian is never something one is, only something one can pray to become."[7] Despite his aversion to the Christian label, Auden formally rejoined the church in 1941.

The poems of Auden's first decade in New York center on exile—"The Age of Anxiety," for example—and love, inspired by his relationship with Kallman. As the literary scholar Nicholas Jenkins put it, "After falling in love with Chester Kallman, whose Jewishness offered Auden access to a world entirely different from his own, Auden almost immediately wrote a number of serenely happy love poems."[8]

More surprisingly, though he had only recently reaffirmed his commitment to Christian beliefs and practices, Auden flirted with the possibility of conversion to Judaism. In the mid-1940s, he told his New School student Alan Ansen, "I've been increasingly interested in the Jews. . . . I wonder what might happen if I converted to Judaism."[9] I would venture that this was one of the poet's more

serious jokes, or as Beth Roberts has noted, "more of a whimsical rhetorical ques-
tion than a serious consideration."[10] In his commentary on Auden's oeuvre, the
critic John Fuller noted, "Auden's Christian jokes about Jews are always deeply
serious. See, for example, his dislike of the doctrine of the Immaculate Concep-
tion, which he felt embodied a 'not very savory wish to make the Mother of God
an Honorary Gentile.'"[11]

Regardless of his sincerity about conversion, Auden had long appreciated Ju-
daism. He had empathized with the persecuted Jews of Germany and derided
anti-Semitism in the work of T. S. Eliot and other poets. In his 1939 poem "Refu-
gee Blues," Auden had expressed both deep sympathy for Europe's Jewish refu-
gees, and anger that they found no home in the West when they were persecuted
and pursued by the Nazis.

In a remarkable Christmas letter to Chester Kallman from early in their re-
lationship, Auden indicated that his lover's Jewishness was of great importance:
"Because it is in you, a Jew, that I, a Gentile inheriting an O-so-genteel anti-
Semitism, have found my happiness; / As this morning I think of Bethlehem, I
think of you." Published after Auden's death, the letter, written on Christmas
Day 1941 and loosely structured as a poem in free verse, revealed the extent to
which the poet's religious ideas were entwined with his feelings for Kallman.
As Auden concluded: "Because our love, beginning Hans Andersen, became
Grimm, and there are probably even grimmer tests to come, nevertheless I be-
lieve that if only we have faith in God and in each other, we shall be permitted
to realize all that love is intended to be; / As this morning I think of the Good
Friday and Easter Sunday already implicit in Christmas day, I think of you."[12]

Kallman's Jewishness was of much greater significance to Auden than it was
to Kallman, who shared Auden's leftist political views but had no interest in
religious ideas or practice. But Auden succeeded in projecting on Kallman the
image of the committed Jew. Their relationship continued for decades, despite
Kallman's serial infidelities and other cruelties. Auden, decades before any public
discussion of gay marriage, wore a wedding ring to show how seriously he took
his commitment to Kallman, who not only did not reciprocate, but mocked
the idea of marriage. These were the "even grimmer tests to come" that Auden
foresaw in his letter.

While Auden referred to Kallman's Jewish roots over the decades, Kallman
himself assiduously avoided the subject of Jewishness. As Beth Roberts noted,
the Christmas letter of 1941 suggests that "Auden felt that his relationships with
Jews brought about his return to the Anglican Church, just as Judaism itself

served as a necessary precursor to Christianity."[13] It would be another thirty years before Kallman would make any public gesture toward his own Jewish identity, and that gesture toward Jewishness was tied to Israel.

During World War II, Auden, as we have seen, expressed his concern for the Jews of Europe. In a 1944 book review of Waldo Frank's *The Jew in Our Day* published in the *Nation*, Auden speculated about the psychological-emotional forces that generate anti-Semitism. Frank's book features an introduction by Reinhold Niebuhr, in which the prominent Protestant theologian makes the case for Zionism. In his review, Auden said that while he rejected all forms of national statehood as "nothing more than a technical convenience," in the Jewish case he agreed with Niebuhr that "as long as there are nation states in which Jews are overtly murdered *en masse*, the demand for a Jewish homeland is politically justified . . . but so long as no one enjoys the full advantages of statehood one cannot congratulate those who do not on being spared its temptations."[14]

Just as Auden was justifying a Jewish homeland in Palestine, Jewish writers in Palestine were on the verge of creating a new Hebrew poetry influenced by Auden and other British and American poets. Foremost among these poets was Yehuda Amichai, who discovered Auden while serving in the Jewish Brigade of the British army in Egypt in 1944. The eighteen-year-old Amichai came across Auden in a copy of *The Faber Book of Modern Verse* salvaged from a British army library van stuck in the desert. As he recounted to the *Paris Review* in 1992:

> The British had these mobile libraries for their soldiers, but of course most of the British soldiers, being from the lower classes and pretty much uneducated, didn't make much use of the libraries. It was mostly us Palestinians who used them—there we were, Jews reading English books while the English didn't. There had been some kind of storm and one of the mobile libraries had overturned into the sand, ruining or half-ruining most of the books. We came upon it and I started digging through the books and came upon . . . a Faber anthology of modern British poetry, which I think came out in the late thirties. Hopkins was the first poet, Dylan Thomas the last. It was my first encounter with modern British poetry—the first time I read Eliot and Auden, for example, who became very important to me. I discovered them in the Egyptian desert in a half-ruined book. . . . I think that was when I began to think seriously about writing poetry.[15]

In the ensuing years, Amichai immersed himself in the work of these modern British poets, seeking especially to emulate Auden. In 1955, a decade after the end

of the war, Amichai, by then a rising literary figure on the Israeli cultural land-scape, visited the United States. In New York, he went to hear Auden give a pub-lic reading at the 92nd Street Young Men's Hebrew Association, or YMHA.[16] Seeing and hearing his favorite English-American poet perform in public was a mixed experience for Amichai, one that shifted his perception of the poet's role.[17] Auden's use of the vernacular influenced Amichai's poetic language. But what Amichai saw of Auden's public persona disturbed him. "Auden spoke quickly and quietly and did not look at the audience while he read," Amichai recalled. "He read as if forced to; not as if he wanted to."[18] He appeared to be posturing for the "bored intellectuals" in the audience at the 92nd Street YMHA, "reading his poems as if he was reading them from the grave, after his death."[19] Amichai decided at that moment that he would not be the type of performer that Auden had become. Rather, he would read his poems to audiences in an engaged and lively manner.

In 1966, more than a decade after attending the Auden reading, Amichai was invited to read at the Spoleto International Arts Festival in Perugia, Italy. There he met Auden, Ezra Pound, and other influential poets, reading with them from the podium. By that time—in the mid-1960s—it had become clear to astute readers of Israeli poetry that among the poets in that Faber anthology, it was Auden who had influenced Amichai most deeply. Auden's use of the contempo-rary English vernacular in his verse influenced Amichai to incorporate Hebrew vernacular into his own poems. Speaking of Amichai and other Israeli poets of his generation, the poet and critic Dennis Silk noted, "The major influences from abroad have so far been in the direction of a colloquial language, closing the once huge gap that existed between the direction of the poem and what gradu-ally emerged as the true spoken language. Flatness, the prosaic perspective of the streets, came to the younger poets mainly via Auden."[20]

Amichai's use of the Modern Hebrew vernacular reflected his understanding of the secularization of the Hebrew language. Hebrew had long been reserved for religious use—both in liturgy and in intellectual discourse. But the Zionist movement called for the revival of Hebrew as a spoken language, envisioning a modern language that would fill needs both secular and sacred. For Amichai, combining the Modern Hebrew vernacular with the Biblical Hebrew of his upbringing came naturally. As he told an interviewer, "My thinking was why not use the language I talk in as well as the language of my Orthodox back-ground—the prayers, the Bible—together, juxtaposing and blending them. I discovered that this was my language. It was, I think, due to my unique personal

background—I'd been raised in a very Orthodox home and the language of the prayers and the Bible were part of my natural language. I juxtaposed this language against the modern Hebrew language, which suddenly had to become an everyday language after having been a language of prayers and synagogue for two thousand years. This was very natural for me—there was nothing programmatic about it. This kind of mixed sensibility or imagination of the language was my natural way to write poems."[21]

Throughout the 1960s, Amichai was in contact with Auden, often crossing paths with him at international poetry festivals. By then, Amichai had become "Israel's Auden," writing accessible poems about war and loss that were read at military funerals. Soldiers, like those I served with, often embarked on their military service carrying copies of Amichai's poems in their kit bags. Lovers, too, exchanged volumes of his poems. At his increasingly frequent public readings, Amichai was charming, friendly, and affirming. The lessons he had learned from Auden's 1955 reading at the 92nd Street YMHA had stayed with him.

By the late 1960s, Auden—often accompanied by Kallman—had traveled to many of the world's great cities, but he had yet to visit Jerusalem, even though a sojourn in the Holy City had occupied his mind for many years. His friendship with Amichai was one of the factors that finally drew him there, but it was far from the only one. As a Christian, Auden was deeply aware of the city's religious and cultural significance, and as a proponent of liberal Christian ecumenism, he thought of Jerusalem as a place where Christian unity might be strengthened, if not fully achieved. In a conversation with Alan Ansen, Auden speculated about the possibility of the various Christian churches overcoming doctrinal and ecclesiastical differences: "Where's the only place to meet that would be satisfactory to all of them? Jerusalem, obviously. That's a holy place for everybody."[22]

In 1970, when Auden and Kallman finally visited Jerusalem, Ansen—who had been a friend of Auden since attending the poet's Shakespeare lectures in New York during the 1940s—accompanied them. While Auden wanted to experience Jerusalem as a Christian, Kallman and Ansen planned to see the city as Jews—though neither man had ever shown much interest in Judaism. But the euphoria and vicarious ethnic pride that American Jews experienced in the wake of the 1967 War reached even those as disaffected and unaffiliated as Kallman and Ansen.

The three men flew to Israel from Athens, where Kallman kept an apartment. In Jerusalem they stayed at the Intercontinental Hotel on the Mount of Olives. Only later did Ansen realize that their European travel agent had

mistakenly booked them there instead of the American Colony Hotel, as he had requested. That was an unfortunate error; perched atop the Mount of Olives, the Intercontinental was not within easy walking distance of the city's main streets.

Reinhold Niebuhr's widow, Ursula, introduced Auden to Jerusalem's charismatic mayor, Teddy Kollek. Renowned for feting international celebrities, Kollek arranged a reception for Auden and took the poet and his companions on a nighttime tour of the united city. Auden, however, found Israel's enforced political and military control of the Arab parts of the city disconcerting; he did not consider Jerusalem truly united. Though he refrained from saying as much to Kollek and his other Israeli hosts, he demonstrated no such restraint with his traveling partners. As Ansen recalled, "Auden didn't believe Jerusalem should only belong to Israel, and expressed this opinion privately to me."[23]

From Jerusalem, Auden, Kallman, and Ansen traveled to Masada. They also visited the Weizmann Institute of Science in Rehovot. These secular shrines to Israeli nationalism impressed Auden less than Israel's sacred places, though he was no doubt aware of the dubious historicity of the holy sites. He found inspiration in the traditional Christian and Muslim holy sites; visiting Bethlehem's Church of the Nativity, Auden turned to Kallman and Ansen and said, "This is the one place where one feels He might really have been present."[24]

In his poem "The Dome of the Rock: Jerusalem (1970)," Chester Kallman evoked a single day's activities in Jerusalem. After a visit to the Church of the Holy Sepulchre, Auden, Ansen, and Kallman had walked to the Western Wall plaza and then ascended to the Haram/Temple area above the Wall. Kallman, invoking the spirit of Auden, in whose memory the poem was written, describes their pilgrimage as one made by "two Jews by birth, one practicing Anglican." But despite their intense day of exposure to the holy places of the three monotheistic traditions, the three visitors were not transformed by the experience; they remained "eternal tourists, never quite at home."

In September 1973, Auden died in Vienna, some three years after his visit to Jerusalem—and just a month before the Yom Kippur War. He was sixty-eight years old. For Amichai, whose literary reputation and popularity in Israel had grown to match Auden's in the English-speaking world, the grief was especially acute. He had lost not only a friend and mentor but also a kindred spirit; both poets had devoted themselves to integrating the secular and the sacred in their work as well as in their lives, linking Israel and the United States in profound and immeasurable ways.

Military Service and the Israeli/Palestinian Debate

Like many other young travelers who came to Israel after the 1967 War, I decided to volunteer to work on a kibbutz. But when the central kibbutz office suggested I work in one near Tel Aviv, I balked; I wanted to be assigned to a place on the border. I wanted to work on a kibbutz where identity was secular and daily life would not be regulated by religious rules. Therefore, they sent me to a new settlement on the Israeli-Jordanian-Syrian border, staffed primarily by a group of eighteen-year-old Israelis who would soon be inducted into the army for their compulsory military service. None of these young people were Orthodox Jews, and as a deserter from Orthodox Judaism I delighted in flaunting the religious rules with them. Particularly appealing to me was the kibbutz members' predilection for pork, known in Israeli secular parlance as white meat. Within six months, I had become so close to this group that I decided to join them in military service by volunteering to serve.

In 1968 Israel was an expanded state that included the captured Palestinian territories. Those Israelis who supported the annexation of these territories into Israel dubbed the new, expanded entity, Greater Israel. The newly transformed land attracted not only more tourists, pilgrims, and immigrants, but also a greater degree of U.S. diplomatic, military, and cultural support. From the conclusion of the war in June 1967 to the outbreak of the next Arab-Israeli war in October 1973, 70 percent of Americans told public opinion pollsters that they favored Israel over its Arab adversaries.[25] For American Jews, the percentage was surely higher, though I do not know of any survey during this period that specifically polled Jewish opinion. Such an effort would have seemed frivolous; there was a tacit assumption among the self-appointed American Jewish leadership that American Jews were solidly pro-Israel and strongly supported the Israeli government's policies. Many considered Israel's victory over the Arab states to be an event of religious or cosmic significance, and this conclusion produced a potent mix of euphoria, self-congratulation, and ethnic pride that strengthened American Jewish identification with the Jewish state. Whether they had relatives in Israel or not, many American Jews came to think of Israelis—by which they meant Israeli Jews, and not Israeli Arabs—as family.

At the same time, U.S. policy-makers began to see Israel as a strategic ally in the Cold War. Battered in their war with Soviet and Chinese proxies in Vietnam, American policy-makers took heart in Israel's victory against the Soviet-armed Arab forces in the Middle East. The perceived contrast between U.S. failures in

Vietnam and Israeli successes on Middle Eastern battlefields provided fodder for conservative critics of the Johnson administration. Frustrated with the apparent limitations on American power in Southeast Asia, these pundits called for the United States to act more like the Israelis in combatting the North Vietnamese army and the Viet Cong.

Ironically, the figure most associated with Israel's military victories of the 1950s and 1960s, General Moshe Dayan, openly criticized America's military methods in Vietnam. Reporting on the U.S. war for *Ma'ariv*, Israel's largest-circulation daily newspaper, Dayan concluded that U.S. forces had neither solid intelligence about their communist opponents nor a clear vision of what the war was about. He found their stated aim of winning Vietnamese hearts and minds to be vague and hopelessly naive. As Dayan wrote in his book *Vietnam Diary*, "The Americans are winning everything except the war."[26]

Yet most Americans, regardless of whether they supported or opposed the U.S. war in Vietnam, had nothing but praise for Israel's successful war against the Arabs. The overall sense was that the Israelis were doing something right even as the United States was getting it wrong in Vietnam. A significant minority of Israelis, however, were far less sanguine than the Americans about their government's actions. Disillusionment with their miraculous June 1967 victory set in as soon as it became clear that the Jewish state had blundered into a colonial situation similar to those from which European nations had only recently freed themselves: that of ruling a conquered indigenous population as an occupying power. The so-called 1948 Arabs—those who had remained in Israel after it became a state in 1948—were officially Israeli citizens, though they lacked the full social status enjoyed by Israel's Jews. But the Palestinians living in the West Bank, Gaza, and the Golan Heights, who now fell under Israeli jurisdiction, would remain stateless. In the West Bank alone, Israel now ruled more than a million Palestinians, half of whom were refugees whose families had fled Israel or been expelled during the 1948 War.

The question of the territories soon preoccupied, or one might say obsessed, Israelis: What would be the fate of the land and people of the West Bank, Gaza, and the Golan Heights? Would Israel annex these areas or hold them as a bargaining chip? Would absorbing their populations strengthen the country or, as the Hebrew University professor Yeshayahu Leibowitz argued, mark the beginning of "the decline and fall of the State of Israel?"[27] Within months of the end of the 1967 War, the Israeli political and cultural class was deeply divided on this issue. As one astute observer noted, Israel's occupation of the territories "engendered a crisis of identity among Zionists."[28] Critics of the government posed this

question: Was Zionism a liberal movement that would honor minority rights or an ethnic nationalist movement devoted to expanding the Jewish homeland?

On the political Right, the movement for a Greater Israel quickly took shape. The Right sought immediate annexation of the occupied territories, invoking the biblical history of the Land of Israel, in contrast to the modern history of the nation. Rather than refer to the West Bank by its geopolitical name, proponents of annexation used the biblical terms "Judea and Samaria." The political Left, on the other hand, staunchly opposed annexation, envisioning instead a land-for-peace agreement with the Arab states; in this scenario, Israel would return Gaza, the Golan Heights, and the West Bank to Egypt, Syria, and Jordan in exchange for a negotiated peace settlement. Many critics of annexation persisted in this peace-oriented view even after the Khartoum Resolution of September 1967. At the conclusion of the Arab League summit in Khartoum, Sudan, the defeated Arab states and their allies issued a declaration that included what are known as the "Three Nos": no peace with Israel, no recognition of Israel, and no negotiations with Israel.

A third body of opinion quietly emerged, but in the late 1960s it was far outside the popular consensus and gained little traction. The Israeli Council for Israeli-Palestinian Peace argued cogently for neither annexation nor a land-for-peace swap, but for the creation of a Palestinian State in the West Bank. Unpopular as this position may have been, it was the position that many of my Israeli friends and I supported. Our military service in the West Bank, Gaza, and the Golan Heights, where repression of the Palestinians was generating heightened resistance to Israeli rule, left us radicalized. We saw the cycle of violence escalating daily, and we saw no way out of that cycle other than the creation of an actual Palestinian State.

Between 1969 and 1972, I served as a combat medic in the Israel Defense Forces, and on occasion, crossed paths with visiting American Jews. Those exchanges left me acutely unsettled, for they revealed that extreme nationalist ideas had found a home among American Jews. In the summer of 1970, I was hitchhiking—in uniform—from the Sinai desert, where I was stationed, to Tel Aviv. An air-conditioned tour bus stopped, and the driver welcomed me warmly. When I got to an empty seat at the back of the bus, a portly American tourist turned to me, pointed at my Uzi, and said, "Soldier boy, how many Arabs have you killed with that gun?" I was shocked into silence—but just for a moment. "Mister, if I hear another remark like that during this bus trip, I'll be tempted to shoot you," I told him. As I would learn during subsequent visits to the United States, such belligerent and racist views were becoming widespread among my

coreligionists, and to my dismay, within my extended family. Some of my American cousins, it turned out, had found themselves swept up by the potent mix of Israeli national euphoria and religious messianism that intoxicated a significant number of young Jews in the late 1960s and early 1970s. In the mid-1970s, these cousins of mine moved to Israel and helped found the earliest Jewish settlements in the West Bank.

My own political development was radically different from that branch of my family. In the IDF, I turned to the political left, not to the right. My three years of army service overlapped with the War of Attrition. Soon after the conclusion of the 1967 War, Israel's borders with Egypt, Jordan, and Syria started to heat up again, as Israeli forces clashed with both regular and guerrilla forces on the Arab side. For several years, these Arab forces engaged in continuous, low-intensity warfare—in the Sinai around the Suez Canal, in the Golan Heights, and in the Jordan Valley—an effort meant to drive up the cost of Israeli occupation and eventually force a withdrawal from the occupied areas. Israel, though, responded forcefully, and at times massively, to these provocations. Repeated small flare-ups and a few large-scale encounters resulted in a steady number of casualties on the Israeli side, darkening the national mood. Many Israeli soldiers died in these encounters, and as a soldier in a combat unit, I attended their military funerals.

My army unit rotated through each of these fronts. In 1971 we were sent to patrol Palestinian refugee camps in Gaza and the West Bank. These camps were a front that my fellow soldiers and I were neither prepared for nor even aware of. Our commanding officer ordered us to enter people's homes forcibly and search for both weapons and subversive printed materials. When we reminded our commander that no one in our small unit read Arabic, he responded, "Just look for pictures of Yasser Arafat—and then destroy them."

Many in our unit were, like myself, from the kibbutz movement and vaguely leftist; we found this encounter with an insurgent civilian population deeply troubling. The national conversation in Israel had focused on territory; the debate hinged on the status of the recently conquered areas, and whether they ought to be called occupied, liberated, or perhaps, as some politicians put it, administered until such time as a peace agreement could be reached. But for myself and my fellow soldiers, the experience of policing the refugee camps, with their tens of thousands of inhabitants, forced us to recognize that the issue was not one of land or territory, but of people and their civil rights. The Palestinians in the camps, many of whom were refugees from Israel, could only be called an occupied people. They surely were not a liberated people, as some naive Americans were given to portraying them.

As an American raised on liberal values, who held humanist views of the Palestinians, I was dubbed by some "the pacifist paratrooper." But I was far from the only soldier disturbed by our assignments, which included arresting men without the right papers, and moving women and children out of houses so that the houses could be searched or even destroyed if the residence in question was deemed a terrorist house. Perhaps because I was an American volunteer and somewhat articulate, I was elected to speak to our commanding officers about the unit's misgivings. A date was set, and when the appointed time of the meeting arrived, much to my surprise, General Ariel Sharon stood in attendance. Sharon, who commanded the Southern Front where the refugee camps were located, excoriated me and my fellow soldiers for daring to question our orders. "What chutzpah!," he yelled. Soon afterward, we were moved out of Gaza and into the Sinai desert, where there were few local inhabitants and no hint of insurgency.

Only decades later would Israeli historians note that it was in the post-1969 period that a radical shift took place in the self-concept of the Israeli army. Ronen Bergman pointed out in his 2018 book *Rise and Kill First* that with the move to use soldiers to police the Palestinians, "the mission of the I.D.F. and its soldiers, particularly the eighteen-to-twenty-one-year-olds doing their compulsory military service, which had been in force since 1949, underwent a fundamental change as well. Whereas before combat troops had patrolled the country's borders, protecting it from external enemies, they were now reassigned to policing Palestinian cities and towns."[29]

Soon after I completed my military service in 1972, I made a short visit to the United States. When I conveyed my misgivings about Israeli policies to my relatives, friends, and school buddies in New York, they expressed shock. Though I explained to them that many Israeli Jews held similar views, they readily dismissed this claim. The American Jewish community had circled the political wagons; Israel could do no wrong. Only an anti-Semite could find something to criticize in the miracle that was reborn Israel! When I went to visit college friends in Wisconsin, I found conservative Christians who were even more gung ho about Israel than my Jewish family and friends. Americans might have shown more understanding of the Palestinian situation if they had known how divided Israelis were over the occupation at the time. But Americans did not hear from Israelis who were critical of their government's policies regarding the territories because any such critic was routinely denied access to American Jewish speaking platforms. U.S. organizations like the Anti-Defamation League of B'nai B'rith saw nothing to gain from fracturing American Jewish opinion on Israel; they actively sought to mute dissenting Israeli voices.[30] The message conveyed

by these dissenters was that the occupation was not only bad for the Palestinians; it was also bad for Israeli Jews. Among the critics of the occupation were Israeli intellectuals, academicians, novelists, poets, and scientists, many of whom would coalesce around the Peace Now movement a decade later. *Haaretz*, Israel's newspaper of record, routinely devoted space to their objections and concerns, earning widespread condemnation from American Jewish leaders. In the Israeli liberal press, particularly in *Haaretz*, the words "conquest" and "occupation" were used regularly. But in American Jewish life the words "Israeli occupation" registered as taboo. "If Haaretz was published in New York City, the local Jewish organizations would burn down the building in which it was published," the American rabbi and social critic Arthur Hertzberg once said.[31]

The Yom Kippur War and the Birth of Breira

By 1972 the War of Attrition was over, and Israel again seemed in control of its borders. But Syria and Egypt's surprise attack in October 1973 shook this new-found sense of security. The ensuing war in the Sinai and Golan Heights did not go well for the Israelis, at least not in the initial stages. The U.S. Air Force's massive airlift to resupply Israel, which was approved by President Richard Nixon during the second week of fighting, helped turn the war in Israel's favor. Still, Israel lost three thousand soldiers in what was quickly dubbed the Yom Kippur War, because the initial attack coincided with the Jewish Day of Atonement. Though Israel technically won the war, the heavy toll of Israeli casualties allowed the Arab coalition—and Egypt in particular—to claim a sort of victory.

Even more than the 1967 Six-Day War, the Yom Kippur War galvanized and reified the American Jewish commitment to Israel. Israel's military setbacks in the first two weeks of the war elicited enormous sympathy and a sense of personal identification among American Jews. Yet the war, though driving American Jewish solidarity with Israel, also held unexpectedly dire consequences for the American public. To punish the United States for its support of Israel, the Arab states first reduced oil production and then declared a full embargo on all oil shipments to America. Once the U.S. supply of oil dwindled, gasoline prices soared, and it seemed to many Americans that Israel's Arab opponents had a stranglehold on the American economy.

The oil shortage and economic downturn that followed would help kindle some measure of general American opposition to Israel's de facto annexation of the territories. A very different sort of opposition to Israeli policies emerged in late 1973 when Rabbi Arnold Jacob Wolf of Chicago founded Breira: A Project

of Concern in Israel-Diaspora Relations. Rabbi Wolf created his organization to oppose Israeli policies in the territories, giving it the name *Breira*—"alternative" or "choice."[32] This wording worked to challenge the popular Israeli slogan *ayn breira* in support of the argument that there was no alternative to current Israeli policy. Though Breira sought to change Israeli government policy by bringing in more American Jewish support for its position, the group also criticized the Palestinian leadership. Rabbi Wolf spoke of "the intransigence of both the PLO leadership and successive Israeli governments in their refusal to explore a peaceful long-term resolution to the Arab-Israeli conflict."[33]

Considered radical at the time, Breira was effectively advocating for what thirty years later would figure as the much-praised but never-realized two-state solution: a call for the existence of a Palestinian state alongside Israel. Breira's twelve hundred members included "secularists and religious Jews—a mix of Conservative and Reform rabbis, professionals from the Jewish communal structure, radical activists, professors and graduate students," as well as public intellectuals like Irving Howe and Leonard Fine.[34] Orthodox Jews remained conspicuously absent; by the mid-1970s they were solidly affiliated with the Greater Israel movement, and its activist arm, the settler movement.

Breira was controversial from the start. As the historian Michael Staub noted, "Its proposals on Israeli–Diaspora Jewish relations and Palestinian nationalism generated fierce international debate over the limits of public dissent and conflict in Jewish communal life, and virtually every major American Jewish organization took a public stand on the group and what it advocated."[35] The American Israel Public Affairs Committee (AIPAC)—then only a decade old and much less powerful than it is today—led the charge against Breira. The Rabbinical Assembly, Conservative Judaism's rabbinic organization, barred Rabbi Wolf and his Breira colleague Rabbi Everett Gendler from joining its executive council. The Conservative rabbinate would not allow criticism of Israel to emerge from within its ranks. The death knell of Breira came in late 1976, when a journalist revealed that two members of the organization had met with representatives of the PLO.

As a consequence, AIPAC and other Jewish organizations branded the organization anti-Israel and a threat to U.S.-Israeli relations. Jewish communal organizations forced activists who were in their employ to disassociate from Breira or face dismissal. As support dwindled, the group was forced to disband in 1977, after four tumultuous years of activism. It would be another twenty-five years before Jewish organizations critical of Israeli policies would emerge again on the American scene. Not coincidentally, during that quarter century the Jewish

settlement effort transformed the physical, political, and ideological nature of Israel. In 1977 the occupied territories contained a few thousand Israeli settlers; by 2002 their ranks had swelled to over a quarter million. And by 2015 they numbered half a million.

Like their Jewish counterparts, most American Christian organizations were wary of criticizing the Israeli government's policies. In the first two decades of Israeli statehood, most American Christians, whether liberal or conservative, were pro-Israel. In the 1970s and 1980s this alignment would grow even stronger. And in the Reagan years, the American Christian Right chose to adopt Israel as one of its principal causes.

Father Daniel Berrigan and Israel

Around the time that Breira emerged, in 1973, some in the American antiwar movement took up the cry against Israel's occupation of Palestinian lands. For the most part, however, such criticism was muted; most American opponents of U.S. actions in Vietnam, of whom there were many, remained reluctant to criticize Israel. The U.S. war in Vietnam might be untenable and reprehensible, but Israel's wars were acceptable because they were deemed "wars of defense."

Public figures in the United States and Israel helped propagate this narrative by consistently portraying the Jewish state—despite its military superiority and aggressive policies—as vulnerable to Arab attack. Many Americans, both Jews and Christians, saw the 1956 Suez War, in which Israel colluded with Britain and France to invade Egypt after it nationalized the Suez Canal, as a legitimate war of defense. In Europe, Asia, and Africa, the Suez War was deemed a colossal colonialist blunder. Similarly, Americans interpreted Israel's preemptive strike in June 1967 as a defensive move by a nation facing imminent attack from its enemies. The very name of Israel's army, the Israel Defense Forces, bolstered this perception of vulnerability—a perception that dominated public opinion in Israel as well as the United States. Successive Israeli governments presented all military action as a matter of survival; security threats were existential threats, and the Arabs, according to Israeli politicians, were planning another Holocaust. Abba Eban, Israel's foreign minister, gave startling voice to this view in 1969 when he called Israel's 1948 borders "Auschwitz borders," suggesting that withdrawal from the territories and a return to the prewar 1948 map of Israel would result in an existential threat equivalent to that posed by the Nazis. Later taken up by the Israeli Right, this phrase resonated deeply with many American Jews.

Though far removed from the daily realities of Israel, they unshakably identified with that perception of existential threat.

Eventually, some in the U.S. antiwar movement began to recognize the inconsistency of their stance concerning Israel. In the eyes of more radical members of the movement, the Viet Cong and the North Vietnamese army were fighting against colonialism. The United States was a colonial power, but so was its Middle Eastern proxy, Israel, with its occupation of the Palestinian territories and repression of the indigenous Palestinian population. Why, they asked, was the fight against the Viet Cong immoral, while the fight against the Palestinians was justified? Weren't both groups conducting wars of national liberation? For those on the left, this contradiction was not sustainable; in retrospect, it is striking that it lasted as long as it did. Slowly, some Vietnam War protesters began to speak out against Israel, too.

With the 1973 Yom Kippur War still raging, Father Daniel Berrigan stood out as one of the first anti-war activists to publicly criticize Israel's policies. Many Americans, as we have seen, understood the conflict as a struggle between a good Israel and an evil group of Arab enemies. Evangelical Christian Zionists in particular invoked the image of "a war between the Sons of Light and the Sons of Darkness."[36] Berrigan, however, broke sharply with this powerful trend in American thought. Speaking to the Association of Arab University Graduates in October 1973, he lambasted Israel as "an imperial nation embarked on an imperial adventure," likening it to such "settler states" as apartheid South Africa and Colonial America.[37]

The timing of the address was significant, not only in terms of international affairs, but also personally for Berrigan. He had been a fugitive fleeing warrants for anti-war activities when the FBI arrested him in the summer of 1970. He was sentenced to three years in prison but was granted early release in 1972 and placed on parole. Berrigan delivered his provocative address about Israel soon after the expiration of his parole sentence. The speech, titled "Responses to Settler Regimes," attracted little public attention until it was published in *American Report*, the journal of Clergy and Laity Concerned About the War in Vietnam, a prominent anti-war organization.

Negative reactions to Berrigan's speech came swiftly. All the large Jewish organizations condemned the message, as well as the messenger. Rabbi Arthur Hertzberg called Berrigan's remarks "old-fashioned theological anti-Semitism."[38] For Hertzberg, Berrigan's training as a Jesuit was sufficient explanation for his antipathy toward Israel. In addition to pointing to the Catholic Church's

historical animosity toward the Jews, many Jewish leaders accused the church of a more recent dereliction: failing to resist the Nazis and help save the Jews of Europe. Other Jewish organizations depicted Berrigan as a radical pandering to the Arab cause. With the United States deeply embroiled in the Cold War, support for the Arab states—which were armed by the Soviet Union—was deemed anti-American and thus outside the political consensus of the mid-1970s. Protesting against the Vietnam War was slowly becoming socially acceptable in liberal circles; protesting Israeli actions was not.

American Jewish organizations succeeded in discrediting Berrigan, thus preventing his message from reaching a wider American audience. The American artists, musicians, and performers who visited Israel in the late 1960s and early 1970s were largely unaware of these debates within American and Israeli Jewish communities. They were instead curious to learn about the storied country so much in the news, one that had just conducted a good war—so different from the U.S. war in Vietnam. They were also lured by the appeal to the biblical past that the movement for Greater Israel was promoting with renewed vigor.

Johnny and June Carter Cash

For Johnny Cash and his wife June Carter Cash, Israel's biblical appeal proved irresistible. Raised in a devout Baptist home, Johnny Cash first discovered music in the local church where his mother sang in the choir. Carrie Cash taught her young son scores of hymns and songs, and he learned to play the guitar when he was ten years old, largely to accompany her. Decades later, he recorded *My Mother's Hymn Book*, an album of songs his mother sang in church, which he cited in the liner notes as his favorite of the more than two hundred albums he recorded.[39]

One of the most moving songs on the album is "I'm Bound for the Promised Land," which opens with an evocation of the singer standing on "Jordan's stormy banks," looking wistfully toward Canaan, "where my possessions lie." For Carrie Cash and the other members of her rural Baptist church in northeastern Arkansas, looking across the Jordan River to "the tranquility of the Promised Land" on the other side was a metaphor for the heavenly reward awaiting the righteous when they cross the threshold of death and enter paradise. Young Johnny absorbed that worldview, but for him the words "Promised Land" were to take on a more literal significance. For Cash and many other American Christians—including his wife June Carter, who grew up with many of the same biblical

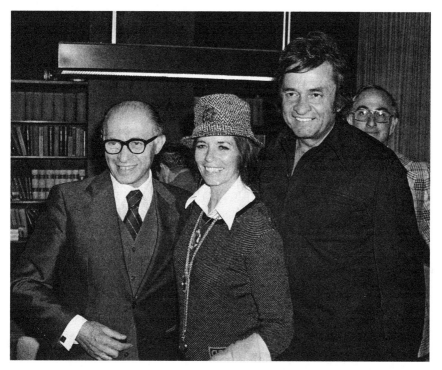

Johnny Cash and June Carter Cash visit with Prime Minister Menachem Begin, November 1, 1977. Associated Press/Max Nash.

references and church songs—those words would extend beyond religious metaphor into political reality.

From his early childhood, Johnny Cash had been steeped in the biblical view of modern history widely accepted by devout Protestant Americans at the time: The "return of Jews to their land" was the fulfillment of the biblical promise. Influenced by the popular Pentecostal preacher Oral Roberts, who made a pilgrimage to Israel in 1961, Cash decided in 1966 to visit Israel, where he saw the Holy Land and the Christian holy sites with his own eyes. He was thirty-four years old at the time.

That first visit was brief. But three years later, Cash returned—this time with his new wife, June Carter Cash, who insisted that they honeymoon in Israel. This second trip resulted in their *In the Holy Land* album, and a few years later, Cash and his wife were inspired to make a film set among the biblical landscapes

they had described in that album. They shot *Gospel Road* on location in 1971. A documentary-style chronicle of the life of Jesus, the film features Cash's narration while June Carter plays Mary Magdalene. Preceding the retelling of Jesus's life, the film opens with Johnny Cash enacting his wife's dream of him preaching to the multitudes. He stands holding a Bible on a mountaintop—Mount Arbel, near the Sea of Galilee—and invites the film's audience to join him on a journey through the Holy Land. Cash's introductory remarks serve as a reminder that American Evangelical enthusiasm for Israel has always been about Jesus and the history of Christianity, not about the modern Jewish experience. For them, Israel is a Christian Holy Land first and foremost, and only secondarily a Jewish homeland; the country is significant because of the part it plays in the life of Jesus, not because it embodies the ideas of Zionist thinkers like Theodor Herzl.

Gospel Road, with music by Kris Kristofferson, Cash, and other songwriters, was a commercial flop at the time of its 1972 release in the United States, but the film had a long afterlife. Campus Crusade for Christ, a parachurch Christian ministry aimed at college students, sponsored regular screenings of the film on U.S. college and university campuses during the 1970s and 1980s. These screenings attracted many Evangelical Christians, as well as their fellow students; in this way, a generation of Americans grew familiar with the film—truly, a cult classic.

Meanwhile, John and June kept returning to Israel. Several years after the release of *Gospel Road*, their children joined them on a pilgrimage to the Holy Land, where—like their parents—they were baptized in the Jordan River. Because of their prominence in the American music industry, the Cashes attracted the attention of Israeli government officials, who treated them like visiting royalty and facilitated their travel within the country. During these visits, the government tourist authority provided cars and professional tour guides, one of whom makes an appearance on the *In the Holy Land* album.

Johnny and June returned to Israel for a fifth and final visit in the mid-1990s, at a time when Palestinian suicide bombings had killed many Israeli civilians and sharply curbed tourism. During this trip, the pair produced a television film titled *Return to the Holy Land*, a musical travelogue through bucolic sites associated with the life of Jesus. Throughout the film, the Cashes—then in their sixties—assured American viewers that Israel was as beautiful and tranquil as ever, urging that they visit the country soon. There is no mention of the conflict with the Palestinians, or of any internal debates or dissension within Israel. Despite the changes in Israel and in world attitudes toward the Jewish state, John and June Carter Cash's zeal for Zion remained undiminished.

June Carter Cash died in May 2003; Johnny's death followed five months later. His recordings continue to sell briskly, particularly the American Recordings series that he made in his last years. When I mention Johnny Cash in my college classroom, the students know his music, though most, born in the late 1990s, were small children when he died. Many have seen the biopic *Walk the Line*, which does an excellent job of depicting the sex, drugs, and rock-and-roll that infused Cash's life and art. But like most Hollywood movies, it steers clear of religion in general and the Evangelical Protestant tradition in particular, ignoring the spiritual struggle and religious engagement that pervaded Cash's personal and professional life. Johnny and June spoke often of "being in Heaven together." Years after their deaths, they are still remembered fondly—or should I say, reverently—by their many fans in Israel, as well as in America. In both the metaphorical and actual senses, they made it to the Promised Land.

Bishop Pike

June Carter and Johnny Cash were not the only Americans in the public eye who sought transformational experiences in Israel in the aftermath of the Six-Day War. Israel post-1967 continued to attract eccentrics, visionaries, and other seekers of spiritual adventure, especially those who were keen to visit newly united Jerusalem, the nearby Judean desert, or the Galilee. In this way, Israel of the 1960s and 1970s competed with India as a spiritual tourism supermarket of cults, creeds, and religions.

While the Cash family's experiences in Israel were overwhelmingly positive, other prominent Americans crashed and burned there, in much the same way as many Westerners of the era did on their spiritual sojourns within India. The Episcopal bishop James Pike, who sought in the Holy Land redemption from personal tragedy and the turmoil of American politics, was the victim of one such spiritual misadventure.

Born and raised in Oklahoma, Pike moved to New York City in the 1950s to serve as a chaplain at Columbia University, where he founded the Department of Religion. He subsequently took on the role of dean of the Cathedral of St. John the Divine, the Episcopal church near the Columbia campus. As one observer put it, "To be dean at the world's largest cathedral in the heart of Manhattan is a plum position, and Pike made the most of it, with superb instincts for working the media."[40] Bishop Pike's sermons at St. John's attracted enormous crowds— some three to four thousand people attended each Sunday.

Pike soon became one of the nation's best-known church leaders. To capitalize on his popularity, ABC produced a weekly television show, *Dean Pike*, which was broadcast live on Sunday afternoons from 1955 to 1961. It attracted a large audience, larger than those of competing TV clerics like Bishop Fulton Sheen and Billy Graham. Pike, who often appeared on the show with his wife at the time, Esther Yanovsky Pike, emerged as a media sensation, his picture soon to appear on the cover of *Time* magazine in 1966. Pike's appeal stemmed from the fact that he was folksy and approachable, and yet worldly and thoroughly modern. He sounded like the midwesterner he was but carried himself like a New York intellectual and bon vivant.

Early in his ecclesiastical career, which he had arrived at in his late thirties following a career in the law and government, Pike's outlook was politically and religiously conservative, but in New York his ideas underwent a liberal transformation. He became a spokesman for rapid, radical change both within the Episcopal Church and in American society at large. As one historian put it, "Pike became an advocate for civil rights, the poor, women's ordination, abortion and homosexual rights."[41]

In 1958 Pike left New York to become the Episcopal bishop of Northern California. His San Francisco pulpit, Grace Cathedral, was the Bay Area's equivalent of Manhattan's Cathedral of St. John the Divine. ABC TV now broadcast his show from the West Coast, and his national audience increased. But Pike paid a price for this success; as a national figure, he was under pressure from prominent conservative Episcopal bishops to conform to church doctrine. Two issues particularly irked his colleagues: Pike urged the church to accept homosexuals, and he fought to allow women to be ordained. In the early 1960s, these were truly radical ideas, and the Episcopal Church launched heresy procedures against Pike. Eventually, the church leaders decided that a public airing of Pike's controversial ideas would harm the denomination.

The pressure on Pike took its toll; he sought refuge in heavy drinking and a series of affairs with secretaries and colleagues. This behavior, in turn, led to the dissolution of his marriage and provided conservative critics within their Episcopal church new ammunition in their efforts to get the bishop defrocked for heresy. In 1966, after a dispute with church officials over his request to marry his research assistant, Diane Kennedy, James Pike resigned from his post. Two years later, he left the Episcopal Church altogether. On that occasion, he wrote, "The poor may inherit the earth, but it would appear that the rich—or at least the rigid, respectable, and safe—will inherit the church."[42]

Between vacating the pulpit and his final break with the Episcopal Church, James Pike suffered another major blow: his twenty-year-old son, James Jr., committed suicide. According to some reports, his death stemmed from a bad LSD trip.[43] Grieving over the loss of his son, Pike turned to spiritualism for solace. In the wake of the resurgence of mysticism in the 1960s, he consulted psychics, who convinced him that it would be possible to establish contact with his dead son. Pike shared this new spiritualist direction with his new wife, Diane Kennedy, and it prompted them to visit Israel in 1969.

Like other mystics of the time, Pike subscribed to the idea that the Essenes, the authors of the Dead Sea Scrolls, had influenced the first Christians. Some even speculated that the Essenes had been the first Christians, and that John the Baptist and Jesus had lived in Qumran, the home of the Essenes near the Dead Sea. Pike wanted to see firsthand where the Dead Sea Scrolls had been discovered. He and his wife desired a mystical connection with the place where they believed early Christians had experienced God.

Pike had made five previous visits to Israel, but this sixth trip would prove to be very different. He and Diane were on a dual quest. In addition to their hope of connecting with the spirit of his son James Jr., with whom Pike had visited Israel only a few years earlier, they had embarked on writing a new spiritual biography of Jesus. As Pike's biographer David Robertson noted, the couple had "disassociated themselves from institutional religion and a conventional livelihood and proposed to study in Israel a historical Jesus far different than the accepted view of most of Christianity."[44]

The couple arrived in Israel in late August 1969 as believers searching for meaning in the land where Jesus walked—much like Johnny and June Carter Cash. But while the Cashes were part of a broad Evangelical consensus on the religious significance and political importance of Israel for American Christians, the Pikes were outliers—dissident truth seekers on a spiritual quest.

Like many prominent international visitors to Jerusalem, the Pikes chose to stay at the Intercontinental Hotel, adjacent to the ancient Jewish cemetery on the Mount of Olives. Within a few days of their arrival, they set out to explore the Judean desert, eager to visit Qumran, where the Dead Sea Scrolls had been discovered in the late 1940s and early 1950s. But instead of taking a guide, as advised, they rented a Jeep and set out on their own. Leaving Bethlehem, they passed Herodion, the ancient palace Herod the Great built on the highest hill in the Judean desert, before turning off on an unpaved track they thought led north to Jericho. Soon they were lost. When the Jeep stalled, they were stranded

in the desert, where the temperature that late-summer day hovered above 100 degrees.

Unable to start the car, the couple set out on foot. After an hour's walk, James collapsed in the heat and could go no farther. Diane, who at thirty-one was some twenty-five years his junior and in much better physical condition, decided to press on. She walked for ten hours before a security guard spotted her. He took her to the police station in Bethlehem, where she told the authorities that she and her husband had "tried to follow Jesus's footsteps. We wanted to see the conditions Jesus knew. . . . It was our first time in the desert. We didn't take a guide. We were very stupid about that."[45] The police sent search parties into the desert. It took them five days to find James Pike's body. It seemed that, after resting, Pike had set out trying to follow Diane's path, and then fallen off a steep cliff and died.

The story was big news in the American press. Bishop Pike was a public figure in the United States, and his disappearance in the Israeli desert generated headlines in all the major American newspapers. It fascinated Israelis as well. I was serving in the Israeli army, in basic training at the time, and vividly remember hearing on army radio about the search for Pike's body.

Several days after his body was recovered, Pike was buried at the seaside cemetery of St. Peter's Church in Jaffa. His life's journey had taken him from a modest Catholic upbringing in Oklahoma to the pinnacle of cultural and religious influence in Manhattan, and then to even greater prominence as an Episcopalian bishop and popular television personality in California. In Jaffa's Protestant cemetery on the shores of the Mediterranean, Pike found his final resting place. "There could have been no more appropriate place for Jim to die, if he had to die," Diane said at her husband's funeral. "He died in the country he loved as though it were his own, in the wilderness where Jesus, according to the Gospels, went to pray and meditate."[46]

Meyer Lansky in Israel

My American Jewish family was among the many who were drawn to Jerusalem after the 1967 War. As I mentioned earlier, one of my great-grandfather's brothers immigrated to Palestine at the end of the nineteenth century, while my great-grandfather and his other siblings came to the United States. Shortly after I was inducted into the Israel Defense Forces in 1969, my mother's two eccentric aunts came to visit Jerusalem, intent on finding the grave of their uncle, Eliezer, my great-grandfather's brother, within the Jewish cemetery on the Mount of Olives.

That cemetery had been vandalized by the Jordanians in the 1948–49 War, but in 1969 it was in the process of being restored by the Israelis. We searched in the summer heat for hours before we found Eliezer's grave. Relieved, my aunts sat down on the ground and, in rapid-fire Yiddish, proceeded to tell their departed uncle every important thing that had transpired in the family since his death in 1895—not only who from our extended family had perished in the Holocaust, but also who had divorced, whose business had failed, whose children had not remained Orthodox, and whose children had.

My great-aunts, quirky as they were, counted as but two of the many American Jews who visited Israel in the heady years immediately after the 1967 War. Unlike those who came to find their Jewish roots through a new sense of identification with the State of Israel, my aunts—who had visited Israel twice in the 1950s and already felt strongly connected to the state—came to seek their family roots in the very concrete manner of locating an ancestor's grave. Other families, whose elderly relatives had traveled to Jerusalem at the end of their lives to be buried on the Mount of Olives, were much less fortunate in their searches. They never found their ancestors' graves, many of which were lost beneath the roads the Jordanians had paved for access to the construction site of the Intercontinental Hotel on the Mount of Olives.

Intrigued by the phenomenon of Jews coming to Jerusalem to find—and, if possible, restore—their ancestors' graves, I delved into the folklore concerning burial in Jerusalem. From my Jewish education, I knew that Jewish tradition affirmed that the resurrection of the dead was expected to usher in the Messianic age, and that those buried on the slopes of Jerusalem's Old City would be resurrected first. Digging deeper into the legends, I learned that the bones of those buried in Jerusalem would be spared the agony of rolling in tunnels under the earth to reach the Holy City. Only after that "battering in the tomb," which transported the dead to Jerusalem, would those unfortunate enough to be buried elsewhere than on the Mount of Olives be restored to life.

Besides studying the legendary and the fantastic—realms that often mix in Jerusalem—I followed the stories of recoveries of other Jewish graves on the slopes of the Mount of Olives. A little over a year after my great-aunts' séance with their dead uncle, I read in the daily newspaper *Maariv* of an unlikely searcher for Jewish ancestors on the Mount of Olives: the American legend Meyer Lansky of Murder Incorporated notoriety. Like so many American Jewish families, including my own, Lansky was linked to Israel through relatives who had lived and died in pre-state Palestine. Lansky was born in 1902 to a Russian Jewish family in what is now Belarus. When he was eight, his paternal grandparents moved

to Ottoman-ruled Jerusalem and urged their son, Max, Meyer's father, to join them. Instead, Max and his family immigrated to the United States. Soon after, they learned that both grandparents had died within a few months of arriving in Jerusalem and were buried on the Mount of Olives. In 1972, seventy years later, Lanksy came to Israel to search for his grandparents' graves.

Starting out as a petty criminal, Lansky had risen quickly in the hierarchy of the Mafia. In the 1930s and 1940s, he was the Mob's most trusted manager of gambling casinos. In 1951 the U.S. Senate Special Committee to Investigate Crime in Interstate Commerce, which was headed by Senator Estes Kefauver, subpoenaed Lansky, whom Kefauver dubbed one of the three principals in the "scum behind a national crime syndicate." As the *New York Times* journalist Selwyn Raab noted, this description of Lansky was overstated. But the committee's mistake elevated Lansky from his role as a wealthy junior partner in the Cosa Nostra to the position of a "Mafia financed Goliath."[47]

Nineteen years after the investigation, the Justice Department indicted Lansky on charges of tax evasion. The former Mob boss, who had visited Israel in 1962 as an enthusiastic tourist, now sought asylum there as a fugitive from American justice. Arriving in 1970, he and his wife, Teddy, hoped to become Israeli citizens under the provisions of the Law of Return, which the Knesset had passed in 1950, the same year that Kefauver's subcommittee was established. The Law of Return promised citizenship to any Jewish person, thereby providing an automatic homeland for stateless Jews. Prime Minister David Ben Gurion described it as "the right inherent in every Jew by virtue of his being a Jew, if it but be his will to take part in settling the land."[48]

In 1954 the Knesset narrowed the law, amending it to exclude applicants with "a criminal past, likely to endanger the public welfare." But that did not stop Jewish criminals fleeing prosecution in their home countries from trying to take advantage of the law. As we saw in the previous chapter, the American scientist Robert Soblen attempted to escape his conviction in the United States by gaining asylum under the Law of Return. The Israelis refused him entry, but Soblen's failure did not deter others. A year later, in 1964, "Doc" Stacher, an associate of Lanksy in the organized crime syndicate, fled to Israel and was granted citizenship under the Law of Return, despite a U.S. indictment for tax evasion.

Indicted for the same crime, Meyer Lansky sought to follow "Doc" Stacher's path. But, as in the Soblen case, the intensification of Israeli-American military and diplomatic ties in the 1960s worked against Lansky. Within weeks of their arrival in Tel Aviv, where they rented rooms at a beachfront hotel, the Lanskys found themselves in the public spotlight. When the American press learned of

Lansky's request for Israeli citizenship, the tale of the fugitive gangster known as the alleged brains of the Mafia broke as a major news story in the United States. This media attention, combined with the 1971 publication of *Lansky* by the *Miami Herald* reporter Hank Messicks—billed as "an astonishing exposé of American crime and the astonishing man who runs it"—turned Lansky's application for Israeli citizenship into an international political issue.

Prior to the intense public scrutiny, Israeli authorities were seriously considering the Lanskys' request for citizenship. Interior Minister Yosef Burg agreed to extend their tourist visas until the applications for citizenship could be approved. As Zachary Lazar noted, Israel, for Lansky, "was the only place in his life that he'd felt truly at home—not just for legal reasons but . . . also for spiritual ones. There in the Jewish homeland, he achieved as much as someone like him could have hoped for, a kind of temporary salvation."[49]

But as word of Lansky's application for Israeli citizenship spread, officials in the United States expressed their uneasiness about the possibility of Israel approving the request. The U.S. Department of Justice wanted to prosecute Lansky for tax evasion, while the Israeli government—wary of alienating the Americans—was growing concerned that the perception of ties to organized crime would tarnish Israel's image in the United States.

No one voiced these objections more strenuously than Israel's American-raised prime minister Golda Meir. Like Lansky, Meir—the former Goldie Meyerson of Milwaukee, Wisconsin—had been born in Russia and immigrated to the United States as a young child. When Interior Minister Burg raised the Lansky case with the prime minister, she said "Dr. Burg? Mafia?—No Mafia in Israel."[50] The prime minister's quick decision sealed the Lanskys' fate. Though the case made its way to the Israeli Supreme Court in 1970, Lansky and his legal team had no chance of receiving citizenship. Prime Minister Meir was dead set against any action that would anger and alienate the American authorities.

In its rejection of Lansky's application, the Israeli Supreme Court cited the Interior Ministry's opinion that Lansky's presence in Israel endangered the public welfare. There was a risk, Dr. Burg wrote, that Israel would develop "the ugly phenomenon of organized crime, as it exists in America."[51] After a two-year stay in Israel, the Lanskys returned to the United States, where Meyer faced a new trial.

Following his acquittal in that trial, Lansky and his wife returned to Miami Beach, but he did not abandon his aspiration to return to Israel. In 1977, when the political upheaval in Israel brought Menachem Begin to power, Lansky wrote to the new prime minister.[52] "Mr. Begin, I have a very keen desire to live

in Israel, but unfortunately I am *verboten*. To begin with, when I spent time in Israel, I fell more in love with the country than I was before. My one wish is to be able to spend the rest of my life there, which, I presume, can't be too long, as I am seventy-five years old." Lansky closed his appeal with this question: "How much harm can an elderly sick man do to Israel? . . . I can enter as I have, any other country without criticism, except the place of my heritage."[53] Begin did not respond to Lansky's request, though some members of his Revisionist party encouraged him to.

IN THE DECADE between 1967 and 1977, Israeli-American ties were challenged, transformed, and deepened. In the military and political spheres, the United States emerged as Israel's main supplier and supporter—a role that had belonged to France before the 1967 War. Some Israeli critics on both the left and the right spoke out against this strengthening and ever-more-entwined relationship. This criticism, powerful as it was, did not weaken or diminish the profound diplomatic, strategic cultural ties that were forming between the two nations and their citizens. If anything, increased American tourism to Israel, combined with the support of high-profile writers and musicians, strengthened U.S. public opinion of Israel—a perspective that in its adoration tended to ignore criticism.

Within Israel, however, the divisions between Right and Left expanded and sharpened. The decline of the Labor party and the 1977 ascent of Menachem Begin's Revisionist party were a *mahapach*, or a revolution of sorts. The intensifying breach would, over the next decades, lead to the formation of the Likud party and the leadership of prime ministers Ariel Sharon and Benjamin Netanyahu. One of the main ideologues of the Right was Benzion Netanyahu, a scholar and academician who spent most of his career teaching at Cornell University and upon his retirement moved to Israel. His son Benjamin, born in 1949, would become Israel's prime minister in 1996, fulfilling his father's dream of turning Israel toward Revisionist Zionism and away from the socialist and egalitarian principles of Labor.

Israel at Thirty

Political Action, Messianic Expectations, and Literary Controversies (1977–1997)

O N MONDAY, MAY 8, 1978, the ABC television network presented *The Stars Salute Israel at 30*, a two-hour, prime-time special celebrating the thirtieth anniversary of Israel's establishment. Filmed the evening before in Los Angeles, the program was broadcast nationally and simulcast in Israel, attracting over eighteen million viewers. With Vice President Walter Mondale the nominal head of the committee that organized the show, the salute had near-official status, even if Mondale was never actually consulted about its format.

The all-star cast featured some of the most popular entertainers in the world at the time, including music stars Sammy Davis Jr., Pat and Debby Boone, and Barry Manilow; actors Kirk Douglas, Anne Bancroft, Henry Fonda, and Gene Kelly; comedians Alan King, Flip Wilson, and Dean Martin; and dancers Mikhail Baryshnikov, and Galina Panova. The Los Angeles Philharmonic Orchestra performed both classical and popular standards, including the theme from the recent blockbuster *Star Wars*, which was conducted by its composer John Williams. Daniel Barenboim performed at the piano. Paul Newman, who had played Ari Ben Canaan in *Exodus*, thrilled the audience with his remarks about Israel. For the finale, Barbra Streisand, after performing several standards, spoke by satellite video link with Golda Meir, who had been Israel's prime minister from 1969 to 1973 and, five years after her resignation, remained a beloved figure among American Jews. Streisand then closed the program with a rousing version of "Hatikvah," the Israeli national anthem, as the audience at the Dorothy Chandler Pavilion waved light sticks.

While Israel was still much admired in the United States, sympathy for the Jewish state was wearing thin on the international stage. Just three years earlier, in 1975, the United Nations had passed a resolution equating Zionism with racism. The U.S. government and many of its allies opposed the measure; Arab and Muslim states, along with many developing nations, had voted in favor of it.

The success of the resolution, however, did not dampen the American public's overwhelming support for Israel; among conservatives as well as liberals, Israel remained Uncle Sam's darling.

Over the next decade, the increasing Palestinian resistance to Israeli rule would begin to challenge American public opinion about Israel. And when the First Intifada, or Palestinian insurrection, broke out in 1987, liberal Americans were forced to rethink their positive perceptions of Israel and its policies in the territories. The initial Israeli response to the uprising, which was harsh and often brutal, was especially troubling to American liberals. But in 1978, the year of the country's thirtieth anniversary, American public opinion remained unwavering in its support of the Jewish homeland.

For many Americans watching *The Stars Salute Israel at 30*, the appearance of Golda Meir served as a poignant embodiment of their feelings for the Jewish state. Meir was the closest thing American Jews had to a saint—Mother Teresa reimagined as a Jewish grandmother. No doubt, many knew that Golda was, like them, an American. Born in Russia, she had lived in Milwaukee, Wisconsin, from the age of eight until as a young adult she settled in British Mandate Palestine in the 1930s.[1]

American viewers, however, would have been shocked to learn of Mrs. Meir's tainted reputation at home. Wildly popular in the United States, Golda remained exceedingly unpopular in Israel, especially among the generation that had fought in the Yom Kippur War. Many Israelis held Meir responsible for the initial setbacks of that war, and she was routinely mocked and vilified by the Israeli political Left. In 1975 she resigned after mass demonstrations and parliamentary dissent indicated that she could no longer effectively lead. But very few of the American celebrants that evening, whether star performers or television audience members, were aware of this dissension within Israeli Jewish society. Even fewer knew of the plight of the Palestinian refugees living under Israeli control in what Menachem Begin's government called the Liberated Territories. Some of the American viewers who claimed to love Israel might have been deeply disturbed to learn of the deep divisions among Israeli Jews over Meir's legacy.

Israel's Political Upheaval and American Reactions

In Israel, the failure of military intelligence to anticipate the Egyptian and Syrian attacks in October 1973 left a deep scar. The resulting setbacks during the first two weeks of the war led voters to blame the military and political leadership, and Prime Minister Meir in particular, for their inability to read the Arab states'

intentions correctly and to defend the state. The postwar, government-appointed Agranat Commission, led by the head of the Supreme Court, confirmed this view, placing the responsibility for Israel's lack of preparedness squarely on both the army and the government.

This gaffe by Israeli intelligence, known as *Hamechdal*, or "the national blunder," led to a transformation in Israeli politics and culture. In 1977 voters rejected Golda Meir's Labor party and brought to power the Revisionist Herut party, led by Menachem Begin, marking a distinct political turn to the right and away from the socialism of the nation's founders. Ethnic resentment also played a role: Golda Meir and her Labor colleagues were the Ashkenazi elite, Jews of European descent. The Right, galvanized by Begin's leadership, appealed to the discontented Jewish voters of Middle Eastern origin, the Mizrahim. In their view, the Ashkenazim had been in power too long—since the establishment of the Jewish state in 1948—and had discriminated against the Mizrahim in areas such as housing, education, and employment. Though Begin himself was an Ashkenazi born and raised in Poland, he skillfully appealed to Mizrahim discontent, earning their vote by promising to pave the way for full social equality. This turn to the right would enable the nascent settler movement, which had emerged fully after the 1973 war, to gain political power and flourish.

Hollywood's *Stars Salute Israel at 30* reflected none of these changes. For participants and viewers alike, it was still 1948—the heroic year of Israel's War of Independence. In American popular culture, Israel was a great success story, but it was seen as a vulnerable David, not a Goliath armed with atomic weapons. Some American performers endorsed this perspective. In the early 1970s, Ray Charles and his backup group, the Raelettes, performed five wildly successful concerts in Israel. During the tour, Charles visited former Israeli prime minister David Ben Gurion at his retirement home at Kibbutz Sde Boker in the Negev, where the two men were filmed singing the Israeli folk song "Hava Nagila." The tour, including Charles's meeting with Ben Gurion, was preserved in a documentary film that was not released until after Charles's death in 2004.[2]

In 1976 B'nai B'rith honored Ray Charles as Man of the Year. Accepting the award at a dinner in Beverly Hills, Charles said, "Even though I'm not Jewish . . . Israel is one of the few causes I feel good about supporting. Blacks and Jews are hooked up and bound together by a common history of persecution. If someone besides a Black ever sings the real gut-bucket blues, it'll be a Jew. We both know what it's like to be someone else's footstool."[3]

In its online biography of Ray Charles, *Rolling Stone* magazine pointed out that Charles had been "active in a range of political and humanitarian causes." In

addition to providing "financial support for the Reverend Martin Luther King Jr. and the civil rights movement, Charles was also a staunch supporter of Israel."[4] Supporting both the American civil rights movement and the State of Israel made sense in the early to mid-1970s, but by the late 1970s, many—including many in the black community—would begin to challenge that assertion. As the Israeli occupation of the territories conquered in the 1967 War entered its second decade, left-leaning activists in the civil rights and anti-war movements started to express solidarity with the Palestinian cause, and hostility toward Israel.

IN ISRAEL, the Jewish population was grappling with the divisive issue of what to do with the territories and their Palestinian inhabitants. From the conclusion of the 1967 War, fractures started opening up across the political landscape. The yearning for and anticipation of *Eretz Yisrael Hashlemah*, or Jewish control over the whole Land of Israel, had been powerful themes in Israeli culture since before the founding of the new state. Many Israelis saw the 1967 War as an act of God that would fulfill the geographical and spiritual promise of Israel. Areas of biblical Israel that had been under Arab control now fell under Israeli military control. The State of Israel, whose culture had been shaped by the secular Israeli Left, now found itself confronted with an ideology influenced by messianism and the maximalist territorial ideology of the political Right.

With Begin's election in 1977, Jews rather than Israelis ascended to power. Of course, the members of both factions were all Israeli Jews, but they were driven by different ideologies. The cultural elites of the first three decades of Israel saw themselves as new Jews who had shed the Jewish weaknesses of diaspora life. The Begin loyalists—some of them secular Jews—were allied with the religious Zionists, who were influenced by the ideas of Rabbi Zvi Yehuda Kook. After the 1967 War, Rabbi Kook, who spoke of the Israeli state as divinely ordained and inevitably triumphant, told his yeshiva students that—now that Israel had returned to its biblical borders—they were obligated to settle in the liberated territories to claim Israel's full biblical heritage.[5] For both Kook and his followers, as well as Begin and his followers, Gaza, the West Bank, and the Golan Heights had to be incorporated into the State of Israel, and the best way to accomplish this objective was to build settlements within the territories. In this way, Greater Israel would become a reality. The people in this emerging political alliance saw themselves as "more Jewish" than their leftist coreligionists.

Strengthened by Begin's 1977 victory, the settler movement continued to gain traction, exerting direct influence on the government. And many American

Jews supported settlement efforts. Some did so financially, while others—like my own cousins—moved to Israel and joined the settler movement as activists and supporters. On my annual research visit to Israel, I would visit these cousins in their West Bank settlements and was astounded both by their conversion to messianic Zionism and by the resources the Israeli government had allotted to the construction of their new homes in the West Bank. A few years earlier, I had visited them in California, New York, and London where they were living thoroughly modern, though not completely secular lives. Transposed to the biblical heartland, they seemed more eccentric to me than any of the countercultural bohemians I knew in Manhattan.

The political divisions between the Israeli Left and Right influenced the terminology used to describe the conquered areas. For the Left, the territories were occupied. For the Right, the West Bank had been liberated, and as part of Greater Israel, it was identified by its biblical names: Judea and Samaria. By the end of the 1970s, these radically different points of view—those in favor of expansion and those opposed to it—had been codified and ingrained within Israeli society. But among the large pro-Israel community in America, right-wing views dominated, and criticism of Israeli policy and the settler movement was muted. As the cultural critic and Columbia University professor Edward Said noted in the 1980s, "The sad truth is that where discussion of Israel is concerned, the United States is well below Israel itself in norms of truth and methods of debate."[6]

The Israeli Right and Its American Christian Supporters

When many Americans, both Jews and Christians, celebrated Israel's thirtieth anniversary, Evangelical Christians paid special attention. American performing artists like Johnny and June Carter Cash, who had ties to the Reverend Billy Graham and other Evangelical leaders, were swept up by religious enthusiasm for Israel. American Evangelicals had long been uneasy about Israeli secularism and found it deeply disturbing that many Israeli officials were assertively secular and hostile to organized religion. As the Evangelical leader Walter Wilson noted: "The nation of Israel has been formed, they have all the likeness of one of the nations of the earth; they have their government, their postal, coinage, and banking system, but there is no God. They have come together as a nation of Israelites, without the God of Israel."[7]

With the triumph of Begin and the religiously oriented Israeli Right, American Evangelicals felt more comfortable with an Israeli culture that was assertively

religious. They now were eager to enter the debate about Israel's territories. In the late 1970s and early 1980s, the Reverend Jerry Falwell articulated the support of the Christian Right for the building of settlements and the annexation of the territories. "Biblically, prophetically, and ultimately, 'The Land' will include the area promised to Abraham in Genesis 15:18," he told an Israeli interviewer. "There is no question that Judea and Samaria should be part of Israel."[8]

Many Israeli Jewish secularists and many of Israel's Arab citizens found this American Evangelical support deeply troubling. For them, Israel's legitimacy was not predicated on biblical promise. Rather, Israel, as a modern nation-state, had gained independence through its own political and military struggles. But for America's religious Jewish Zionists and their Christian allies, Israel was more of a theological issue than a political one. Or, more precisely, pro-Israel policy represented a fusion of religion and politics, a fusion that would exert considerable influence in American life.

Falwell's support of Israel bordered on the fanatic, exceeding that expressed by some American Jews. As he told an interviewer in 1984: "The destiny of the State of Israel is without question the most crucial international matter facing the world today. I believe that the people of Israel have not only a theological but also a historical and legal right to the land. I am personally a Zionist, having gained the perspective from my belief in Old Testament Scriptures." After supporting Israel's right to all the land, Falwell then went on to clarify his theological understanding of the underpinnings of the Israeli state: "I am convinced that the miracle of statehood in 1948 was providential in every sense of the word. God promised repeatedly in the Old Testament that He would re-gather the Jewish people unto the land which He had promised—namely the Land of Israel. He has kept his word."[9]

In fact, Falwell made U.S. support of Israel a key principle of the Moral Majority, the consortium of conservative Christian political action committees that he cofounded in 1979. "We support the state of Israel and the Jewish people everywhere," read the founding charter. It was not just generosity or empathy that drove this commitment to Israel; Falwell saw the Jewish state as vital to Christianity's future. "I believe that if we fail to protect Israel, we will cease to be important to God," he told his Virginia congregation. "We can and must be involved in guiding America towards a biblical position regarding her stand on Israel."[10] In this soon-to-be-popular view, the spiritual welfare of Americans—their very value in God's eyes—depended on their support of the Jewish state. Conservative Christians found proof of this claim in Genesis 12:3, where God

tells Abraham, "Those that bless you shall be blessed and those that curse you shall be cursed."

When Falwell visited Israel in the late 1970s, Prime Minister Begin welcomed him personally. Begin cultivated Christian Zionist support throughout his tenure as prime minister, from the time that he took office in 1977 until his resignation in 1983. In the fall of 1981, the Israeli prime minister attended an event sponsored by the American-funded International Christian Embassy in Jerusalem (ICEJ), a recently established Christian Zionist advocacy group. The ICEJ organized an event on the Jewish holiday of Sukkot, the Feast of Tabernacles at which Christians demonstrated solidarity with Israel and its policies. Begin welcomed the large crowd of assembled Christian Zionists to Jerusalem, saying: "Tonight, I know that we are not alone."[11] In subsequent decades, this Christian celebration expanded into an annual event attended by many thousands.

Despite its name, the International Christian Embassy in Jerusalem has no diplomatic or official standing. It was the invention of Dutch and American Christian Zionist activists who claimed that Israel had been abandoned by the international community after its 1980 passage of the Jerusalem Law, which allowed the government to annex greater East Jerusalem and impose Israeli law on the Palestinian population living there. While much of the international community condemned Israel's creeping annexation of Jerusalem and other areas of the occupied territories, the ICEJ applauded it. According to ICEJ founder Jan Willem van der Hoeven, for Israel to negotiate the future of the territories rather than annex them would be "a second betrayal of Jesus."[12]

Israeli liberals and their American allies found Van der Hoeven's comment strange and unsettling. It chastised Jews for betraying Jesus, and for considering betraying him again by relinquishing areas of the Land of Israel promised to them by God. The implication seemed to be that Jews could repent for their betrayal of Jesus by supporting Israel unconditionally.

In the late 1970s, those in favor of the annexation of the territories regularly turned to the memory of the Nazi Holocaust to justify their maximalist territorial ambitions. After Begin's rise to power, government and military spokesmen frequently wielded Holocaust rhetoric in both domestic and international forums. As we have seen, Labor governments had used this rhetoric as well—as in Abba Eban's 1969 comment about Auschwitz borders. But the parties of the Right indulged in Holocaust speech with alarming frequency. For America's Christian Right and the emerging American Jewish Right, the Israeli government's persistent claims that all threats to Israel were existential, and that the

Arabs were planning another Holocaust, proved highly effective in bolstering U.S. support for Israel.

Israeli Jewish Opposition to the Occupation

In the late 1970s Israeli intellectuals who were opposed to the Greater Israel movement and its call for annexation of the territories criticized the Israeli government's use of Holocaust analogies to justify its occupation of Arab lands. In their view, "Holocaust awareness was an official propagandistic indoctrination, a churning out of slogans and a false view of the world, the real aim of which is not at all an understanding of the past, but a manipulation of the present." The Israeli public intellectual Boaz Evron asserted that "the memory of the Nazi extermination served as a powerful tool in the hands of the Israeli leadership and that of the Jews abroad."[13]

Dissident Israeli intellectuals like Evron criticized the euphoria generated by the Israeli victory in the Six-Day War, a euphoria that had persisted for years. For these critics of the Israeli government, and for the Palestinian population in the territories, the outcome of the war was occupation, not liberation, and, in their eyes, Israel bore the blame for the constant state of siege imposed on the Palestinian population. Increasingly, these critics fulfilled the role of secular Jewish prophets; in the Hebrew Bible, one hallmark of a true prophet is his willingness to speak up against injustice—especially injustice committed by the state. Speaking of ancient Israel and its prophets, Abraham Joshua Heschel noted that "of paramount importance in the history of Israel was the freedom and independence enjoyed by the prophets, their ability to upbraid the kings and princes for their sins."[14]

Who were these modern secular prophets, and what did they foretell? The Hebrew University polymath Yeshayahu Leibowitz, a professor of biochemistry, neurophysiology, and philosophy of science, as well as a noted Israeli public intellectual, was one of the first to call for a pragmatic approach to the Palestinian issue after the Six-Day War—a call he uttered with increasing urgency six years later, after the Yom Kippur War. Initially, his warning that Israel's occupation of the territories would lead to disaster evoked much anger, before gaining some traction. As Leibowitz wrote in the late 1970s, "Today, after the 1973 war and the ensuing developments, including the peace with Egypt, many more people refer to those concerns, and many also remark that my fears are being justified."[15]

Leibowitz believed that the only way for the Jewish state to survive was to withdraw from the territories. Otherwise, Israel's occupation of the West Bank

and Gaza would make possible its self-destruction. It would "lead to the establishment of a political structure combining the horrors of Lebanon with those of Rhodesia—the state of a people possessing a common national heritage will turn into a system of imposed rule over two peoples, one ruling and the other ruled."[16] In addition, the occupation would dramatically worsen Jewish-Arab relations within Israel's borders, heightening the solidarity of the half-million Israeli-Arab citizens with the Palestinians in the occupied territories. "This will lead to a radical change in their state of mind," Leibowitz argued. "Inevitably, they will no longer regard themselves as Arab citizens of the state of Israel, but rather as members of a people exploited by that state. In such a situation, one must expect the constant incidence of terror and counterterror."[17]

Leibowitz spent decades opposing Israeli policy. He was particularly disconcerted when Prime Minister Begin appointed Ariel Sharon minister of defense in 1982. Leibowitz called on Israeli soldiers to refuse to serve in the forces that Sharon ordered to invade Lebanon in June that year, in what is known in Israel as the First Lebanon War. Ostensibly a defensive effort to push the forces of the Palestinian Liberation Organization north and away from the Israel-Lebanon border, the war resulted in an extended and costly conflict that led to an Israeli occupation of Southern Lebanon that lasted until 2000.

America's Jewish and Christian Zionists considered such criticism misguided at best, dismissing Leibowitz as an ivory-tower liberal with no political or military experience. Some—especially Orthodox Jews steeped in the messianic ideas of Gush Emunim, or "The Block of the Faithful," the Israeli activist movement that served as the ideological standard-bearer of the settler movement—were disturbed by the fact that Leibowitz himself was a committed Orthodox Jew and a teacher of Jewish philosophy. This, they believed, should have made him an unequivocal supporter of Greater Israel. Because Leibowitz was an Orthodox insider, his critique was all the more threatening. It challenged the religious nationalist view of Israel, which had messianic tendencies, while at the same time affirming the need for a strong Jewish state. As Leibowitz wrote, "It is a brute fact that the major portion of Jewish history has taken place in the absence of a Jewish state. I might add that it is possible to have a very highly refined Judaism outside of Israel. Still, I am a Zionist, which is to say that I do not wish to live a Jewish life within the framework of the Gentile world, subjected to its rule. I have had my fill of this rule. But important as the existence of the state is for me, I do not attribute to it any elements of sanctity and do not regard religion as functioning in its behalf, any more than I regard it as performing a function on behalf of the Jewish people."[18]

While his opinions were ridiculed and discounted in the United States, where the majority of Zionists did in fact attribute "elements of sanctity" to the Jewish state, Leibowitz remained a vibrant and provocative oppositional presence in Israel. "Early this year a ninety-year-old man was driving Israelis crazy," Avishai Margalit noted in the *New York Review of Books* in 1993, after the Israeli Ministry of Education announced plans to award Leibowitz the prestigious Israel Prize, the state's highest cultural honor.[19] The political Right was outraged, and a public furor ensued; in the end, Leibowitz declined to accept the prize. Vilified but uncowed, the nonagenarian scholar continued to warn of the consequences of Israeli rule over the Palestinian population of the West Bank and the Gaza Strip—a warning that remained mostly ignored or disparaged in the United States. For decades, the Anti-Defamation League kept files on Leibowitz and other Israeli critics of the occupation and worked to limit their ability to lecture in the United States. Members of the Israeli parliament were not immune from these attempts at censorship. When Knesset member Uri Avnery visited the United States in the 1970s, the ADL sent out a not-for-publication memo that described him as "an opponent of the traditional concepts of Zionism and Judaism. He may say things which will trouble and even embarrass the Jewish community."[20]

It was more difficult for American Jewish leaders to ignore similar warnings about the Occupation from Yehoshafat Harkabi, the former head of Israeli military intelligence. Harkabi's early books on the Arab-Israeli conflict, especially his 1972 work *Arab Attitudes to Israel*, were considered authoritative regarding Arab hostility to the Jewish state. The Israeli government as well as American Jewish publications often quoted Harkabi to justify Israeli control of the territories. To this day, any suggestion that Israel might bear some responsibility for its political-military situation is liable to prompt the rejoinder: "Haven't you read Harkabi's books? Don't you know that the Arabs hate Israel? There is nothing Israel can do but control them, and if necessary, fight them and defeat them."

But Harkabi's subsequent research, conducted in the 1970s and 1980s, led him to revise his central thesis. He believed that Arab attitudes had changed since the 1967 War. This shift in his thinking went unnoticed among American supporters of Israel. For Harkabi, Israel's 1982 Lebanon War was a disastrous turning point in Israeli history. "Israel has gained something from all of the wars that it initiated, except for the Lebanon War, which was a great disaster," he argued. "Its main damage wasn't in the number of killed and wounded—one surely wouldn't want to take lightly these great losses to the families and to the nation—but in its lasting negative effect on Israel's strategic situation."[21] From his position

as a professor of international relations at Hebrew University, Harkabi derided Israel's policies in the West Bank and Gaza, particularly the establishment of the settlements, which Harkabi concluded were "an obstacle to peace" and "a military liability, not an asset."[22]

Harkabi determined that self-criticism—not territorial expansion—was the key to Israel's political and military survival. The Jewish state needed to examine its actions with a cold, critical eye "to overcome a tendency to self-righteousness, a tendency which results from Jewish approaches to history, from our historical experience, and from the ethos of self-righteousness as promoted by Prime Minister Begin," he said. "There is no greater threat to our survival than this ethos of self-righteousness. It renders us blind and unable to understand our situation—and it gives legitimacy to bad national leadership."[23]

Harkabi came to believe that the onus was squarely on Israel to settle the conflict. His book *Israel's Fateful Hour* predicted the First Intifada, warning that anything short of Israel's total evacuation of the settlements and resolution of the refugee issue would create a permanent state of siege. In interviews on the arguments advanced in his book, Harkabi said, "Some of the settlers will exploit Palestinian hostility to them to bring into being a system of extreme repression," he wrote. "The greater the repression, the greater the Arab rebellion will be. . . . We won't be able to turn the Arabs' lives into hell without our own lives turning into hell. The harm to us will be both internal and external. The international community will condemn us."[24]

In an interview from his hospital bed during his final illness, Harkabi told a reporter that he feared that a rightist fanatic would assassinate then prime minister Yitzhak Rabin—Rabin had played a key role in the 1993 Oslo Accords, in which Israel and the PLO granted each other full recognition. If a compromise was achieved through negotiation, it would mean the end of the settlers' dream of permanent occupation of what they dubbed the liberated territories. Within a year of Harkabi's death in 1994, his prophecy was fulfilled; Rabin was murdered in November 1995 by Yigal Amir, a supporter of the settler movement.

Leibowitz died the same year as Harkabi. Toward the end of their lives, both men spoke in prophetic terms about Israel's bleak political-military future, and both proved to be accurate in their predictions that Israeli conduct as an occupying power would determine the state's future. In any other country and in any other context, that message might seem so obvious as not to require the services of a prophet. But in Israel—and, more pointedly, among American Jewish supporters of Israel—that simple message required a number of prophetic voices, all of which went unheeded.

Within the American Jewish community, criticism of the Begin government's expansionist policies was muted at best. One rare exception came from Rabbi Arthur Hertzberg, who in 1987 marked the twentieth anniversary of the Six-Day War with an article in the *New York Review of Books* titled "Israel: The Tragedy of Victory." Hertzberg noted that the emergence of the lobby group the American Israel Public Affairs Committee (AIPAC) had moved Jewish leaders—and Jewish causes, including Israel—into the mainstream of American politics. "The Jewish Lobby . . . has acquired a place among the forces with which even the most powerful American politicians must reckon," he wrote. But that influence came with responsibility, and Hertzberg was harshly critical of the chauvinistic tendencies that had emerged within American Judaism since 1967. "The American Jewish community cast itself very early for the role of chief priest of the temple of unqualified admiration of Israel," he wrote. "If Jews were now to be proud and unafraid everywhere, then Israel, which was the source of this pride, could not ever be seen as wrong. It was irrelevant that within Israel itself criticism had begun to rise as early as . . . three weeks after the end of the Six-Day War."[25]

I would amend Hertzberg's observation to say that in the United States, Israel's self-criticism was soon thought of as worse than irrelevant. American Jewish organizations deemed such criticism dangerous and defeatist and sought to quash it.

On the broader world stage, however, organizations like AIPAC were not yet a major force. Liberals in Western Europe and the United States were beginning to see Israel as heir of European colonialism. Liberal American Protestant church denominations, in contrast to the Evangelical churches, distanced themselves from Zionism during this period, as their perception of Israel shifted from David to Goliath, from a state of victims to a state of victimizers. For many liberals, the Palestinians living under Israeli rule now assumed the role of David, garnering considerable international sympathy and support.

Cracks in American Public Opinion

In September 1978, several months after *The Stars Salute Israel at 30* anniversary celebration on American television, Israel was again at the forefront of American public attention during the dramatic negotiations at Camp David. At President Jimmy Carter's urging, Israeli prime minister Menachem Begin and Egyptian president Anwar Sadat, each accompanied by military and political aides, spent close to two weeks at the American presidential retreat, engaged in talks to try to bridge the gap between them.[26] One popular American view of the negotiations,

and of the treaty that followed, was that the parties were representing their respective religious traditions. In the words of the journalist Lawrence Wright, "Three men, representing three religions, met for thirteen days at the presidential retreat of Camp David in the autumn of 1978 in order to solve a dispute that religion itself had largely caused."[27] While a religiously inflected view of Middle Eastern politics is now common, the signatories themselves might have questioned Wright's assertion. Religion, per se, had very little to do with these negotiations.

Following the framework agreed to in the Camp David Accords of September 1978, Begin and Sadat signed the Egypt-Israel Peace Treaty in a moving, much-photographed White House ceremony on March 26, 1979. The image of former enemies shaking hands at the urging of the U.S. president became part of America's proud collective memory. But it set up towering expectations for future Arab-Israeli peacemaking negotiations, none of which would be successful.

Three years after the Camp David Accords, Israel returned to U.S. headlines during the Iran-Iraq War. The war broke out in the fall of 1980 in the wake of the Iranian Revolution, and by the summer of 1981, Iraq and the Islamic Republic of Iran were deeply embroiled in an intense military conflict that would last nearly a decade and claim over a million victims. Behind the scenes, Israel sided with Iran. The two countries had maintained a close political, military, and commercial relationship during the reign of the shah. Following the 1979 Iranian Revolution, Israel and Iran, despite the harsh anti-Israel rhetoric of the Iranian regime, remained connected in two important ways: they shared a mutual enmity toward Iraq and its leader Saddam Hussein, and Israel continued to supply Iran with military equipment. As far as Israel was concerned, Saddam Hussein represented the greater danger.[28]

Soon after the Iran-Iraq war began, the Iranian air force bombed Iraq's Osirak nuclear reactor, some forty miles north of Baghdad. The attack damaged the control room but not the reactor itself. Fearing Iraq's nuclear capabilities, Israel, in June 1981, sent fighter jets to destroy the reactor, finishing the job that the Iranians had attempted the previous year. Announcing the raid, Prime Minister Begin described the action as a "morally supreme act of national self-defense." He claimed that Iraq was building bombs with Israeli targets in mind, and once again invoked the Holocaust. "There won't be another Holocaust in history," he said. "Never again, never again."[29]

Initially, the newly elected U.S. president Ronald Reagan was angered by the Israeli air strike. Israel had not notified the United States of its plan to attack. The State Department had been trying to cultivate Iraq as a strategic ally in the

region in order to oppose revolutionary Iran, and U.S. officials feared that the strike had weakened Iraq. Ten days later, however, Reagan moderated his view of the bombing. "In view of the past history of Iraq, which has never signed a cease-fire or recognized Israel as a nation," Reagan said that Israel had reason for concern about Iraq's nuclear capabilities.[30]

Begin himself made the case directly to the American people. In a letter published in major newspapers across the United States, the Israeli prime minister explained Israel's decision to destroy Osirak, appealing broadly to Americans' religious identities; indeed, the letter was addressed to "my American friends, Christians and Jews."[31] According to one widely disseminated account, Begin told Jerry Falwell about the successful strike on Osirak before he informed the U.S. president. Though that story proved to be false, the fact that it persists to this day demonstrates the perception that, as early as 1981, there were powerful ties between the Israeli prime minister and the American Evangelical leadership. In subsequent decades, those ties between Israeli politicians and American Evangelical pastors would grow much stronger.

The American Evangelical leadership also had strong ties to President Reagan. In fact, Jerry Falwell may have influenced Reagan's positive response to the unannounced Israeli attack. In a conversation with the newly elected president, the leader of the Moral Majority, an organization that had mobilized Evangelicals nationwide to support Reagan in the 1980 election, pointed out that "God's attitude towards the nations is dictated by the nations' attitude toward Israel."[32] After the Osirak airstrike, Falwell praised Israel for destroying the nuclear reactor; he was also involved in the ongoing Israeli *hasbara* or propaganda effort to justify the bombing to an American audience, encouraging viewers to phone and write the White House to express their support for Israel. Long before his conversation with Falwell, Reagan was predisposed to support Israel; raised in the Restorationist-minded Disciples of Christ Church, he was religiously attached to the Return to Zion concept and "revered the Jewish state," as the historian Michael Oren has noted.[33]

These American views, however, were out of step with global opinion. The Israeli airstrike received widespread condemnation in the UN and other international forums. Even in U.S. political circles, concerns about Israel's cavalier belligerence were growing. In the U.S. Senate, John Glenn of Ohio led the criticism of the Israeli bombing. An advocate for nuclear nonproliferation safeguards, he remarked that the Israeli attack was "the first gigantic vote of no confidence in the international non-proliferation regime" and in the International Atomic Energy Agency.[34]

For America's Evangelicals and for Orthodox Jews, Jerusalem was at the center of the American conversation about the Jewish state, while American liberals were more interested in Tel Aviv, Israel's largest city and the center of its political, military, and cultural life. Visiting American Evangelicals saw secular Tel Aviv as a modern Sodom and Gomorrah, and they tended to avoid it in favor of the sacred places in Jerusalem and Christian holy sites in the Galilee. Their preference for the Holy City over the "first Jewish city," as Tel Aviv was dubbed at its founding in 1909, aligned America's religious conservatives with Israel's Orthodox Jews and came to be a powerful factor in the developing alliance between the Christian Right and the Jewish settler movement. These two groups found common ground in rejecting the secular and invoking the sacred, bound by a yearning for Zion, as Jerusalem is called in the Psalms. For Christians, Jerusalem was "The City of the Great King," Jesus. For religious Jews, it was the home of the two temples of the past and of the hoped-for third temple of the future.

A year after the Osirak strike, this burgeoning alliance got a boost when Israel embarked on another—and larger—military adventure: the invasion of Lebanon.[35] The immediate trigger for the war was an attempt by Palestinian militants to assassinate the Israeli ambassador in London, but tensions had been building for a decade. Beginning in the early 1970s, growing numbers of Palestinians had settled in southern Lebanon, where guerrillas engaged in constant low-level warfare with Israeli troops across the border. In June 1982, the Israeli army invaded Lebanon.

As with the Osirak bombing, the initial American diplomatic response to the Israeli action was negative, while the Christian Right approved of the invasion. Israel had allied itself with Lebanon's Christian Phalangist forces, led by the Gemayel family, which allowed conservative American Evangelicals to portray the conflict as a battle of Jews and Christians allied against Muslims. This dichotomy, between an imagined Judeo-Christian alliance fighting an alien, pagan Islam, had deep roots in conservative Evangelical thought. In the 1990s this hostility to Islam would become an influential force in American politics. And after the 9/11 attacks, that hostility registered as the "new normal."

In the aftermath of the First Lebanon War, Falwell and other American Evangelical leaders used their influence to raise money for Israeli causes and charities, particularly for Jewish settlements in the West Bank and Gaza. In addition, Falwell, Pat Robertson, and other Evangelical pastors organized international tours of Christian holy sites that included large groups—sometimes numbering in the hundreds—of church members, handlers, and supporters. In contrast to the Israel tours arranged by European Christians and American Catholics,

these American pilgrimages rejected the sites sacred to the Catholic and Eastern Orthodox traditions, focusing instead on open-air sites associated with the life of Jesus—much as the visitors to the 1904 World's Fourth Sunday-School Convention, examined in chapter 1, did. In Jerusalem, for example, the Garden Tomb associated with the Protestant traditions emerged as a favorite stop for visiting American Evangelicals of the 1970s, 1980s, and 1990s. These pilgrims steered clear of the Church of the Holy Sepulchre, which was associated with the Catholic and Eastern Orthodox churches.

Jerusalem Syndrome and Its American Consequences

Not all "Jesus tourism" to Israel was a group endeavor. Many American Christian pilgrims visited Israel on their own. Once on the ground in Zion, some individuals developed a puzzling, but well-documented psychiatric condition known as "Jerusalem syndrome," in which the visitor imagines that they receive instructions from God and assume the role of the Messiah. The syndrome grew common enough that a Jerusalem psychiatric hospital, Misgav Ladach, dedicated itself to the short-term care of those most acutely afflicted with its symptoms.[36] But for the most part, the stricken burdened only their families and friends with their delusions, and their cases generally resolved themselves. However, one American who heard God's voice in Jerusalem carried the message back to the United States, ultimately with tragic consequences.

Vernon Wayne Howell—a Texan who had been brought up in a splinter group of the Seventh Day Adventist Church—was twenty-six when he visited Jerusalem in 1985. He had spent the previous four years living in a commune in Waco, Texas, with a group that called themselves the Branch Davidians, after biblical verses in Jeremiah and Romans. Arriving in Jerusalem with his pregnant wife, Rachel, Howell claimed that while in the city he had received a revelation from God telling him that he was the Messiah, and that in the Final Days he would lead his community to the Holy Land. Upon his return to Waco, he adopted a new name: David, after the biblical king who served as the prototype and ancestor of the Messiah, and Koresh, the Hebrew form of the name Cyrus, after the Persian king extolled in the Bible as the Messiah for bringing the Jews back to Jerusalem from exile in Babylonia. David Koresh, rather than Vernon Wayne Howell, seemed to be an appropriate name for the new Messiah, who would lead his followers from Texas to the Holy Land and, in the process, bring about the redemption of the world.[37]

The seeds of David Koresh's messianic and end-time ideas and his connection to modern Israel lay in the history of the Branch Davidians and their early doctrine. In 1955 Florence Houteff, the wife of the founder of the sect and a prophetess of dissident Adventists, told her Branch Davidian followers that the establishment of the Jewish state, in existence then for seven years, was a harbinger of the end time; Armageddon was coming. She traveled to Israel in 1958 to "prepare the way" for the redemption of the Davidians. Houteff prophesied that the final battle would take place in the Holy Land in 1959 and the Davidians would then be called by God to move from Texas to Israel to set up the new Kingdom of David. When 1959 came and went, Houteff was forced to admit that her prophecy had been wrong, and many of her followers abandoned the sect. Only a handful of the faithful remained, but the link to Israel had been firmly established.

In 1989, four years after his return from Jerusalem, Koresh became the head of the Branch Davidian community at the Mount Carmel Center. Under his leadership, the population at the Waco compound grew to almost 150 people. Through the early 1990s, the community weathered accusations of child abuse, sexual abuse, and illegal gun possession. Koresh, like Houteff, told his followers that the events of the end time and the Battle of Armageddon were imminent. In February 1993, seemingly in fulfillment of Koresh's prophecy, agents from the Bureau of Alcohol, Tobacco, and Firearms attempted to raid the compound; several federal agents as well as several Davidians were killed in the confrontation. The fifty-one-day standoff that followed culminated in an FBI assault in March that left most of the Davidians, including David Koresh, dead. Despite evidence that some of the Davidian deaths were self-inflicted, the incident has remained controversial, with many of the circumstances of the assault still disputed.

David Koresh's case of Jerusalem syndrome was, of course, among the most extreme. But in a number of ways, Koresh and Waco are emblematic of the power of end-time ideas in American culture, and they remind us of the centrality of Israel in the apocalyptic imagination of American extremists.

Another somewhat earlier American religious fanatic, Jim Jones of the Peoples Temple, was also influenced by end-time ideas associated with Jewish and modern Israeli history. Preaching to the hundreds of inhabitants of his compound in Guyana, Jones frequently invoked the story of Masada in which the defenders of that stronghold in the Judean desert chose to commit suicide rather than submit to defeat at the hands of the Romans. Similarly, Jones implied, the members of the Peoples Temple, under siege in their jungle, should kill themselves rather

than submit to U.S. authorities. And when, in November 1978, Jones and his followers did kill themselves, they were inspired by the Masada story to kill their children first.[38]

Political extremism linked to messianic expectations was but one of the ways Israel was linked to the United States; popular fiction and journalism joined American and Israeli cultures, too. And in the mid-1980s, several Israel-related or Israel-inspired books dominated the best-seller lists.

Israel on America's Best-Seller List

THE HAJ (1984)

In the prelude to Leon Uris's best-selling novel, *The Haj*, which opens in 1922 in an Arab village in Palestine, a local sheikh tells his son Ibrahim that a dagger, though small, is "the way by which we rule our people, who know the meaning of the dagger and the courage of the man who can drive it to the hilt."[39] As he grows to adulthood, Ibrahim sees the wisdom of his father's words. Though only in his mid-twenties, he wins the struggle to lead his village because he understands "the power of the dagger" in Arab life. The novel's message is clear: Arabs, especially the Arabs of Palestine, are inherently violent; they are brought up to use violence as a political tool.

Uris's prelude sets the tone for the long novel to follow. *The Haj* is the 1984 sequel to Uris's best-selling 1958 novel, *Exodus*, discussed in chapter 4. At the beginning of the novel, Ishmael, the narrator, explains his intimate knowledge of the events about to unfold: "How could I know of these? Do not forget, my esteemed reader, that we Arabs are unusually gifted in matters of fantasy and magic. Did we not give the world *A Thousand and One Nights*?"[40] Uris suggests that the *Arabian Nights*, though written in the fourteenth century, is a useful guide to Arab life in the mid-twentieth century. Thus, before the reader reaches page three, she is told two things: that violence is the key to understanding Arab life, and that Arabs, gifted in fantasy and magic, are inherently unreliable.

In Uris's fiction, all Arabs share this predilection for violence and treachery. Jews, by contrast, are depicted as noble and rational, always seeking reconciliation and peace. For example, the fictional Zionist pioneer leader Gideon Asch is "a man of fifty-three who still had the stamina to go tracking in the wilds with the youngest, hardiest soldiers of the Jews." Uris presents Asch as a character imbued with fundamental human goodness, a man who has made an honest attempt to understand and live with Arabs, only to acknowledge the futility of

his efforts. He had, the reader is told, "walked a lifetime through the labyrinth of the Arab mind, seeking accommodation, friendship, and peace. It had all eluded him." Ultimately, Asch realizes that, unpalatable as it may be, the only way to deal with the Arabs is through force: "The illusion of brotherhood with the Arabs was also overtaken by the reality that if the dream of Zion were to come to pass, the Jews must go on an offensive repugnant to their souls."[41]

This idea—that the Arabs were putting peace-loving Jews in an untenable position by leaving them no option but to fight—resonated with many readers. Israeli leaders had propagated the same self-righteous narrative for years; as Golda Meir allegedly said in the 1960s, "What we hold against [the Egyptian leader Gamal Abdel] Nasser is not only the killing of our sons but forcing them for the sake of Israel's survival to kill others."[42]

The anti-Arab message of *The Haj* was especially resonant among American Evangelical Christians, whose hostility to Islam, according to the historian Thomas Kidd, "derives from a long historical tradition." American Protestant aversion to Islam predates the American Revolution and, according to Kidd, is grounded in two key elements: the rarely successful missionary effort to bring Muslims to Christianity, and long-held British and American speculation about the end time that portrays Islam as the Antichrist. Referring to the ideas of the theologian Jonathan Edwards and other influential American thinkers of the eighteenth century, Kidd notes: "There was a time in America . . . when such (negative) ideas about Islam would not have generated any outrage, for they reflected commonly held interpretations."[43] This long tradition of American Evangelical Christian antipathy toward Islam translated, in the context of the America-Israel relationship, into steadfast support for the Israeli government's anti-Arab policies, including the construction of settlements in the territories.

FROM TIME IMMEMORIAL (1984)

The Haj was an international best seller; its negative descriptions of fictitious Arabs resonated strongly with Western readers eager to have their prejudices about Islam confirmed. The novel's nonfiction counterpart, published the same year, proved to be an even more potent cultural weapon in the pro-Israel arsenal. *From Time Immemorial: The Origins of the Arab-Jewish Conflict over Palestine*, written by the journalist Joan Peters, claimed to be a historical work and seemed at first glance to be well-documented.

The book, however, was in fact a polemic against the Palestinians, whose cause had gained considerable international support during the preceding decade. Rather than attack their rationale or methods, *From Time Immemorial* simply

denied the existence of a Palestinian people. According to Joan Peters, the Arabs of British Mandate Palestine had settled there recently, after migrating across the porous borders of pre-state Israel. They migrated to Palestine because the Jewish colonists—as they made the desert bloom—had provided jobs and other economic opportunities. Thus, Palestinian claims against the Israelis not only lacked historical justification, but they also demonstrated a callous ingratitude. In Peters's formulation, the Israelis were in fact the Arabs' benefactors, not their dispossessors or antagonists.

For Peters, the Arabs displaced during the establishment of the State of Israel in 1948 were only part of the story. As she wrote, "Also around 1948, whole Jewish populations from numerous Arab countries had been forced to flee as refugees to Israel."[44] Peters considered these displacements as roughly equivalent, arguing that the Jewish refugees—"the unacknowledged 'other' refugees: the Arab-born Jews who are the mass of Israel's 'Sephardic' majority"—had been overlooked or ignored.[45]

In the United States, *From Time Immemorial* garnered lavish praise in both large circulation dailies and prestigious academic journals. The novelist Saul Bellow could barely contain his enthusiasm for the book's attack on Middle East experts who supported Palestinian claims. "The great merit of this book is to demonstrate that, on the Palestinian issue, the experts speak from utter ignorance," he wrote. "Millions of people the world over, smothered by false history and propaganda, will be grateful for this account of the origins of the Palestinians."[46] The historian Barbara Tuchman was even more fulsome in her praise: "This book is an historical event in itself, a discovery that has lain in the dark all along, until its revelation by Joan Peters's unrelenting research. It could well change the course of events in the Middle East."[47]

Not all American critics agreed. In 1988 Edward Said and Christopher Hitchens published the edited volume *Blaming the Victims: Spurious Scholarship and the Palestinian Question,* which included two essays attacking Peters, one by Said and one by the American political scientist Norman Finkelstein. Finkelstein caustically ranked Peters's book "among the most spectacular frauds ever published on the Arab-Israeli conflict. In a field littered with crass propaganda, forgeries, and fakes, this is no mean distinction."[48]

But the harshest reviews came from outside of the United States and the harshest review of all from Israel. British newspapers and scholarly journals refuted many of Peters's spurious claims. Writing in the *Observer,* the British Middle East historian Albert Hourani of Oxford University described the book and its arguments as "ludicrous and worthless."[49] One of the most devastating

critiques came from the pen of the well-respected Israeli historian Yehoshua Porath in the pages of the *New York Review of Books*: "Much of Mrs. Peters's book argues that at the same time that Jewish immigration to Palestine was rising, Arab immigration to the parts of Palestine where Jews had settled also increased. Therefore, in her view, the Arab claim that an indigenous Arab population was displaced by Jewish immigrants must be false, since many Arabs only arrived with the Jews. The precise demographic history of modern Palestine cannot be summed up briefly, but its main features are clear enough and they are very different from the fanciful description Mrs. Peters gives." Porath went on to note that, despite the display of hundreds of footnotes, "Mrs. Peters's use of sources is very selective and tendentious, to say the least."[50]

It is worth noting that Peters drew to some extent—as numerous pro-Israel advocates before and since have—on Mark Twain's description of mid-nineteenth-century Palestine to support her argument. Toward the middle of her book, she trots out Twain's familiar 1867 description of the Jezreel Valley: "There is not a solitary village throughout its whole extent—not for thirty miles in either direction. There are two or three small clusters of Bedouin tents, but not a simple permanent habitation. One may ride ten miles hereabouts and not see ten human beings."[51]

Israeli politicians and diplomats often quoted Mark Twain's descriptions of the dismal state of nineteenth-century Palestine to support Israeli claims to the land. As I noted in chapter 1, Israeli prime minister Yitzhak Shamir, at the 1991 Madrid Peace Conference, cited Twain's comments in his argument against Palestinian claims.

THE COUNTERLIFE (1986)

Two years after the publication of *The Haj* and *From Time Immemorial*, another American best seller examined Israeli politics with an uncharacteristically critical eye, reflecting an emerging chorus of U.S. voices alarmed by Israel's occupation of the territories. Philip Roth's 1986 novel, *The Counterlife*, centers on the relationship between the novelist Nathan Zuckerman and his brother, Henry, who in one possible outcome of the story has left his life as a successful dentist in suburban New Jersey to live on a religious Zionist settlement in the West Bank. Responding to his brother's arguments for jettisoning the American dream in order to fulfill the Zionist dream, Nathan says: "Your connection to Zionism seems to me to have little to do with feeling more profoundly Jewish or finding yourself endangered, enraged, or psychologically straitjacketed by anti-Semitism in New Jersey—which doesn't make the enterprise any less 'authentic.' It makes

it absolutely classical. Zionism, as I understand it, originated not only in the deep Jewish dream of escaping the danger of insularity and the cruelties of social injustice and persecution but out of a highly conscious desire to be divested of virtually everything that had come to seem, to the Zionists as much as to the Christian Europeans, distinctively Jewish behavior—to reverse the very form of Jewish existence."[52]

Nathan describes this attempt to overturn and redefine Jewish life in the West as a utopian effort to construct a "counterlife," one that would "reverse and negate the burdens of the 'old life,' one in which Jews were perennial victims." As Nathan notes, this unlikely idea has had many champions in the Christian West and many enemies in the Arab East: "The construction of a counterlife that is one's own anti-myth was at its very core. It was a species of fabulous utopianism, a manifesto for human transformation as extreme—and, at the outset, as implausible—as any ever conceived. A Jew could be a new person if he wanted to. In the early days of the state the idea appealed to almost everyone except the Arabs. All over the world people were rooting for the Jews to go ahead and un-Jew themselves in their own little homeland. I think that's why the place was once universally so popular—no more Jewy Jews, great!"[53] Roth's insights about the popularity of Israel in the United States of the 1980s are trenchant and scathing. The possibility of transforming the Jews, of "un-Jewing" them and making them Israelis, appealed to many Jews, and to Christians uncomfortable with "Jewy" Jews.

Roth is most biting when describing the emotional reactions of American Jewish tourists to Israel and its military ethos. In Israel, Nathan Zuckerman seeks out his old friend Shuki, whom Zuckerman had met twenty years earlier on his first trip to Israel, to help him locate his brother. When Nathan mentions his brother's pistol, Shuki sarcastically says that Henry must find carrying a weapon very romantic. "The American Jews get a big thrill from the guns," Shuki says. "They see Jews walking around with guns and they think they're in paradise. Reasonable people with a civilized repugnance for violence and blood, they come on tour from America, and they see the guns and they see the beards, and they take leave of their senses. . . . Jews ignorant of history, Hebrew, Bible, ignorant of Islam and the Middle East, they see the guns and they see the beards, and out of them flows every sentimental emotion that wish fulfillment can produce."[54]

Roth's mid-1980s novel about Israel and its role in the American imagination was both a vivid depiction of that role and a sign of an emerging American critique of Israeli policies.

AS MAINLINE AMERICAN Protestant churches grew more critical of Israeli policies, Evangelicals reacted by deepening their support of those policies. So, too, did the Mormons, who were, in fact, the first American Christian Zionists; they had visited the Holy Land and supported Jewish return long before Evangelicals took up the Zionist cause. As seen in chapter 1, the founder and prophet Joseph Smith sent a disciple, Orson Hyde, on a pilgrimage to Jerusalem in 1841, with the express purpose of blessing the city and praying for the restoration of the Jews to Palestine.[55] One hundred and forty years later, in the mid-1980s, Brigham Young University (BYU) built a satellite campus on the Mount of Olives in East Jerusalem. Despite resistance from some Jews who were concerned that the center would become a base for Mormon proselytizing, the BYU Jerusalem Center for Middle East Studies opened to students in May 1988. In late 1992, the Mormon Tabernacle Choir embarked on its first tour of Israel, performing in Jerusalem, Haifa, and Tel Aviv. The choir released a recording, *Live in Jerusalem*, in 1994. The album, which included versions of "Hatikva," "Jerusalem of Gold," and other popular Israeli songs, was a great success in both Israel and the United States.[56]

American Jewish organizations also doubled down on their support of Israel, often expressing their pro-Israel sentiments through cultural performances, film screenings, and readings. The film *Exodus* was shown to generations of schoolchildren and young adults in schools, synagogues, and summer camps. And the musical *Milk and Honey*, a Broadway hit of the 1961–62 season about a group of American widows hoping to find husbands on a bus trip in Israel, was revived off-Broadway in 1994. The State of Israel had changed radically in the three decades between the first production of that musical and its revival, but for the audiences who flocked to the 1994 performances, time stood still; Israel was still the brave, beleaguered state that had made the desert bloom. They had little idea that Israel in 1994 was a deeply troubled society in which Jews and Arabs were more bitterly divided than ever before, and that divisions within the Israeli Jewish public would within a year lead to the assassination of Prime Minister Rabin.

Responding to the First Intifada

While revivals of these Israel-advocacy classics flourished, others in the American creative class were joining Philip Roth and turning more critical of Israeli society. They had good reason to be critical. In December 1987, twenty years after the Israeli conquest of the West Bank, the First Intifada—Arabic for shaking-off or insurrection—broke out in Gaza and the West Bank. At the time, a quarter

of a million Palestinians lived in Gaza and another 350,000 lived in the West Bank. Many of these people were refugees from either the 1948 War or the 1967 War; some were refugees from both wars. A generation of Palestinians had been exiled from Israel to the Kingdom of Jordan in 1948; then nineteen years later, when Israel occupied the West Bank, they or their descendants were exiled again.

For both the Israelis and the Palestinians, the intensity of the rebellion was shocking. What started as a local incident—a car accident in which an Israeli military vehicle collided with a civilian vehicle, killing four Palestinian men— spread within a few days to most of the cities, towns, and refugee camps under Israeli military control. The Israeli army, the occupying force in the territories, was now under attack—not by foreign armies, as in previous conflicts, but by a civilian population intent on defying military control of the area.

In response, the Israeli army deployed some eighty thousand troops to the territories. Some fifteen hundred Palestinians were killed and thousands more wounded over the course of the uprising. More than one hundred and fifty Israeli Jews died in the ensuing violence. The rebellion, and the harsh Israeli response to it, radicalized many of the Arab citizens of Israel—the so-called 1948 Arabs who had remained in the new State of Israel. Many of these Arab citizens came to identify politically with the Palestinians in the territories, creating an internal problem for Israeli authorities. Externally, the UN General Assembly condemned Israel for its response to the intifada, with the majority of member states supporting the Palestinians. But the United States blocked several Security Council resolutions that would have held Israel accountable for its actions during the rebellion.

Among those in the American creative class who spoke out against the Israeli response to the intifada was the comedian and filmmaker Woody Allen, who in 1988 published an op-ed in the *New York Times* titled, "Am I Reading the Papers Correctly?" Allen described Israel's actions toward the Palestinians as "painful and confusing," arguing that "a stand must be taken." Though he was careful to precede his criticism of Israeli policy with a token of support for the Jewish state, Allen's anger and indignation were palpable: "As a supporter of Israel, and as one who has always been outraged at the horrors inflicted on this little nation by hostile neighbors and much of the world at large, I am appalled beyond measure by the treatment of the rioting Palestinians by the Jews."[57]

The harsh Israeli response that made Allen so incensed was perhaps best articulated by Yitzhak Rabin, defense minister at the time. In what became known as Rabin's break-their-bones policy, the defense minister instructed Israeli troops to "start using your hands, or clubs, and simply beat the demonstrators in order

to restore order." A high-ranking Israeli officer in the West Bank ordered soldiers to "break the arms and legs" of Palestinians "because the detention camps are full." His reasoning was that handicapping demonstrators would take them out of action without necessitating arresting and imprisoning them.[58] It was the sort of punishing logic that Meyer Lansky's Murder Incorporated colleagues, for one, would have understood.

In his op-ed, Allen attacked this policy head on. "I mean, fellas, are you kidding? Beatings of people by soldiers to make examples of them? Breaking the hands of men and women so they can't throw stones? . . . Are we talking about state sanctioned brutality and even torture?," he wrote. It is worth noting that Allen's concerns focused on Israel's future: "Perhaps for all of us who are rooting for Israel to continue to exist and prosper, the obligation is to speak out and use every method of pressure—moral, financial, and political—to bring this wrongheaded approach to a halt."[59]

Woody Allen's op-ed, qualified as it was, generated fury in the American Jewish establishment. As it had appeared in the pages of the prestigious *New York Times*, many self-appointed defenders of Israel wrote irate letters to the newspaper's editor. Some of these letters were published; many were not. And American Jewish organizations, both privately and publicly, objected vociferously to Allen's suggestion that methods of pressure be used to try to change Israeli policies.

A Second White House Ceremony

Many Americans looked back on the 1978 Camp David peace accords with pride and nostalgia. The image of Jimmy Carter with Sadat and Begin on the White House lawn was forever instilled in the collective memory of the American public. When elected president nearly fifteen years later, Bill Clinton sought to replicate that historic encounter. In September 1993, Clinton invited Israeli prime minister Yitzhak Rabin and Palestinian Liberation Organization chairman Yasser Arafat to Washington for the signing of the first of the Oslo Accords, an agreement that established an initial framework for future negotiations the parties hoped would lead to the resolution of the Palestinian conflict.

The public ceremony at the White House produced a highly telegenic, much-praised Rabin-Arafat handshake, but it did not bring about the cessation of hostilities the way the Israel-Egypt accords did. Sadat and Begin had negotiated face-to-face at Camp David; Rabin and Arafat exchanged letters through a series of secret negotiations in Oslo, Norway. At the conclusion of the process, the Palestinians recognized "Israel's right to exist in peace and security," and Israel

recognized the Palestinian Liberation Organization as "the representative of the Palestinian people." The agreement marked a sharp departure from the Camp David Accords, which had deliberately avoided the Palestinian issue. Though the Oslo Accords of 1993 confronted that issue, they did not succeed in implementing a viable solution. And in 1995, the assassination of Israeli prime minister Yitzhak Rabin destroyed any possibility of reconciliation.

The unraveling of the Oslo Accords—under the stress of Palestinian suicide bombings in Israel and further Israeli entrenchment in the West Bank and Gaza—would lead in just a few years to the Second Intifada, which erupted in 2000.

The election of Benjamin Netanyahu in 1996 put great strains on the Israeli-American relationship at the governmental level. President Clinton, who favored the candidacy of Shimon Peres, had done everything possible to prevent Netanyahu's election but it was to no avail.

Within Israel, members of the "peace camp" mourned Rabin's death and feared that Netanyahu's electoral victory signaled the end of any possibility of territorial compromise. Novelist and political activist David Grossman expressed their trepidation in an open letter to the prime minister. Would the Israeli government, he asked, recognize that the Palestinians live in a situation that generates frustration and rage, or would it deny that reality and offer only cosmetic half-solutions?

Israeli voters had brought to power a politician who was as much an American as he was an Israeli. Though born in Israel, "Bibi" Netanyahu was educated in U.S. schools and shaped by decades of American life. Netanyahu delighted in telling audiences that he had been the debate team champion at his American high school, where he won thirty debate contests. And until 1982, when Netanyahu became an Israeli diplomat, he held on to his American citizenship. A very persuasive public speaker, Bibi wielded idiomatic American English and idiomatic Sabra Hebrew with equal facility. In 1996 no political pundit foresaw that Bibi's Israeli-American synthesis would shape the next two decades of politics in both Israel and the United States.

Cross-Cultural Admiration and Upheaval

Three Divas and Bitter Critiques (1997–2017)

WHEN MADONNA FIRST VISITED Israel in 1993 on The Girlie Show World Tour, she performed at a sold-out concert in Tel Aviv, where the public and the press warmly received her. At the time, she expressed no special enthusiasm for Israel or Israelis; her fans were her fans, wherever they were, and Tel Aviv was but one stop on her months-long world tour. Such was the case for many American performers during the early to mid-1990s, including Michael Jackson and Stevie Wonder, who gave sold-out concerts in Israel in the mid-1990s. Much of the excitement in that period was due to Israel's signing of a historic peace treaty with Jordan a year after the first of the Oslo Accords with the Palestinians. This October 1994 agreement vastly improved the region's prospects for peace, and diminished perceptions—prevalent since the outbreak of the First Intifada—that Israel was a dangerous place to visit. With this change in outlook, American pop stars began to add the Jewish state to their tour itineraries. The rapid Americanization of Israeli culture had created a devoted fan base for American musical artists, and promoters in both countries saw an opportunity to capitalize on this audience by scheduling performances in Israel. But no American superstars better embodied the intimacy of U.S.-Israel relations during the 1990s than a trio of America's most gifted, beloved divas: Whitney Houston, Barbra Streisand, and Madonna. Wittingly or not, these three American musical icons transmitted their enthusiastic support of Israel to millions of their fans in the United States and around the world. Regardless of their motivations or allegiances, all three women had the good fortune to engage with Israel during the peace bubble of the early 1990s—a bubble that would eventually burst.

Madonna in Israel

In Israel, the highly charged relationship between religion and secularism is often mediated in unexpected ways. Within Israel's Jewish communities, which represent 75 percent of the country's population, it is often the actions of outsiders, not of insiders, that illuminate the religious-secular divide most clearly. Israeli Jew's reactions to Madonna serve as an unlikely guide to this thorny division.

Madonna's first trip to Israel in the early 1990s, while successful, didn't visibly change or affect her. It was only after she became a student of Kabbalah in the mid-1990s that her attachment to Israel started to flourish. By the time Madonna returned to Israel in 2004, she had adopted the Kabbalah name Esther.[1] Some of the more religiously literate of her fans explained the name as a "manifestation of the divine *shekhinah*," which in Kabbalah denotes the feminine aspect of God's presence. Madonna claimed to have studied all the women of the Old Testament but was most drawn to Esther because she saved the Jews of Persia from annihilation. Despite the excitement her visit generated, Madonna was not in Israel to perform; she was instead part of a pilgrimage organized by the Kabbalah Centre of Los Angeles. The trip was led by Rabbi Michael Berg, whose father, Philip—a former insurance salesman who first encountered Kabbalah on a trip to Israel—had founded the Kabbalah Centre in the 1960s. The group included some two thousand pilgrims, in addition to Madonna and her husband at the time, the British filmmaker Guy Ritchie.

Not surprisingly, Madonna's visit to Israel received an overwhelming amount of media and government attention, and that attention resulted in unforeseen diplomatic consequences. Angered by her enthusiastic support for Israel, members of the Egyptian parliament banned Madonna from their country, instructing their embassies to deny her a visa if she tried to visit Egypt.[2] She had not announced plans to visit Egypt and did not request a visa to do so, but it seems that Egyptian politicians needed to make the point that she was not welcome.

The *Jerusalem Post* responded to Madonna's visit with an editorial titled "Welcome, Esther." After noting that, despite her adopted name, the singer had not converted to Judaism, the editorial went on to acknowledge the tremendous impact of her visit. "At a time when anti-Semitism and anti-Zionism are rampant, she is an open philo-Semite who has done more than many Jews, let alone Jewish entertainers, have done: visited Israel," it read. The *Post*'s editorial writers could not resist using Madonna's visit to attack other performers—most prominently, Roger Waters of Pink Floyd—who had supported calls for a boycott of Israel over the building of the West Bank separation barrier in the wake of the

Second Intifada. "If Madonna were simply mindlessly joining the legions of the politically correct, she might have carefully parceled her time between Tel Aviv and Ramallah, or lent her name to common anti-Israel causes, such as opposition to our security fence," the editorial continued. "Instead, she has come to Israel on a spiritual quest." It concluded by giving Madonna and her embrace of Kabbalah the benefit of the doubt: "Perhaps Madonna will lead some Jews and others astray and give a rich and sophisticated branch of Judaism a bad name. Perhaps, however, some of the many Jews and others who seek spirituality and community in other quarters, such as Eastern religions, will be inspired to explore what Judaism has to offer."[3]

Madonna's public embrace of California-style Kabbalah did not appeal to all Israelis, and it left many rolling their eyes. Traditional Jews wondered what these ideas had to do with the actual Jewish mystical tradition. The Hebrew University professor Joseph Dan, a scholar of Jewish mysticism, linked the Kabbalah Centre's teachings more closely to "New Age mishmash" than to traditional Jewish mysticism.[4] And the religion scholar Tamar Frankiel urged caution in evaluating "groups that specialize in Kabbalah for a general audience . . . because some of these groups are of doubtful authenticity and/or use questionable methods to gain adherents."[5]

The New Age self-help focus of the Kabbalah Centre is prevalent in the books produced by the Berg family. For example, the inside flap of Yehuda Berg's *72 Names of God: Technology for the Soul* (2004), refers to the book as "a simple and concise, yet hip and modern guide to dealing with life and its challenges," while the back flap promises that it is "the ultimate pill for anything and everything that ails you." Berg—an ordained rabbi like his brother Michael—pitches his mystical use of the letters of the different Hebrew names of God as an easy way to transform your world. "Dealing with a difficult person or situation, having doubts, struggling with your thoughts?," he asks. "Whatever the situation, there is a Name that can give you your power back. With *The 72 Names of God* wall chart, you can access this ancient technology on your wall, desk, dashboard, or wherever you need it."[6] Karen Berg, Philip Berg's second wife and the mother of Michael and Yehuda, dubs her 2005 book *God Wears Lipstick: Kabbalah for Women* "the first Kabbalist Bible for women." She promises that the tools she offers will "enhance your everyday life and give you the nourishment to go further and become as great as you can be in your potential spiritual enlightenment."[7]

Still, many Israelis, including some traditional rabbis, tolerated Madonna's brand of Kabbalism, in part because it drew attention to Jewish mysticism and to Israel and Judaism. In a 2007 interview, Rabbi Mordechai Siev, director of the

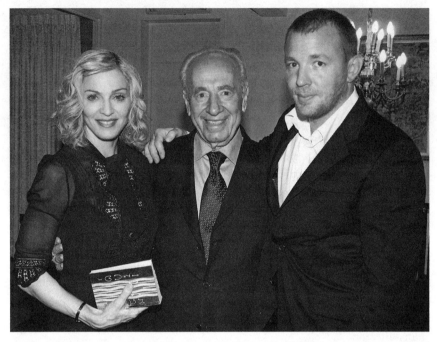

President Shimon Peres poses with Madonna and then-husband Guy Ritchie, September 17, 2007. Reuters Pictures.

English-language program at the Ascent Center in Safed, Israel, claimed that "Madonna happened to be a vehicle of God." Safed, which is one of traditional Judaism's four Holy Cities, has been a center of Kabbalah and Jewish mysticism for more than four hundred years; it draws Kabbalah enthusiasts from around the world. The Los Angeles rabbi Shlomo Schwartz was equally enthusiastic. "Thank God for Madonna; she is responsible for putting Kabbalah on the front pages, the rabbis are not as popular as Madonna, they are not on MTV."[8]

Israeli politicians were especially susceptible to Madonna's charms, regardless of her beliefs. When she returned to Israel in 2007, on a private visit to attend a Rosh Hashana celebration at the Kabbalah Centre in Tel Aviv, Madonna met with then president Shimon Peres. She and Peres exchanged gifts, expressing boundless admiration for each other. "I am an ambassador for Judaism," she proclaimed.[9]

In 2009 Madonna celebrated the Sabbath with Prime Minister Netanyahu and his wife, Sarah, who are not known for their adherence to Jewish ritual

practice. Madonna was in Israel to perform two concerts at Tel Aviv's Hayarkon Stadium, the final shows of her Sticky & Sweet World Tour. An official statement from the Prime Minister's Office said that the singer spent two hours with the Netanyahus, "lighting Shabbat candles and reciting a blessing together."[10] Not to be seen as choosing sides in Israeli politics, the pop star dined with opposition leader Tzipi Livni several days prior to her meeting with the Netanyahus. In what the media dubbed a "double date," Madonna and her new boyfriend, Jesus Luz, joined Livni and her husband in the private room of a fashionable Tel Aviv restaurant for a late-night dinner.[11] It is worth noting the oddity of a celebrity couple named Madonna and Jesus visiting the leaders of the Jewish state, though the irony of this situation was lost on most of Madonna's Israeli fans.

Unlike Israeli politicians, most Orthodox rabbis were neither charmed nor flattered by Madonna's interest in Israel and Kabbalism. When she arrived in Israel in 2009, Shmuel Eliyahu, the official rabbi of Safed, the birthplace of the Kabbalistic tradition, wrote an open letter to the singer in which he pointed out that her performances and public behavior were not in keeping with the values of Kabbalah, "the enchanting wisdom you have so much respect for." Rabbi Eliyahu argued that exposing a woman's body "may raise the lust instead of raising the love," and appealed to Madonna to "honor this place with modesty, to honor the land you are stepping on."[12]

In between her meetings with Livni and Netanyahu and her two sold-out concerts, Madonna made a late-night pilgrimage to Safed, to the tomb of Rabbi Isaac Luria, the sixteenth-century mystic. Accompanied by the Kabbalah Centre's Michael Berg, who was part of her entourage, Madonna sang a traditional Sabbath song and paid her respects to the memory of the great Kabbalist.[13]

Madonna returned to Israel again in 2012, opening her MDNA Tour at Ramat Gan Stadium in Tel Aviv. She also continued to make private trips to Israel, eventually purchasing a penthouse in Tel Aviv in 2015. On Madonna's repeat visits to the Holy Land over more than two decades, she came to express a more universalistic idea of Israel, one that included Arabs as well as Jews. On each of her visits, she made an effort to meet with Palestinian Arabs as well as Israeli Jews. At her concerts, she made statements in favor of peace and compromise. In 2012, for example, Madonna told the audience that if they supported her, they supported peace. "No matter if you are Muslim, Christian, atheist, gay, straight, black, Asian, we are all people," she said. "We all bleed the same color and we all want to love and to be loved."[14]

Madonna's love for the Jewish state appeared to be sincere. As she told her 2009 Hayarkon Stadium audience: "Every time I come here, I get so supercharged

with energy. I truly believe that Israel is the energy center of the world."[15] But her religious position was more complicated. Many fans assumed that Madonna had converted to Judaism, despite her clarifications to the contrary. When the music journalist Brian Hiatt asked her directly, "To what extent would you characterize yourself as Jewish?," during a 2015 interview for Ireland's *Independent*, the singer responded: "I don't affiliate myself with any specific religious group. I connect to different ritualistic aspects of different belief systems, and I see the connecting thread between all religious beliefs."[16]

Here, Madonna was invoking a form of perennial philosophy—the idea that all religions at their core are concerned with the same issues and ultimate questions, and that the forms and rituals are secondary. This universalistic idea is extremely popular among those who dub themselves spiritual, but not religious. Sociologists of religion include this self-identification under the rubric of "nones," those who do not identify with a particular organized religion or religious tradition. Nones may adopt a specific spiritual practice, but they are not interested in the origins or traditional context of that practice; they might practice Kabbalah divorced from Judaism, or yoga divorced from Hindu traditions, or meditation without any interest in Buddhism, or Sufi chanting and dancing without engaging with Islam.

Madonna told her interviewer that, although she had studied Kabbalah for many years and chosen to follow many Jewish religious practices—like observing the Shabbat and having a Bar Mitzvah for her son—she had not converted. "This appears like I'm Jewish, but these rituals are connected to what I describe as the Tree of Life consciousness and have more to do with the idea of being an Israelite, not Jewish," she said. She then drew a strong distinction between the early practices of the Israelites and the later formalized religion of Judaism. "The tribes of Israel existed before the religion of Judaism existed, so you have to do your history," she explained. "So, am I Jewish? I mean, some people would say, well, you do a lot of things that Jews do, but I would say I do a lot of things that people did before Judaism existed. And I believe what I practice has to do with something deeper than religion, that it embodies all religions, including Judaism. And Christianity. And Islam."[17]

When the interviewer asked about the small cross Madonna was wearing around her neck, the pop star answered: "I like crosses. I'm sentimental about Jesus on the cross. Jesus was a Jew, and . . . a catalyst, and I think he offended people because his message was to love your neighbor as yourself; in other words, no one is better than somebody else. He embraced all people, whether it was a

beggar on the street or a prostitute, and he admonished a group of Jews who were not observing the precepts of the Torah. So he rattled a lot of people's cages."[18]

Thus, to some extent, Madonna's view of Israel emphasized the Holy Land as the land where Jesus walked. But unlike Johnny Cash or Frank Sinatra, Madonna adopted some Jewish religious practices; Israel, for her, signified both a devotion to Kabbalah and to the perennial philosophy.

A Jewish Star Is Born

Like Leonard Bernstein and Frank Sinatra in an earlier generation, Barbra Streisand, so obviously ethnic, refused to change her name—or to get a nose job. Rather, she made her ethnic identity part of her appeal; she featured it, rather than fixed it. And her American Jewish upbringing of the 1940s and 1950s made her keenly aware of Israel; indeed, at that time identification with Israel was becoming the core value of American Jewish life.

Streisand's career as a singer and actress blossomed in the early 1960s, and she quickly took Hollywood by storm. Passionate and outspoken, she seemed to relish mixing politics with art. In the mid-1960s, the Oscar-winning film director William Wyler cast Egyptian heartthrob Omar Sharif opposite Streisand in *Funny Girl*. Streisand had already starred in the Broadway musical, but the film version would be her cinematic debut. Sharif had played starring roles in both *Lawrence of Arabia* and *Dr. Zhivago*, and Streisand was enthusiastic about working with him. Then, in June 1967, the Six-Day War broke out, throwing the project into jeopardy. "All the investors in the production were Jewish," Sharif recounted in his autobiography, *The Eternal Male*. "The atmosphere at Columbia Pictures was pro-Israel and my co-star was Jewish. . . . And I was an Egyptian from Nasser's regime. A wave of panic swept over the set."[19]

Wyler, who like Streisand was Jewish, reacted strongly, putting his considerable prestige on the line to keep Sharif on the project. "We're in America, the land of freedom," he said. "Not hiring an actor because he is an Egyptian is outrageous. If Omar doesn't make the film, I don't make it either."[20] Streisand, like Wyler, insisted that Sharif's Egyptian citizenship should not block his participation in the film. The director and the female lead prevailed, Sharif starred with Streisand, and *Funny Girl* emerged as a huge hit, receiving eight Academy Award nominations. Streisand won Best Actress, and though her subsequent romance with Sharif raised eyebrows among the Hollywood and New York elite, it surely did not hurt their box-office numbers.

From her auspicious film debut, Streisand went on to star in a string of successful films, including *Hello Dolly*, *The Owl and the Pussycat*, *The Way We Were*, and *A Star Is Born*. She famously said, "You don't become *really* famous until you're a movie star,"[21] and though she achieved this status at an early age, she remained unfulfilled by her silver-screen success. By the mid-1970s, Streisand had grown determined to direct, and she began looking for a story to make into a film. Simultaneously, she—like many Americans of that era—became interested in exploring her ethnic roots. These twin searches led her to Isaac Bashevis Singer's short story "Yentl: The Yeshiva Boy," in which a young woman from a traditional Polish Jewish family disguises herself as a man to receive a Talmudic education.

The project faced a torturous path to fruition. Streisand had optioned the story in the late 1960s, but she did not acquire sufficient financial backing to move forward with it until 1979. In addition to doubting Streisand's ability as a first-time director to pull off a multimillion-dollar production, the Hollywood studios thought the project was too ethnic. Though Singer wrote the first screenplay, Streisand rejected it as "too dark" and replaced him with another screenwriter; in the end, she rewrote the script herself. Streisand spent hours researching the story's Jewish themes. "I talked to all of the rabbis I could talk to, searching for different points of view from the Reform, Conservative, and Orthodox rabbis," she said. "It's a complex thing. It's men through the centuries who have found a way to use Jewish law to enslave women. That was a fascinating thing for me to find out."[22]

With Streisand as producer, director, screenwriter, and star, *Yentl* opened to mixed reviews in 1983—a full fifteen years after she had first conceived the idea. The film would gross more than $40 million, and Streisand would succeed as the first woman to win a Golden Globe for Best Director. She ascribed her unwavering determination to make the film to a 1979 visit to her father's grave in Queens. Streisand's father, Emanuel, had died when she was only fifteen months old. She never fully recovered from that loss and has spoken or written about it at many points in her life. On the tombstone next to her father's, she noticed the Yiddish name "Anshel"—the same name Singer had given to Yentl's dead brother; it is his identity that she adopts in Singer's story. "To me it was a sign, you know, a sign from my father that I should make this movie," she said.[23]

Streisand's father was much on her mind in April 1984, when she visited Jerusalem to dedicate a new building in his memory at Hebrew University. As with the building Frank Sinatra dedicated there a decade earlier, assorted donors and friends of the star had pitched in to raise the money. Streisand's visit coincided

with the Israeli premiere of *Yentl*, and she could not resist linking the film with the building dedication. "I'm so glad that at the Emanuel Streisand School of Jewish Studies, women will be able to study Jewish thought and law without having to disguise themselves as men," she said during her remarks.[24]

Streisand's subsequent visits to Israel were mostly philanthropic and personal, but she continued to speak out about gender politics and the role of women in Israel. In 2013, when pro-Palestinian activists were pressuring American entertainers to boycott Israel, Streisand performed her first concert in Tel Aviv. During that weeklong visit to Israel, Streisand received an honorary doctorate from Hebrew University. "I realize it's not easy to fully grasp the dynamics of what happens in a foreign land," she said in her acceptance speech. After acknowledging the special relationship between Israel and the United States as "two great and noble countries . . . always striving to shine as a beacon of hope," Streisand then went on to criticize the Orthodox practice of gender separation: "So it's distressing to hear about women in Israel being forced to sit at the back of a bus, or when we hear about Women of the Wall having metal chairs hurled at them when they attempt to peacefully pray, or when women are banned from singing in public ceremonies."[25]

Women of the Wall is a liberal, multidenominational movement that seeks full equality of religious expression at Israel's national shrine, the Western Wall. To this day, men and women pray separately in the formal prayer sections of the Western Wall plaza in Jerusalem, and all religious rituals are performed in keeping with Orthodox tradition. Accordingly, only men may wear prayer shawls and read from the Torah scroll. Influenced by the more liberal traditions of Conservative and Reform Judaism, Women of the Wall participants seek to perform the same rituals as men do. They have petitioned the Israeli government for space adjacent to the wall for egalitarian prayer that would not be controlled by the Rabbinate—but, a compromise has yet to be reached, and, in fact, may never be reached.

In response to Streisand's comments, Anat Hoffman, chairwoman of the Women of the Wall, said she was "'delighted beyond words' that a well-known female Jewish voice like Streisand spoke about their issue."[26] At that time, American Jewish feminists were wrestling with two contradictory ideas: that women should fully participate in the ritual lives of their religious communities, and that they should support the official Israeli Rabbinate, which limited full participation to males. This contradiction between liberal ideas and traditional Jewish practices mirrored the debate among American Jews over Israel's policies toward the Palestinians, which clashed with the liberal political views of

many American Jews—especially those unaffiliated with a synagogue or other organizations. For Streisand to make the case for liberal policies on gender and religion was a significant gesture in the evolving debates in the American Jewish community about Israeli policies.

Whitney Houston and Israel

For Whitney Houston, Israel held rich Christian and African American associations, associations that—similar to her interest in music—developed out of her upbringing in the Baptist Church. Whitney's mother, Cissy Houston, grew up as part of a prominent musical family, which included her cousin, the opera singer Leontyne Price, and her niece, pop diva Dionne Warwick. Cissy went on to enjoy a long career in soul and gospel music, forming the Sweet Inspirations in 1963, a group that provided backup vocals for some of the leading recording artists of the decade, including Otis Redding, Wilson Pickett, Van Morrison, Aretha Franklin, and in 1969, Elvis Presley. Over the next two decades, Cissy Houston worked with artists as varied as Bette Midler, Linda Ronstadt, Herbie Hancock, and J. J. Cale, before becoming a Grammy-winning gospel singer in the 1990s. Throughout her long career in popular music, Cissy Houston remained the director of the Youth Inspirational Choir at New Hope Baptist Church in Newark, New Jersey, a position she held for more than fifty years.

Whitney grew up singing in that choir and was often a featured soloist. She made her debut at age eleven, singing "Guide Me, O Thou Great Jehovah," a well-known Welsh hymn. She learned to play the piano there as well. In her late teens, Whitney would occasionally join her mother onstage at nightclub performances. It was at one of these performances in New York City that the record producer Clive Davis discovered Whitney and signed her to Arista Records. Over the next three decades, she would figure as the most-awarded female singer in history, selling more than two hundred million records worldwide, while enjoying a successful second career as a film actress.

In the late 1990s, when addiction to cocaine and other drugs began to derail her life and her career, Whitney Houston reached out to the African Hebrews of Dimona, Israel. The community is famous for its gospel choir, which tours internationally to raise money for the community. Houston knew that other American pop stars like Stevie Wonder had visited the group and performed in concert with them.

Formally known as the African Hebrew Israelite Nation of Jerusalem, the group has been in Israel since 1969, when a Chicagoan named Ben Carter led

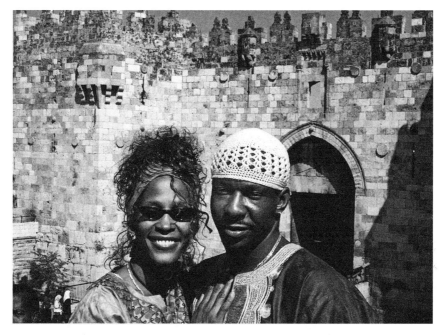

Whitney Houston and her husband, Bobby Brown, at the Damascus Gate in Jerusalem's Old City, May 28, 2003. Reuters Pictures.

several hundred followers to the Holy Land by way of Liberia. But the link between Africa and Israel goes back further still, to the early twentieth century, when some African American Christians began to turn to forms of religious expression other than Christianity, which they identified with the legacy of slavery. Islam and Judaism, by contrast, were not. By asserting that Judaism had African origins, these African Americans claimed a biological connection to the ancient Hebrews. They believed that the connection had been obscured, if not erased, by slavery, and that it was their obligation to reclaim their lost heritage. In the 1920s and 1930s, Black Hebrew congregations sprang up in New York and Chicago, and though small, they persisted for decades. During the 1960s and 1970s, the idea of "Black Israel" underwent a revival, producing groups like the African Hebrew Israelites. Carter and his cofounders "were part of a larger zeitgeist in the early 1960s that grappled with the identity and advancement of African Americans," the religion scholar Jacob Olupona has noted. For these groups, "it was important to get out of the United States as soon as possible in order to escape the 'culture of poverty.'"27

In May 1967, Ben Carter—now known as Ben Ammi—and two other men from the Abeta Hebrew Israel Cultural Center of Chicago, an African American congregation that advocated repatriation to Africa, traveled to Liberia to seek a home for their fellow Black Hebrews. They acquired land in Liberia, and Abeta families began to arrive. But within two years, their communal experiment had failed, and some succumbed to disease. In 1969 the leaders regrouped, setting out this time for Israel. Upon arrival, they petitioned the Israeli government to accept them as citizens under the Law of Return, which promises citizenship to all Jews who immigrate to Israel. The Ministry of the Interior, however, rejected the immigration request, granting the group temporary tourist visas instead. As far as Israeli officials were concerned, the African Hebrews were not Jews. Despite this rejection, many Abeta members still chose to follow Carter to Israel, with some three hundred Black Hebrews arriving in Israel between 1969 and 1972. The Israeli government provided residences for them while it debated their immigration status, but these residences were on the periphery—in the southern desert towns of Dimona, Arad, and Beersheba, not in the urban centers of Tel Aviv, Haifa, or Jerusalem, where Jewish immigrants from Europe, the Soviet Union, and North America were settled by the government.

The Israeli government insisted that the African Hebrew group undergo *giyur*, or conversion to Judaism, but Ben Ammi rejected this demand. He told Israeli officials that his people were not Jews, but Israelites. Abraham, the progenitor of the Hebrews, and the prophet Moses had been black men, Ben Ammi explained. Therefore, white Europeans who claimed to be Jews could not be the actual descendants of their putative forebears. And the African Hebrews should be as eligible as any Jew, if not more so.

The two sides stood at an impasse. Israeli officials would not accept the Black Hebrews under the Law of Return, and the Black Hebrews would not relinquish their claim to be the original Israelites. In the first years of their sojourn, a few African Hebrews considered converting to Judaism, a move that would have eased their integration into Israeli society. But Ben Ammi would not allow it. When their tourist visas expired, and the group faced possible deportation, Ben Ammi lashed out at the Israeli government, dubbing it in the American press "a racist Jim Crow country."[28] But African Hebrew Israelites from America continued to arrive in Israel. Slowly, over the next two decades, both Ben Ammi's rhetoric and the official Israeli position would moderate to the extent that the government, in the 1990s, would relent and grant the group citizenship through a process of naturalization.

By the time Whitney Houston arrived in 2003 on her first and only trip to the Holy Land, the African Hebrew Israelites were well-established in Dimona and Beersheba. Houston, her husband, Bobby Brown, and their daughter, Bobbi Kristina, along with their large entourage of family and friends traveled throughout Israel; they spent most of their six-day visit with the African Hebrews. Members of the Dimona community baptized Houston and her family in the Jordan River, a ceremony which was filmed and later broadcast on Israeli television and on Jon Stewart's *Daily Show*. Patricia Houston, Whitney's sister-in-law and spokeswoman, also a part of the entourage, told the press that Whitney was "a spiritual woman and wanted to come here and touch the land and be around the Saints of Dimona." In Jerusalem, Houston and Brown met with Prime Minister Ariel Sharon, who was not a supporter of the Black Hebrews' demand for Israeli citizenship. When Sharon asked Whitney how she felt in Israel, she replied, "It's home, it's home."[29] The couple spoke of "a redemptive process" that they found working in the Holy Land, but in the end, it was not enough to save Whitney Houston from the drug abuse that would hasten her death in 2012.

The visits to Israel by our three divas—Madonna, Streisand, and Houston—took place during a period of hopeful anticipation that Israeli-Palestinian peace was in the offing. Their messages of reconciliation resonated with Israeli audiences, and with their fans throughout the world. But the much-vaunted peace initiative of that period would soon come to an end.

The Rabin Assassination

Despite the excitement and hope that the Oslo Accords had generated during the first half of the 1990s, the buoyant mood did not last. In 1993 Palestinian opponents of the peace process launched a series of suicide bombing attacks against Israeli civilian targets that would continue through the decade, deepening the many rifts in Israeli society. Political violence threatened to split the country. Both the right-wing settlers and their left-wing opponents spoke in apocalyptic terms. Galvanized by leader Benjamin Netanyahu's rhetoric, the Likud party portrayed its leftist opponents in the Labor party as traitors for their continued support of the peace process. Likud rallies featured posters in which Prime Minister Yitzhak Rabin's face had been superimposed onto the figure of a Nazi SS officer.

On November 4, 1995, Rabin attended a large public gathering in Tel Aviv, which was billed as a peace rally in support of the Oslo Accords. Convened by

the Peace Now Movement, the event drew more than one hundred thousand people. In his speech, Rabin told his audience, "I was a military man for twenty-seven years. I fought as long as there was no chance for peace. I believe there is a chance now, a great chance, and we must take advantage of it."[30] The prime minister then joined the crowd in singing the anthem of the Israeli peace movement, "Shir Hashalom," or "The Song of Peace." Written in the early 1970s and popularized by the army choral group Lahakat Hanahal, the song had been revived in the mid-1990s, following the Oslo Accords. The song lyrics proclaim, "Sing a song for peace, don't whisper a prayer. Better to sing a song for peace, shout it out loud." As the program concluded and Rabin left the stage to walk to his car, a gunman opened fire. Shot twice, the prime minister died on the hospital operating table less than an hour later. A blood-soaked copy of "The Song of Peace" taken from Rabin's shirt pocket became a sacred relic for those in Israeli society who mourned the prime minister's assassination. But not all Israelis did.

Rabin, a latecomer to the idea of a peace settlement with the Palestinians, was anathema to supporters of the settlement movement, who believed that returning the occupied territories to the Palestinians was treasonous. His assassin, Yigal Amir, was an Orthodox Jewish student from Bar Ilan University and a passionate supporter of West Bank settlement. While many in Israel mourned the murder of the prime minister, and the demise of the prospects for an Israeli-Palestinian peace based on territorial compromise, a minority of settlers and other right-wing supporters approved of the assassination. As they saw it, Amir, by killing Rabin, had saved Greater Israel.

The Rabin murder deepened the fault lines in Israeli political life. The Right remained determined to retain the territories, while the Left continued to argue that making territorial concessions to the Palestinians would lead to peace. This division affected the American Jewish community as well. On the right of the political spectrum, the Zionist Organization of America, the National Council of Young Israel, and other more conservative American Jewish organizations spoke out strongly against the implementation of the Oslo Accords, while the Reform movement supported the peace initiatives.

When the major American Jewish organizations organized a memorial event in honor of the murdered prime minister, the National Council of Young Israel, an American association of Orthodox synagogues, declined to participate. The ostensible reason Young Israel gave for its refusal to take part in the memorial was that women would be singing at the event, and Orthodox Jews objected to women singing in public—a law expressed in the Rabbinic dictum that "a woman's voice is her nakedness." Many observers, however, suspected that the

reasons for Young Israel's absence were more political. Young Israel, as well as most of the other American Orthodox Jewish organizations, identified with the settler movement and its ideological commitment to Greater Israel. Members of the Orthodox synagogue organization could not identify with those Israeli Jews who called for territorial compromise. Nor could Evangelical Christians. They, too, considered concessions to the Palestinians to be a betrayal of Israel's destiny. And many Evangelicals joined Israeli rightists in denying that the Palestinians were a people in any ethnic or political sense.

Christian Zealots for Zion

Rabin's assassination reinforced the unlikely alliance between American Evangelical Christians and the Israeli settler movement. Both groups viewed modern Israel as a manifestation of God's hand moving in history. The Evangelical pastor John Hagee wrote in his 1998 book *Final Dawn over Jerusalem*, "The shot that killed Yitzhak Rabin launched Bible prophecy onto the fast track."[31] Indeed, Rabin's assassination spawned a rush of end-time literature that found an eager audience among American Evangelicals. In *Final Dawn* and subsequent books, Hagee criticized any attempt to achieve Israeli-Palestinian peace. "Islamic fundamentalists will not honor or abide by any Roadmap for Peace," he wrote in his 2006 book *Jerusalem Countdown: A Warning to the World*. "Their objective will be the destruction of Israel."[32] The end-time scenario that Hagee unfolds in his books has Israel at the center of world events—or should we say, "end-of-the-world" events. As Hagee says on the first page of *Jerusalem Countdown*: "The rise of terrorism in our world and the emerging crisis in the Middle East . . . are part of a much bigger picture—that of God's plan for the future of Israel and the entire world. We are going to discover we are facing a countdown in the Middle East—the Jerusalem Countdown, a battle such as the world has never seen or will ever see again. It is a countdown that will usher in the end of the world."[33]

Before Hagee's books, the most successful expression of this end-time scenario was in the Left Behind series, a series of twelve novels published between 1995 and 2004. These novels are among the most successful titles of all time; by a conservative estimate, more than sixty-five million copies have been sold. The series steadily gained in popularity as each new book appeared: in 1995 the first novel, *Left Behind: A Novel of the Earth's Last Days*, had an initial print run of 150,000 copies; five years later in 2000, the eighth book, *The Mark: The Beast Rules the World*, had an initial print run of 2.5 million copies.[34] The books are steeped in Christian scriptural and postscriptural tradition, particularly with regard to the

detailed descriptions of the "last days" or "end of time" found in the Old Testament Book of Daniel and the New Testament Book of Revelation.

During the 1990s and early 2000s, the Jewish settler movement and American Evangelicals forged a powerful political alliance. Its most effective expression was the formation, by John Hagee, of CUFI—Christians United for Israel, an organization proud to describe itself as "the Christian AIPAC." The Left Behind series was immensely popular with those who were drawn to this Christian Zionist organization.

In turn, the Left Behind authors presented their books as nothing short of prophecy. "God has chosen to bless this series," said Tim LaHaye, coauthor of *The Mark*. "In doing so, He's giving the country, and maybe the world one last, big wake-up call before the events transpire."[35] As the historian of religion Yaakov Ariel noted, "LaHaye and Jenkins [his coauthor] should be viewed as heirs and continuers of a long chain of evangelists and writers who have promoted the dispensationalist messianic faith."[36]

Stevie Wonder Changes His Tune

The Rabin assassination drove home the realization among American liberals that the Israeli Right was not interested in compromise. Many liberals moved toward more vocal support of the Palestinian cause. American performers in particular struggled to adjust to this political sea change. In some cases, performers experienced a profound shift in their viewpoint over the course of just a few years.

Stevie Wonder was one such example. When he arrived in Israel in late August 1995, he seemed to relish the experience. "I'm very excited to be in this part of the world for many reasons," he said during a press conference at Ben Gurion Airport. "When I was very small, before my mother had accepted that I was visually impaired, she wanted to bring me to the Holy City in hopes I would get my sight back."[37] Wonder, touring behind his album *Conversation Peace*, played several sold-out concerts, receiving rave reviews in the Israeli media. In between performances, he met with Prime Minister Rabin and visited the African Hebrew Israelite community at Dimona. Three years later, in 1998, he performed at a New York City gala marking Israel's fiftieth anniversary.

A decade and a half later, Stevie Wonder's views on Israel had changed, the singer avowing more sympathy for the Palestinian perspective. In 2012 Wonder was scheduled to headline the Friends of the Israeli Defense Forces annual benefit in Los Angeles, but he pulled out of the performance after an online petition

circulated by pro-Palestinian groups received several thousand signatures. The appeal read, "You were arrested in 1985 protesting South African Apartheid, now we ask you: please remember that apartheid is apartheid, whether it comes from White Afrikaans settlers of South Africa or from Jewish Israelis in Israel."[38] In the wake of this social-media pressure, Wonder claimed that the United Nations had recommended he cancel the performance because it conflicted with his status as an official UN "Messenger of Peace." He noted in his statement that he had made this decision with a heavy heart, but "I am and always have been against war, any war, anywhere."[39]

Classical Music against Ignorance

Popular music was not the only realm of the musical world affected by the Israel-Palestine conflict. As we have seen, classical musicians helped build Israel's cultural institutions, including the Israel Philharmonic Orchestra, and American musicians such as Leonard Bernstein and Isaac Stern were passionate supporters of Israeli statehood. As the twentieth century drew to a close, many classical musicians developed a more nuanced sense of support for the Jewish state, some hoping to promote peace in addition to art.

In the late 1990s, the conductor Daniel Barenboim and the literary critic Edward Said, himself an accomplished pianist, founded the West–Eastern Divan Orchestra, an international youth orchestra with both cultural and political aims. As politicians and religious leaders were becoming increasingly discouraged about the prospects of settling the Israeli-Palestinian conflict, Barenboim and Said sought to ameliorate the situation rather than resolve it. The new orchestra was to consist of musicians from the Palestinian territories, the Arab states, and Israel. From its inception, Barenboim was realistic about the aims of the project. Though the orchestra was "very flatteringly . . . described as a project for peace," Barenboim conceded that it was "not going to bring peace." Rather, the goals were more modest: to "create the conditions for understanding" and to "awaken the curiosity of each individual to listen to the narrative of the other."[40]

Much earlier in his career, Barenboim, born in Argentina and brought up in Israel, had used his prodigious musical talent in support of Israel. At the outbreak of the Six-Day War in June 1967, Barenboim and his companion, the cellist Jacqueline du Pré, flew to Tel Aviv to perform for Israeli soldiers at the front. They were married weeks later in a ceremony at the Western Wall in the recently occupied Old City of Jerusalem. The couple again performed for Israeli troops during the 1973 Yom Kippur War. And in 1978 Barenboim was featured on the

ABC television special *The Stars Salute Israel at 30*. In 1999 Barenboim was making the case for Israeli-Palestinian rapprochement. "It is absolutely essential for people to get to know the other, to understand what the other thinks and feels, without necessarily agreeing with it," Barenboim explained to an interviewer in 2008. "I'm not trying to convert the Arab members of the Divan Orchestra to the Israeli point of view and I'm not trying to convince the Israelis of the Arab point of view.... I'm trying to create a platform where the two sides can disagree and not resort to knives."[41]

The early days of the orchestra were not free of conflict. At the workshop held in Weimar, Germany, in 1999, the young musicians from Israel and Palestine demonstrated a great deal of uneasiness. Barenboim conducted morning and afternoon orchestra rehearsals, while Said led evening discussions about music, culture, and politics. All the musicians were flattered to have been invited to the workshop, but many were skeptical as to whether political, religious, and ethnic differences could be overcome through shared artistic expression.

The following year, in a public conversation in New York, Barenboim and Said shared their experiences from that first workshop. "Most of the participants were between the ages of eighteen and twenty-five," noted Said, and came from Syria, Jordan, the Palestinian territories, Egypt, Lebanon, and Israel. "It was remarkable to witness the group, despite the tensions of the first week or ten days, turn themselves into a real orchestra.... All of them suddenly became cellists and violinists playing the same piece in the same orchestra under the same conductor."[42]

Barenboim found each side's lack of knowledge about the other extraordinary. "The Israeli kids couldn't imagine that there are people in Damascus and Amman and Cairo who can actually play violin and viola," he said. "I think the Arab musicians knew that there is a musical life in Israel, but they didn't know very much about it." He went on to describe a young Syrian musician who had never met an Israeli and considered Israel a threat to his country: "That same boy found himself sharing a music stand with an Israeli cellist. They were trying to play the same note ... to do something together, something about which they both cared, about which they were both passionate. Well, having achieved that one note, they already can't look at each other the same way."[43]

Barenboim concluded his comments about the Berlin workshop by acknowledging that "the real test is how productive this contact will be in the long run ... if we foster this kind of a contact, it can only help people feel nearer to each other, and this is all."[44] The West–Eastern Divan Orchestra is now based in Seville, Spain, and hosts an annual summer workshop and concert tour. Since that

first workshop in 1999, the orchestra has come to fruition as a critically acclaimed musical force, performing in cities around the world and releasing a number of acclaimed concert recordings.

Ariel Sharon and the Second Intifada

In early 2001, Ariel Sharon, former Israeli defense minister and architect of the 1982 War in Lebanon, led the Likud party to victory, making him prime minister. In the United States, Sharon's election energized right-wing forces in the American Jewish community; in fact, some of those forces had helped him rise to power. Among Sharon's most prominent supporters was the worldwide Hasidic organization Chabad-Lubavitch, which raised money for Sharon's campaign and spoke out strongly for the Greater Israel cause. More concretely, Chabad leaders provided Israelis living in the United States who promised to support Likud with round-trip airline tickets to Israel to vote in the election.

Sharon, who had served as minister of defense in the early 1980s, strongly supported the concept of a Greater Israel, which included the West Bank, Golan Heights, and Gaza territories captured during the 1967 War. In the view of Greater Israel's supporters, the pre-1967 state of Israel, cut off from its biblical roots in Hebron, Shechem, and the Old City of Jerusalem, was just another southern Mediterranean country. But with the 1967 conquest, the State of Israel had been transformed into the Land of Israel. Both Sharon and his Likud rival Benjamin Netanyahu knew that this Greater Israel idea appealed to many American Christians as well as Jews. Conservative Christians were more comfortable with Israelis invoking biblical borders than they were with secular Israelis who disdained Orthodoxy and called for territorial compromise. Evangelicals' positive feelings about Israel were only enhanced by the millennial fervor that accompanied the arrival of the year 2000.

Sharon's American backing was long-standing and powerful. In the 1980s, the New York law firm Shea and Gould had filed a libel suit on Sharon's behalf against *Time* magazine, for a 1983 story that implied that Israeli troops under Sharon's command bore ultimate responsibility for the 1982 massacre carried out by Lebanese Christian militias in the Sabra neighborhood and adjacent Shatila refugee camp in Beirut. The American jury concluded that the *Time* article was defamatory; in contrast, an Israeli government investigation found Sharon responsible for the massacre because his troops were in control of Beirut at the time. Sharon was forced to resign his position as defense minister, though he remained in the Begin cabinet as a minister without portfolio. By 2000 this

stain on Sharon's reputation had been mostly forgotten, even among Israelis. He appeared as a hero to the majority of Israeli voters as well as to their American Jewish counterparts, many of whom admired tough Jews like Ariel Sharon.

In late September 2000—accompanied by a large retinue of police, soldiers, and journalists—Sharon paid an official visit to the Temple Mount in Jerusalem. Since 1967, with the agreement of the Israeli government, Jerusalem's Muslim religious authorities had administered the Temple Mount, while Jewish religious authorities administered the Western Wall, which lies below the Temple Mount. Sharon's visit signaled to Palestinians Israel's desire to exercise complete control over the area. The visit was timed to appeal to the Likud voter base, which favored a tough stance toward the Palestinians.

The riots that broke out in response to Sharon's provocation quickly spiraled out of control, setting in motion the Second Intifada. A year later, in the wake of escalating violence, Sharon instructed Israeli forces to quash the uprising, and the military moved in with great force to suppress rebellion in the West Bank. As the Israeli historian Ahron Bregman noted, "The continuing violent uprising of the Palestinians in the occupied territories and the suicide attacks in Israel proper ended Israelis' romance with peace."[45]

Sharon's hawkish stance helped him win the 2001 Israeli election. The 9/11 attacks seven months later bolstered the American public's already strong support of Israel and dampened any potential criticism of the country's rightward turn under Sharon. As one astute Israeli journalist remarked to me in the aftermath of 9/11: "For the next hundred years, the Americans are going to love us and hate the Arabs."[46] Many Americans now saw the two countries as united against a common enemy—Islamic extremism—in much the same way the United States and Israel had been aligned against communism. In the post-9/11 anti-Arab atmosphere, criticizing Israeli policy was considered unpatriotic in both Israel and the United States.

In that period, dissent coming from within Israel went largely unreported in the U.S. media. Much of that criticism appeared in Hebrew and was not translated into English. And even if translated, most critical articles and books were still ignored. If that had proved impossible, the authors of those books and articles might have found themselves accused of anti-Semitism. If the critics were Jewish, they were dubbed self-hating Jews.

Sharon's policies were supported by Chabad Hasidim, religious Zionist settlers, and American Evangelical Christians. This broad support spoke to the power of the Greater Israel idea—both within Israel itself and with Jewish and Christian communities worldwide. Sharon lost much of that support in late

2003, when he decided to unilaterally withdraw Israeli troops and settlers from Gaza. In August 2005, the Israeli army carried out the evacuation of the eight Jewish settlements in Gaza, as well as a small number in the West Bank. This disengagement was, in Sharon's words, "a redeployment of IDF forces and a change in the deployment of settlements, to reduce the number of Israelis located in the heart of the Palestinian population."[47] Like Rabin before him, Sharon had concluded that the price of Israeli rule over the Palestinians was too high. He had sought a way to disengage the Palestinian civilian population from the Israeli military. But for Israeli settlers and their supporters—including both Jewish and Christian conservatives in America—this was unacceptable; they considered Gaza to be a vital part of Greater Israel.

Shunning Israel's Critics

Some Americans who dared to criticize Israeli policies paid a steep price. In 2002, on the thirty-fifth anniversary of the 1967 War, the New York University professor and intellectual historian Tony Judt wrote a provocative book review in the *New Republic* that nearly ruined his career. Reviewing Michael Oren's book, *Six Days of War: June 1967 and the Making of the Modern Middle East*, Judt refused to treat Israel as a special case in international affairs. He criticized Israeli policies in the same way that he had criticized the governments of Eastern Europe, his area of expertise. Raised in a British Zionist home, Judt had lived in Israel in the 1960s and knew its political culture firsthand. He was not swayed by sentimental ties to Israel, as were many American and British Jews.

While praising Oren's mastery of "gripping detail and an immense amount of research," Judt disagreed with the book's conclusion. Judt argued that the consequences of the 1967 War included an "aggressive nationalism paired with a sort of born-again, messianic Judaism, a combination hitherto largely unknown in Israel."[48] Judt went on to state that, "since June 1967, Israel has entered fully into the Middle Eastern world. It too has crazed clerics, religious devotees, nationalist demagogues, and ethnic cleansers. It is also, sadly, less secure than at any time in the past forty years."[49] This conclusion angered many *New Republic* readers, prompting Judt's removal from the magazine's editorial board.

Despite a forceful rebuttal by Oren in the next issue of the *New Republic*, Judt persisted in his criticisms of Israel. In a 2003 *New York Review of Books* essay titled "Israel: The Alternative," he argued that, because Israeli settlements in the territories had doomed the two-state solution, a single binational state, improbable as it seemed, was now Israel's best option. Years later, recalling the "firestorm

of resentment and misunderstanding" that the essay had generated, Judt noted that he was "deliberately trying to pry open a suppressed debate by casting a stone into the placid pool of yea-saying uncritical assent that characterizes the self-defined Jewish 'leadership' here in the U.S."[50]

In the week following publication of "Israel: An Alternative," the *New York Review of Books* received thousands of letters, many attacking Judt as an anti-Semite and self-hating Jew. Over the next few years, as Judt continued to criticize Israeli policy, American Jewish organizations continued to attack him, at one point intervening to cancel a public lecture at the Polish Embassy in New York. Judt claimed that in fact he was banned from many New York venues. In a conversation with the Yale University historian Timothy Snyder, Judt described the aftermath of the controversy as a "shunning."[51]

I experienced a similar shunning in Atlanta around the same time. My articles and public talks included harsh criticism of Israeli policies. Like many Israeli critics during those years, I focused on Ariel Sharon, who was prime minister at the time. I had firsthand experience of Sharon's policies: I had served in the Israel Defense Forces under his command and had spoken with him on two occasions. But when I included those stories in my articles, Atlanta's conservative Jewish community treated my insider criticism as nothing less than betrayal. Scheduled talks of mine were canceled, and members of the small Orthodox synagogue I attended shamed me in public—at prayer services. One Saturday, when I was called up for an Aliyah—the blessing over the Torah—a man jumped up and yelled, "Goldman is a traitor! He should not be honored in our synagogue!" I completed the ritual but never returned to that synagogue.

Along with other such traitors, I also felt the wrath of powerful American Jewish organizations. The organizers of the annual Festival of Faith in St. Louis canceled a lecture they had invited me to give on the Dead Sea Scrolls after a leader of the local Jewish Federation had identified me as "an enemy of the Jewish people." In a subsequent phone call, the event's non-Jewish organizer expressed some regret and embarrassment, but his hands were tied; there was nothing he could do about the canceled talk. Some of Atlanta's conservative Christians were also outraged by my criticisms of Israel. As a consequence, I was attacked by Sean Hannity on his Atlanta radio talk show.

These attacks—on Tony Judt, me, and others—presaged a wider set of attacks on critics of Israeli policies in the years to come. The mid-2000s saw the publication of three American books that greatly provoked the ire of Israelis and of American Jewish leaders. Two of them—Jimmy Carter's *Palestine: Peace Not Apartheid* and John Mearsheimer and Stephen Walt's *The Israel Lobby and U.S.*

Foreign Policy—were widely reviewed, sold thousands of copies, and spent weeks on the *New York Times* best-sellers list. The third book, Nadia Abu El-Haj's *Facts on the Ground: Archaeological Practice and Territorial Self-Fashioning in Israeli Society*, was written more for an academic audience than a mass-market one. The author was a Palestinian American scholar who taught at Barnard College in New York. Each of these three books elicited passionate negative responses from the self-appointed leadership of the American Jewish community, as well as from members of the conservative media and many influential Jews and Evangelical Christians.

Demonizing Jimmy Carter

President Carter's book *Palestine: Peace Not Apartheid*, published in 2006, generated the most controversy. As a former president and the mediator of the Camp David Accords, Carter's book likely would have received a heightened level of attention under any circumstances. But his use of the word "apartheid" to describe Israel's rule of the Palestinian territories sparked outrage among the American Jewish community and resulted in particularly hostile responses. The Anti-Defamation League of B'nai B'rith attacked the book, running full-page advertisements in national newspapers condemning it for promoting "myths like Jewish control of the government and the media."[52] The Harvard Law School professor Alan Dershowitz spoke for much of the organized Jewish community when he asked, "What would motivate a decent man like Carter to write such an indecent book?"[53] Several years later, Dershowitz would respond to Carter with his own best seller *The Case for Israel*, a spirited defense of the Jewish state and its policies.

Much of the criticism of Carter's book focused on its lack of sympathy toward Israel and its harsh comparison of Israeli rule in the territories to the policies of South Africa. Writing in the *New York Times* Sunday Book Review, Ethan Bronner dismissed *Palestine: Peace Not Apartheid* as "a strange little book" in which "Israeli bad faith fills the pages." After condemning it for "misrepresentations" and an "awfully narrow perspective," he explained that the "biggest complaint against the book—a legitimate one—is the word 'apartheid' in the title, with its false echoes of the racist policies of the old South Africa." Unlike other reviewers, however, Bronner attributed the former president's comparison to passionate overstatement, not to anti-Semitism.

In interviews about the book, Carter refused to back down from his use of the term "apartheid." He made it clear that the term applied only to Israeli policies

toward the Palestinians in the territories, not to those policies governing its own Arab citizens, who comprise 20 percent of the state's total population. He remarked that, within Israel, critics of government policy "have all used and explained the word 'apartheid' in much harsher words than mine."[54] This observation was an accurate representation of a liberal sector of Israeli Jews, but it did little or nothing to mollify Carter's American Jewish critics, who had either been shielded from these dissenting voices, or simply rejected them.

With the Carter Center located in Atlanta and the former president affiliated with Emory University, Atlanta's Jewish community responded to the book with special fury. That community, whose liberal Jewish congregations had supported the civil rights movement during the 1960s and 1970s, had a reputation for being very defensive about criticism of Israel. This stemmed in part from the fact that the Israeli Consulate General to the Southeastern United States, which is situated in Atlanta, had—unlike the more liberal consulates in New York and Los Angeles—hewed to the outlook of the political Right in Israel.

After the publication of *Palestine: Peace Not Apartheid*, the Emory College professor Kenneth Stein, a member of Atlanta's Jewish community and an adviser to President Carter on Middle East issues since the early 1980s, publicly resigned his long-held position at the Carter Center. In an article entitled "My Problem with Jimmy Carter's Book," Stein argued that Carter "allows ideology or opinion to get in the way of facts." The book, according to Stein, "contains egregious errors of both commission and omission," while Carter also "manipulates information, redefines facts, and exaggerates conclusions."[55] Stein went on to suggest that the former president's motivation was located in an ambivalent attitude toward Israel and that his "distrust of the U.S. Jewish Community and other supporters of Israel runs deep."[56]

I was teaching at Emory University when Carter's book came out, and I witnessed this hostile reaction to Carter firsthand. Carter, who is a University Distinguished Professor at Emory, agreed to respond publicly to student and faculty criticism of the book. At the talk, demonstrators against Carter thronged the entrance to Emory's Glenn Memorial Auditorium, the Methodist church on the Emory campus. Within the sanctuary many students wore T-shirts that said, "What are you afraid of, Jimmy?"—a reference to Carter's decision to appear alone at the event rather than engage in a debate with one of his detractors. The atmosphere in the chapel soon turned ugly as the demonstrators turned their backs on Carter when he took the podium. Reflecting on this meeting and others like it, Carter told a journalist, "I've been through political campaigns for

state senator, governor, and president, and I've been stigmatized and condemned by my political opponents. But this is the first time that I have ever been called a liar. And a bigot and an anti-Semite and a coward and a plagiarist. This is hurtful," he said.[57]

In sharp contrast to the former president's critics, Carter biographer and Dartmouth College professor Randall Balmer saw Carter's interventions in the Israeli-Palestinian conflict as a demonstration of "both the power of his connections as president and his freedom, as an ex-president, to press his concerns without regard for the political consequences." Unlike most politicians, Carter was able to challenge both the pro-Israel lobby and its Evangelical allies. Balmer concluded that, "whatever the specific merits of his criticism, Carter was able to strike a prophetic stance, one that called powerful interests and politicians to account."[58]

My response to Carter's book was closer to Balmer's than to that of most of my coreligionists. Many years earlier I had read Carter's 1982 book *The Blood of Abraham: Insights into the Middle East* and understood that, like many of his more conservative Baptist coreligionists, Carter held a biblical view of the Middle East, and of the Israeli-Palestinian conflict in particular. For Carter, Jews and Arabs were the descendants of Abraham and Ishmael; thus, they were destined to be in conflict. For more conservative Evangelicals, a biblical understanding meant unconditional support for Israel; for Carter, it meant justice for the Palestinians in the context of a guarantee of peace for Israel. Modern Israel, in Carter's understanding, should be held to the standards that the prophets of ancient Israel demanded. Carter was not a Christian Zionist, but he had a biblical view of Israel.

Mearsheimer and Walt, and Abu El-Haj

The backlash against President Carter was a prelude to the attack unleashed against academicians John Mearsheimer and Stephen Walt and their 2007 book *The Israel Lobby and U.S. Foreign Policy*. While Carter had alluded to the power of the pro-Israel lobby in *Palestine: Peace Not Apartheid*, Walt and Mearsheimer's book chronicled the history of that lobby and argued that it influenced U.S. foreign policy well beyond the Israeli-Palestinian conflict. Specifically, the book alleged that pro-Israel American opinion and policy-makers had encouraged the 2003 U.S. invasion of Iraq. Abraham Foxman, the national director of the Anti-Defamation League, responded to *The Israel Lobby and U.S. Foreign Policy* with

a full-length book titled *The Deadliest Lies: The Israel Lobby and the Myth of Jewish Control* in which he portrayed Mearsheimer and Walt as authors in the tradition of European anti-Semitism.

The following year, another Israel-related book generated new controversy. Though scholarly in nature, Nadia Abu El-Haj's *Facts on the Ground: Archaeological Practice and Territorial Self-Fashioning in Israel Society* elicited a fresh set of attacks by Israel's staunchest supporters. Published by the University of Chicago Press in 2001, the book made the case that Israeli archaeological projects were assertively nationalist. In 2007 the book came to public attention when the author was being considered for tenure at Barnard College. Abu El-Haj argued that Israeli authorities favored projects that had the potential to demonstrate that ancient Israel existed and flourished, and that the biblical account was historically accurate, while Israeli funding agencies ignored projects that focused on the centuries of Muslim rule in Palestine.

Thus, Israel used archaeology to validate its claims—and invalidate Palestinian claims—to the land. These assertions were not new—they had been made earlier by American and Israeli observers—but in the mid-2000s they generated renewed controversy. Abu El-Haj was herself Palestinian, which made her the target of pro-Israel pundits. They called on Barnard to deny Abu El-Haj's tenure, though her case had already been vetted and approved. As Eric Alterman noted in the *Nation*, "Denying Abu El Haj tenure became a cause célèbre among this community of right-wing Jews, neoconservative adventurers, and pseudo-scholars."[59] Despite internet petitions and threats by major donors to withhold bequests, Barnard granted Abu El-Haj tenure in November 2007. Columbia University approved her tenure case a year later, a requirement of Barnard's affiliation with the university.

Cultural Boycotts of Israel

Opponents of Israeli policies in the territories had long called for economic boycotts of the Jewish state; in the early 2000s they began to target the Israeli cultural establishment as well. Boycott supporters pressured artists to refuse to perform in Israel or to collaborate with Israeli artists, and they asked Western cultural institutions to cut ties with parallel institutions in Israel. The model for these campaigns was the cultural boycott of South Africa's apartheid regime in the 1980s and early 1990s. Archbishop Desmond Tutu himself encouraged this comparison; in 2002 he equated the Palestinian struggle with that of South Africa's blacks, saying, "Yesterday's South African township dwellers can tell

you about today's life in the Occupied Territories."[60] He asked the international community to join the campaign to divest from Israel.

In 2004 the Palestinian leader Omar Barghouti initiated the BDS movement, dubbing it the "Palestinian Campaign for the Academic and Cultural Boycott of Israel." The effort soon began to catch on in leftist circles in Europe. A similar campaign was initiated by the prominent British novelist and critic John Berger. Unlike Barghouti, who called for a broad boycott of Israeli artists and all Israeli academic and cultural institutions, Berger's campaign called on British writers and artists to boycott only state-sponsored events and institutions, not individual Israeli artists. For Berger, the boycott was "a way of encouraging the very courageous Israelis who oppose their government, and an encouragement to Palestinians to somehow go on surviving."[61] But this distinction was lost on the great majority of American and Israeli Jews, who tend to dismiss all boycotts of Israel as anti-Semitic.

Over the course of the first decade of the twenty-first century, these two boycott movements, the Palestinian and British, began to converge. In 2005 a consortium of Palestinian groups, including Barghouti's Palestinian Campaign for the Academic and Cultural Boycott of Israel, joined forces to create an international boycott, divestment, and sanctions (BDS) campaign. The BDS movement encompasses academic, economic, and cultural campaigns to pressure organizations and individuals around the world—companies, church denominations, union organizations, cultural associations, academics, intellectuals, artists—to divest from Israel.

The BDS cultural campaign has been particularly visible in its targeting of performers and celebrities. It has succeeded in convincing American artists—including Santana, Elvis Costello, and Gil Scott-Heron—to cancel concerts in Israel. In 2010, when Elvis Costello pulled out of two Israeli concerts, Omar Barghouti told the *Guardian*, "This is not boycotting the Jewish people, or the Israeli people, it is boycotting the occupation. More and more people are convinced that something should be done, and the peaceful and non-violent way to do it is by boycott, divestment, and sanctions."[62]

The BDS movement has created some unexpectedly awkward moments for celebrities and their sponsors. In early 2014 the movement called on the American actress Scarlett Johansson to step away from her endorsement of SodaStream, the Israeli producer of home devices that make seltzer water. The SodaStream factory was located in an Israeli settlement in the occupied West Bank. The actress responded to BDS pressure with a statement claiming that SodaStream was "building a bridge to peace between Israel and Palestine, supporting neighbors

working alongside each other, receiving equal pay, equal benefits, and equal rights"; Johansson refused to sever her relationship with the Israeli company.[63] Weeks later, the actress ended her eight-year relationship with Oxfam, the international consortium of nongovernment organizations committed to ending poverty. Oxfam, which had come under increasing BDS pressure, stated that Johansson's endorsement of SodaStream was "incompatible with her role as an Oxfam global ambassador."[64] By the end of the year, SodaStream had announced plans to move its factory from the West Bank to a new location in southern Israel.[65]

Other artists have resisted the pressure to boycott Israel. The British novelist Ian McEwan, who was awarded the Jerusalem Prize in 2011, traveled to Israel to accept the award, despite pressure from colleagues like John Berger to refuse the prize. "If I only went to countries that I approve of I probably would never get out of bed," McEwan said. "It's not great if everyone stops talking."[66]

In response to these boycott campaigns, the Israeli government embarked on its own vigorous countereffort. It branded the BDS movement as an existential threat and dedicated considerable resources to social media campaigns depicting Israel as "cool" and progressive. The ADL and other Jewish organizations have vigorously promoted the notion that BDS is anti-Semitic and that the movement represents a threat to American Jews.

Bob Dylan in Israel

With the rapid expansion of digital media in the early 2000s, criticism of Israel—and rebuttal of that criticism—cropped up as a constant feature of American public discourse. In the digital-media glare, performers and artists suddenly found themselves under much sharper scrutiny, with audiences around the world dissecting their every word and gesture. This was especially true regarding Israel, where it was fast becoming controversial for American musicians to perform. Some chose to boycott Israel, while others continued to visit and give concerts there. One towering popular-music icon, Bob Dylan, decided to perform in Israel in 2011—though in his usual enigmatic manner, he did not say why. But many of his fans in both Israel and the United States read his return to Israel as a gesture of support for the Jewish state in the face of widespread criticism by other performers.

When Dylan took the stage at Tel Aviv's Ramat Gan Stadium in June 2011, it had been eighteen years since he last performed in Israel, though he had made many personal visits in the interim. He was, of course, a household name in

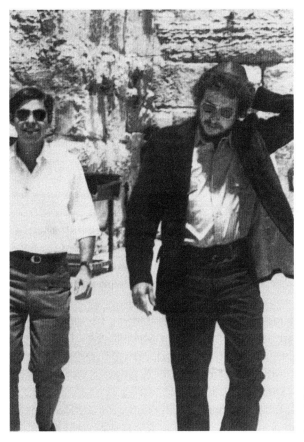

Bob Dylan at the Western
Wall, May 26, 1971.
Bettman/Getty Images.

Israel, revered by the young as well as the not-so-young. The audience members
that evening, according to the *Haaretz* reporter who covered the event, were
"overwhelmingly young, overwhelmingly native-born Israelis."[67] Surely everyone
in attendance knew that Dylan had been born Robert Zimmerman. Some no
doubt also knew he had had a Bar Mitzvah, married a Jewish woman with whom
he had five children, and been affiliated with religious traditions as diverse as
Evangelical Christianity and Chabad Hasidism.

Indeed, Dylan had a long and complicated relationship with Israel, and with
Judaism itself. Young Robert Zimmerman grew up in Duluth, Minnesota, in
a home that emphasized Jewish identity, if not its religious rituals. A visiting
Orthodox rabbi had prepared him for his Bar Mitzvah, which took place in
May 1954, with four hundred guests in attendance. That summer, Zimmerman

attended Camp Herzl, a Jewish summer camp in Wisconsin with a Zionist ori-
entation; he would return there the following three summers as well. He formed
his first musical group, the Jokers, with two friends from Camp Herzl.

Dylan made his first private visit to Israel in 1969, and he returned regularly
in the early 1970s. In May 1971, he celebrated his thirtieth birthday in Jerusalem;
photos of him at the Western Wall appeared in Israeli and American newspa-
pers, fueling speculation that he had found religion in the Holy City and would
soon be spending more time in the Jewish state. But Dylan confounded both
his admirers and his critics, turning abruptly in the late 1970s to Evangelical
Christianity rather than traditional Judaism. After his conversion, Dylan took
a three-month course at Vineyard Christian Fellowship in Los Angeles, which
emphasized the end-time narratives of the New Testament Book of Revelation.
His years as a born-again Christian resulted in a series of gospel-influenced al-
bums. Dylan visited Israel at least once during this early 1980s gospel period,
and in 1987 he gave his first concerts in Israel, kicking off his Temples in Flames
world tour alongside Tom Petty and the Heartbreakers with performances in
Jerusalem and Tel Aviv.

Dylan further confounded his critics and confused his many fans—
including the more scholarly obsessives known as "Dylanologists"—by forging
ties to Chabad, the worldwide Hasidic movement. Between 1986 and 1991, he
made three appearances on the Chabad "To Life" Telethon, an annual fund-
raiser broadcast from Los Angeles. Because Dylan was—and is—so private and
publicity-shy, it is difficult to know whether such ecumenism represented true
spiritual seeking, a political statement, or sheer mischief. But by the 1990s, his
fans had learned to accept his shifts in religious allegiance.

Whether he was presenting himself as a born-again Christian, a supporter of
the Chabad movement, or just a rock and roller, Dylan seemed inextricably con-
nected to Israel in all its complexity. The song "Neighborhood Bully" on his 1983
Infidels album was thought to be a "declaration of full-throated Israel support."[68]
The lyrics presented the title character as an unrepentant, besieged man—"His
enemies say he's on their land / They got him outnumbered a million to one /
He got no place to escape to, no place to run." Dylan performed again in Israel
in June 1993, bringing his Still on the Road summer tour to Tel Aviv, Beersheba,
and Haifa. It would be nearly two decades before his next public performance
in Israel.

By the time Dylan returned in 2011, performing in Israel had become con-
troversial. The BDS movement publicly pressured the singer to cancel his Tel

Aviv show. Appealing to his past support of the American civil rights movement, the group called on Dylan "not to perform in Israel until it respects Palestinian human rights. A performance in Israel, today, is a vote of support for its policies of oppression, whether you intend for it to be that, or not."[69] Ever the enigmatic artist, Dylan did not respond to the BDS appeal, nor did he cancel his concert. Tel Aviv welcomed him with open arms, including doing a preperformance television news profile of his life, musical career, and Jewish affiliations. Though he said nothing from the stage during the performance—late-career Dylan is notorious for not addressing the audience in between songs—Israeli fans saw the concert as a triumphant homecoming. As the *Haaretz* reviewer said: "Dylan lives here. He lives in the culture of Israel. . . . He has influenced Israel for the better more than any other American Jew."[70]

When Beit Hatfutsot, the Museum of the Jewish People in Tel Aviv, reopened in 2016 following an extensive renovation, it featured the exhibit "Forever Young—Bob Dylan at 75," a thematic retrospective of the artist's worldwide influence on music and his complex relationship with his Jewish identity. Although Dylan did not participate directly in the events associated with the exhibit, which opened on his seventy-fifth birthday, his manager worked with the museum to assemble film, photos, and music. "So many people have written about Bob Dylan as a prophet, and Bob Dylan's Jewish influence and Jewish thematical thinking," said the exhibit curator Asaf Galay. "We just wanted to show his feelings, and also the tradition of this kind of music."[71] Many thousands of Israelis visited the exhibit; "Forever Young" ran for eighteen months, closing in January 2018.

Israel and the Beatles

Like Bob Dylan, Paul McCartney also refused to cancel his Israel travel plans, despite requests by BDS supporters that he do so. In 2008 the Israeli government organized a yearlong series of events to celebrate the state's sixtieth anniversary. The festivities included a Paul McCartney concert in Tel Aviv. In addition to what had by that time become the standard pressure to boycott Israel, McCartney also received death threats from militant activists, but he refused to cancel his performance. "I do what I think and I have a lot of friends who support Israel," McCartney said.[72]

McCartney's September 2008 concert was his first performance in Israel, and it was the result of a very special invitation, or perhaps we should say, apology.

Early in 2008, the Israeli Foreign Ministry published a very unusual set of letters to McCartney, Ringo Starr, and the families of John Lennon and George Harrison.

Eager to have McCartney and Starr perform in Israel as part of the sixtieth anniversary celebrations, Israeli diplomats hoped to smooth over a rough patch in Israel-Beatle relations dating back to the mid-1960s, when Israel had missed a great opportunity to host the Beatles. Soon after the Beatles emerged as international superstars, an Israeli producer had proposed inviting them to perform in Tel Aviv. Unable to raise the fees that the Fab Four demanded, the producer turned to the Israeli government for backing. But the government committee charged with funding cultural events turned down the producer's request, claiming that the band had "no artistic merit" and was likely to "cause hysteria and mass disorder among young people."[73] The Israeli government in effect canceled the concert.

In the January 2008 letters of apology, the Israeli ambassador to Britain Ron Prosor wrote that Israel had "missed a chance to learn from the most influential musicians of the decade, and the Beatles missed an opportunity to reach out to one of the most passionate audiences in the world."[74] According to the Israeli Beatles historian Yarden Uriel, the author of two books about the band, "When Beatlemania swept the world, Israel was like a side observer that didn't take part in the actual game."[75]

In 2008 McCartney, though not Ringo Starr, accepted Israel's invitation to participate in its sixtieth anniversary celebration, saying that he was looking forward to his visit "43 years after being banned by the Israeli government." He dubbed his September 2008 performance at Tel Aviv's Yarkon Park "Friendship First," telling reporters, "I'm bringing a message of peace, and I think that's what the region needs."[76] A decade later, in February 2018, Paul McCartney received Israel's prestigious Wolf Prize. The announcement called him "one of the greatest songwriters of all time," who has "touched the hearts of the entire world."[77] In that same year, Ringo Starr would bring his All Starr Band to Israel as part of his summer 2018 European tour.[78]

Klinghoffer Controversy

In the twenty-first century, the Israeli-Palestinian controversy extended beyond academics, intellectuals, former presidents, musical conductors, and rock legends, to the usually genteel world of opera. In 2014 New York's Metropolitan Opera decided to stage a new production of *The Death of Klinghoffer*, a 1991

opera based on the true story of the *Achille Lauro*. In October 1985, a faction of the Palestinian Liberation Organization had hijacked an Italian cruise ship. The four gunmen who took the ship demanded the release of Palestinians held in Israeli prisons. As the ship sailed around the Eastern Mediterranean, the gunmen shot and killed Leon Klinghoffer, a sixty-nine-year-old American Jew from New Jersey, who was confined to a wheelchair. They threw the wheelchair and his body into the sea.

Two days later, the ship returned to Port Said in Egypt, where the hijackers agreed to release their hostages in exchange for safe passage to Tunisia. Several days later, U.S. fighter jets intercepted a plane carrying the four gunmen and their leader, Abu Abbas, and forced the plane to land in Italy, where the men were arrested. The four gunmen were eventually tried, convicted, and imprisoned, but Abu Abbas was released because the extent of his involvement in the hijacking was not clear at the time. U.S. Special Forces would capture him eighteen years later, in 2003, in Iraq, lending credence to U.S. claims that Saddam Hussein was harboring terrorists. Abu Abbas died in U.S. military custody a year later.

The original production of *The Death of Klinghoffer*, with music by John Adams, libretto by Alice Goodman, choreography by Mark Morris, and stage direction by Peter Sellars, sparked both enthusiasm and dread in the weeks leading up to its 1991 opening at the Brooklyn Academy of Music. The opera had debuted several months earlier in Brussels, Belgium. Critics claimed that it engaged anti-Semitic stereotypes and glorified terrorism. Following the opening night performance in Brooklyn, Klinghoffer's daughters issued a statement condemning the "exploitation" of their father's murder for "a production that appears to us to be anti-Semitic." The daughters then took issue with the opera's attempt to deal evenhandedly with both Palestinian and Jewish perspectives: "The juxtaposition of the plight of the Palestinian people with the coldblooded murder of an innocent disabled American Jew is both historically naïve and appalling."[79] The furor over Alice Goodman's libretto ended her career as a librettist, as she was unable to get commissions after *Klinghoffer*. Those first productions in Brussels and New York were held under high security.

The Metropolitan Opera's 2014 revival of *The Death of Klinghoffer* faced opposition from local and national Jewish organizations. In June 2014, the Anti-Defamation League pressured the company not to perform the opera, to remove it from their upcoming season. The *New York Post* claimed that the opera was "sympathetic to the hijackers" and asked sarcastically, "When do we get an opera painting the 9/11 bombers as 'men of ideals'?"[80] The Met kept the production

on its calendar but agreed under pressure to cancel a planned live simulcast that would have reached movie theaters around the world. Despite his declaration that the opera was not itself anti-Semitic, the Met general manager Peter Gelb claimed to be responding to Jewish concerns that the live transmission "would be inappropriate at this time of rising anti-Semitism, particularly in Europe."[81]

The Met's production of *The Death of Klinghoffer* ran for seven performances in October and November 2014. Opening night included protestors in wheelchairs outside Lincoln Center, with some shouting, "Shame!" and "Terror is not art!" Inside, individual protestors interrupted the performance twice during the evening. As Peter Gelb noted, "There are obviously some people who came here to be heard . . . but we expected worse."[82]

THESE CONTROVERSIES about artistic performances and their political agendas and implications are common in democratic cultures. American readers and viewers are no strangers to them. Yet, when these controversies are about Judaism and Israel, American reactions seem particularly passionate.

American culture and Israeli culture are now inextricably intertwined. What happens in one country will have a powerful effect in the other. A startling example that ties together many of our themes was one particular American-Israeli event of the late 1990s: in celebration of Israel's fiftieth anniversary in 1998, Prime Minister Netanyahu's office organized a cultural extravaganza that would highlight the nation's artistic achievements. U.S. vice president Al Gore was invited to attend as the guest of honor, while among the scheduled performers were the members of the Batsheva Dance Company. (This was the company that Jerome Robbins had helped found in the 1950s.) However, due to objections by Israeli Orthodox rabbis and their Israeli and American supporters—the rabbis found the dancers' costumes "scanty and immodest"—the dance troupe's performance was canceled at the last moment. This political-religious ruckus caused considerable embarrassment to the prime minister and his American guest. Netanyahu, the most American of all Israeli leaders, apologized to Vice President Gore and other guests but the cultural and diplomatic harm had been done.[83]

Five years later, in 2013, Netanyahu's embrace of American culture was so complete and his alliance with Christian Zionists in the United States so strong that he delivered a Christmas greeting from the prime minister's office. This was not the annual greeting to Israeli's Christian minority but rather a message to Christians everywhere.

According to the *Jerusalem Post*, Netanyahu, speaking over a video link, said, "This is Jerusalem of gold, now it's Jerusalem of snow. We celebrate Christmas with you. We know the importance you attach to our common heritage, to the State of Israel, and to the city of Jerusalem, where so much of our common history was forged. We have a great past, we have common values, we have the desire to seize a common future of security, prosperity, and peace."[84]

Israel at Seventy,
Dancing on a World Stage

✳ ✳
✳ **B** Y THE BEGINNING of the twenty-first century, Israeli culture had grown so compatible with American popular culture that it was having a direct creative influence on the American entertainment industry and its global market. This influence was felt in the realms of film, dance, and music. But the most visible and far-reaching effect of Israeli culture in the United States was on American television, which in the early 2000s entered a new Golden Age. Three very successful American television shows—*Homeland*, *In Treatment*, and *The Affair*—are remakes of Israeli television originals. Additional shows based on Israeli prototypes are now in development for American TV audiences. *Variety*, the trade journal of the entertainment industry, has noted that "Israel has now firmly positioned itself as a TV content breeding ground—from silly game shows to subversive comedies—with massive global reach."[1] This assertion of Israeli soft power has raised the ire of activists in the movement to boycott, divest, and sanction Israel. While BDS has had some success in persuading musical performers to cancel performances in Israel, it has not succeeded in influencing TV executives, who have mobilized to defend their adoption of Israeli programming.

Of these three Israeli TV shows, only *Homeland* in its American version still has an explicit Israeli connection in some of its episodes. *In Treatment*, *The Affair*, and other Israeli shows have been adapted for U.S. TV with a thoroughly American setting. Only the credits reveal the Israeli origins. This changed in 2016 when the media giant Netflix bought the Israeli series *Fauda* and broadcast it to great acclaim. Named one of the best shows of 2017 by the *New York Times*, *Fauda* was an international hit. The show, a very gritty depiction of Israeli-Palestinian violence in the West Bank, has garnered many viewers in the Arab world, where it has some fans and many detractors. In 2018 BDS advocates

urged Netflix to cancel the show. But their campaign failed after a media coun-
tercampaign in which fifty Hollywood film executives called on Netflix to resist
"this blatant attempt at artistic censorship."[2]

The continuing popularity of Israeli-originated television among American
viewers is emblematic of the evolving similarity between the two cultures. This
similarity has been developing over the past seventy years, at first gradually,
then at much greater speed and intensity during the past two decades. For many
twenty-first-century Americans, Israel is viewed as a U.S. outpost in the Arab
world. The persistent claim by American politicians—and aspirants to political
office—that Israel is the only democracy in the Middle East seems impervious
to argument or refutation. Counterarguments that point out the inconsistency
between Israel's democratic system for Jews, and its decidedly undemocratic sys-
tem for the Palestinians living under Israeli control, are summarily dismissed as
anti-Israeli or anti-Semitic.

Among the influential performing artists who continue to advocate for Israeli-
Palestinian dialogue and compromise, Daniel Barenboim is the most prominent
and persistent. In 2018 his West-Eastern Divan Orchestra, founded with Edward
Said in 1998, celebrated its twentieth anniversary with a tour of five American
cities. Though the orchestra has not yet played in Israel, and it has performed only
once in the West Bank, Barenboim and the musicians still manage to convey an
air of optimism. For many, the Arab, Israeli, and European members of the or-
chestra provide both an example and a symbol of the potential for reconciliation.

As has been true since the first U.S. encounters with the Holy Land in the
early nineteenth century, Protestant religious ideas—ideas that sparked the
Palestine Manias of the nineteenth and early twentieth centuries—continue to
influence American perceptions of Israel, its policies, and its people. For a great
many twenty-first-century conservative Christians, the rebirth of Israel is a sign
of God's actions in history. Jerry Falwell's comment that, with the 1948 creation
of Israel, the clock of history began to move again, both reflected conservative
Christian thinking of the 1970s and helped shape the thinking of the subsequent
decades. In particular, a pro-Israel stance was one of the founding principles of
the Moral Majority movement of the Reagan years. Then, throughout the 1980s,
1990s, and early 2000s, Israel as a Christian cause became increasingly influen-
tial in American politics. By extension, the rise of the Christian Right and the
infusion of Evangelical Christian activists and ideas into the Republican Party
made Christian Zionism a potent force in American life. The 9/11 attacks rein-
forced this tendency by swaying American public opinion even more toward the

Israelis and against the Arabs. Conservative Evangelical hostility toward Islam further strengthened pro-Israel sentiment.

One of the surprising aspects of today's Christian Zionism is that Israel has become as significant a religious symbol for Christians as it is for Jews. In the past few years this attachment has facilitated alliances between Jewish and Christian supporters of the Israeli government, most strikingly in the form of Christian Evangelical pilgrimages to Jerusalem—where the leadership and rank and file of the movement are addressed by the Israeli political leadership. As the historian of religion Martin Marty had remarked, "No American can understand foreign policy in respect to the Middle East, especially when Israel is the focus without having to deal with the cohort of the population which is dispensationalist."[3] For that growing group of conservative Evangelical Americans, the current dispensation, or age, is coming to an end, and the millennium prophesied in the New Testament is near. But the millennium can only be ushered in by great suffering, the period of Jacob's tribulations. Israel is the place where these tribulations will begin, and where they will culminate in the Second Coming.

As we have seen, strange bedfellows indeed have resulted from the politics of Evangelical support of Israel. In 1981 the Israeli prime minister Menahem Begin awarded the Jabotinsky Medal to the Evangelical leader Jerry Falwell. Like his predecessors in the office of prime minister, Begin knew that Christian Zionist support was a powerful political force in the United States. Yet the Evangelical idea that support for Israel was predicated on a vision of the end time in which Jews suffer and accept Jesus was not taken seriously by Israelis. Two decades before Begin awarded the Jabotinsky Medal to Falwell, David Ben Gurion, Israel's first prime minister, spoke before a delegation of visiting American Pentecostals. It seems that he was unaware that the official theology of the Assemblies of God, then the largest Pentecostal group, was very explicit about the need to convert Jews to Christianity. Support for the State of Israel was central to Pentacostal theology, as the restoration of the Jews to their land was the sign of the imminent Second Coming. A tract about the Jews published by the Assemblies of God stated, "the final blow upon this unfortunate and stubborn people will come during the Tribulation period; and it will be this awful time of suffering that shall break their will and turn the remnant to acceptance of the once hated Nazarene, the Lord Jesus Christ."[4] In the past two decades, some Israeli liberals have become aware that Christian admiration of Israel may be combined with hostility to Judaism, and they have criticized their government for cultivating ties with American Evangelicals. But this awareness has not had any influence on a governmental level. Israeli officials now seem much more comfortable with

conservative American Evangelicals than they do with liberals, whether they be American or Israeli.

During the Clinton administration and in both Bush administrations, the political power of Christian Zionism grew exponentially. Much of that power is now expressed by CUFI—Christians United for Israel, the Evangelical lobby founded by the Reverend John Hagee of Texas in 2006. Since CUFI's founding, it has garnered considerable financial and political power. The support that Donald Trump received from conservative Christians in his 2016 election campaign clearly links to his assertively pro-Israel stance, illustrated by his announcement that he would move the U.S. embassy to Jerusalem. The declaration, made at the National Prayer Breakfast where three thousand Evangelical pastors and lay leaders gathered to hear an address by President Trump, received a standing ovation. Regarding the embassy's actual move from Tel Aviv to Jerusalem, Evangelical Christians were more jubilant, in fact, than many American Jews. While the vast majority of American Evangelicals approved of the administration's announcement concerning Jerusalem, fewer than a third of American Jews voiced similar approval.[5]

Though the move of the U.S. embassy to Jerusalem was condemned in many international and American forums, the Trump administration insisted that the move made the United States more beloved around the world than it had been during the Obama years. In July 2018, reporters traveling with the president on Air Force One were told by Deputy Press Secretary Hogan Gidley that Trump's recent actions concerning Israel were radically different from those of Obama. Israel, Hogan declared, is "the only democracy in the region, and it's important that we keep our partners close and happy, and that's what [Trump] did there."[6]

While many European, Asian, and African states condemned the embassy move, some Latin American states praised it. Soon after the United States moved its embassy to Jerusalem, Guatemala did the same. And in November 2018, Brazil announced its intention to follow in Guatemala and the United States's footsteps. These countries' rightist governments tend to support Trump's policies. Brazil and Guatemala's Evangelical Christian voters, who have turned away from the Catholic Church, are staunch Christian Zionists.

A related factor in conservative Christian support for Israel's Likud-dominated governments and policies is antipathy toward Islam. The proposed Muslim ban of Trump's 2016 presidential campaign and the 2018 enactment of restrictive immigration legislation both reflected and intensified American suspicion of Arabs specifically, and of Muslims more generally. Since 9/11, more than fifteen American state governments have passed bills limiting Sharia law.

The polemical and prejudicial force of these bills is particularly stark in states where the Muslim population is very small, but where anti-Muslim sentiment is nevertheless strong. Furthermore, in the Trump years the term "Judeo-Christian," long employed in conservative Christian political rhetoric, is used more and more to exclude Islam, one of the three historical monotheisms.

The Trump administration's withdrawal from the nuclear treaty with Iran resonates with this anti-Muslim worldview. The Iranians are deemed untrustworthy; they want to acquire nuclear technology by stealth. In contrast, the Israelis, who have had nuclear weapons since the 1960s, are deemed more than trustworthy—they are America's allies in an anti-American neighborhood, and they can be included in the Judeo-Christian tradition so beloved of conservative Christian spokespersons.

President Trump and Prime Minister Netanyahu seem to have developed a mutual admiration society that fulfills the political needs of the moment. When Trump called for a wall to be built on the U.S.-Mexican border, Netanyahu tweeted: "President Trump is right. I built a wall along Israel's Southern border. It stopped all illegal immigration. Great success. Great idea."[7] No doubt this mutual admiration stems from Netanyahu's American-ness. Though Netanyahu was born in Israel, his formative years, including all four years of high school and two years of graduate school, were spent in the United States. Netanyahu's American English is idiomatic, and his style and political instincts are thoroughly American. "Bibi," as he is known to friend and foe, is the ultimate product of the American-Israeli symbiosis.

While in high school in Philadelphia in the early 1960s, Netanyahu, like many in his generation in America, fell under the spell of Ayn Rand's blockbuster novel *The Fountainhead*. According to his biographer Anshel Pfeffer, "Bibi was taken with its hero, the architect Howard Roark. . . . Rand's muscular blend of capitalism and individualism appealed to Netanyahu and has influenced his political and economic thinking ever since."[8] Other influential Israelis, opponents of the socialist policies of the Labor governments that dominated Israel in its first three decades, were also inspired by Ayn Rand's books, as were many influential American conservatives.

So we see again the capacity of soft power to shape political commitments and, by extension, the linked trajectories of the United States and Israel. Certainly, America's obsession with Israel—an obsession that is reflected in both the passionate approval of a great many conservative Americans and the equally passionate condemnation of some liberals—has, as we have seen, deep roots, a

long history, and varied forms of expression. At the same time, the mutual embrace of the creative class in both Israel and the United States demonstrates that cross-cultural exchange in its many and varied forms will continue to influence both countries. Ultimately, the United States and Israel find themselves locked in an intricate dance on the world stage, a dance made ever more fascinating and fraught by their mutual celebration of the arts.

NOTES

Introduction

1. Turner, *Man Called Cash*, 126–28.
2. Twain, *Innocents Abroad*, 486.
3. Baldwin, *Cross of Redemption*, 234.
4. Obenzinger, "Herman Melville Returns to Jerusalem," 32.
5. Klatzker, "British Jerusalem in the News," 5.
6. Bernstein, *Leonard Bernstein Letters*, 244.
7. "Marilyn Monroe."
8. McCullough, *Truman*, 596.
9. Quoted in Brownfeld, "Redefining Anti-Semitism."
10. Silver, *Our Exodus*, 100.
11. Jacobs and Stadiem, *Mr. S*, 188.
12. Kidd, *American Christians and Islam*, 9.
13. Goldman, *Zeal for Zion*, 294.
14. Allen, "Am I Reading the Papers Correctly?"
15. Allen.
16. FitzGerald, *Evangelicals*, 475.
17. Bergman, *Rise and Kill First*, 24.
18. Saval, "Israeli TV Makes Huge Inroads Stateside."
19. Rosenberg, "Five Key Takeaways from Gallup's Annual Poll."

Chapter One

1. Pliny Fisk Papers, Middlebury College.
2. Heyrman, *American Apostles*, 90–92, 284.
3. Heyrman, 92.
4. Goldman, *God's Sacred Tongue*, 11–12.
5. Vogel, *To See a Promised Land*, 101.
6. Finley, *Pilgrim in Palestine*, 66.
7. Obenzinger, "Holy Land Narrative and American Covenant," 245.
8. Heyrman, *American Apostles*, 93.
9. See Banks, *T. DeWitt Talmage*.
10. Quoted in Kazin, *God and the American Writer*, 86–87.
11. Kazin, 90–91; Parker, *Herman Melville*, 2:313–20.
12. Obenzinger, "Herman Melville Returns to Jerusalem," 32.

13. Kahn, "Cedars of Lebanon."
14. Miller, *Reader's Guide to Herman Melville*, 195.
15. Mumford, *Herman Melville*, 320.
16. Holmes, *Forerunners*, 85.
17. Holmes, 26.
18. Hyde, *Voice from Jerusalem*, 14.
19. Holmes, *Forerunners*, 181.
20. Holmes, 187.
21. Smith, *History of the Reorganized Church*, 438–39.
22. Holmes, *Forerunners*, 191.
23. Holmes, 188.
24. Powers, *Mark Twain*, 183.
25. Powers, 183.
26. Kaplan, *Mr. Clemens and Mark Twain*, 19.
27. Vogel, *To See a Promised Land*, 146.
28. Goldman, *Zeal for Zion*, 11.
29. Twain, *Innocents Abroad*, 607.
30. See Ginsburg, "Less Awe Than Shucks"; Twain, *Innocents Abroad*, 606.
31. See Vogel, *To See a Promised Land*, 161–65, 258.
32. Trumbull, *Pilgrimage to Jerusalem*, 290.
33. World Sunday-School Convention, *Cruise of the Eight Hundred*, 6.
34. Trumbull, *Pilgrimage to Jerusalem*, 295.
35. World Sunday-School Convention, *Cruise of the Eight Hundred*, 25.
36. World Sunday-School Convention, 25.
37. Twain, *Innocents Abroad*, 481.
38. World Sunday-School Convention, *Cruise of the Eight Hundred*, 5.
39. Trumbull, *Pilgrimage to Jerusalem*, vi.
40. Trumbull, 260.
41. See Obenzinger, *American Palestine*.

Chapter Two

1. Kurth, *American Cassandra*, 163, 423.
2. "Zionists Jeopardize Status of U.S. Jews."
3. Goodwin, *Fitzgeralds and the Kennedys*, 473.
4. "Joseph P. Kennedy."
5. Goodwin, *Fitzgeralds and the Kennedys*, 473.
6. Nasaw, *Patriarch*, 501–3; Gabler, *Empire of Their Own*, 344; Hecht, *Child of the Century*, 520.
7. Nasaw, *Patriarch*, 501.
8. Gabler, *Empire of Their Own*, 342–45.
9. Goodwin, *Fitzgeralds and the Kennedys*, 471–72.

10. Goodwin, 471–72.

11. Finley, *Pilgrim in Palestine*, viii.

12. Finley, 17.

13. Sherman, *Mandate Days*, 36.

14. Gardner, *Allenby of Arabia*, 160.

15. Klatzker, "British Jerusalem in the News," 4.

16. Klatzker, 5.

17. Finley, *Pilgrim in Palestine*, 62.

18. Nesvisky, "Mencken in Palestine."

19. Millgram, *Jerusalem Curiosities*, 325.

20. Allenby speeches, lectures, and articles, April 1933, Liddell Hart Centre for Military Archives, Kings College, London.

21. Allenby Speeches, lectures, and articles

22. Millgram, *Jerusalem Curiosities*, 275.

23. Kautz Family YMCA Archives, Elmer L. Anderson Library, Minneapolis.

24. Teveth, *Ben Gurion*, 410.

25. Shindler, *Land beyond Promise*, 11.

26. Shindler, 14.

27. Laqueur, *History of Zionism*, 328–29.

28. Laqueur, 374.

29. Bergman, *History of Israel*, 24.

30. Sheean, *In Search of History*, 417.

31. Shindler, *Land beyond Promise*, 24.

32. Shindler, 24.

33. S. Katz, *Battleground*, ix.

34. Laqueur, *History of Zionism*, 251.

35. Bentwich, *For Zion's Sake*, 174.

36. Goren, *Dissenter in Zion*, 271.

37. Kotzin, *Judah L. Magnes*, 197–203.

38. Laqueur, *History of Zionism*, 260.

39. Teveth, *Ben Gurion*, 539.

40. Kolatt, Reinharz, and Shapira, "Zionist Movement and the Arabs," 638.

41. Wise, "Statement from *The Jewish Chronicle*."

42. Gandhi, "Interview to *The Daily Herald*."

43. Gandhi was against partition, but his vision of a united India was unfulfilled. In 1947 the subcontinent was cleaved in two, with Pakistan established as an Islamic state. The Indian Republic, established in 1950, quickly entered a series of conflicts with Pakistan; in the nationalistic fervor of the time, Gandhi's ideas were jettisoned, his followers exiled to the political wilderness.

44. Greenberg, "Letter to Gandhi."

45. Greenberg.

46. Gandhi, "Jews."

47. Gandhi.

48. Gandhi, "Some Questions Answered."

49. Buber, "Letter to Mahatma Gandhi."

50. Buber.

51. Fischer, *Life of Mahatma Gandhi*, 348.

52. Greenberg, "Address Delivered at Memorial for Gandhi."

53. "German Invitation Refused by Dancer."

54. Hecht, *Child of the Century*, 517.

55. Hecht, 519.

56. Hecht, 519–20.

57. Hecht, 576.

58. Breitman and Lichtman, *FDR and the Jews*, 219; Whitfield, "Politics of Pageantry,"
 242.

59. Whitfield, "Politics of Pageantry," 221.

60. Medoff, "Ben Hecht's 'A Flag is Born.'"

61. Whitfield, "Politics of Pageantry," 246, 250–51.

Chapter Three

1. Burton, *Leonard Bernstein*, 85.

2. Goldman, "Mr. Sinatra Adored Israel."

3. Sherman, *Mandate Days*, 171.

4. Kurzman, *Ben Gurion*, 272; citing Bar-Zohar, *Ben Gurion*, 141.

5. Tessler, *History of Israeli-Palestinian Conflict*, 258.

6. Laqueur and Rubin, *Israel-Arab Reader*, 97.

7. Knowles, "No Ordinary Orchestra."

8. M. Meir, *My Mother Golda Meir*, 45.

9. "Kennedy and Bradford Condemn U.S. Policy."

10. Kramer, "Special Relationships."

11. R. Kennedy, "British Hated by Both Sides."

12. Oz, *Tale of Love and Darkness*, 353.

13. Oz, 357–58.

14. Myers, "Partition and the Triumph of Zionist Pragmatism."

15. Lebor, *City of Oranges*, 114.

16. Bernstein, *Leonard Bernstein Letters*, 244.

17. Burton, *Leonard Bernstein*, 183–85.

18. "Mozart in the Desert," 74.

19. Burton, *Leonard Bernstein*, 183.

20. "Mozart in the Desert," 74.

21. Half a century before Bernstein first visited Israel, Gustav Mahler, the composer
 and conductor with whom Bernstein identified most strongly, converted to Roman
 Catholicism from Judaism, an act that allowed him to receive an appointment to
 the Vienna Court Opera. See A. J. Goldmann, "Measuring Mahler."

22. Burton, *Leonard Bernstein*, 170.

23. Burton, 187.

24. See Kaiser, *Gay Metropolis*, 89–94.

25. Fishco, "Real-Life Drama behind 'West Side Story.'"

26. Lawrence, *Dance with Demons*, 375.

27. Lawrence, 190.

28. Jowitt, *Jerome Robbins*, 192–94, 284–85.

29. Jowitt, 375.

30. Lawrence, *Dance with Demons*, 284.

31. Burton, *Leonard Bernstein*, 204.

32. Burton, 209–10.

33. Gottlieb, *Working with Bernstein*, 267.

34. Kurzman, *Ben Gurion*, 335.

35. "Israeli Premier's First Official Declaration."

36. Burton, *Leonard Bernstein*, 199.

37. Burton, 232.

38. Burton, 281–82.

39. "Israel Ready to Defend Its Independence."

40. Bass, *Support Any Friend*, 53.

41. "Marilyn Monroe."

Chapter Four

1. Neff, *Warriors at Suez*, 124.

2. Ben-Zvi, *Decade of Transition*, 96, 189.

3. *New York Post*, July 2, 1959.

4. Silver, *Our Exodus*, 99, 246n2.

5. Silver, 99, 246n2.

6. Whitfield, "Israel as Reel," 314.

7. Uris, *Exodus*, 238–39.

8. Langman and Borg, *Encyclopedia of American War Films*, 185.

9. Moore, "*Exodus*: Reel to Real to Reel."

10. Pratley, *Cinema of Otto Preminger*, 135.

11. Whitfield, "Israel as Reel," 305.

12. Freund, "Israel Leon Uris Made."

13. Brinn, "Pat Boone's Christmas Present to the Jews."

14. Silver, *Our Exodus*, 100.

15. Gill, "Son of Kong."

16. Davis, *Like Young*, 11.

17. Goldman, "Mr. Sinatra Adored Israel."

18. Goldman.

19. Weiner, "When Old Blue Eyes Was 'Red.'"

20. Shaw, *Sinatra*, 84.

21. Goldman, "Mr. Sinatra Adored Israel."

22. Goldman.

23. Jacobs and Stadiem, *Mr. S*, 189.

24. Jacobs and Stadiem, 189.

25. Jacobs and Stadiem, 213.

26. Schoffman, "Robert Capa's Road to Jerusalem."

27. Magnum Photographers, *Israel, Fifty Years*, 1.

28. Ben-Zvi, *Decade of Transition*, 163n79.

29. On Byroade's opposition to Zionism, see "Byroade Inferentially Blames Israel."

30. Ben-Zvi, *Decade of Transition*, 47.

31. Scheinerman, "Israel Government and Politics."

32. Ben David Typescript, Houghton Library, Harvard College Library, 177.

33. Goldman, *Jewish-Christian Difference*, 36–38.

34. Ben David Typescript, 306.

35. Russo, "I Am Juanita."

36. Baldwin, "Harlem Ghetto."

37. Baldwin, *No Name in the Street*, 469.

38. Leeming, "James Baldwin," 130.

39. Baldwin, *Cross of Redemption*, 234.

40. Hardy, "James Baldwin as Religious Writer," 63.

41. Baldwin, *Cross of Redemption*, 234–35.

42. See Patten, *Israel and the Cold War*; and Curtis and Gitelson, *Israel in the Third World*.

43. Baldwin, *Cross of Redemption*, 243.

44. Leeming, "James Baldwin."

45. In Standley and Pratt, *Conversations with James Baldwin*, 85–86.

46. Baldwin, "Negroes Are Anti-Semitic."

47. Standley and Pratt, *Conversations with James Baldwin*, 149.

48. Baldwin, "Open Letter to the Born Again."

49. On Steinbeck's continuing popularity, see Rogers, "Bard for the Powerless."

50. Harmon, *John Steinbeck and Newsday*, 54.

51. Kreiger and Goldman, *Divine Expectations*, 155–66.

52. Harmon, *John Steinbeck and Newsday*, 54.

53. Harmon, 57.

54. Harmon, 57.

55. Parini, *John Steinbeck*, 469–70.

56. Atlas, *Bellow*, 369.

57. Atlas, 369–70.

58. Bellow, *It All Adds Up*, 206.

59. Bellow, 207.

60. Bellow, 208.

61. Bellow, 208.

62. Bellow, 209.

63. Howe, "People on the Edge of History."

64. Bellow, *To Jerusalem and Back*, 14.

65. Howe, "People on the Edge of History."

66. Bellow, *To Jerusalem and Back*, 127.

Chapter Five

1. Jenkins, "Auden at 100," 6.

2. Mendelson, *Later Auden*, 259.

3. Ansen, *Table Talk of W. H. Auden*, 86.

4. Mendelson, *Later Auden*, 3.

5. Mendelson, "European Auden," 66; Davenport-Hines, *Auden*, 336; Fuller, *W. H. Auden*, 515.

6. Fussell, "Poet Himself."

7. Mendelson, "Auden and God."

8. Jenkins, "Auden in America," 47.

9. Ansen, *Table Talk of W. H. Auden*, 32; Roberts, "W. H. Auden and the Jews," 87.

10. Roberts, "W. H. Auden and the Jews," 106n1.

11. Fuller, *W. H. Auden*, 515.

12. Farnan, *Auden in Love*, 65.

13. Roberts, "W. H. Auden and the Jews," 94.

14. Auden, *Complete Works of W. H. Auden*, 2:224–25.

15. Amichai, "Art of Poetry No. 44," 215.

16. Kronfeld, *Full Severity of Compassion*, 332.

17. Abramson, *Writings of Yehuda Amichai*, 92–93; Kronfeld, *Full Severity of Compassion*, 297n34, 332n63.

18. Amichai, "Art of Poetry No. 44," 217–18.

19. Amichai, 219.

20. Silk, *Fourteen Israeli Poets*, 16.

21. Amichai, "Art of Poetry No. 44," 221.

22. Ansen, *Table Talk of W. H. Auden*, 78.

23. Ansen, "With Wystan and Chester in Jerusalem."

24. Ansen.

25. Goldman, *Zeal for Zion*, 31.

26. van Crefeld, "Moshe Dayan, Vietnam, and Iraq."

27. Goldman, "Two Modern Israeli Prophets."

28. Kornberg, "Zionism and Ideology," 1.

29. Bergman, *Rise and Kill First*, 121.

30. On the continuing conflict between the Anti-Defamation League and dissenters on Israeli policy, see Rosen, "Respect Jewish Dissent on Israel."

31. Goldman, "Quashing Jewish Dissent on Israel."

32. See Kornberg, "Zionism and Ideology"; Alex Klein, "Before There Was J Street"; and Shattan, "Why Breira?"
33. For Palestinian interest in Breira, see the citations from the Israeli press quoted in "Breira Conference," 147–49.
34. Kornberg, "Zionism and Ideology," 104.
35. Staub, *Torn at the Roots*, 190.
36. For a survey of Fundamentalism and Zionism, see Goldman, *Zeal for Zion*, 289–308.
37. Berrigan, "Responses to Settler Regimes."
38. Fergenson, "Problem of Transcendental Politics," 114.
39. See the album liner notes for Cash, *My Mother's Hymn Book*.
40. Maudlin, "Be Careful What You Pray For."
41. Maudlin.
42. Yudkin, "Holy Land Headliners."
43. Holzer, *Psychic World of Bishop Pike*, chap. 4.
44. Maudlin, "Be Careful What You Pray For."
45. Yudkin, "Holy Land Headliners."
46. Yudkin.
47. Raab, *Five Families*, 100–101.
48. "Law of Return," *Encyclopedia Judaica* 1st ed. (Jerusalem: Keter, 1972), col. 1486.
49. Lazar, "Myer Lansky's Ghost Haunts My Visit to Miami Beach."
50. Lacey, *Little Man*, 347.
51. Lacey, 349.
52. See photograph of letter in Lacey, *Little Man*, 404.
53. Quoted in Lazar, "Myer Lansky's Ghost Haunts My Visit to Miami Beach."

Chapter Six

1. Gitell, "Night to Remember."
2. "Soul of the Holy Land."
3. Charles, "Quotes of Israel & Judaism."
4. "Ray Charles Bio."
5. Goldman, *Zeal for Zion*, 280.
6. Said and Hitchens, *Blaming the Victims*, 30.
7. Goldman, *Zeal for Zion*, 302.
8. Goldman, 295.
9. Goldman, 294.
10. McAlister, "Prophecy, Politics, and the Popular," 780.
11. Parsons, "Begin and the Evangelicals."
12. Goldman, *Zeal for Zion*, 301.
13. Evron, "Holocaust."
14. Heschel, *The Prophets*.
15. Leibowitz, *Judaism, Human Values, and the Jewish State*, 233.

16. Leibowitz, 238.
17. Leibowitz, 239.
18. Leibowitz, 211.
19. Margalit, "Prophets with Honor."
20. Waskow, *Bush Is Burning*, 72.
21. Goldman, "Two Modern Israeli Prophets."
22. Goldman.
23. Goldman.
24. Goldman.
25. Hertzberg, "Israel."
26. See Wright, *Thirteen Days in September.*
27. Wright, ix.
28. See Feldman, "Bombing of Osirak."
29. Shipler, "Prime Minister Begin Defends Raid."
30. Feldman, "Bombing of Osirak," 129.
31. Nakdimon, *First Strike*, 254.
32. Nakdimon, 254.
33. Oren, *Power, Faith, and Fantasy*, 552.
34. Silverberg, "International Law and the Use of Force," 63n161.
35. Raviv and Melman, *Spies against Armageddon.*
36. See Stone, *Damascus Gate*, for a fictional representation of Jerusalem Syndrome.
37. See "1993—Branch Davidians," chap. 4 in Wessinger, *How the Millennium Comes Violently*, 56–119.
38. Guinn, *Road to Jonestown.*
39. Uris, *Haj*, "Prelude 1922."
40. Uris, 5.
41. Uris, 82.
42. G. Meir, *As Good as Golda*, 28.
43. Kidd, *American Christians and Islam*, xi.
44. Peters, *From Time Immemorial*, 4.
45. Peters, 10.
46. Peters, back cover.
47. Peters, front cover.
48. Finkelstein, "Disinformation and the Palestine Question," 34.
49. Finkelstein, *Image and Reality*, 45.
50. Porath, "Mrs. Peter's Palestine."
51. Peters, *From Time Immemorial*, 159.
52. Roth, *Counterlife*, 147.
53. Roth, 147.
54. Roth, 75.
55. Goldman, *Zeal for Zion*, 13, 311n5; also see Goldman, *God's Sacred Tongue*, 176–98.
56. Goldman, *Zeal for Zion*, 44.

57. Allen, "Am I Reading the Papers Correctly?"
58. Bregman, *Cursed Victory*, 161.
59. Allen, "Am I Reading the Papers Correctly?"

Chapter Seven

1. Hoffman, "Just Call Me Esther."
2. Aaron Klein, "Egypt Bans Madonna."
3. "Welcome Esther."
4. Dan, *Heart and the Fountain*, 285n56.
5. Frankiel, *Kabbalah*, xv–xvi.
6. Y. Berg, *72 Names of God*.
7. K. Berg, *God Wears Lipstick*, 14.
8. "Israel Reels in Kabbalah Enthusiasts."
9. "Madonna: 'I Am an Ambassador for Judaism.'"
10. "Madonna Lights Shabbat Candles."
11. "Madonna and Tzipi Hang Out in Tel-Aviv."
12. Nahshoni, "Safed Rabbi."
13. Ashkenazi, "Mystical Madonna."
14. Steinberg, "Madonna Launches Tour."
15. "Madonna in Tel-Aviv."
16. Hiat, "Live to Tell."
17. Hiat.
18. Hiat.
19. Sharif, *Eternal Male*, 67.
20. Edwards, *Streisand*, 184–85.
21. Edwards, 185.
22. Edwards, 416.
23. Edwards, 398.
24. Borsten, "Streisand Dedicates Building in Israel."
25. Chabin, "Streisand Wows Israelis."
26. Chabin.
27. Olupona, review of *Thin Description*, 872.
28. Kestenbaum, "Ben Ami Ben Israel's Spiritual Journey."
29. Ben-Tovim, "In Israel, Whitney Houston Remembered."
30. Ephron, *Killing a King*, 174.
31. Hagee, *Final Dawn over Jerusalem*, 33.
32. Hagee, *Jerusalem Countdown*, 24.
33. Hagee, 1–2.
34. Forbes and Kilde, *Rapture, Revelation, and the End Times*, 7.
35. Goldman, *Zeal for Zion*, 293.
36. Forbes and Kilde, *Rapture, Revelation, and the End Times*, 133.

37. "Stevie Wonder in Israel for Concerts."
38. "Stevie Wonder to Reportedly Pull Out of Friends of IDF Gig."
39. "With 'a Heavy Heart,' Stevie Wonder Pulls Out of Friends of the IDF Concert."
40. Vulliamy, "Bridging the Gap, Part Two."
41. Vulliamy.
42. Barenboim and Said, *Parallels and Paradoxes*, 9–10.
43. Barenboim and Said, 10.
44. Barenboim and Said, 11.
45. Bregman, *History of Israel*, 275–76.
46. Personal communication, September 20, 2001.
47. Gorenberg, *Accidental Empire*, 373.
48. Judt, *Reappraisals*, 282.
49. Judt, 284.
50. Judt and Snyder, *Thinking the Twentieth Century*, 117–18.
51. Judt and Snyder, 118.
52. Bronner, "Jews, Arabs and Jimmy Carter."
53. Balmer, *Redeemer*, 172.
54. Powell, "Jimmy Carter's 'Peace' Mission."
55. Stein, "My Problem with Jimmy Carter's Book."
56. Stein, 6.
57. "Carter Defends 'Apartheid Book.'"
58. Balmer, *Redeemer*, 173.
59. Alterman, "Motzira."
60. Tutu, "Of Occupation and Apartheid."
61. Higgins, "John Berger Rallies Artists."
62. Dodd and McCarthy, "Elvis Costello Cancels Concerts."
63. Staff and Kamin, "Scarlett Johansson Rejects Criticism."
64. Child, "Scarlett Johansson Steps Down."
65. Tharoor, "Why Scarlet Johansson's SodaStream Is Leaving."
66. Sherwood and Kalman, "Stephen Hawking Joins Academic Boycott of Israel."
67. Burston, "Bob Dylan, It Turns Out, Does Live in Israel."
68. Freidman, "Bob Dylan's Forgotten Pro-Israel Song."
69. "Bob Dylan Will You Heed the Call?"
70. Burston, "Bob Dylan, It Turns Out, Does Live in Israel."
71. Kamin, "Bob Dylan's Life and Work Examined."
72. Michaels, "Paul McCartney Promises Israel Gig Will Go Ahead."
73. O'Loughlin, "Truth after 42 Years."
74. "Paul McCartney Performs First Israel Concert."
75. McSmith, "Israel Lets It Be."
76. "Paul McCartney Performs First Israel Concert."
77. "Paul McCartney Wins Israel's Prestigious Wolf Prize."
78. Steinberg, "Beatles Drummer Ringo Starr to Hit Tel Aviv."

79. Kozinn, "Klinghoffer Daughters Protest Opera."

80. Torossian, "Metropolitan Opera Romanticizes One NYer's Murder."

81. Cooper, "Met Opera Cancels Simulcast of 'Klinghoffer.'"

82. Cooper, "Protests Greet Metropolitan Opera's Premiere of 'Klinghoffer.'"

83. Pfeffer, *Bibi*, 259.

84. "Netanyahu Sends Christmas Greeting."

Epilogue

1. Saval, "Israeli TV Makes Huge Inroads Stateside."

2. On BDS and Israeli TV, see Brown, "How Israel Became a Television Powerhouse."

3. Goldman, "Christians and Zionism."

4. Goldman.

5. Lovett, "Christians Push Israel Shift."

6. "White House Says Improved Ties with Israel Show U.S. More 'Beloved.'"

7. Freedland, "Trump's Chaver in Jerusalem."

8. Pfeffer, *Bibi*, 67.

BIBLIOGRAPHY

Manuscripts

Elmer L. Anderson Library, Minneapolis, Minn.
　　Kautz Family YMCA Archives
　　Records of YMCA International Work in Israel and Palestine
Liddell Hart Centre for Military Archives, Kings College, London
　　FM Edmund (Henry Hynman) Allenby, 1st Viscount Allenby of Megiddo
　　　　(1861–1936), Speeches, lectures, and articles (1925–1936)
Houghton Library, Harvard College Library, Cambridge, Mass.
　　Ruth Ben David, Typescript
Middlebury College, Middlebury, Vt.
　　Pliny Fisk Papers

Published Sources

Abramson, Glenda. *The Writings of Yehuda Amichai: A Thematic Approach.* SUNY Series
　　in Modern Jewish Literature and Culture. Albany: State University of New York Press,
　　1989.
Abu El-Haj, Nadia. *Facts on the Ground: Archaeological Practice and Territorial Self-
　　Fashioning in Israeli Society.* Chicago: University of Chicago Press, 2001.
Allen, Woody. "Am I Reading the Papers Correctly?" *New York Times,* January 28, 1988,
　　op-ed page.
Alterman, Eric. "Motzira—Making on the Right: The Politics of Tenure at Barnard
　　and Beyond." *Nation,* April 17, 2008. https://www.thenation.com/article/motzira
　　-making-right/.
Amichai, Yehuda. "The Art of Poetry No. 44." Interview by Lawrence Joseph. *Paris
　　Review,* no. 122 (Spring 1992).
Anderson, Elliot, ed. "Contemporary Israeli Literature." Special issue, *Triquarterly* 39
　　(Spring 1997).
Ansen, Alan. *The Table Talk of W. H. Auden.* New York: Seacliff Press, 1989.
———. "With Wystan and Chester in Jerusalem." *W. H. Auden Society Newsletter,* no. 16
　　(May 1997). http://audensociety.org/16newsletter.html#P63_24604.
Arendt, H., and J. Magnes. *Commentary,* October 1948.
Ashkenazi, Eli. "Mystical Madonna Visits Safed Tomb of Kabbalistic Great." *Haaretz,*
　　April 9, 2009. https://www.haaretz.com/1.5469210.
Atlas, James. *Bellow: A Biography.* New York: Random House, 2000.

Auden, W. H. *Collected Poems*. Edited by Edward Mendelson. New York: Random House, 1976.

———. *The Complete Works of W. H. Auden*. Vol. 2, *Prose: 1939–1948*. Edited by Edward Mendelson. Princeton, N.J.: Princeton University Press, 2002.

Baldwin, James. *The Amen Corner*. New York: Dial Press, 1968.

———. *The Cross of Redemption: Uncollected Writings*. New York: Pantheon, 2010.

———. *The Fire Next Time*. New York: Vintage, 1991.

———. "The Harlem Ghetto: Winter 1948." *Commentary*, February 1, 1948. https://www.commentarymagazine.com/articles/from-the-american-scene-the-harlem-ghetto-winter-1948/.

———. "Negroes Are Anti-Semitic Because They're Anti-White." *New York Times Magazine*, April 9, 1967.

———. *No Name in the Street*. New York: Vintage, 2007.

———. "Open Letter to the Born Again: Sometimes, Our Best Efforts at Peace Are Betrayed." *Nation*, September 29, 1979. https://www.thenation.com/article/open-letter-born-again/.

Balmer, Randall. *Redeemer: The Life of Jimmy Carter*. New York: Basic Books, 2014.

Banks, Louis A., ed. *T. DeWitt Talmage: His Life and Work*. Philadelphia: John C. Winston, 1902.

Barenboim, Daniel, and Edward W. Said. *Parallels and Paradoxes: Explorations in Music and Society*. Edited by Ara Guzelimian. New York: Vintage Books, 2002.

Bar-Zohar, Michael. *Ben Gurion: A Biography*. New York: Delacorte Press, 1979.

Bass, Warren. *Support Any Friend: Kennedy's Middle East and the Making of the U.S.-Israel Alliance*. Oxford: Oxford University Press, 2003.

Bellow, Saul. *It All Adds Up: From the Dim Past to the Uncertain Future*. New York: Viking, 1994.

———. *To Jerusalem and Back: A Personal Account*. New York: Penguin Books, 1998.

Ben-Tovim, Ron. "In Israel, Whitney Houston Remembered for Huge Voice and One Strange Visit." *Haaretz*, February 12, 2012. https://www.haaretz.com/israel-news/culture/1.5184609.

Bentwich, Norman. *For Zion's Sake: A Biography of Judah L. Magnes*. Philadelphia: Jewish Publication Society of America, 1954.

Ben-Zvi, Abraham. *Decade of Transition: Eisenhower, Kennedy, and the Origins of the American-Israeli Alliance*. New York: Columbia University Press, 1996.

Berg, Karen. *God Wears Lipstick: Kabbalah for Women*. New York: Kabbalah, 2005.

Berg, Yehuda. *The 72 Names of God: Technology for the Soul*. New York: Kabbalah, 2004.

Bergman, Ronen. *Rise and Kill First: The Secret History of Israel's Targeted Assassinations*. New York: Random House, 2018.

Bernstein, Leonard. *The Leonard Bernstein Letters*. Edited by Nigel Simeone. New Haven, Conn.: Yale University Press, 2013.

Berrigan, Daniel. "Responses to Settler Regimes." *Mondoweiss: News Opinion About Palestine, Israel, and the United States*, September 2, 2016. http://mondoweiss.net/2016/09/berrigans-prophecy-becoming/.

Black, Ian, and Benny Morris. *Israel's Secret Wars: A History of Israel's Intelligence Services.* New York: Grove Press, 1991.

Blumenthal, Ralph. "Daniel Berrigan's Speech to Arabs Stirs a Furor over Award." *New York Times*, December 16, 1973. http://www.nytimes.com/1973/12/16/archives/daniel -berrigans-speech-to-arabs-stirs-a-furor-over-award-released.html?_r=0.

"Bob Dylan Will You Heed the Call?" BDS Boycott. Accessed February 16, 2018. http:// www.boycottisrael.info/content/bob-dylan-will-you-heed-call.

Borsten, Joan. "Streisand Dedicates Building in Israel in Father's Name." *Barbra Streisand Archives Library*, April 4, 1984. http://barbra-archives.com/bjs_library/80s/israel _dedicates_building.html.

Bregman, Ahron. *Cursed Victory: Israel and the Occupied Territories; A History.* New York: Pegasus Books, 2015.

———. *A History of Israel.* Palgrave Macmillan, 2002.

"The Breira Conference." *Journal of Palestine Studies* 6, no. 4 (Summer 1977): 147–49.

Breitman, Richard, and Allan J. Lichtman. *FDR and the Jews.* Cambridge, Mass.: Belknap Press, 2013.

Brinn, David. "Pat Boone's Christmas Present to the Jews." *Jerusalem Post*, February 10, 2010. http://www.jpost.com/Arts-and-Culture/Music/Pat-Boones-Christmas-present -to-the-Jews-168341.

Bronner, Ethan. "Jews, Arabs and Jimmy Carter." *New York Times*, January 7, 2007. http://www.nytimes.com/2007/01/07/books/review/Bronner.t.html.

Brown, Hannah. "How Israel Became a Television Powerhouse." *Commentary*, June 2018.

Brownfeld, Allan C. "Israel Has Abandoned Ben-Gurion's Assurance That American Jews Are 'Americans.'" *Washington Report on Middle Eastern Affairs*, June–July 2013, 47–48. https://www.wrmea.org/2013-june-july/israel-and-judaism-israel-has-abandoned-ben -gurions-assurance-that-american-jews-are-americans.html.

———. "Redefining Anti-Semitism: An Effort to Silence Criticism of Israel." *Issues of the American Council for Judaism* (Winter 2018). http://www.acjna.org/acjna/articles _detail.aspx?id=2690.

Buber, Martin. "Letter to Mahatma Gandhi, February 24, 1939." *Jewish Virtual Library*, http://www.jewishvirtuallibrary.org/letter-from-martin-buber-to-gandhi.

Burston, Bradley. "Bob Dylan, It Turns Out, Does Live in Israel." *Haaretz*, June 21, 2011. https://www.haaretz.com/bob-dylan-it-turns-out-does-live-in-israel-1.5023083.

Burton, Humphrey. *Leonard Bernstein.* New York: Doubleday, 1994.

"Byroade Inferentially Blames Israel for Middle East Tension." Jewish Telegraphic Agency, April 12, 1954. https://www.jta.org/1954/04/12/archive/byroade-inferentially-blames -israel-for-middle-east-tension.

Cain, Seymour. "Berrigan, Buber, and the 'Settler State.'" *Christian Century*, June 26, 1974, 664–68. https://www.religion-online.org/article/berrigan-buber-and-the-settler -state/.

"Carter Defends 'Apartheid Book,' Says Attack on Character Hurt." *Haaretz*, January 24, 2007. https://www.haaretz.com/1.4953804.

Carter, Jimmy. *Palestine: Peace Not Apartheid.* New York: Simon and Schuster, 2006.

Cash, Johnny. *My Mother's Hymn Book*. Audio CD and liner notes. American Recordings, 2004.

Chabin, Michele. "Streisand Wows Israelis, Makes Headline for Segregation Stand." *USA Today*, June 21, 2013. https://www.usatoday.com/story/news/world/2013/06/21 /streisand-israel-concert-jewish-roots/2445991/.

Charles, Ray. "Quotes on Israel & Judaism." *Jewish Virtual Library*. Accessed February 15, 2018. http://www.jewishvirtuallibrary.org/ray-charles-quotes-on-judaism-and-israel.

Child, Ben. "Scarlett Johansson Steps Down from Oxfam Ambassador Role." *Guardian*, January 20, 2014. https://www.theguardian.com/film/2014/jan/30/scarlett-johansson -oxfam-quits-sodastream.

Chomsky, Noam, and Ilan Pappé. *On Palestine*. Chicago: Haymarket Books, 2015.

Cohen, Mitchell. "Going Under with Klinghoffer." *Jewish Review of Books*, Spring 2015. https://jewishreviewofbooks.com/articles/1609/going-under-with-klinghoffer/.

Cooper, Michael. "Met Opera Cancels Simulcast of 'Klinghoffer.'" *New York Times*, June 17, 2014. https://www.nytimes.com/2014/06/18/arts/music/met-opera-cancels -telecast-of-klinghoffer.html.

———. "Protests Greet Metropolitan Opera's Premiere of 'Klinghoffer.'" *New York Times*, October 20, 2014. https://www.nytimes.com/2014/10/21/arts/music/metropolitan -opera-forges-ahead-on-klinghoffer-in-spite-of-protests.html?_r=0.

Copland, Aaron. "A Visit to Israel." *Boosey and Hawkes Newsletter*, no. 3 (Spring 1969): 13–14.

Curtis, Michael, and Susan A. Gitelson, eds. *Israel in the Third World*. Brunswick, N.J.: Transaction, 1976.

Dan, Joseph, ed. *The Heart and the Fountain: An Anthology of Jewish Mystical Experience*. New York: Oxford University Press, 2002.

Davenport-Hines, Richard. *Auden*. New York: Vintage: 1999.

Davis, Francis. *Like Young: Jazz, Pop, Youth, and Middle Age*. Cambridge, Mass.: Da Capo Press, 2001.

Dodd, Vikram, and Rory McCarthy. "Elvis Costello Cancels Concerts in Israel in Protest at Treatment of Palestinians." *Guardian*, May 18, 2010. https://www.theguardian.com /music/2010/may/18/elvis-costello-cancels-israel-concerts.

Doran, Michael. *Ike's Gamble: America's Rise to Dominance in the Middle East*. New York: Free Press, 2016.

Dudman, Helga, and Ruth Kark. *The American Colony: Scenes from a Jerusalem Saga*. Jerusalem: Rubin Mass, 1998.

Edwards, Anne. *Streisand: A Biography*. Lanham, Md.: Taylor Trade Publishing, 1996.

"1891 Blackstone Memorial." Archives of the Billy Graham Center, Wheaton College. http://www2.wheaton.edu/bgc/archives/docs/BlackstoneMemorial/1891A.htm.

Ephron, Dan. *Killing a King: The Assassination of Yitzhak Rabin and the Remaking of Israel*. New York: W. W. Norton, 2015.

Evron, Boas. "Holocaust: The Uses of Disaster." *Radical America* 17, no. 4 (July–August 1983): 7–21. https://libcom.org/files/Rad%20America%20V17%20I4.pdf.

Farnan, Dorothy. *Auden in Love: The Intimate Story of a Lifelong Love Affair*. New York: Meridian, 1984.

Feldman, Shai. "The Bombing of Osirak—Revisited." *International Security* 7, no. 2 (Fall 1982): 114–42.

Fergenson, Laraine. "Thoreau, Daniel Berrigan, and the Problem of Transcendental Politics." *Soundings: An Interdisciplinary Journal* 65, no. 11 (Spring 1982): 103–22.

Field, Douglas, ed. *A Historical Guide to James Baldwin*. New York: Oxford University Press, 2009.

Fink, Robert. "Klinghoffer in Brooklyn Heights." *Cambridge Opera Journal* 17, no. 2 (July 2005): 173–213.

Finkelstein, Norman G. "Disinformation and the Palestine Question: The Not-So-Strange Case of Joan Peter's *From Time Immemorial*." In *Blaming the Victims: Spurious Scholarship and the Palestinian Question*, edited by Edward Said and Christopher Hitchens, 33–68. Verso, 1988.

———. *Image and Reality of the Israel-Palestine Conflict*. London: Verso, 1995.

Finley, J. *A Pilgrim in Palestine: Being an Account of Journeys on Foot by the First American Pilgrim after General Allenby's Recovery of the Holy Land*. Scribner's Sons, 1919.

Fischer, Louis. *The Life of Mahatma Gandhi*. New York: Harper Collins, 1950.

Fishco, Sara. "The Real-Life Drama behind 'West Side Story.'" *NPR*, January 7, 2009. https://www.npr.org/2011/02/24/97274711/the-real-life-drama-behind-west-side-story.

FitzGerald, Frances. *The Evangelicals: The Struggle to Shape America*. New York: Simon and Schuster, 2017.

Forbes, Bruce D., and Jeanne H. Kilde. *Rapture, Revelation, and the End Times: Exploring the Left Behind Series*. New York: Palgrave Macmillan, 2004.

Ford, Alexander H. "Our American Colony at Jerusalem." *Appleton's Magazine* 8, no. 6 (December 1906): 643–55. https://www.loc.gov/resource/mamcol.031/?sp=1.

Frankiel, Tamar. *Kabbalah: A Brief Introduction for Christians*. Woodstock, Vt.: Jewish Lights, 2006.

Fraser, T. G. *The Arab-Israeli Conflict*. New York: Palgrave Macmillan, 2007.

Freedland, Jonathan. "Trump's Chaver in Jerusalem." *New York Review of Books*, August 16, 2018.

Freidman, Gabe. "Bob Dylan's Forgotten Pro-Israel Song, Revisited." *Times of Israel*, May 24, 2016. https://www.timesofisrael.com/bob-dylans-forgotten-pro-israel-song -revisited/.

Freund, C. P. "The Israel Leon Uris Made." *Daily Star* (Beirut), July 15, 2003.

Frischauer, Willi. *Behind the Scenes of Otto Preminger*. New York: Morrow, 1974.

Fuller, John. *W. H. Auden: A Commentary*. London: Faber and Faber, 2007.

Fussell, Paul. "The Poet Himself." *New York Times*, October 4, 1981. http://www.nytimes .com/1981/10/04/books/the-poet-himself.html.

Gabler, Neal. *An Empire of Their Own: How the Jews Invented Hollywood*. New York: Anchor Books, 1988.

Gandhi, Mohandas K. "Interview to *The Daily Herald*, March 16, 1921." *Jewish Virtual*

Library. http://www.jewishvirtuallibrary.org/interview-to-the-daily-herald-london-by -gandhi-march-1921.

———. "The Jews." *Harijan*, November 26, 1938. *Jewish Virtual Library*. http://www .jewishvirtuallibrary.org/lsquo-the-jews-rsquo-by-gandhi.

———. "Some Questions Answered." *Harijan*, December 17, 1938. *Jewish Virtual Library*. http://www.jewishvirtuallibrary.org/some-questions-answered-by-gandhi -december-1938.

Gardner, Brian. *Allenby of Arabia, Lawrence's General*. New York: Coward-McCann, 1966.

Geniesse, Jane Fletcher. *American Priestess: The Extraordinary Story of Anna Spafford and the American Colony in Jerusalem*. New York: Doubleday, 2008.

"German Invitation Refused by Dancer: Martha Graham Declines to Go to Represent United States at International Festival." *New York Times*, March 13, 1936.

Gill, Brendan. "Son of Kong." *New Yorker*, April 9, 1966, 88–91.

Ginsburg, Mitch. "Less Awe Than Shucks for the Holy Land's First US Visitors." *Times of Israel*, July 4, 2014. https://www.timesofisrael.com/from-melville-to-roosevelt-to-twain -celebrating-the-holy-lands-first-americans/.

Gitell, Seth. "A Night to Remember: Thirty Years Ago Golda and Barbra Made Nice in Prime Time." *Tablet Magazine*, May 28, 2008. http://www.tabletmag.com/jewish -arts-and-culture/1292.

Godfrey, Lionel. *Paul Newman: Superstar*. London: Robert Hale, 1978.

Goldman, Shalom. "Christians and Zionism: A Review Essay." *American Jewish History* 93, no. 2 (June 2007): 245–60.

———. *God's Sacred Tongue*. Chapel Hill: University of North Carolina Press, 2004.

———. "The Holy Land Appropriated: The Careers of Selah Merrill, Nineteenth Century Christian Hebraist, Palestine Explorer, and U.S. Consul in Jerusalem." *American Jewish History* 85, no. 2 (June 1997): 152–72.

———. *Jewish-Christian Difference and Modern Jewish Identity: Seven Twentieth-Century Converts*. Lanham, Md.: Lexington Books, 2015.

———. "Mr. Sinatra Adored Israel, and Israel Adored Him Back." *Tablet Magazine*, May 14, 2015. http://www.tabletmag.com/jewish-arts-and-culture/music/190959 /sinatra-israel.

———. "Quashing Jewish Dissent on Israel." *Informed Comment: Thoughts on the Middle East, History and Religion*, July 15, 2014. https://www.juancole.com/2014/07/quashing -jewish-dissent.html.

———. "Two Modern Israeli Prophets—And Their Unheeded Warnings." *Shalom Center*, September 8, 2001. https://theshalomcenter.org/node/47.

———. *Zeal for Zion*. Chapel Hill: University of North Carolina Press, 2009.

Goldmann, A. J. "Measuring Mahler, in Search of a Jewish Temperament." *Forward.com*, July 7, 2010.

Goodwin, Doris Kerns. *The Fitzgeralds and the Kennedys*. New York: St. Martin's Press, 1987.

Goren, Arthur A. *Dissenter in Zion: From the Writing of Judah L. Magnes*. Cambridge, Mass.: Harvard University Press, 1982.

Gorenberg, Gershon. *The Accidental Empire: Israel and the Birth of the Settlements, 1967–1977*. New York: Henry Holt, 2006.

Gottlieb, Jack. *Working with Bernstein*. Milwaukee, Wis.: Amadeus Press, 2010.

Gray, Michael. *The Bob Dylan Encyclopedia*. New York: Continuum, 2006.

Greenberg, Hayim. "Address Delivered at Memorial for Gandhi, February 1, 1948." *Jewish Virtual Library*. http://www.jewishvirtuallibrary.org/address-by-hayim -greenberg-at-a-memorial-for-gandhi-in-new-york-february-1948.

———. "A Letter to Gandhi." *Jewish Virtual Library*. http://www.jewishvirtuallibrary .org/a-letter-to-gandhi-by-hayim-greenberg-1937.

Guinn, Jeff. *The Road to Jonestown: Jim Jones and the Peoples Temple*. New York: Simon and Schuster, 2017.

Hagee, John. *Final Dawn over Jerusalem*. Nashville, Tenn.: Thomas Nelson, 1999.

———. *Jerusalem Countdown: A Warning to the World*. Lake Mary, Fla.: FrontLine, 2006.

Hamilton, Nigel. *J. F. K.: Reckless Youth*. New York: Random House, 1992.

Hardy, Clarence E., III. "James Baldwin as Religious Writer: The Burdens and Gifts of Black Evangelicalism." In *A Historical Guide to James Baldwin*, edited by Douglas Field, 61–82. New York: Oxford University Press, 2009.

Harkabi, Yehoshafat. *Israel's Fateful Hour*. New York: Harper and Row, 1988.

Harmon, Robert Bartlett. *John Steinbeck and Newsday, with a Focus on "Letters to Alecia": An Annotated and Documented Reference Guide*. New York: R. B. Harmon, 1999.

Hauzer, Katarzyna. "So This Is Peace?: The Postwar Ventures by John Steinbeck, Irwin Shaw, and Robert Capa." *Ad Americam* 14 (2013): 51–62.

Hecht, Ben. *A Child of the Century*. New York: Simon and Schuster, 1954.

Hertzberg, Arthur. "Israel: The Tragedy of Victory." *New York Review of Books*, May 28, 1987. http://www.nybooks.com/articles/1987/05/28/israel-the-tragedy-of-victory/.

Heschel, Abraham Joshua. *The Prophets*. Philadelphia: Jewish Publication Society, 1962.

Heyrman, Christine Leigh. *American Apostles: When Evangelicals Entered the World of Islam*. New York: Hill and Wang, 2015.

Hiat, Brian. "Live to Tell . . . an Exclusive Interview with Madonna." *Independent.ie*, March 23, 2015. https://www.independent.ie/entertainment/music/live-to-tell-an -exclusive-interview-with-madonna-31074485.html.

Higgins, Charlotte. "John Berger Rallies Artists for Cultural Boycott of Israel." *Guardian*, December 14, 2006. https://www.theguardian.com/uk/2006/dec/15/israel.booksnews.

Hirst, David. *The Gun and the Olive Branch*. London: Faber and Faber, 1984.

Hobson, Fred. *Mencken: A Life*. New York: Random House, 1994.

Hoffman, Bill. "Just Call Me Esther—Madonna Takes Old Hebrew Name." *New York Post*, June 17, 2004. https://nypost.com/2004/06/17/just-call-me-esther-madonna-takes -old-hebrew-name/.

Holmes, Reed M. *The Forerunners: The Tragic Story of 156 Down-East Americans Led to*

Jaffa in 1866 by Charismatic G. J. Adams to Plant the Seeds of Modern Israel. Independence, Mo.: Herald Publishing House, 1981.

Holzer, Hans. *The Psychic World of Bishop Pike.* New York: Pyramid, 1971.

Howe, Irving. "People on the Edge of History: Saul Bellow's Vivid Report on Israel." *New York Times Book Review,* October 17, 1976. http://www.nytimes.com/books/00/04/23 /specials/bellow-jerusalem.html.

Hyde, Orson. *A Voice from Jerusalem, or A Sketch of the Travels and Ministry of Elder Orson Hyde, Missionary of the Church of Jesus Christ of Latter-Day Saints, to Germany, Constantinople, and Jerusalem.* Liverpool: P. P. Pratt, 1842.

"Israel Ready to Defend Its Independence." *Jewish Telegraphic Agency,* February 25, 1958.

"Israel Reels in Kabbalah Enthusiasts." *Religion News Blog,* July 26, 2007. http://www .religionnewsblog.com/18840/kabbalah-2.

"Israeli Premier's First Official Declaration Clarifying Relationships between Israel and Jews in the United States and Other Free Democracies." *American Jewish Committee,* September 10, 1950. http://www.ajcarchives.org/AJC_DATA/Files/508.PDF.

Jacobs, George, and William Stadiem. *Mr. S: My Life with Frank Sinatra.* New York: Harper Collins, 2003.

Jenkins, Nicholas. "Auden in America." *The Cambridge Companion to W. H. Auden,* edited by Stan Smith, 39–54. Cambridge: Cambridge University Press, 2004.

———. "Historical as Munich—Auden at 100: Who Is He Now?" *Times Literary Supplement,* February 9, 2007, 12–15.

"Joseph P. Kennedy." John F. Kennedy Presidential Library and Museum. Accessed February 24, 2018. https://www.jfklibrary.org/JFK/The-Kennedy-Family/Joseph-P-Kennedy .aspx.

Jowitt, Deborah. *Jerome Robbins: His Life, His Theater, His Dance.* New York: Simon and Schuster, 2004.

Judt, Tony. *Reappraisals: Reflections of the Forgotten Twentieth Century.* New York: Penguin Group, 2008.

Judt, Tony, and Timothy Snyder. *Thinking the Twentieth Century.* New York: Penguin Group, 2012.

Kahn, Sholom J. "Cedars of Lebanon: Herman Melville in Jerusalem." *Commentary* 23 (February 1957): 167–72. https://www.commentarymagazine.com/articles/cedars -of-lebanon-herman-melville-in-jerusalem/.

Kaiser, Charles. *The Gay Metropolis: The Landmark History of Gay Life in America.* New York: Grove Press, 1997.

Kallman, Chester. "The Dome of the Rock: Jerusalem (1970)." *New York Review of Books,* December 12, 1974.

Kamin, Debra. "Bob Dylan's Life and Work Examined in New Israeli Exhibit." *Times of Israel,* April 23, 2016. https://www.timesofisrael.com/bob-dylans-life-and-work -examined-in-new-israeli-exhibit/.

Kaplan, Justin. *Mr. Clemens and Mark Twain: A Biography.* New York: Simon and Schuster, 1966.

Katz, Emily. *Bringing Zion Home: Israel in American Jewish Culture.* Albany: State University of New York Press, 2016.

Katz, Samuel. *Battleground: Fact and Fantasy in Palestine.* New York: Bantam Books, 1985.

Kazin, Alfred. *God and the American Writer.* New York: Knopf, 1997.

"Kennedy and Bradford Condemn U.S. Policy on Palestine." *Christian Science Monitor,* April 5, 1948. Shapell Manuscript Foundation. http://www.shapell.org/manuscript /jfk-partition-plan-1948-truman.

Kennedy, Robert. "British Hated by Both Sides: Struck by Antipathy Shown by 'Arabs and Jews.'" *Boston Post,* June 1948. *Jewish Virtual Library.* http://www.jewishvirtual library.org/quot-british-hated-by-both-sides-antipathy-shown-by-lsquo-arabs-and-jews -rsquo-quot.

Kestenbaum, Sam. "Ben Ami Ben Israel's Spiritual Journey from Segregated Chicago to Negev Desert." *Forward,* December 31, 2014. https://forward.com/news/israel/211907 /ben-ammi-ben-israels-spiritual-journey-from-segreg/.

Kidd, Thomas S. *American Christians and Islam: Evangelical Culture and Muslims from the Colonial Period to the Age of Terrorism.* Princeton, N.J.: Princeton University Press, 2013.

Klatzker, David. "British Jerusalem in the News." *Middle East Quarterly* 1, no. 4 (December 1994). http://www.meforum.org/198/british-jerusalem-in-the-news.

Klein, Aaron. "Egypt Bans Madonna after Israel Visit: Cairo's Exclusion Order Seen as Routine Vilification of Jewish State." *WND (WorldNetDaily),* September 24, 2004. http://www.wnd.com/2004/09/26721/.

Klein, Alex. "Before There Was J Street, There Was Breira." *Tablet Magazine,* March 23, 2012. http://www.tabletmag.com/jewish-news-and-politics/94906/j-streets-forerunner.

Knowles, Calvin. "No Ordinary Orchestra—In War and in Peace, the Israel Philharmonic Plays On." *Jewish Journal,* January 25, 2007. http://jewishjournal.com/culture /music/14337/.

Kolatt, I., Jehuda Reinharz, and Anita Shapira. "The Zionist Movement and the Arabs." In *Essential Papers on Zionism,* edited by Jehuda Reinharz and Anita Shapira, 617–47. New York: New York University Press, 1996.

Kornberg, Jacques. "Zionism and Ideology: The Breira Controversy." *Judaism* 27, no. 1 (Winter 1978): 103–14.

Kotzin, Daniel. *Judah L. Magnes: An American Jewish Nonconformist.* Syracuse, N.Y.: Syracuse University Press, 2010.

Kozinn, Alan. "Klinghoffer Daughters Protest Opera." *New York Times,* September 11, 1991. http://www.nytimes.com/1991/09/11/arts/klinghoffer-daughters-protest-opera .html.

Kramer, Martin. "Special Relationships." *Sandbox,* December 3, 2013. http://martin kramer.org/sandbox/tag/john-f-kennedy/.

Kreiger, Barbara. *Divine Expectations: An American Woman in 19th-Century Palestine.* With Shalom Goldman. Athens: Ohio University Press, 1999.

Kronfeld, Chana. *The Full Severity of Compassion: The Poetry of Yehuda Amichai*. Stanford Studies in Jewish History and Culture. Stanford, Calif.: Stanford University Press, 2016.

Kurth, Peter. *American Cassandra: The Life of Dorothy Thompson*. New York: Little, Brown, 1990.

Kurzman, Ben. *Ben Gurion: Prophet of Fire*. New York: Simon and Schuster, 1983.

Lacey, Robert. *Little Man: Meyer Lansky and the Gangster Life*. New York: Little, Brown, 1991.

Langman, Larry, and Ed Borg. *Encyclopedia of American War Films*. Garland Reference Library of the Humanities. New York: Garland, 1989.

Laqueur, Walter. *A History of Zionism*. New York: Holt, Rinehart and Winston, 1972.

Laqueur, Walter, and Barry Rubin. *The Israel-Arab Reader: A Documentary History of the Middle East Conflict*. 8th rev. ed. New York: Penguin Books, 2016.

Lawrence, Greg. *Dance with Demons: The Life of Jerome Robbins*. New York: G. P. Putnam's Sons, 2001.

Lazar, Zachary. "Myer Lansky's Ghost Haunts My Visit to Miami Beach." *Tablet Magazine*, April 14, 2014. http://www.tabletmag.com/jewish-arts-and-culture/books/169279/my-hunt-for-meyer-lansky.

Lebor, Adam. *City of Oranges: An Intimate History of Arabs and Jews in Jaffa*. New York: W. W. Norton, 2007.

Leeming, David. "James Baldwin: Voyages in Search of Love." *James Baldwin Review* 1 (2015): 130–39. https://jbr.openlibrary.manchester.ac.uk/index.php/jbr/article/view/7/7>.

Leibowitz, Yeshayahu. *Judaism, Human Values, and the Jewish State*. Edited by Eliezer Goldman. Cambridge, Mass.: Harvard University Press, 1992.

Levi, Lawrence. "A Fine Mess: How a Filmmaker Turned His Movie Flop into a Groundbreaking Book." *Tablet Magazine*, April 13, 2007. http://www.tabletmag.com/jewish-arts-and-culture/1234/a-fine-mess.

Liebman, C. "Diaspora Influence on Israel: The Ben-Gurion: Blaustein 'Exchange' and Its Aftermath." *Jewish Social Studies* 36, nos. 3–4 (July–October 1974): 271–80.

Lovett, Ian. "Christians Push Israel Shift." *Wall Street Journal*, December 8, 2017.

"Madonna: 'I Am an Ambassador for Judaism.'" *UPI*, September 17, 2007. https://www.upi.com/Madonna-I-am-an-ambassador-for-Judaism/28841190053178/.

"Madonna Lights Shabbat Candles with Netanyahu Family in Jerusalem." *Jerusalem Post*, September 4, 2009. http://www.jpost.com/Breaking-News/Madonna-lights-Shabbat-candles-with-Netanyahu-family-in-Jerusalem.

"Madonna in Tel-Aviv: Israel Is the Energy Center of the World." *Haaretz*, September 1, 2009. https://www.haaretz.com/1.5098260.

"Madonna and Tzipi Hang Out in Tel-Aviv." *Ynetnews*, September 1, 2009. https://www.ynetnews.com/articles/0,7340,L-3770121,00.html.

Magnes, J. L., and Martin Buber. *Two Letters to Gandhi from Martin Buber and J. L. Magnes*. Jerusalem: Rubin Mass, 1939.

Magnum Photographers. *Israel, Fifty Years: As Seen by Magnum Photographers*. New York: Aperture, 1998.

Margalit, Avishai. "Prophets with Honor." *New York Review of Books*, November 4, 1993. http://www.nybooks.com/articles/1993/11/04/prophets-with-honor/.

"Marilyn Monroe Doing a Ceremonial First Kick of a Soccer Ball before a Match between USA and Israel in 1957." https://histolines.wordpress.com/2017/08/18/marilyn-monroe -doing-a-ceremonial-first-kick-of-a-soccer-ball-before-a-match-between-usa-and-israel -in-1957/.

Maudlin, Michael. "Be Careful What You Pray For: The Strange Tale of the Controversial Bishop Pike and His Fatal Quest for Relevance." *Books Culture: A Christian View*, August 2014. http://www.booksandculture.com/articles/webexclusives/2004/august /040830a.html.

McAlister, Melani. "Prophecy, Politics, and the Popular: *The Left Behind Series* and Christian Fundamentalism's New World Order." *South Atlantic Quarterly* 102, no. 4 (Fall 2003): 773–98.

McCullough, David. *Truman*. New York: Simon and Schuster, 1992.

McSmith, Andy. "Israel Lets It Be—with Apology for Banning Beatles 43 Years Ago." *Independent*, January 29, 2008. http://www.independent.co.uk/news/world/middle -east/israel-lets-it-be-ndash-with-apology-for-banning-beatles-43-years-ago-775174 .html.

Mearsheimer, John J., and Stephen M. Walt. *The Israel Lobby and the U.S. Foreign Policy*. New York: Farrar, Straus and Giroux, 2007.

Medoff, Rafael. "Ben Hecht's 'A Flag Is Born': A Play That Changed History." David S. Wyman Institute for Holocaust Studies. April 2004. http://new.wymaninstitute.org /2004/04/special-feature-ben-hechts-a-flag-is-born-a-play-that-changed-history/.

Meir, Golda. *As Good as Golda: The Warmth and Wisdom of Israel's Prime Minister*. Compiled and edited by Israel Shenker and Mary Shenker. New York: McCall, 1970.

Meir, Menahem. *My Mother Golda Meir: A Son's Evocation of Life with Golda Meir*. New York: Arbor House, 1983.

Mendelson, Edward. "Auden and God." *New York Review of Books*, December 6, 2007. http://www.nybooks.com/articles/2007/12/06/auden-and-god/.

———. "The European Auden." In *The Cambridge Companion to W. H. Auden*, edited by Stan Smith, 55–67. Cambridge: Cambridge University Press, 2004.

———. *Later Auden*. New York: Farrar, Straus and Giroux, 1999.

Meyer, Kinereth. "John Steinbeck's Promised Lands." *Steinbeck Studies* 15, no. 2 (Fall 2004): 75–88.

Michaels, Sean. "Paul McCartney Promises Israel Gig Will Go Ahead Despite Death Threats." *Guardian*, September 16, 2008. https://www.theguardian.com/music/2008 /sep/16/mccartney.refuses.to.cancel.gig.

Miller, J. E., Jr. *A Reader's Guide to Herman Melville*. New York: Farrar, Straus and Cudahy, 1962.

Millgram, Abraham E. *Jerusalem Curiosities*. Philadelphia: Jewish Publication Society, 1990.

Moore, Deborah Dash. "*Exodus*: Real to Reel to Real." In *Entertaining America: Jews, Movies and Broadcasting*, edited by J. Hoberman and Jeffrey Shandler. Princeton, N.J.: Princeton University Press, 2003.

"Mozart in the Desert." *Time* 52, no. 23 (December 6, 1948).

Mumford, Lewis. *Herman Melville*. New York: Harcourt, 1929.

Myers, David M. "Partition and the Triumph of Zionist Pragmatism." *Jewish Journal*, November 24, 2015. http://jewishjournal.com/opinion/179835/.

Nadel, Ira. *Leon Uris: Life of a Best Seller*. Austin: University of Texas Press, 2010.

Nahshoni, Kobi. "Safed Rabbi Asks Madonna to 'Perform in Modest Clothing.'" *Jewish World*, August 31, 2009. https://www.ynetnews.com/articles/0,7340,L-3769802,00 .html.

Nakdimon, Shlomo. *First Strike: The Exclusive Story of How Israel Foiled Iraq's Attempt to Get the Bomb*. New York: Harper Collins, 1987.

Nasaw, David. *The Patriarch: The Remarkable Life and Turbulent Times of Joseph P. Kennedy*. New York: Penguin Books, 2012.

Neff, Donald. *Warriors at Suez: Eisenhower Takes America into the Middle East*. New York: Linden Press / Simon and Schuster, 1981.

Negbi, Moshe. *Coming Apart: The Unraveling of Democracy in Israel*. Jerusalem: Keter, 2004.

Nesvisky, Matt. "Mencken in Palestine." *Jerusalem Report*, July 26, 2004.

"Netanyahu Sends Christmas Greeting from Snowy Jerusalem." *Jerusalem Post*, December 24, 2013. https://www.jpost.com/International/Netanyahu-sends-Christmas -greeting-from-snowy-Jerusalem-336044.

Obenzinger, Hilton. *American Palestine: Melville, Twain, and the Holy Land Mania*. Princeton, N.J.: Princeton University Press, 1997.

———. "Herman Melville Returns to Jerusalem." *Journal of Palestine Studies* 43 (2010): 31–39. http://www.palestine-studies.org/jq/fulltext/78374.

———. "Holy Land Narrative and American Covenant: Levi Parsons, Pliny Fisk and the Palestine Mission." *Religion Literature* 35, no. 2/3 (Summer–Autumn 2003): 241–67.

O'Loughlin, Toni. "Truth after 42 Years: Beatles Banned for Fear of Influence on Youth." *Guardian*, September 21, 2008. https://www.theguardian.com/world/2008/sep/22 /israelandthepalestinians.thebeatles.

Olupona, Jacob. Review of *Thin Description: Ethnography and the African Hebrew Israelites of Jerusalem*, by John L. Jackson Jr. *Journal of the American Academy of Religion* 84, no. 3 (September 2016): 872–77.

Oren, Michael. *Power, Faith, and Fantasy: America in the Middle East, 1776 to the Present*. New York: W. W. Norton, 2007.

Oz, Amos. *A Tale of Love and Darkness*. Translated by Nicholas de Lange. New York: Harcourt, 2004.

Pappé, Ilan. *The Forgotten Palestinians: A History of the Palestinians in Israel*. New Haven, Conn.: Yale University Press, 2013.

Pardes, I. *Melville's Bibles*. Berkeley: University of California Press, 2008.

Parini, Jay. *John Steinbeck: A Biography*. New York: Henry Holt, 1995.

Parker, H. *Herman Melville: A Biography*. Baltimore: Johns Hopkins University Press, 1996–2002.

Parsons, David. "Begin and the Evangelicals." The Blogs, *Times of Israel*, March 27, 2014. http://blogs.timesofisrael.com/begin-and-the-evangelicals/.

Patten, H. A. *Israel and the Cold War: Diplomacy, Strategy and the Policy of the Periphery at the United Nations*. London: I. B. Tauris, 2013.

"Paul McCartney Performs First Israel Concert in Tel-Aviv." *Fox News*, September 25, 2008. http://www.foxnews.com/story/2008/09/25/paul-mccartney-performs-first -israel-concert-in-tel-aviv.html.

"Paul McCartney Wins Israel's Prestigious Wolf Prize." *Jewish Telegraphic Agency*, February 12, 2018. https://www.jta.org/2018/02/12/news-opinion/israel-middle-east /paul-mccartney-wins-a-prestigious-prize-in-israel.

Pearlman, Wendy. *Occupied Voices: Stories of Everyday Life from the Second Intifada*. New York: Nation Books, 2003.

Perry, Yaron. "John Steinbeck's Roots in Nineteenth-Century Palestine." *Steinbeck Studies* 15, no. 1 (2004): 46–72.

Peters, Joan. *From Time Immemorial: The Origins of the Arab-Jewish Conflict over Palestine*. New York: Harper and Row, 1984.

Pfeffer, Anshel. *Bibi: The Turbulent Life and Times of Benjamin Netanyahu*. New York: Basic Books, 2018.

Porath, Yehoshua. "Mrs. Peter's Palestine." *New York Review of Books*, January 16, 1986. http://www.nybooks.com/articles/1986/01/16/mrs-peterss-palestine/.

Powell, Michael. "Jimmy Carter's 'Peace' Mission to Brandeis." *Washington Post*, January 24, 2007. http://www.washingtonpost.com/wp-dyn/content/article/2007/01/23 /AR2007012301668.html.

Powers, Ron. *Mark Twain: A Life*. New York: Free Press, 2005.

Pratley, Gerald. *The Cinema of Otto Preminger*. Bailiwick of Jersey: A. S. Barnes, 1971.

Raab, Selwyn. *Five Families: The Rise, Decline, and Resurgence of America's Most Powerful Mafia Empires*. New York: Thomas Dunne Books, 2005.

Raviv, Dan, and Yossi Melman. *Spies against Armageddon: Inside Israel's Secret Wars; Updated and Revised*. New York: Levant Books, 2014.

"Ray Charles Bio." RollingStone. Accessed February 15, 2018. https://www.rollingstone .com/music/artists/ray-charles/biography.

Roberts, Beth E. "W. H. Auden and the Jews." *Journal of Modern Literature* 28, no. 3 (Spring 2005): 87–108.

Rogers, Lisa. "A Bard for the Powerless." *Humanities* 22, no. 6 (November/December 2001). https://www.neh.gov/humanities/2001/novemberdecember/feature/bard -the-powerless.

Rogovoy, Seth. *Bob Dylan: Prophet, Mystic, Poet.* New York: Scribner, 2009.

Rosen, Bryant. "Respect Jewish Dissent on Israel." *Forward*, August 22, 2013. https://forward.com/opinion/israel/182803/respect-jewish-dissent-on-israel/?attribution=author-article-listing-5-headline.

Rosenberg, Yair. "Five Key Takeaways from Gallup's Annual Poll That Found American Support for Israel at Record High." *Tablet Magazine*, March 15, 2018. http://www.tabletmag.com/scroll/257597/five-key-takeaways-from-gallups-annual-poll-finding-american-support-for-israel-at-record-high.

Roth, Phillip. *The Counterlife.* New York: Farrar, Straus and Giroux, 1986.

Russo, Yocheved Miriam. "I Am Juanita." *Jerusalem Post*, May 24, 2007. http://www.jpost.com/Features/I-am-Juanita.

Said, Edward, and Christopher Hitchens, eds. *Blaming the Victims: Spurious Scholarship and the Palestinian Question.* London: Verso, 1988.

Sarris, Andrew. *Interviews with Film Directors.* New York: Bobbs-Merrill, 1967.

Sasson, Theodore. *The New American Zionism.* New York: New York University Press, 2014.

Saval, Malina. "Israeli TV Makes Huge Inroads Stateside." *Variety*, June 8, 2017. http://variety.com/2017/tv/awards/israeli-tv-makes-huge-inroads-stateside-emmis-wisdom-crowd-1202457550/.

Scheinerman, Naomi. "Israel Government and Politics: Policy on Extradition." *Jewish Virtual Library.* Accessed January 13, 2018. https://www.jewishvirtuallibrary.org/israeli-policy-on-extradition.

Schoffman, Stuart. "Robert Capa's Road to Jerusalem." *Jewish Review of Books*, Winter 2016. https://jewishreviewofbooks.com/articles/1969/robert-capas-road-to-jerusalem/.

Segev, Tom. *Elvis in Jerusalem: Post-Zionism and the Americanization of Israel.* Translated by Haim Watzman. New York: Metropolitan Books, 2001.

———. "J. F. K. in the Land of Milk and Honey." *Haaretz*, October 19, 2012. https://www.haaretz.com/.premium-jfk-in-the-land-of-milk-and-honey-1.5193683.

Sharif, Omar. *The Eternal Male.* With Marie Thérèse Guinchard. Translated by Martin Sokolinsky. Garden City, N.Y.: Doubleday, 1977.

Shattan, Joseph. "Why Breira?" *Commentary*, April 1, 1977. https://www.commentarymagazine.com/articles/why-breira/.

Shavelson, Melville. *How to Make a Jewish Movie.* New York: W. H. Allen/Virgin Books, 1971.

Shaw, Arnold. *Sinatra: Twentieth-Century Romantic.* New York: Holt, Rinehart and Winston, 1968.

Shawn, Allen. *Leonard Bernstein: An American Musician.* New Haven, Conn.: Yale University Press, 2014.

Sheean, James Vincent. *In Search of History.* London: Hamish Hamilton, 1935.

Sherman, A. J. *Mandate Days: British Lives in Palestine, 1918–1948.* London: Thames and Hudson, 1998.

Sherwood, Harriet, and Matthew Kalman. "Stephen Hawking Joins Academic Boycott of

Israel." *Guardian*, May 7, 2013. https://www.theguardian.com/world/2013/may/08
/stephen-hawking-israel-academic-boycott.

Shindler, Colin. *The Land beyond Promise: Israel, Likud, and the Zionist Dream*. London:
I. B. Tauris, 2002.

Shipler, David K. "Prime Minister Begin Defends Raid on Iraqi Nuclear Reactor; Pledges
to Thwart a New 'Holocaust.'" *New York Times*, June 10, 1981. http://www.nytimes
.com/1981/06/10/world/prime-minister-begin-defends-raid-iraqi-nuclear-reactor
-pledges-thwart-new.html?pagewanted=all.

Silk, Dennis, ed. *Fourteen Israeli Poets: A Selection of Modern Hebrew Poetry*. London:
Deutsch, 1976.

Silver, M. M. *Our Exodus: Leon Uris and the Americanization of Israel's Founding Story*.
Detroit, Mich.: Wayne State University Press, 2010.

Silverberg, Marshall. "International Law and the Use of Force: May the United States
Attack the Chemical Weapons Plant at Rabta?" *Boston College International and
Comparative Law Review* 13, no. 1 (1990): 53–89. http://lawdigitalcommons.bc.edu/cgi
/viewcontent.cgi?article=1356context=iclr.

Sizer, Stephen. *Christian Zionism: Road-Map to Armageddon?* London: IVP Academic,
2006.

Smith, Herman C., ed. *History of the Reorganized Church of Jesus Christ of Latter Day
Saints*. Vol. 4, 1896. Accessed January 27, 2018. http://www.centerplace.org/history/ch
/v4ch25.htm.

Solomon, Abba A. *The Speech and Its Context: Jacob Blaustein's Speech, "The Meaning of
Palestine Partition to American Jews," Given to the Baltimore Chapter, American Jewish
Committee, February 15, 1948*. Lulu.com, 2011.

"Soul of the Holy Land—The Lost Concert (1972)." Ray Charles Video Museum, Febru-
ary 26, 2010. http://raycharlesvideomuseum.blogspot.com/2010/02/soul-of-holy-land
-lost-concert.html.

Spender, Stephen, ed. *W. H. Auden: A Tribute*. London: Weidenfeld and Nicholson, 1975.

Staff, Toi, and Debra Kamin. "Scarlett Johansson Rejects Criticism of Her SodaStream
Role." *Times of Israel*, January 25, 2014. https://www.timesofisrael.com/scarlett
-johansson-responds-to-sodastream-criticism/.

Standley, Fred R., and Louis H. Pratt, eds. *Conversations with James Baldwin*. Jackson:
University Press of Mississippi, 1989.

Staub, Michael E. *Torn at the Roots: The Crisis of Jewish Liberalism in Postwar America*.
New York: Columbia University Press, 2002.

Stein, Ken. "My Problem with Jimmy Carter's Book." *Middle East Quarterly* 14, no. 2
(Spring 2007): 3–15. http://www.meforum.org/1633/my-problem-with-jimmy
-carters-book.

Steinberg, Jessica. "Beatles Drummer Ringo Starr to Hit Tel Aviv in June." *Times of Israel*,
January 2, 2018. https://www.timesofisrael.com/beatles-drummer-ringo-starr-to
-hit-tel-aviv-in-june/.

———. "Madonna Launches Tour with a Bang, Tells Crowd They Can't Admire Her and

Not Want Peace." *Times of Israel*, May 31, 2012. https://www.timesofisrael.com
/madonna-concert/.

"Stevie Wonder in Israel for Concerts." *UPI*, August 23, 1995. https://www.upi.com
/Archives/1995/08/23/Stevie-Wonder-in-Israel-for-concerts/9428809150400/.

"Stevie Wonder to Reportedly Pull Out of Friends of IDF Gig." *Times of Israel*, November 29, 2012. http://www.timesofisrael.com/stevie-wonder-to-reportedly-pull-out-of
-friends-of-idf-gig/?fb_comment_id=406112089459538_4337595#f2ce754b7d78d9.

Stone, Robert. *Damascus Gate*. New York: Mariner Books, 2011.

Tessler, Mark. *A History of Israeli-Palestinian Conflict*. Bloomington: Indiana University
Press, 1994.

Teveth, Shabtai. *Ben Gurion: The Burning Ground, 1886–1948*. New York: Houghton
Mifflin, 1987.

Tharoor, Ishaan. "Why Scarlet Johansson's SodaStream Is Leaving the West Bank."
Washington Post, October 31, 2014. https://www.washingtonpost.com/news
/worldviews/wp/2014/10/31/why-scarlett-johanssons-sodastream-is-leaving-the
-west-bank/?utm_term=.0a0eb9c878ad.

Torossian, Ron. "Metropolitan Opera Romanticizes One NYer's Murder." *New York Post*,
June 16, 2014. https://nypost.com/2014/06/16/metropolitan-opera-romanticizes
-one-nyers-murder/.

Trumbull, C. G. *A Pilgrimage to Jerusalem: The Story of the Cruise to the World's Fourth
Sunday-School Convention, held in the City of Jerusalem, and of a Ride through Palestine*. Philadelphia: Sunday School Times, 1905.

Turner, Steve. *The Man Called Cash: The Life, Love, and Faith of an American Legend*.
New York: Thomas Nelson, 2005.

Tutu, Desmond. "Of Occupation and Apartheid, Do I Divest?" *Tricenter*, October 19,
2002. http://www.trinicenter.com/modules.php/modules.php?name=Newsfile
=printsid=83.

Twain, Mark. *The Innocents Abroad, or the New Pilgrims' Progress*. Hartford, Conn.:
American Publishing, 1897.

Uris, Leon. *Exodus*. Garden City, N.Y.: Doubleday, 1958.

———. *The Haj*. Garden City, N.Y.: Doubleday, 1984.

van Crefeld, Martin. "Moshe Dayan, Vietnam, and Iraq." Shalom Center, June 30, 2004.
https://theshalomcenter.org/content/moshe-dayan-vietnam-iraq.

Vester, Bertha Spafford. *Our Jerusalem: An American Family in the Holy City, 1881–1949*.
Garden City, N.Y.: Doubleday, 1950.

Vogel, Lester I. *To See a Promised Land: Americans and the Holy Land in the Nineteenth
Century*. University Park: Pennsylvania State University Press, 1993.

Vulliamy, Ed. "Bridging the Gap, Part Two." *Guardian*, July 13, 2008. https://www
.theguardian.com/music/2008/jul/13/classicalmusicandopera.culture.

Warren, R. P. "Melville the Poet." *Kenyon Review* 8 (1946): 208–23.

Waskow, Arthur. *The Bush Is Burning*. New York: Macmillan, 1971.

Weiner, John. "When Old Blue Eyes Was 'Red': The Poignant Story of Frank Sinatra's

Politics." *New Republic*, March 31, 1986. https://newrepublic.com/article/125328/old
-blue-eyes-red.

"Welcome Esther." Editorial. *Jerusalem Post*, September 20, 2004.

Wessinger, Catherine. *How the Millennium Comes Violently: From Jonestown to Heaven's
Gate*. New York: Seven Bridges Press, 2000. http://people.loyno.edu/~wessing/book
.htm.

"White House Says Improved Ties with Israel Show U.S. More 'Beloved' around the
World." *Jewish Telegraphic Agency*, July 5, 2018.

Whitfield, Stephen J. "Israel as Reel: The Depiction of Israel in Mainstream American
Films." In *Envisioning Israel: The Changing Ideals and Images of North American Jews*,
edited by Allon Gal. Jerusalem: Magnes Press, 1996.

———. "Leon Uris (1924–2003)." *Jewish Quarterly Review* 94, no. 4 (Fall 2004): 666–71.

———. "The Politics of Pageantry, 1936–1946." *American Jewish History* 84, no. 3
(September 1996): 221–51.

Wise, Stephen. "Statement from *The Jewish Chronicle*, London, October 30, 1931."
Jewish Virtual Library. http://www.jewishvirtuallibrary.org/statement-by-dr-stephen
-wise-on-gandhi-october-1931.

"With 'a Heavy Heart,' Stevie Wonder Pulls Out of Friends of the IDF Concert." *Times
of Israel*, December 1, 2012. https://www.timesofisrael.com/citing-a-heavy-heart-stevie
-wonder-pulls-out-of-friends-of-the-idf-concert/.

World Sunday-School Convention (4th: 1904: Jerusalem) Central Committee. *The Cruise
of the Eight Hundred to and through Palestine*. New York: Christian Herald, 1905.

Wright, Lawrence. *Thirteen Days in September: The Dramatic Story of the Struggle for
Peace*. New York: Vintage, 2015.

Yudkin, Gila. "Holy Land Headliners: Whatever Happened to Bishop Pike?" *Pilgrimage
Panorama with Gila, Your Holy Land Guide*. Accessed January 17, 2018. http://www
.itsgila.com/headlinersbishoppike.htm.

"Zionists Jeopardize Status of U.S. Jews." *Jewish Telegraphic Agency*, November 2, 1949.
https://www.jta.org/1949/11/02/archive/zionists-jeopardize-status-of-u-s-jews
-dorothy-thompson-tells-council-for-judaism.

INDEX

Abraham, 29, 136, 137, 168, 181
Abu El-Haj, Nadia, 179, 182
Achille Lauro (cruise ship), 189
"Action for Palestine," 82
Adams, George, 18–22, 23, 24
Adams, John, 189
Adams, Julia, 11
Adams Colony, 18–22, 23, 24, 25
Affair, The (television show), 9, 192
African Hebrew Israelite Nation of
 Jerusalem, 9, 166–69, 172
African nations, 3, 94, 95, 96
"Age of Anxiety, The" (Auden), 105
Agranat Commission, 133
Albright, William Foxwell, 60
Alcoholics Anonymous, 59
Algeria, 62
Allen, Woody, 8, 154–55
Allenby, Edmund, 31, 32, 35, 39–40
Alley, Abigail, 22
Al Qaeda, 8
Alta California newspaper, 23
Alterman, Eric, 182
Amen Corner, The (Baldwin), 3, 96
American Academy of Arts and Letters,
 59
American Bible Belt, 7
American Christian Palestine Committee,
 60
American Colony Hotel Jerusalem, 24, 27,
 110
American Colony in Jerusalem, 24, 25–27,
 28
American Communist Party, 67
American Evangelical Christians: support
 for Israel, 6–7, 8, 119, 122, 125, 153, 179,
 181, 193–95; and Christian Zionism, 8,
80, 119, 137; Islam condemned by, 8, 149,
 194; and end-time ideas, 15; and World
 War I victory in Palestine, 31; and *Gospel
 Road,* 122; and Johnny Cash, 122, 123,
 125; support for Israeli Right, 135–38,
 144, 171, 172, 175; on occupied territo-
 ries, 136; and First Lebanon War, 145;
 Jerusalem as focus of, 145, 146; and Leon
 Uris's *The Haj,* 149; and Ariel Sharon,
 176; and Bob Dylan, 185, 186; and U.S.
 embassy in Jerusalem, 195
American Fund for Israel Institutions, 68,
 69
American Hotel, Jaffa, 24
American Israel Cultural Foundation, 69,
 96
American-Israeli cultural exchange: and
 U.S.-Israel relationship, 2, 3, 6, 7, 9, 130,
 131, 190, 197; and television program-
 ming, 9, 192–93; and Leonard Bernstein,
 58, 59, 63–65, 66, 69–70, 72, 173; and
 American creative class, 68–69, 71; and
 Leon Uris's *Exodus,* 80; and boycott of
 Israel, 182–84
American Israel Public Affairs Committee
 (AIPAC), 117, 142, 172
American Jewish Committee (AJC), 70–
 71, 93
American Jewish Right, 137
American Jewish Zionism, 35, 41
American League for a Free Palestine, 53
American Mercury, 38
American Pentecostals, 94, 96, 121, 194
American Red Cross, 35
American Report (journal), 119
American School of Oriental Study and
 Research in Palestine, 28

Americans for Democratic Action, 59
Amichai, Yehuda, 104, 107–9, 110
Amir, Yigal, 141, 170
Amit, Meir, 72
Andover Theological Seminary, 10, 11, 12–13
Anglican Church, 3–4, 21, 105, 106
Ansen, Alan, 105, 109–10
Anti-Defamation League, 115, 140, 179, 181–82, 184, 189
Arab Attitudes to Israel (Harkabi), 140
Arab-Israeli relationship: and wars, 5, 111; in Leon Uris's *Exodus*, 75–76, 77; in Otto Preminger's film *Exodus*, 77–78; and Israel's wars of defense, 118; and occupied territories, 139, 140; in Joan Peters's *From Time Immemorial*, 149–51
Arab-Jewish relations: Jerusalem riots of 1929, 43–44, 47; and Revisionism, 45; and Hebrew University, 46; and bi-nationalism, 47, 51; Martin Buber on, 51
Arab League, 62–63, 82, 113
Arab Question, 45–46
Arab Revolt of 1916, 32
Arab Revolt of 1936, 46
Arafat, Yasser, 114, 155
Ariel, Yaakov, 172
Armageddon, 6, 147
Ascent Center, Safed, Israel, 160
Ashdod, as ancient Hebrew place-name, 14–15
Ashkenazi elite, 133
Asia, and American Zionism, 47, 48, 49
Assemblies of God, 194
Association of Arab University Graduates, 119
Aswan Dam, 75
Atlas, James, 100, 102
Auden, W. H., 104–10
Avnery, Uri, 140

Baldwin, James, 2–3, 93–97, 99–100
Balfour Declaration, 21, 30, 31–32, 43, 45, 48

ballets: USA (dance troupe), 69
Balmer, Randall, 181
Bancroft, Anne, 7, 131
Baptist Church, 120, 166
Barenboim, Daniel, 71, 131, 173–75, 193
Barghouti, Omar, 183
Baryshnikov, Mikhail, 7, 131
Batsheva Dance Company, 190
Battle Cry (Uris), 74
Battle of Beersheba, 62, 63, 65
BDS movement, 183–84, 186–87, 192–93
Beatles, 187–88
Beat poets, 104
Bedouins, 29
Beecher, Henry Ward, 23
Beersheba, Israel, 168, 169, 186
Beethoven, Ludwig van, 64
Begin, Menachem: on Vladimir Jabotinsky, 44; on Robert Soblen, 88; and Revisionist Zionism, 88, 130, 133; and Meyer Lansky, 129–30; and Palestinian refugees, 132; election of, 134, 135; Holocaust rhetoric of, 137, 143; and Jerry Falwell, 137, 194; and Ariel Sharon, 139, 175; Yehoshafat Harabi on, 141; and Camp David Accords, 142, 155; and Iraq's Osirak nuclear reactor, 143, 144
Beirut, Port of, steamship travel to, 16, 23
Beitar Hymn, 42
Beitar movement, 92
Beit Hatfutsot, Museum of the Jewish People, Tel Aviv, 187
Belafonte, Harry, 6
Bellow, Alexandra, 101
Bellow, Saul, 100–102, 150
Ben Ammi (Ben Carter), 166–69
Ben David, Ruth, 89–91
Ben Gurion, David: on Leon Uris's *Exodus*, 6, 80; as Labor Zionist, 42, 43; as prime minister of Israel, 43, 70; on Revisionism, 43, 92; and Judah L. Magnes, 46–47; on Biltmore Declaration, 54; on Jewish homeland, 56; establishment of state

of Israel, 62, 86; and Leonard Bernstein, 70, 72; and Jacob Blaustein, 70–71; and Israel's Independence Day celebrations, 83; and Robert Capa, 84, 86; and Yossele Schumacher, 90, 91, 92; on Law of Return, 128; and Ray Charles, 133; and visiting American Pentecostals, 194

Ben Gurion, Paula, 70

Ben Hecht (ocean liner), 53

Berg, Karen, 159

Berg, Michael, 158–59, 161

Berg, Philip, 158–59

Berg, Yehuda, 159

Berger, John, 183–84

Bergman, Ronen, 8, 115

Berlin Olympics (1936), 52

Bernstein, Felecia, 71–72

Bernstein, Leonard: U.S.-Israel relationship, 2; support for Israel in First Arab-Israeli War, 4, 63–64; and American Zionism, 55, 56, 58, 59, 67; and Israel, 55, 56, 59, 63, 65–66, 67, 68, 69, 70; support for state of Israel, 55, 56, 59, 63, 65–66, 67, 68, 173; on suggestion of name change, 55–56, 84, 163; support for musical institutions in Palestine, 58, 59; and Israel Philharmonic Orchestra, 63–65, 66, 69–70, 72, 173; performances for Israeli troops, 63–65, 71; political activism of, 66, 67–68; collaboration with Jerome Robbins on *West Side Story*, 66–68, 71

Bernstein, Shirley, 71

Berrigan, Daniel, 119–20

Bethlehem, 1, 16, 110

biblical archaeology, 13, 14, 28, 60, 182

Biltmore Declaration, 54

Biltmore Hotel, New York, 33, 54

Biryonim (Thugs), 46

Black Hebrews, 167, 168, 169

Black Israel, 167

Black Scholar (journal), 97

Blackstone, William, 25

Blackstone Memorial, 25, 30

Blaming the Victims (Said and Hitchens), 150

Blaustein, Jacob, 70–71

Blood of Abraham, The (Carter), 181

B'nai B'rith, 115, 133, 179

Book of Mormon, 20

Boone, Debby, 131

Boone, Pat, 7, 80, 131

Boston Post, 61

Boston Symphony Orchestra, 55–56

Branch Davidians, 146–47

Brando, Marlon, 53

Brazil, 195

Bregman, Ahron, 176

Breira, 116–17, 118

Brethren of the Twelve, 21

Brigham Young University (BYU), 20, 153

Britain: Palestine as British Mandate territory, 3–4, 27, 32, 35–36, 41, 43, 45, 46, 48, 56–57, 58, 60, 61, 132, 150; American colonies of, 11–12, 20; Balfour Declaration, 21, 30, 31–32, 43, 45, 48; attack on *Exodus 1947*, 57; and Suez War of 1956, 71–72; and Robert Soblen, 88; Jewish Brigade of army, 107

British Jews, and Zionism, 47, 177

British National Council, 38

British Royal Commission, 47

British World's Sunday School Association, 27–28

Brit Shalom (Covenant of Peace), 45–46

Bronner, Ethan, 179

Brooklyn Academy of Music, 189

Brown, Bobbi Kristina, 169

Brown, Bobby, 9, 169

Brynner, Yul, 80

Buber, Martin, 50–51

Burg, Yosef, 129

Burton, Humphrey, 65–66, 69

Bush, George H. W., 195

Bush, George W., 8, 195

Byroade, Henry, 87
BYU Jerusalem Center for Middle East
Studies, 153

Cale, J. J., 166
Calvary, 28
Camp Agudah, Ferndale, New York, 91
Camp David Accords (1978), 142–43, 155,
156, 179
Camp Herzl, Wisconsin, 186
Campus Crusade for Christ, 122
Capa, Robert, 84–86
Capra, Frank, 52
Carter, Ben, 166–68
Carter, Jimmy, 60, 97, 142–43, 155, 178–
81
Carter Center, Atlanta, 180
Case for Israel, The (Dershowitz), 179
Cash, Carrie, 120
Cash, Johnny, 1–2, 6, 103, 120–23, 125, 135,
163
Cash, June Carter, 1–2, 6, 120–23, 125,
135
Cast a Giant Shadow (film), 80–81, 84
Cathedral of St. John the Divine, New
York City, 123, 124
Catskill Mountains, 91
Chabad Hasidim, 176, 185, 186
Chabad-Lubavitch, 175
Champney, Elizabeth, 16
Charles, Ray, 2, 133–34
Chautauqua Lake, New York, 16
Children's Museum, Yad Vashem Holo-
caust Memorial, 84
China, 111
Cholera, 22
Christians and Christianity: Jerusalem as
site of New Testament events, 14, 57,
110; conversions of Muslims to, 38; and
Jerusalem YMCA, 38; stereotypes of
Jews, 50; and W. H. Auden, 104, 105,
106–7, 109; and ecumenism, 109; Israel
as religious symbol for, 194

Christian Science Monitor, 80
Christians United for Israel (CUFI), 172,
195
Christian Zionism: and support for Israel,
2, 6, 7, 59–61, 80, 193, 194, 195; and Old
Testament, 7, 136–37; and First Intifada,
8; and American Evangelical Christians,
8, 80, 119, 137; and British forces in Jeru-
salem in 1917, 31; and Dorothy Thomp-
son, 33; and Menachem Begin, 137; and
Benjamin Netanyahu, 190–91
Church, Frederick, 13
Churchill, Winston, 56
Church of Jesus Christ of Latter-day
Saints. See Mormon Church
Church of the Holy Sepulchre, 28, 110,
146
Church of the Messiah, 18, 19, 20, 23
Church of the Nativity, Bethlehem, 110
Clarel (Melville), 18
Clergy and Laity Concerned About the
War in Vietnam, 119
Clinton, Bill, 155–56, 195
Clouds over Europe (film), 34
Coca-Cola, 62–63
Cohen, Leonard, 65
Cold War, 58, 75, 111–12, 120
Columbia University, 97, 123
Commentary (journal), 93
Communist Party, 67, 69, 105
Confessions of a Nazi Spy (film), 34
Confidence Man, The (Melville), 17
Connolly, Cyril, 104
Conservative Jews, 58, 68, 117, 165
Conversation Peace (record album), 172
Copland, Aaron, 4, 67
Coptic Christians, 28
Cosa Nostra, 128
Costello, Elvis, 183
Counterlife, The (Roth), 151–53
Cruise of the Eight Hundred to and through
Palestine, The, 29
Crusades, 35

Dan, Joseph, 159
Darby, John Nelson, 26
Davis, Clive, 166
Davis, Francis, 81
Davis, Sammy, Jr., 7, 131
Dayan, Moshe, 6, 83, 112
Deadliest Lies, The (Foxman), 182
Dead Sea Scrolls, 125, 178
Dean Pike (television show), 124
Death of Klinghoffer, The (opera), 188–90
Dershowitz, Alan, 179
Dickinson, Angie, 80
Dimona, Israel, 9, 166, 168, 169, 172
Disciples of Christ Church, 144
"Dome of the Rock, The: Jerusalem (1970)" (Kallman), 110
Dorothy Chandler Pavilion, Los Angeles, 131
Douglas, Kirk, 7, 80, 84, 131
Dr. Zhivago (film), 163
Dulles, John Foster, 87
Du Pré, Jacqueline, 173
Dylan, Bob, 2, 103, 184–87

Eastern Orthodox Church, 14, 15, 28, 38, 146
Eban, Abba, 118, 137
Edwards, Jonathan, 149
Egypt: American missionaries imprisoned in, 12; British commissioner in, 32; Arab League's boycott of Israel, 62; and First Arab-Israeli War, 62; and Suez War of 1956, 71–72, 118; U.S. relations with, 75; expulsion of UN peacekeepers on Sinai Peninsula, 100; and Six-Day War, 100, 103; Jewish Brigade of British army in, 107; and land-for-peace agreement, 113; Israeli relations with, 114, 138, 142–43; and Yom Kippur War, 116, 132; and Camp David Accords, 142; and Madonna, 158
Egypt-Israel Peace Treaty (1979), 143
Eichmann, Adolph, 90, 91

Eisenhower, Dwight, 72
Eliot, T. S., 106, 107
Eliyahu, Shmuel, 161
Emanuel Streisand School of Jewish Studies, 165
Emory University, 180–81
end-time speculation, 10, 14, 26, 147–48, 171–72, 175, 186, 194
Ephraimites, 21
Episcopal Church, 123, 124–25
Eretz Yisrael Hashlemah, 134
Eshkol, Levi, 92
Esquire, 94
Essenes, 125
Eternal Male, The (Sharif), 163
European Left, 104
European Protestants, 27
Evron, Boaz, 138
Exodus (film), 5, 74–75, 77–79, 80, 131, 153
Exodus (Uris), 5–6, 74, 75–77, 78, 79, 80, 148
Exodus 1947 (ship), 57, 76

Faber Book of Modern Verse, The, 107, 108
Facts on the Ground (Abu El-Haj), 179, 182
Fairbanks, Douglas, Jr., 34
Falwell, Jerry, 7, 136–37, 144–45, 193–94
Fauda (television program), 192–93
FBI, 91–92, 119, 147
Feraille, Claude, 89, 90, 91
Feraille, Madeleine, 89–90
Festival of Faith in St. Louis, 178
Fine, Leonard, 117
Finkelstein, Norman, 150
Finley, John H., 35, 37
Fire Next Time, The (Baldwin), 95
Fischer, Louis, 51
Fisk, Pliny, 10–13, 18, 19, 21
Flag Is Born, A (pageant), 53
Floyd, Rolla, 24
Fonda, Henry, 131
For Whom the Bell Tolls (Hemingway), 85
Fountainhead, The (Rand), 196

Foxman, Abraham, 181–82
France, 71–72, 130
Frank, Waldo, 107
Frankiel, Tamar, 159
Franklin, Aretha, 166
Frank Sinatra Brotherhood and Friendship
 Center for Arab and Israeli Children,
 83
Fredric R. Mann Auditorium, Tel Aviv, 72
French Resistance, 89
Freund, Charles Paul, 79
Friedmann, Endre. *See* Capa, Robert
Friends of Gandhi Dinner, New York City,
 48
Friends of the Israeli Defense Forces,
 172–73
From Time Immemorial (Peters), 149–51
Fuller, John, 106
Fuller, Melville, 25
Funny Girl (Broadway musical), 163
Funny Girl (film), 163
Fussell, Paul, 105

Galay, Asaf, 187
Galilee, 29, 145
Gandhi, Mohandas, 48, 49–50, 51, 52,
 201n43
Gaza City, 101
Gelb, Peter, 190
Gemayel family, 145
Gendler, Everett, 117
German Templer settlers, 24
Germany: and World War I, 31
Gershwin, George, *Rhapsody in Blue*, 64
Ghana, 95
Gidley, Hogan, 195
Gill, Brendan, 80
Glenn, John, 144
God Wears Lipstick (Karen Berg), 159
Goebbels, Joseph, 52
Golan Heights: Frank Sinatra's visit to, 83;
 and Six-Day War, 103; Palestinians living
 in, 112; annexation of, 113, 134; Arab

forces engaged in, 114; and Yom Kippur
 War, 116; Israeli occupation of, 175
Goldman, Ari, 58, 73
Goldman, Dov, 58
Goodman, Alice, 189
Goodwin, Doris Kearns, 34
Gordon, Charles, 28
Gore, Al, 190
Gospel Road (film), 6, 122
Go Tell It on the Mountain (Baldwin), 94
Grace Cathedral, San Francisco, 124
Graham, Billy, 1, 124, 135
Graham, Franklin, 8
Graham, Martha, 4, 52
Great Depression, 75
Greek Orthodox Church, 37–38
Greenberg, Hayim, 49, 51
Grosser Kurfurst (steamer), 27, 29
Grossman, David, 156
Guardian, 183
Guatemala, 195
Guayana, 147–48
Guggenheim, Harry, 98
Gun Fight at the O.K. Corral (film), 77
Gush Emunim (The Block of the Faithful),
 139

Haaretz (newspaper), 116, 185, 187
Habimah Theatre Company, 69
Haganah (The Defense): and Labor Zion-
 ism, 43, 78; as Yishuv self-defense force,
 43; American supporters of, 57, 76; and
 First Arab-Israeli War, 62; in Leon
 Uris's *Exodus*, 76, 78; in Otto Premin-
 ger's film *Exodus*, 78; Frank Sinatra's
 support for, 82
Hagee, John, 171–72, 195
Haifa, Israel, 63, 186
Haj, The (Uris), 148–49, 151
Hamechdal (the national blunder), 133
Hamill, Pete, 81
Hampton, Lionel, 93
Hancock, Herbie, 166

Handy, Clarence E., III, 94

Hannity, Sean, 178

Harel, Isser, 90–91

Harijan (newspaper), 49

Harkabi, Yehoshafat, 140–41

Harlem, New York, 93

"Harlem Ghetto: Winter 1948" (Baldwin), 93

Harmon, Arthur, 37

Harper's Magazine, 94, 95

Harrison, Benjamin, 25

Harrison, George, 188

Hart, Moss, 53

Hartford, Connecticut, Israel celebration in, 5

Hartford Theological Seminary, 28

Hartshorn, William, 27

Hasbara (propaganda effort), 144

"Hatikvah" (Israeli national anthem), 7, 72, 131, 153

"Hava Nagila" (folk song), 133

Hawthorne, Nathaniel, 3, 17

Hebrew Bible, 76, 138

Hebrew language, 68, 108–9, 156, 176

Hebrew University, Jerusalem: Land of Israel course at, 25; Judah L. Magnes as president of, 45, 46, 50; Arab language course, 46; Mt. Scopus Campus of, 84; and Alexandra Bellow, 101; and Yeshayahu Leibowitz, 138; and Frank Sinatra, 164; and Barbra Streisand, 164–65

Hebron, 175

Hecht, Ben, 41, 52–53

Hello Dolly (film), 164

Hemingway, Ernest, 85

Herodian, 125

Hertzberg, Arthur, 116, 119–20, 142

Herzl, Theodor, 122

Herzog, Isaac Halevi, 93

Heschel, Abraham Joshua, 138

Hiatt, Brian, 162

Hill of Memory, Yad Vashem Holocaust Memorial, 83

Hinduism, 48, 104

Histadrut, 41–42

Hitchens, Christopher, 150

Hoffman, Anat, 165

Hollywood Bowl, 82

Hollywood film industry, 5, 33–34, 74–75, 77–81

Holocaust: survivors of, 5, 78, 79; in Leon Uris's *Exodus*, 76; in Otto Preminger's film *Exodus*, 78, 79; Saul Bellow on, 102; Arab threat compared to, 118; rhetoric of, 137, 143; as justification for territorial ambitions, 137–38

Homeland (television show), 9, 192

homosexual rights, 124

Hopkins, Gerard Manley, 107

Hourani, Albert, 150

House I Live In, The (film), 81–82, 83

House Un-American Activities Committee, 67, 69

Houston, Cissy, 166

Houston, Patricia, 169

Houston, Whitney, 2, 9, 157, 166, 169

Houteff, Florence, 147

Howard University, 96

Howe, Irving, 101–2, 117

Howell, Rachel, 146

Howell, Vernon Wayne, 146–47

Hurok, Sol, 69

Hussein, Saddam, 142, 189

Hussein, Sharif of Mecca, 32

Hyde, Orson, 20–21, 153

"I'm Bound for the Promised Land" (hymn), 120

Independent, 162

India, 13, 48–49, 50, 51, 123

Indian independence movement, 48

Indian Republic, 201n43

Infidels (record album), 186

Innocents Abroad (Twain), 2, 23, 24–25, 29

Intercontinental Hotel, Mount of Olives, 109, 125, 127

International Atomic Energy Agency, 144
International Christian Embassy in Jerusalem (ICEJ), 137
International Committee of the YMCA in North America, 38
"Internationale, The" (anthem), 42
International YMCA Committee, 39
interreligious cooperation, 35, 38
In the Holy Land (record album), 1, 6, 121, 122
In Treatment (television show), 9, 192
Iran, 95, 196
Iranian Revolution (1979), 143
Iran-Iraq War (1981), 143
Iraq, 62, 143–44, 145, 181
Irgun, 33, 43, 53, 62, 78
Isherwood, Christopher, 104
Ishmael, 29, 181
Islamic states, 131–32
isolationists, 32, 60
Israel Bonds, 72, 73, 93
Israel Defense Forces, 113, 114, 115, 118, 126, 177, 178
Israel Festival of Music and Drama, 96
Israel, Fifty Years (Capa), 86
Israeli Arabs, 111, 112, 139
Israeli Consulate General to the Southeastern United States, 180
Israeli Council for Israeli-Palestinian Peace, 113
Israeli Foreign Ministry, 95, 96, 188
Israeli Interior Ministry, 129, 168
Israeli Jews: in Leon Uris's *Exodus*, 76; Saul Bellow on, 100–101, 102; American Jews' identification with, 111; Israeli Arabs' social status compared to, 112; on Israeli-Palestinian relationship, 112–15, 180; on Golda Meir, 132; and social equality, 133; ideologies of, 134; opposition to occupation, 138–42; divisions of, 153; and First Intifada, 154; and Madonna, 158, 161; on boycotts of Israel, 183

Israeli Law of Return (1950), 86–87, 88, 128, 168
Israeli Left, 130, 132, 134, 135, 170
Israeli Supreme Court, 90, 92, 129
Israelites, 11, 20, 39, 93, 135, 162, 168
Israel Lobby and U.S. Foreign Policy, The (Mearsheimer and Walt), 178–79, 181–82
Israel Philharmonic Orchestra, 63–65, 66, 69–70, 72, 173
Israel Prize, 140
Israel's Fateful Hour (Harkabi), 141
Italian Americans, 81
Italian fascism, 44, 59
It All Adds Up (Bellow), 100
Ives, Burl, 67

Jabotinsky, Vladimir, 42–44, 45, 46
Jabotinsky, Ze'ev, 92
Jabotinsky Medal, 194
Jackson, Michael, 157
Jacobs, George, 6, 83–84
Jaffa: steamship travel to, 13, 16; and Adams Colony, 19, 21–22, 24; and American pilgrimages to Jerusalem, 19, 26, 27; and German Christians, 98
Jarvie, James Newbegin, 38, 39–40
Jenkins, Jerry B., 172
Jenkins, Nicholas, 104, 105
Jerusalem Law, 137
"Jerusalem of Gold" (Israeli song), 153
Jerusalem Post, 158, 191
Jerusalem Prize, 184
Jerusalem syndrome, 146–48
Jerusalem YMCA: funding of, 35, 37, 38; and interreligious cooperation, 35, 38, 39–41; Jerusalem Youth Chorus, 37; American Protestants' support for, 37, 38, 39; and promotion of musical arts, 37, 40; as cultural center, 37, 40–41; building design, 37–38, 39; dedication ceremony for, 39–40; in World War II, 40; membership of, 40–41; and United

Nations Special Committee on Palestine
(UNSCOP), 56–57
Jewish Agency, 54, 56
Jewish Federation, 178
Jewish Frontier (magazine), 49
Jewish mysticism, 159, 160
Jewish National Fund, 35, 80
Jewish paramilitary groups, 33
Jewish youth movements, 42
Jews of Yemen, 69
Johansson, Scarlett, 183–84
Johnson, Lyndon, 99, 112
Jones, Jim, 147–48
Jordan: and United Nations Special
Committee on Palestine (UNSCOP),
57; Arab League's boycott of Israel, 62;
and First Arab-Israeli War, 62, 127, 154;
Christian holy sites in, 83, 104; John
Steinbeck on, 99; and Six-Day War, 100,
103, 127; and land-for-peace agreement,
113; Israeli relationship with, 114; Israel's
peace treaty with, 157
Jordan River, 39, 42, 103, 120, 122, 169
Jowitt, Deborah, 68–69
Judea, 17, 42, 113, 123, 125, 135, 136, 147
Judeo-Christian tradition, 196
Judt, Tony, 177–78

Kabbalah Centre in Tel Aviv, 160
Kabbalah Centre of Los Angeles, 158–59,
161
Kabbalism, 158–63
Kaddish, 92
Kallenbach, Herman, 49
Kallman, Chester, 104, 105, 106–7, 109–10
Kaplan, Justin, 23
Kefauver, Estes, 128
Kelly, Gene, 131
Kennedy, John Fitzgerald, 4, 34, 60–61, 72,
82, 86
Kennedy, Joseph P., 33–34, 60
Kennedy, Joseph P., Jr., 34
Kennedy, Robert, 60, 61, 91, 103

Khartoum Resolution of September 1967,
113
Kibbutz movement, 43, 89, 100, 111, 114
Kibbutz Sde Boker, Negev, 133
Kidd, Thomas, 149
King, Alan, 131
King, B. B., 65
King, Martin Luther, Jr., 60, 134
King David Hotel, Jerusalem, 33, 38
Klatzker, David, 36
Klausner, Amos, 61
Klinghoffer, Leon, 189
Knesset (Israeli parliament): and Israeli
Law of Return, 86, 87, 128; and Yossele
Schumacher, 89; and Ze'ev Jabotinsky's
burial in Jerusalem, 92
Kollek, Teddy, 82, 110
Kook, Zvi Yehuda, 134
Koran, 8
Koresh, David, 146–47
Koussevitzky, David, 93
Koussevitzky, Serge, 55–56, 64–65, 69–70
Kristofferson, Kris, 122
Ku Klux Klan, 52

Labor rights, 67
Labor Zionism: American support for,
41; and Histadrut, 41–42; on need for
national home, 41, 42; tensions with
Revisionism, 41–42, 44, 45, 78; gradual-
ism of, 42; internal divisions of, 42; and
Haganah, 43, 78; decline of, 130; voter
rejection of, 133; and Holocaust rhetoric,
137; tensions with Likud party, 169
Ladach, Misgav, 146
Lahakat Hanahal, 170
LaHaye, Tim, 172
Lake Success, New York, 61
Land-for-peace agreement, 113
Lansky, Max, 128
Lansky, Meyer, 127–30, 155
Lansky, Teddy, 128–29
Lansky (Messicks), 129

Laqueur, Walter, 46
Laurents, Arthur, 66–67
Lawford, Peter, 79
Lawrence, T. E. (Lawrence of Arabia), 32
Lawrence of Arabia (film), 163
Lazar, Zachary, 129
League of Nations, 35–36
Lebanon: and World War I, 31; and United Nations Special Committee on Palestine (UNSCOP), 57; Arab League's boycott of Israel, 62; and First Arab-Israeli War, 62; political structure of, 139; and First Lebanon War, 139, 140, 145, 175; Christian Phalangist forces of, 145
LeBor, Adam, 62
Leeming, David, 94, 95
Leibowitz, Yeshayahu, 112, 138–40, 141
Lennon, John, 188
"Letters from a Journey" (Baldwin), 95
Liberal democracy, 5, 99
Liberia, 95, 167, 168
Life magazine, 85
Likud party, 44, 130, 169, 175, 176
List, Eugene, 93
Live in Jerusalem (record album), 153
Liverpool, England, 17
Livni, Tzipi, 161
Los Angeles Philharmonic Orchestra, 131
Lowenthal, Herman, 21
Luria, Isaac, 161

Ma'ariv (newspaper), 112, 127
McCartney, Paul, 187–88
McCullough, David, 4
McEwan, Ian, 184
McNeil, Claudia, 96
Mad Men (HBO series), 79
Madonna, 2, 9, 157, 158–63, 169
Madrid Peace Conference (1991), 25, 151
Mafia, 128, 129
Magnes, Judah L., 45–47, 50, 51
Magnum Photos, 85–86
Mahler, Gustav, 65, 202n21

Manilow, Barry, 7, 131
Marcus, David "Mickey," 80
Margalit, Avishai, 140
Mark, The (Hagee and LaHaye), 171, 172
Marshall, George, 5
Martin, Dean, 131
Marty, Martin, 194
Masada, 14, 103, 110, 147–48
Massachusetts Jewish War Veterans, 60
Mearsheimer, John, 178–79, 181–82
Meir, Golda, 7, 61, 95, 129, 131–33, 149
Meir, Menachem, 59
Melville, Herman, 3, 13, 17–18, 23–24, 30
Mencken, H. L., 4, 36–37, 38
Mencken, Sara, 4, 38
Mendelson, Edward, 104, 105
Merrill, Robert, 93
Merrill, Selah, 26–27, 28
messianism, 114, 127, 134, 135, 139, 148, 172
Messicks, Hank, 129
Metropolitan Opera House, New York City: Israel Night, 93; and *The Death of Klinghoffer*, 188–90
Middle Eastern Christians, 27
Midler, Bette, 166
Milk and Honey (Broadway musical), 153
Miller, James E., Jr., 18
Mineo, Sal, 78
Misgav Ladach, Jerusalem, 146
Mishkan Tefila Temple, Boston, 68
Mishkenot Sha'anaim, 101
Mizrahim, 133
Moby Dick (Melville), 3, 17, 18
Mondale, Walter, 131
Monroe, Marilyn, 4, 72–73
Moody, Dwight L., 26
Moore, Deborah Dash, 78
Moral Majority, 7, 136, 144, 193
Morgan, J. P., 25
Mormon Church, 19–21, 153
Mormon Tabernacle Choir, 153
Mormon Temple, Kirtland, Ohio, 20
Moroccan immigrants, 89

Morocco, 62
Morris, Jay, 21–22
Morris, Mark, 189
Morrison, Van, 166
Moscow Philharmonic Society, 55
Moses, 168
Mosque of Omar, 28
Mossad (intelligence agency), 90–92
Mostel, Zero, 67
Mount Arbel, 122
Mount Carmel Center, Texas, 147
Mount of Olives, 109–10, 125, 126–28, 153
Mozart, Wolfgang Amadeus, 64
Mr. S: My Life with Frank Sinatra (Jacobs), 83
Mumford, Lewis, 18
Muni, Paul, 53
Murder Incorporated, 127, 155
Mussolini, Benito, 44
My Mother's Hymn Book (record album), 120
Mysticism, 125

Nakba (catastrophe), 62
Nasser, Gamal Abdel, 72, 75, 100, 149, 163
Nation, 60, 94, 97, 107, 182
National Council of Young Israel, 170–71
National Council on American-Soviet Friendship, 67
NATO, 95
Nazareth, 83
Nazareth Youth Center, 84
Negev, Israel, 63–65, 133
"Negroes Are Anti-Semitic Because They're Anti-White" (Baldwin), 96
Negro Soldier, The (documentary), 52
Nellie Chapin (steamship), 18–19, 21
Netanyahu, Benjamin, 44–45, 130, 156, 160–61, 169, 175, 190–91, 196
Netanyahu, Benzion, 44–45, 130
Netanyahu, Sarah, 160–61
Netflix, 192–93
Neturei Karta, 89

New Deal, 67
New Left, 102
Newman, Paul, 75, 79, 131
New Republic, 177
New School, 105
New York American, 32
New York City, 54, 72–73, 104–5, 108, 123
New York City Evening Mail, 32
New Yorker, 80, 94, 95, 101
New York Herald, 23
New York Newsday, 98, 100
New York Philharmonic, 66
New York Post, 189
New York Review of Books, 140, 142, 151, 177–78
New York Times, 8, 37, 66, 88, 128, 154, 155, 179, 192
New York Times Book Review, 101–2
New York Times Magazine, 96
New York Tribune, 23
New York World, 44
Niebuhr, Reinhold, 59–60, 107, 110
Niebuhr, Ursula, 110
Night Train to Munich (film), 34
9/11 attacks, 8–9, 145, 176, 193–94, 195
Nixon, Richard, 84, 116
Notes of a Native Son (Baldwin), 94
Nothing Sacred (film), 52

Obama, Barack, 60, 195
Observer, 150
Old South Church, Boston, 10–11
Olupona, Jacob, 167
"Open Letter to the Born Again" (Baldwin), 97
Oren, Michael, 144, 177
Orthodox Jews: in Palestine, 36; conflict with secular Jews, 88–91, 111; in Paris, 90–91; and Biblical Hebrew, 108–9; and Greater Israel movement, 117, 139; on Madonna, 161
Osirak nuclear reactor, 143–44, 145

Oslo Accords (1993), 27, 141, 155–56, 157, 169, 170

Ottoman Empire: Jerusalem ruled by, 4, 35, 128; and American missionaries imprisoned in Egypt, 12; Palestine ruled by, 14, 16, 24, 31, 35, 182; and World War I, 31; British encouraging rebellion of Arab population, 32; and John Steinbeck's family history in Jaffa, 98

Outrages of Jaffa of 1858, 98

Owl and the Pussycat, The (film), 164

Oxfam, 184

Oz, Amos, 61

Pakistan, 201n43

Palestine: Peace Not Apartheid (Carter), 178–81

Palestine Mania, 3, 30, 193

Palestine Park, Chautauqua, New York, 16

Palestine Philharmonic Orchestra, 40

Palestine Symphony Orchestra, 55, 56, 58–59, 69

Palestinian Authority, and Oslo Accords, 27

Palestinian Campaign for the Academic and Cultural Boycott of Israel, 183

Palestinian Liberation Organization (PLO), 97, 117, 139, 141, 155–56, 189

Panova, Galina, 131

Parini, Jay, 99

Paris Review, 107

Parsons, Levi, 10–13, 18, 19, 21

Parsons, Louella, 81–82

Paton, L. B., 28

Peace Now movement, 116, 170

Peel, Robert, Lord, 47

Peoples Temple, 147–48

Pepsi-Cola, 63

Peres, Shimon, 156, 160

Peters, Joan, 149–51

Petty, Tom, 186

Pfeffer, Anshel, 196

Philology and comparative linguistics, 14

Philo-Semitism, 19, 20, 60, 158

Pickett, Wilson, 166

Pike, Diane Kennedy, 124–26

Pike, Esther Yanovsky, 124

Pike, James, 123–26

Pike, James, Jr., 125

Pilgrimage to Jerusalem, A (Trumbull), 29–30

Pilgrim in Palestine, A (Finley), 37

Plains of Sharon, 19

Plymouth Brethren, 26

Popular Front, 59

Porath, Yehoshua, 151

Pound, Ezra, 108

Powell, Adam Clayton, 93

Preminger, Otto, 75, 77–79

Presbyterian Church, 26

Presley, Elvis, 166

"Previous Condition" (Baldwin), 93

Price, Leontyne, 166

Prideaux, Humphrey, 7

Progressive causes, 67–68

Promised Land, 6–7, 9, 11, 20, 120

Prosor, Ron, 188

Proto-Zionism, 19, 20

Prussia, 98

Quaker City (steamship), 23

Qumran, 125

Raab, Selwyn, 128

Rabbinical Assembly, 117

Rabin, Yitzhak, 8, 141, 153, 154–56, 169–71, 172, 177

Rabinowitz, Jerome Wilson. *See* Robbins, Jerome

Raelettes, 133

Rand, Ayn, 196

Reagan, Ronald, 6, 84, 118, 143–44, 193

Red-baiters, 67

Red Channels, 67

Redding, Otis, 166
Reform Judaism, 47, 48, 58, 165
"Refugee Blues" (Auden), 106
Report on Israel (Shaw and Capa), 86
Republican Party, 193
Return to the Holy Land (television film), 122
Return to the Promised Land (television program), 6
Rhodesia, 139
Ribicoff, Abraham, 5
Ritchie, Guy, 158
Robbins, Jerome, 4, 66–67, 68, 69, 190
Roberts, Beth, 106–7
Roberts, Oral, 6, 121
Robertson, David, 125
Robertson, Pat, 8, 145
Robinson, Edward, 11, 14
Rockefeller, John D., 25
Rolling Stone magazine, 133–34
Romney, Richard, 63
Ronstadt, Linda, 166
Room, George Williams, 39
Roosevelt, Eleanor, 53
Roosevelt, Franklin D., 33–34
Rose, Billy, 53
Roth, Philip, 151–52, 153
Rubinstein, Arthur, 72
Russian Empire, pogroms of early 1880s, 15, 25
Russian Jews, immigration to Palestine, 14, 15, 25
Russian Journal, A (Steinbeck and Capa), 85
Russian Orthodox Church, 55

Sadat, Anwar, 142–43, 155
Safed, Israel, 160, 161
Said, Edward, 135, 150, 173–74, 193
Saint, Eva Marie, 75, 79
St. Peter's Church, Jaffa, 126
Samaria, 113, 135, 136

Santana, Carlos, 183
Sarris, Andrew, 79
Satmar Hasidim, 91
Satyagraha (the force of truth), 50–51
Scarface (film), 52
Schary, Dore, 74
Schlesinger, Arthur, Jr., 60
Schumacher, Yossele, 88–92
Schwartz, Shlomo, 160
Scopes Trial, 36
Scott, Hazel, 93
Scott-Heron, Gil, 183
Sea of Galilee, 83, 122
Second Coming, 7, 10, 26, 194
Second Intifada (2000), 156, 159, 176
Second Temple, and scale model of Palestine in New York, 16
Seeger, Pete, 6
Sellars, Peter, 189
Serenity Prayer, 59
Seventh Day Adventist Church, 146
72 Names of God (Yehuda Berg), 159
Seymour, David, 86
Shamir, Yitzhak, 25, 151
Sharett, Moshe, 87
Sharia law, 195
Sharif, Omar, 163
Sharon, Ariel, 9, 115, 130, 139, 169, 175–77, 178
Shaw, Irwin, 86
Shawn, William, 94
Shea and Gould, 175
Shechem, 175
Sheean, Vincent, 43–44
Sheen, Fulton, 124
Shekhinah, 158
Shin Bet (internal security service), 90
"Shir Hashalom" ("The Song of Peace"), 170
Siev, Mordechai, 159–60
Silk, Dennis, 108
Silver, M. M., 76

Sinai Campaign of 1956, 5, 72

Sinai Peninsula, 100, 101, 103, 114, 116

Sinatra, Frank: and U.S.-Israel relationship, 2; performances for Israeli troops, 6, 65; support for Zionism, 53, 82; on suggestion of name change, 56, 84, 163; in *Cast a Giant Shadow*, 80–81; and civil rights movement, 81; support for Israel, 81; organized crime links of, 82; concerts in Israel, 82–83; world tour of 1962, 82–83; political views of, 84

Sinatra, Nancy, 82

Sinatra in Israel (documentary), 83

Singer, Isaac Bashevis, 164

Sirhan, Sirhan, 61

Six Days of War (Oren), 177

slavery, 11, 19, 75, 167

Smith, Joseph, 19–20, 21, 153

Smith, Juanita, 93

Snyder, Timothy, 178

Soblen, Jack, 87

Soblen, Robert, 87–88, 92, 128

socialism, 42, 67, 104, 130, 133

Socialist Zionism, 45

Societies for the Amelioration of the Condition of the Jews, 10

SodaStream, 183–84

Sondheim, Stephen, 66

South Africa, 43, 49, 50, 96, 119, 173, 179, 182–83

South African Zionist Federation, 49

Southeast Asia, 112

Southern Front, 115

Soviet Union, 72, 75, 87–88, 95, 111, 120

Spafford, Anna, 26–27

Spafford, Bertha, 26

Spafford, Grace, 26

Spafford, Horatio, 26–27

Spanish Civil War, 84, 85

spiritualism, 26

Spoleto International Arts Festival, 108

Stacher, "Doc," 128

Star Is Born, A (film), 164

Starr, Ringo, 188

"Star-Spangled Banner, The" (U.S. anthem), 72

Stars Salute Israel at 30, The (television show), 7, 131, 132, 133, 142, 174

Star Wars (film), 131

Staub, Michael, 117

Stein, Kenneth, 180

Steinbeck, Elaine, 97–98

Steinbeck, John, 76, 85, 97–100, 101

Stern, Isaac, 72, 173

Stern Gang, 33, 62

Stewart, Jon, 169

Straits of Tiran, 100

Streisand, Barbra, 2, 9, 131, 157, 163–66, 169

Streisand, Emanuel, 164

Stuart, Moses, 12–13

Suez Canal, 72, 100, 118

Suez War of 1956 (Suez Crisis, Second Arab-Israeli War), 71–72, 118

Sweet Inspirations, 166

Switzerland, 90

Sword of Truth and Harbinger of Peace, The (magazine), 19

Syria: and World War I, 31; and United Nations Special Committee on Palestine (UNSCOP), 57; and First Arab-Israeli War, 62; and Six-Day War, 100, 103; and land-for-peace agreement, 113; Israeli relations with, 114; and Yom Kippur War, 116, 132

Talmage, Thomas DeWitt, 16

Tel Aviv, Israel: James Baldwin in, 3; Leonard Bernstein in, 4, 63; Stevie Wonder in, 8; American Embassy moved from, 9, 195; and Palestine Philharmonic Orchestra, 40; Jerome Robbins in, 68, 69; Hazel Scott in, 93; and Baldwin's *The Amen Corner*, 96; John Steinbeck in, 98; as focus of American liberals, 145; Madonna in, 157, 161–62; Barbra Streisand in, 165; Yitzhak Rabin in, 169–70; Bob

Dylan in, 184–87; Paul McCartney in, 187–88

Tel Aviv Museum, 62

Ten Lost Tribes of Israel, 21

Tessler, Mark, 56–57

"This Land is Mine" (song), 80

Thomas, Dylan, 107

Thompson, Dorothy, 5, 33

"Three Nos," 113

Three Vassar Girls in the Holy Land (Champney), 16

Time magazine, 65, 95, 124, 175

To Jerusalem and Back (Bellow), 101–2

Tom Petty and the Heartbreakers, 186

Toscanini, Arturo, 58–59

Town Hall Hootenanny concerts, New York, 6

Transjordan, 31

Truman, Harry, 4–5, 60–62

Trumbull, Charles Gallaudet, 29–30

Trump, Donald, 195–96

"Tsenah, Tsenah" (folksong), 6

Tuchman, Barbara, 150

Tunisia, 62

Turkey, 94, 95

Turks: of Palestine, 17. *See also* Ottoman Empire

Tutu, Desmond, 182–83

Twain, Mark, 2, 3, 13, 23–25, 29, 30, 36, 151

Twelve-step programs, 59

United Nations: and British Mandate, 56–57; recognition of Jewish state, 58, 59, 61–62, 78; Palestine partition plan, 58, 61, 82; Egyptian expulsion of UN peacekeepers, 100; resolution equating Zionism with racism, 131–32; condemnation of Israeli airstrike on Iraq, 144; and Stevie Wonder, 173

United Nations General Assembly, 154

United Nations Security Council, 154

United Nations Special Committee on Palestine (UNSCOP), 56–57

United Negro and Allied Veterans of America, 67

U.S. Air Force, 116

U.S. Bureau of Alcohol, Tobacco, and Firearms, 147

U.S. Justice Department, 128, 192

U.S.-Mexican border, 196

U.S. Senate Special Committee to Investigate Crime in Interstate Commerce, 128

U.S. Special Forces, 189

U.S. State Department, 72, 75, 86–87, 96, 143–44, 145

U.S. Supreme Court, 88

U.S. War on Terror, 8

Uriel, Yarden, 188

Uris, Leon, 5–6, 74, 75–79, 80, 86, 148–49, 151

Van der Hoeven, Jan Willem, 137

Variety (journal), 9, 192

Vatican, recognition of Israel, 60

Victoria (queen of England), 39

Vietnam Diary (Dayan), 112

Vietnam War, 99, 111–12, 118, 119, 120, 134

Ville du Havre (luxury liner), 26

Völkischer Beobachter (newspaper), 39

Waco, Texas, 146–47

Wagner, Richard, 71

Walk the Line (film), 1, 123

Walt, Stephen, 178–79, 181–82

War of Attrition, 114, 116

Warsaw Ghetto uprising of April 1943, 51

Warwick, Dionne, 166

Waters, Roger, 158

Wayne, John, 80

Way We Were, The (film), 164

Weavers, 6

Weill, Kurt, 53

Weiner, Jon, 81

Weizmann, Chaim, 42

Weizmann Institute of Science, Rehovot, 110

West–Eastern Divan Orchestra, 173–75, 193

West Side Story (Broadway show), 66–67, 72

West Side Story (film), 67

WEVD (New York City), "Jewish News Hour," 41

We Will Never Die (dramatic pageant), 53

"Where is Yossele?" (song), 90, 91

Whitfield, Stephen, 53, 77, 79

Williams, John, 131

Wilson, Flip, 131

Wilson, Walter, 135

Wilson, Woodrow, 31, 42

Wise, Stephen S., 48

Wolf, Arnold Jacob, 116–17

Wolf Prize, 188

Woman's Home Companion (magazine), 29

Women of the Wall, 165

Wonder, Stevie, 8, 157, 166, 172–73

World's Fourth Sunday-School Convention (1904), 27, 28–30, 146

World War I, 31

World War II: and Joseph Kennedy, 34; British soldiers in Jerusalem, 40; Russia as U.S. ally in, 67; and Robert Capa, 85; and W. H. Auden, 106, 107. *See also* Holocaust

Wright, Lawrence, 143

Wuthering Heights (film), 52

Wyler, William, 163

Yad Vashem Holocaust Memorial, 83–84

Yemenite immigrants, 89

Yentl (film), 164–65

Yiddish, 41, 68, 81, 127, 164

Yishuv, politics of, 41–45, 56

YMCA (Young Men's Christian Association), 37, 38, 39. *See also* Jerusalem YMCA

Yom Kippur War (1973), 44, 110, 111, 116, 119, 132, 138, 173

Young, Andrew, 97

Young, Brigham, 20

Young Men's Hebrew Association (YMHA), 108, 109

Youth Inspirational Choir, New Hope Baptist Church, Newark, New Jersey, 166

Zionist Congress (1925), 41

Zionist Organization of America, 48, 170